The Natural History of the Traditional Quilt

The Natural History of the Traditional Quilt

JOHN FORREST
and
DEBORAH BLINCOE

with illustrations by the authors

University of Texas Press, Austin

Requests for permission to reproduce material from this work should be sent to
Permissions, University of Texas Press, Box 7819, Austin, TX 78713-7819.

∞The paper used in this publication meets the minimum requirements of
American National Standard for Information Sciences—Permanence of
Paper for Printed Library Materials, ANSI z39.48-1984.

Library of Congress Cataloging-in-Publication Data

Forrest, John, date
 The natural history of the traditional quilt / John Forrest and Deborah Blincoe. —
1st ed.
 p. cm.
 Includes bibliographical references and index.
 ISBN 0-292-70809-2
 ISBN 0-292-72497-7 (pbk.)
 1. Quilts—Design. 2. Quiltmakers—Psychology. 3. Quilting—Technique.
4. Folk art. I. Blincoe, Deborah, date. II. Title.
NK9104.F67 1995
 746.46—dc20 94-45169

To Aunt Elizabeth and Aunt Virginia

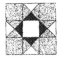

Contents

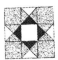

"Toward the End of Winter . . ." ix

"I Never Saw My Mamaw Making Quilts . . ." xv

Preface xix

Acknowledgements xxv

1. Taxonomy 1
 1.1. Introduction 1
 1.2. The Cell 20
 1.3. Seamed Base Categories 30
 1.4. Unseamed Base Categories 51
 1.5. Hybrids and Anomalies 58

2. Morphology 61
 2.1. Introduction 61
 2.2. Overall Construction 61
 2.3. Materials 75
 2.4. Pathology and Anomaly 91

3. Life Cycle 96
 3.1. Introduction 96
 3.2. Conception 97
 3.3. Gestation 126
 3.4. Life Span 153
 3.5. Death (and Rebirth) 157

4. Ecology 160
 4.1. Introduction 160
 4.2. Interaction with Artifacts 161

4.3. Interaction with People 171
4.4. Interaction with the Natural Environment 204

5. Case Study 208
 5.1. Introduction 208
 5.2. Extant Quilts of Anna Butcher Mayo 211
 5.3. The Quilts in the Lives of the Quilter and Her Family 262
 5.4. Kindred Cells in Kindred Quilts 285
 5.5. Anomaly as a Clue to Innovation 310

6. Conclusion 318
 6.1. Quilts and the Transmission of Culture 318

References 327

General Index 331

Index of Quilt Names 347

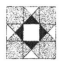 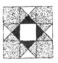

"Toward the End of Winter . . ."

Toward the end of the winter of 1977–1978, I traveled up to the northern Tidewater of North Carolina to live in a small, isolated town for a year and gather data on local aesthetics. My rather grand idea was to document *all* the aesthetic forms of a community and show how they fit together in some— as yet unknown—way. But taking on such a gargantuan enterprise left a serious question: where to start. For obvious reasons I was reluctant to walk up to people's houses and say, "Hi, I'm here for a year studying local aesthetic values and I'd like to get some idea of your concepts of beauty, artistry, and creativity, as well as some notion of their intersection with aspects of your daily life." It's easy enough to appear a fool as a fieldworker without trying that hard.

At least the question of *who* to start with was taken out of my hands by Florence, the woman I was boarding with, who said casually over breakfast on my first morning in town, "Miss Leonora down on the swamp road said she'd be happy to see you this morning and get you started." Since I was without any ideas of my own and only dimly aware that this was more of an imperative than a suggestion (calculated to see what kind of a person I was), I headed off to Leonora's.

She proved to be a cherub faced woman in her seventies living by herself in a large house somewhat separated from the rest of the town. We sat down at the kitchen table over a cup of coffee, and when she asked, "What would you like to know about?" I replied, "Do you have any quilts?" In a way this was a bit of a peculiar thing to ask because her house was stuffed with antique furniture, decorated in exotic fabrics, and enhanced with fine ceramics and carvings. But something made me want to start with quilts.

As a newcomer to the United States from England, I had been immediately captivated by quilts and soon discovered, as a student in folklore, that I had an immense amount to learn about even their basic construction. It was also readily apparent to me that much of the variation I saw in them reflected a range of social and historical issues; it had not taken me long to learn the hallmarks of an Amish, or Depression era, or Victorian quilt.

Some of my fellow students had constructed questionnaires of exquisite complexity to be used in interviews with quilters concerning particular quilts, and I was both daunted and intrigued by the possibility that a material object could be used to elicit so much information. Yet there seemed nothing inherently implausible in this situation. Quilts looked mighty complex to me.

So sitting with Leonora amidst all her finery, I wanted to begin with quilts. After all, I had been in fancy houses many times before, but I had yet to sit down with a traditional quilt and its owner and get down to the serious business of finding out what quilting was all about. As it happened, Leonora had but one quilt, made by her step-great-grandmother and stored away as an heirloom. It turned out to be an extraordinary artifact that eventually set all kinds of wheels in motion.

With the quilt on my knees, I started asking routine questions about the quilt and its maker. In the process I began to discover that every quilt is at the center of a very large web of knowledge. I had a few stock questions on hand, but each brought forth a flow of information that was at once exciting and intimidating:

"What fabric is this, do you think?"

"Well, it could be percale."

"How do you spell that?"

"P-E-R-C-A-L-E. It's a kind of cotton weave they used in good quilts a lot back then."

I was obviously not going to overwhelm her with my encyclopedic knowledge, but I pressed on, seeing an avenue to explore. "So when was it made?"

"Well, let me see . . . it was made by Lizzy Brown, my daddy's granddaddy's second wife when they were first married. I think he was around 42 or 3 at the time. Now, he died when I was 5 and he was 93, and I was born in 1902, so you work it out."

Glad to have something I knew how to do, I obliged. "OK, he must have died in 1907 at the age of 93, so he was born in 1814, which would have made him 42 in 1856. That means it's about 120 years old."

But I wasn't sure whether knowing how old it was in years carried the kind of meaning that Leonora's recitation did. Saying it was 120 years old was just a bald, objectified, chronological fact. Saying that it was made by "daddy's granddaddy's second wife when they were first married" and linking that event to his death and her birth pulled three significant rites of passage together in one mental package wrapped up in the quilt that was sitting on my lap. Still it was my first day on the job and I was nervous about recording

The Natural History of the Traditional Quilt

useful data, so I jotted down in my notebook "approx. 120 yrs old." Fortunately my tape recorder remembered Leonora's exact words for me, so that I could understand them (as I came to understand so many things about her life), in the fullness of time.

The interview stumbled along at this rate, me trying to get the "facts," and Leonora trying to explain what she knew in her own terms, until I gave up asking formal, step-by-step questions and just let her talk about her life and her memories. In the end I learned much more about the quilt and the people who had cherished it. But its own visual properties held yet more surprises.

I knew from countless slide presentations and picture books that pictures of quilts are conventionally taken by holding them up or hanging them from specially designed frames. However, Leonora, even if she had not been a mere five feet tall, could not have held up this quilt—which was made for a double bed—by herself, and I had no fancy frames or other equipment with me. I tried hanging it on Leonora's clothesline but it was so low (Leonora being so short), that I had to fold the quilt double to stop it from dangling on the ground. This was all right for close-ups, but I wanted a full length view of the entire face.

Inspired by the clothesline idea, I decided to buy another length of the same kind of line and string it high enough so that I could hang the whole quilt vertically. This entailed a walk over to the general store, followed by a precarious half hour or so getting the line strung eight feet off the ground and taut enough that it wouldn't sag too badly when the heavy quilt weighted it down. I suppose at that moment I should have realized that I was doing something unnatural. The fact that I could find no convenient way to view a quilt in its entirety ought to have signaled to me that this was not something that local people did, and, therefore, all I could expect to discover would be data created as much by the mode of documentation itself as by the aesthetic habits of the people I was supposedly studying (without interfering too much!).

In any event my gymnastics amused Leonora, and, having shot off a few dozen slides, I took down the temporary line, packed away my things, and trotted off feeling as if I was well on the way to piling up loads of useful data. I had the slides processed by mail and checked them over briefly when they came back to make sure they were properly exposed and composed, then I tucked them away for later analysis.

That summer I went back to my university for a spell to gather all my rough field data in some semblance of order and to embark on a preliminary analysis to help guide my continued fieldwork. As part of the process, I spent

some time with my slides and with the full length view of Leonora's quilt in particular. Initially I didn't see any more than I had seen on the day I photographed it. The top consisted of a relatively simple repeated basket design, executed in store-bought materials of bright yellow, maroon, and green. But something about the design caught my eye, although at first I was not sure quite what it was. The tops of the baskets ran diagonally across the face of the square patches they were set in, so that the entire patch could be oriented in one of four ways—that is, with the basket right side up or upside down and, in each case, with the top of the basket running from the top left to the bottom right corner or vice versa.

What I had thought originally, by failing to study the orientation of the patches properly, was that the basket tops were arranged so as to form a concentric diamond pattern over the entire face of the quilt. But when I examined the top more closely, I saw that this was not quite the case. To begin with, I realized that the general pattern was not symmetrical at all. Toward the edges of the overall design, the baskets seemed to be facing all which ways, and the whole diamond business (if it was anything more than a superimposition of my own), was off center horizontally and vertically. At first I was puzzled as to why someone would go to the trouble of buying expensive materials and painstakingly sewing them up into patches, only to make an elementary blunder in putting them all together. Then something clicked. I was the one making an elementary blunder.

I had all the time been viewing the quilt out of all reasonable contexts. The only context I was seeing it in was one I had invented, and yet I had the temerity to say that the quilter had made an error because her quilt didn't fit *my* frame of reference. If I was to understand the design at all, I needed to see the quilt in the context that its maker intended for it—that is, *on a bed*, not dangling in thin air where I had placed it for my own convenience. When I hung that quilt on the clothesline I was tacitly making decisions about what edges were up or down, and right or left, when, to begin with, a vertical orientation, whatever way the edges faced, was outside of the normal aesthetic realm of the community, and, furthermore, with the quilt in its normal context on a bed, right and left were strictly relative to the viewer. This moment of understanding was a turning point that changed the direction of all my subsequent fieldwork.

I began to photograph quilts wherever I found them: on beds, in barns and boats, and, once, wrapped around a beloved pet dog who had just died. My job of documentation was made immensely more difficult than it had been in the clothesline days because I was rarely able to compose a shot that showed the entire quilt at once. Sometimes I had to take two or three rolls

just to have all the parts recorded. Even so, I felt that such images were more legitimate than my earlier crucified anatomical offerings, because they recorded the quilts as their owners saw them.

That was not the end of the story, however. Once I had become sensitive to quilts in their natural settings, I realized that they changed character as the light changed during the day and over the seasons. So I found myself going back to take a few more slides of quilts I had already documented, and at one stage went completely nuts and took three hundred pictures of one quilt over the course of four months—at midday and midnight, on sunny and cloudy days, in bright summer light and under soft autumnal hues.

This passion for close observation of quilts in their habitual surroundings has culminated in my part of the analysis in this book. That quilts need to be viewed in their social (and other) contexts is pretty standard fare for anthropologists, but what I have discovered for myself is that if you pay careful attention, quilts will guide you to what you need to know about them. They are packed with knowledge, if you will only sit silently with them long enough to heed it. And, most important, you must not drown out the quilt's voice with your own noise.

J.F.

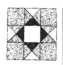
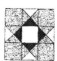
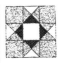
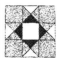

"I Never Saw My Mamaw Making Quilts . . ."

I never saw my Mamaw making quilts. She was my great-grandmother, my mother's father's mother, and she lived into her nineties. I was nine years old by the time she died, so I had plenty of opportunities to visit her. But I never saw her working on any of the possibly two hundred or more quilts she made during her lifetime. I think the reason I never saw her quilting was that visits to her at her daughter's home, where she lived the last years of her life, were state occasions. She was dressed in her company finery, and so were we. We sat in the living room, which had suddenly taken on the air of a formal parlor, and we "visited." That meant that the grown-ups made what talk they could, and the children "behaved." It certainly did not mean that the honored matriarch would divide her attention between visiting and quilting.

One time in particular, I remember being taken to see Mamaw because she had a special present to give me. It was a rag doll, one of scores she made and gave away to three generations of offspring. I had been forewarned that this was a great treasure which I must make much over as I received it. At the time, the doll did not seem like very much in comparison with my plastic, store-bought toys. She wore a long silk dress with petticoat and bloomers, a pair of red high-top shoes, and a sunbonnet—like any decent old-time lady of the Kentucky mountains my family would always know as home. I will always be grateful that my mother had the pride and sense to recognize the doll as something to be valued and kept. The rag doll looks at me today from under the brim of her bonnet, reminding me by her existence of a heritage handed on by example and bestowal.

The same kind of giving and showing brought me into lifelong intimacy with quilts. How is it that I never saw one made before I took fabric in hand to create one myself, yet the act of making came naturally, arising from a need I never questioned? There is no one moment in my memory when I "discovered" quilts, and, at the same time, there was never a time in my life when I did not notice and love them. We children—my sister and I—grew up sleeping under them and on them. Whenever we moved, and before the

furniture was all assembled, we were bedded down on pallets on the floor—stacks of folded quilts which made a firm but yielding sleeping surface, the old-time equivalent of a current bourgeois American favorite adopted from Japan, the futon. We took them into the yard to lie on in the sun; we made tents of them in play; we snuggled into them on the couch when we were sick, stripping the one we loved the most from our mother's bed on this excuse.

Our parents and grandparents used them, too. On moving day, older quilts were always used as furniture padding or to cover windows before curtains could be hung. Ironing board covers, under their asbestos upper lining, turned out to be ancient, paint-spattered fragments of quilts. Winter coats carried old quilts as interlinings. On summer afternoons, the women would sometimes decide that a picnic was worth the trouble, and we would feast on fried chicken, sliced tomatoes, and potato salad, all the while seated on the cushioning coolness of a quilt spread under a tree. And, of course, quilts were always on hand to be used as bedcovers, their particular usage determined according to their thickness and beauty, to the season and population of the household.

Mamaw made many of the quilts I grew up with—and the ones I always loved the most. Others had been bought by my father's mother from quilting churchwomen; my father's family, being of Bluegrass stock and newly wealthy, was more inclined to buy traditional quilts than make them. But whatever their origins, I always knew that these quilts had been made by human hands—women's hands. They were real, warm, comprehensible, because I knew that women had sewn them, just as my mother and grandmother regularly sewed our clothes; and somewhere in my heart I must have registered the fact that quilts, these beautiful and comforting aspects of home, were a treasure store which could be accumulated through a kind of work I could understand.

When I first wanted to make a quilt, my mother and grandmother both dismissed the idea with the comment that "it's an awful lot of work." Neither of them had made a quilt, and neither has to this day. On the other hand, I had never stitched clothing, which seemed to me to be much more daunting in its complexity than a quilt. A quilt might take time, but I had plenty of that. So, as a teenager, I began what would become ten years later my first finished quilt. I had no instruction—only a paper pattern from which to cut the pieces, and I got that out of a magazine. But what I did have was a visceral understanding of why the labor was necessary. I wanted quilts—my own quilts, with human love and sweat built in (sweat that corroded needles!)—

quilts that would delight and fascinate the eye, and lie heavy across a sleeping body. My own separate household, when I established it, would be cold and alien without them.

The years of becoming a quilter and a folklorist and anthropologist were roughly coterminous; yet, for many years, the two enterprises did not touch. Quilting was what I did for pleasure, an act which made me feel at home in the world and added to my ability to create a comfortable environment for myself or to give what I felt to be the most suitable welcoming gift to a new baby. Studying the aesthetic aspects of culture was in my mind a different sort of vocation, connected to abstract concepts of cultural appreciation and the desire for understanding, but not linked directly with my own personal experience. For that matter, I had rejected early on the notion of examining traditional Appalachian culture, because I figured it had already been done to death—which, in some ways it has been, figuratively and literally. Greater maturity showed me what had yet to be adequately addressed, and geographic and psychic distance helped me to see that I knew more than I had realized about the Southern mountains. But it was a meeting with an English anthropologist—now my husband and coauthor—which awakened an active interest in pursuing research on that which had been so much a part of my daily life as a child: traditional quilts.

This man had gone into a remote region of coastal North Carolina and come away with, among other things, a collection of data concerning the community's traditional quilts—and he was obsessively interested in their formal qualities and the process that generated them. At first, I was only politely engaged—after all, these items were neither exotic nor mysterious to me. I could appreciate them, I thought, for what they were, but I could not see what he was so insistently curious about. Of course they were beautiful and much to be praised. But what more could there be to say about how these women went about their work? But the more I listened to him pose questions about the material and its formal intricacies which before then I had not consciously considered, the more I came to respect the direction of his inquisitiveness.

Gradually, a collaboration developed. We began with his questions and analysis as an outsider and my experience and insight as an insider; but soon his knowledge of the quiltmaker's technology and culture and my training as a visual artist and anthropologist swept us into an interchange of ideas without regard to insider or outsider roles. Entire summers passed as we worked together on sets of drawings, plotting the relationships among patterns. We evolved an agenda for field research, and other summers found me visiting

quilters and their families, testing ideas and seeking information on the creative process as we were coming to understand it.

Meanwhile, my own quiltmaking became a laboratory in which we could watch the quilts taking shape. I could set for myself different rules for working or simply make myself aware of the rules I naturally used and then observe their effect on the appearance of the finished quilt. I could keep track of the junctures at which decisions had to be made and of the ways in which choices were determined. I noted the kinds of errors which could occur in the course of construction, what I might do about them, and what the results were for the finished quilt. And, through showing my work to traditional quilters in the field, I could learn something about how they interpreted what they saw in terms of what I had done.

This book, then, could be said to have four sources of energy: the cultural questions and insights of the anthropologist; the aesthetic quest of the folklorist and lover of art; the formalism of the scientist and mathematician; and the lived truth of the quiltmaker herself. No one source is preeminent, although all the rest are subject to validation in terms of the practice of the quiltmaker. Seeking understanding through the impetus of these four drives has enriched my own appreciation of a tradition which has helped to shape my life. My hope is that the results of this research will help to increase the enjoyment of those who encounter traditional quilts, and that the approach we propose will lead to a greater respect for all traditional quilters and a deeper understanding of all of the particular quilts there are to love and study in the world.

D.B.

The Natural History of the Traditional Quilt

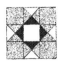 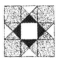

Preface

There are many reasons in the world for being interested in traditional quilts and, therefore, many different ways to think about what traditional quilts are. Collectors like quilts because they are beautiful or "valuable"—which, connoisseurs may tell you, signifies some combination of old, rare, attractive, and skillfully made. Artists might recognize traditional quilting as a source of inspiration, or as a "craft" with which their own "art" should be contrasted. Bourgeois hobbyists may regard traditional quilts as inspirationally charming but imperfect versions of patterns which they will more beautifully realize. Historians or folklorists may see in quilts the ethnic and social backgrounds of their makers. Feminists admire quilts as vehicles of women's creativity and friendship, or they lament the conditions which cause women to produce quilts rather than, say, paintings. And so on.

People outside of the realm of the traditional quilter regularly use quilts to suit conceptual purposes selected from an array of issues and interests lying beyond the quilts themselves. The meanings and uses of traditional quilts in their own terms are discounted as irrelevant to their "real" meanings in terms of the intellectually or socially more important values of consumers in the nontraditional world. In a parallel fashion, these same quilt-consuming people put traditional quilts to a variety of mundane, unthinking, reverential, or outlandish physical uses, once again in the name of the "higher" purposes which the traditional quilter is not expected to foresee or understand. The error can be couched in terms of a disease of voracious acquisitiveness, in material or intellectual terms, but the remedy can be spoken of in simpler fashion: if women spend days and years of their lives making quilts, we must expect that a true appreciation of quilts will come only from a similar devotion of attention to the quilt itself, in a way specially appropriate only to it and to its milieu. If a woman sits stitching over a quilt for hundreds of hours, it is supremely presumptuous to imagine that we can know *anything* about that quilt or that quilter without giving both of them something like the same methodological, meticulous, intimate attention that the quiltmaker gives to her work.

If one had to pick a common element out of the multiplicity of interests regarding traditional quilts, it would be this: people are interested in quilts because people make and use them. Traditional quilts embody and imply human values. If we are to understand the human meanings of a quilt and of quiltmaking, we must follow the example of the quiltmaker, staying with the quilt and making it the focus of labor and attention. Focusing theoretically upon the quilt has several advantages: (1) a quilt is a concrete, enduring object, with attributes which can be investigated and which can guide inquiry and confirm or disconfirm hypotheses; (2) a quilt is the tangible result of intersecting processes of different orders: mental, social, and technical—and is an index of these processes and their interactions; (3) the quilt contains its meanings or, at least, the questions connected with its meanings; that is, focus on the quilt leads *appropriately* outward, letting the quilt itself generate the questions it needs answered.

A succinct way of describing what we think is the proper approach to traditional quilts is to say that each quilt can be considered to have a *life history* that encompasses more than the life of any one individual and, to some degree, more than its own lifespan as a quilt. What we advocate is a natural history of traditional quilts—the detailed study of the typology, morphology, behavior, and ecology of quilts in their native environment: the homes of humans who make them, use them, keep them, bestow them. Through this loving attention to the quilts themselves, we believe that we do the greatest service to an understanding and appreciation not only of the quilts but also of their makers. We believe that a rigorous and thorough consideration of all of the factors which make up the natural history of the quilt leads to an enlightened respect for quiltmakers which can be acquired through no other means. Informed celebration of the lives of traditional quiltmakers proceeds from just such detailed examination of their works as we propose.

The domain of the traditional quilt, as opposed to the revival quilt or the art quilt, is the focus of our attention in this study. Although the perspective we propose may be applied to revival materials, the details as we have laid them out are specific to traditional quiltmaking. A traditional quilter has her roots in traditional culture, and her quilts participate in traditional lineage and life. The traditional quilter may live in a traditional society, characterized by face to face interactions and oral transmission of values and practices, or she may inherit her tradition through a family line which traces back to traditional roots. (One important aspect of traditional societies everywhere is the division of customary attributes, functions, and occupations along gender lines. Our use throughout this work of feminine pronouns and references

reflects the fact that quilting has traditionally been a part of women's culture—although men often participate and some are adept.) The traditional quilter's modes of creativity, resources, and the social context of her work differ from those of the revival quilter who picks up her ideas and interests exclusively from women's magazines, hobby classes, or textile disciplines in the fine arts and has no traditional foundation for her work as a quilter—although there may be parallels and congruities. Some of the same kinds of questions may apply to both, but the shape of the answers will be different.

In the same way, the details of our suggestions for constructing a life history of the traditional quilt are based upon the Euro-American quilt as prototype. As such, the framework for investigation which we propose will apply equally well to Polynesian tifaifai, African-American strip quilts, Hmong reverse appliqué, or Sioux star quilts; but the specifics of our discussion will pertain most closely to Euro-American quilts. It should be borne in mind that some traditions, such as the African-American and Native American traditions of quiltmaking, represent syncretisms of non-European and European practice, and, therefore, some details of the model as we discuss it will apply quite well. It will be noted, moreover, that different sections of the natural history model will be differentially informative depending upon which tradition one studies. Questions of detailed taxonomy may not be as pertinent to Hawaiian quilts as to African-American scrap geometric patchwork, for example; and questions of use may be redundant in the case of Sioux star quilts made especially for give-aways. In fact, this is true in the case of individual quilts: a life history will take its own shape, and not that of a generic model.

Our natural history is divided into four sections—taxonomy, morphology, life cycle, and ecology—each building on the concepts elaborated in previous sections. As the names imply, we follow the biological metaphor reasonably closely throughout. Our taxonomy, for example, like the Linnaean system, is rooted in the mechanics of replicating quilts so that it can be used to understand evolutionary and genetic relationships between quilt types. Our morphology section anatomizes normal and abnormal physical features of quilts. The sections on the life cycle and ecology discuss how the processes of replication, bestowal, and use intersect with environmental factors. A lengthy case study shows the methodology in operation, revealing the human dimensions of the works of a single prolific quilter. A concluding discussion relates the points of the case study and of the work in general to current issues in cultural anthropology, folklore, archaeology, and related fields.

Like any natural history, our text is liberally sprinkled with anatomical and analytic sketches. We hope that these illustrations have aesthetically pleasing qualities, but it must be borne in mind at all times that their purpose is primarily forensic. In many cases we have dissected away components of the quilts not relevant to a particular argument and used symbols and icons to express relationships on which we focus in our discussion. Nowhere in our drawings can the smell and feel of a quilt when rubbed against the cheek be perceived. The colors, textures, and the puckered surface characteristic of hand quilting are discernible not in our schematics but only through intimate acquaintance with real quilts. Our diagrams are aids in perceiving aspects of real quilts, not substitutes for them. If our drawings can serve as informative maps of the features of actual quilts, then they have fulfilled their purpose.

It may seem at first that the use of a biological metaphor to frame our analysis is likely to suffer the limitations of any attempt to transfer an autonomous methodology from one discipline to another. But the procrustean problems in this pursuit seem to us minor in comparison with those raised in the seemingly more obvious endeavor of analyzing quilts as art. No doubt the desire to treat quilts as art has a noble motive: it seems to elevate folk practitioners to a higher status than normally accorded them (even if the appellation "folk" pulls them down again), and suggests that observers accord their products the same kind of attention to color, design, and technique as they give to a Mondrian. This promotion comes at a price that, we feel, is too steep. The term "folk art" doubly handicaps traditional quilts: "folk" denigrates the already marginalized category of "art."

For most people, art is something that hangs on a wall (usually in a museum) and is not for touching. So when you go to a quilt exhibit—whether in a museum, a private collector's home, or a quilt guild's annual show—chances are you will see quilts hanging on walls and surrounded by DO NOT TOUCH signs. This approach just conceivably draws attention to visual elements in the quilts that might otherwise be lost, but the concomitant loss of sensual and contextual data is painfully high.

A quilt is made to go on a bed; its edges fold over the sides. In its natural situation, one sees the quilt's design horizontally and vertically at the same time, and often one cannot see the whole pattern at once. By walking around the bed, one sees the quilt from different angles and takes in different parts of the pattern. As afternoon follows morning, the light coming through different windows highlights and subdues areas on the quilt. A person may even get in the bed and observe the effect of the volume of his or her body under the quilt. One can touch the fabric and feel its texture.

The Natural History of the Traditional Quilt

When a Rembrandt gets dirty, it goes to a conservator; when a traditional quilt gets dirty, it goes to the washtub or washing machine. The conservator's job involves restoration and preservation—protecting the object from the effects of the passage of time. The washing machine does not preserve but, rather, changes the physical character of the quilt as it cleans it. Fabrics soften and fade until eventually they fray and fall apart. Then the quilt is given over to other uses or transformed into something else. In short, the quilt has an interactive role to play with its environment that changes over time. It has stages in its journey from creation to destruction. It has a life cycle, and so can be profitably viewed—mutatis mutandis—as analogous to a living organism. Far from overlooking the human aspects of quiltmaking, such treatment brings into focus precisely the environment which quilts and humans share largely through the agency of human intention and creativity.

As a caution, we must add that our decision not to confine or contain our analysis of quilts under the rubric "art" is in no way meant to suggest that we do not think of them as aesthetic forms: quite the opposite. Quilts have obvious and enduring aesthetic qualities—many more than most works of visual art. But not all that is aesthetic need be subsumed under the category "art" (see Forrest 1988: 19–33). Art is an aesthetic form that exists in a certain kind of ("art") context. Quilts exist in a different—occasionally overlapping, but generally wider and richer—context, and the dimensions of this context are what we wish to explore in this book. Thus our aim is not to discourage viewers from appreciating the visual qualities of quilts, but to enhance and expand that appreciation by extending awareness to all of the aesthetic qualities and dimensions of significance which quilts present.

Our intention is to investigate, in as exhaustive detail as possible, every avenue quilts lead us down. Sometimes we take the posture of outside observers; sometimes we see quilts through the eyes of their makers. Neither position is uniquely privileged to see all there is to see. But our ultimate purpose is even broader. We hope to provide students of material culture with a general methodology that is widely applicable. Although some changes to our specific observations would have to be made, our overall approach could equally well apply to, say, duck decoys, bobbin lace, or prehistoric potsherds. Our insistence upon beginning with the object itself as the basis for all analysis leads, for instance, to the discovery of the particular ways in which the technology peculiar to quilts is foundational to an understanding of replication of and innovation in design. The principle of specific technology as basic to style and creativity, as explored in our discussion, could be applied by

archaeologists, folklorists, and other material culture specialists to whatever forms they study.

The idea that objects have a material and conceptual context is old news to folklorists, anthropologists, and art historians, just as sailors long knew there was a northwest passage from the Atlantic to the Pacific. For scholars and sailors alike, the foundational knowledge was easy to come by. Charting the exact course, in both cases, took patience and persistence.

 # *Acknowledgements*

The authors would like to thank the following quilters, owners of quilts, and relatives of quilters who have generously given extensive interviews for the purposes of the research for this book: Elizabeth and Ellis Bailey, Elizabeth Blincoe, Elsie Carter, Libby Carter, Mary Anne Donovan, Analie Francis, Virginia Francis, Elinor Hackney, Linda Dyer Hoagland, Holmes and Helen Mayo, Sandra Ogden, Bob and Sue Pantley, and Bonnie Sheard. Thanks also to the following individuals and organizations for assistance in arranging and implementing quilt documentation days: Elaine Giguere, Mary Curtis, and the Delaware Valley Arts Alliance; Peter Osborne and the Minisink Valley Historical Society; and Charles Thomas, Wayne Decker, and the Neversink Valley Area Museum. We are extremely grateful to all the participants in the quilt days. Special thanks to Margaret and Jerry Peill and to Judith Sellars at the library of the Museum of International Folk Art for indispensable assistance with last-minute reference checks.

We offer our deepest appreciation to: Simon Ottenberg, for reading the manuscript and supplying his customarily perceptive comments; William K. MacDonald, for reading early versions of the case study and providing guidance into the archaeological literature on style; Rodney Needham, for kindly interest and sporadic transatlantic snippets of data; Terrence Epperson, for helping to sharpen our point about the term "folk art"; Joseph Dumit and Deborah Heath, for (separately) recognizing our theoretical construct as a model of quilt as cyborg; and Al Blank, for solving a mathematical conundrum.

We thank the following for small grants in aid of research: the University of North Carolina at Chapel Hill; the New York State Council on the Arts; and the State University of New York, College at Purchase. Thanks also to the National Endowment for the Humanities and the School of American Research for support in aid of the production of the manuscript.

Finally, we would like to express our heartfelt gratitude to our son, John Royston Forrest-Blincoe (a.k.a. the Badger), who after an infancy of insomniac chaos finally consented to take prone and more or less predictable naps, thus permitting us to complete the illustrations.

 # 1. Taxonomy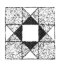

1.1. INTRODUCTION

Quilt taxonomy is in disarray: no one system exists which is universally understood and used, nor any single standard for classification. Moreover, those classification schemes which do exist are inadequate for the purposes of programmatic research—even, in most cases, for identifying individual quilts within the scheme. Although a number of analysts have felt the need for a system of classifying quilts, most of the resulting taxonomies have had limited aims and in consequence are limited in utility. The numerous taxonomic systems currently in existence are not consistent with one another, either in principle or in detail. Therefore, comparisons between data-sets are often difficult or impossible. Finally, many of the taxonomies are internally inconsistent, making them unsuitable for use in rigorous study.

The most rudimentary schemes are those used by collectors, museologists, art historians, and the like. They usually have no underlying rationale beyond the immediate needs of the collection, exhibit, or historical account. They may be based on quilt names, construction techniques, historical factors, ethnic origins, or motifs; most commonly, a combination of several of these factors are used. The particularism of these categorizations reflects the heuristic aims of the curator or collector and is not based on a systematic analysis of an individual quilt's place within the universe of traditional quilts.

A substantial majority of quilt books and catalogues use names to classify quilts, usually without any indication that no simple one to one relationship obtains between names and patterns. To be sure, a number of designs are attached to only one name, but many popular ones are associated with more than one. The design in Figure 1 may be called "Job's Troubles," "Four Point," "Kite," or "Snowball" (Hall and Kretsinger 1935:65). Conversely, one name may be attached to several different designs. The pattern in Figure 1 may be called "Snowball," but so may those in Figures 2 (Malone 1982: 27), 3 (Malone 1982:195), and 4 (Malone 1982:195).

Even supposing such ambiguities could be ironed out by standardizing nomenclature—which is happening to some extent—naming is not really a

Figure 1

Figure 2

Figure 3

Figure 4

Figure 5

Figure 6

Figure 7

taxonomic so much as an indexing system, because the names do not rationally or consistently refer to specific design elements. The name may refer to an image or motif in the pattern in a relatively straightforward manner, as in the case of "Basket of Lilies" (Figure 5; Hall and Kretsinger 1935:127). Or the motif may express the name in a more abstract way. "Flock of Geese," for example, reduces the outline of a flying goose to a simple triangle (Figure 6; Hall and Kretsinger 1935:75). At the furthest end of the scale are those names which, like "Nelson's Victory" (Figure 7; Hall and Kretsinger 1935: 98), are arbitrarily connected to certain patterns. That is, the name may be

The Natural History of the Traditional Quilt

associated with the design for social or commemorative reasons, but the visual image is not a depiction of the name.

Knowing the common name of a quilt pattern can help in comparing a quilt with others of similar design in compendia or collections. But because quilts usually do not come with names attached, a catalogue of patterns organized by name only is as much use for identifying unknown patterns as an alphabetically arranged medieval bestiary is for identifying animals. The only cure is to search diligently page after page until you find a match.

Carrie Hall in part 1 of *The Romance of the Patchwork Quilt in America* (Hall and Kretsinger 1935:48–127) makes as good an effort as can be made to convert a simple naming system into a kind of hierarchically organized taxonomy. Despite its age, Hall's work remains a standard reference and is still an encyclopedic classic in terms of sheer number and selection of entries. Hall's grouping system, however, is more idiosyncratic than rational and occasionally falls apart completely. It works best where the groups of names indicate readily identifiable motifs in the patterns. "Roman Cross," for example, can be found with little difficulty among the crosses (Hall and Kretsinger 1935:69), which are a subcategory in a section comprising mostly geometric pattern names. Another major section is made up of botanical names subdivided into trees, shrubs, and bulbs, each further subdivided according to individual plant names. So if the design you are trying to identify has a motif in the form of a star, rose, or lily, you have a moderately good chance of finding it in Hall's list without a lot of page turning.

By comparison, her groups of names based on historical events, political figures, and biblical references are a jumble and no help in the identification process. "Job's Troubles," for example (Figure 1), has no iconic reference points in the pattern, so a person might well spend wasted time looking for it among the stars or crosses where, if the system were based on design alone, it might rationally belong.

Unlike many more recent and more sophisticated classificatory schemes, Hall's has one overwhelming advantage: it is potentially all-inclusive and expandable to include new designs as they come along (provided they have names—traditionally attached or curatorially assigned). It can handle appliqué and pieced designs equally well, where other systems do best with pieced designs only. Unfortunately, the system's ability to handle appliqué and pieced designs is due to its inability to tell them apart: formal, technological, and social differences notwithstanding, a pieced "tulip" (e.g., "Full-Blown Tulip") and an appliqué "tulip" (e.g., "Colonial Tulip") belong, by Hall's lights, in the same group because of the names attached to them.

Hall's use of names may also preserve, to some extent, implicit folk tax-

onomies and other ethnographic information associated with naming. For example, a woman may make a quilt expressly because its name has special significance for her. But it is equally important to note that deep research into quilting often reveals an indifference to names on the part of prolific quilters (see Forrest 1988:78). Ruth McKendry sums it up:

> When one is talking today to women who did a great deal of quilting in their day, it is surprising how difficult it is to get them to give names to patterns, even common ones.
> (MCKENDRY 1979:102)

Neither can it be assumed that the groupings devised by Hall reflect conceptual or practical groupings used by quilters, or that groupings are uniform between communities, even provided the quilters commonly use names for their designs.

Thus, a naming taxonomy cannot expect to replicate folk systems in any but a partial way, if at all (and even if it did, it would not serve the purposes of a scientific taxonomy). More often than not, quilt names are used to classify quilts without any acknowledgement of this complication. When a quilt name appears in a book or museum catalogue, is this the name given by the maker, or owner, or has it been taken from a standard compendium by a curator? In most cases there is no way to tell. Names as used by quilters have a place in quilt ethnography, but, of course, their analysis belongs with other ethnographic concerns (see Section 4.3). Because of all these problems, any taxonomy built on systems of names is bound to lead to more confusion than clarity.

Despite the problems with names, researchers, collectors and exhibitors use them all the time. Often, however, curators and collectors have more specific concerns that create, in addition to categories based on names, ad hoc and frequently overlapping categories in which to place quilts. Some people are primarily interested in the ethnic or cultural affiliations of quilters (Bishop and Safanda 1976; Haders 1976; Hammond 1986; Pellman and Pellman 1984), the regional associations of quilt styles (Clarke 1976; Irwin 1984; McKendry 1979), defined time spans (Woodard and Greenstein 1988), or combinations thereof (Cooper and Buferd 1978; Pottinger 1983; Lasansky 1985). As a result, quilt compendia and exhibit catalogues use an informal, descriptive indexing system that lumps all of these concerns together (Binney and Binney-Winslow 1984; *Quilter's Choice* 1978; Newman 1978; Schwoeffermann 1984; Betterton 1978). Typically in these catalogues, a quilt is accompanied by its name (with no indication of who endowed it thus) and

some or all of the following data when known: maker's name, date of construction, and maker's regional or ethnic associations. In addition, the quilts are often typed in very basic construction categories (pieced or appliqué being normal), with stock curatorial data, such as size, appended.

This kind of accumulative indexing system certainly supplies data and is useful in comparative research, but it is no closer to being a taxonomic system than using names alone and suffers all the same problems. In particular, the categories are not well defined: what is a region? a cultural group? a suitable time period? Also, because the categories overlap, one quilt may simultaneously belong in several. In what way or ways is a 1921 Indiana Amish quilt called "Lone Star" like or unlike a 1929 Appalachian Scotch-Irish quilt called "Lone Star"?

In systematic biology the categories are arranged in a hierarchical tree structure so that the more general subsumes the more specific. So, to discover how related humans are to siamangs, we compare their relative positions on the grand hierarchy. Humans belong to the species *sapiens* and siamangs to *syndactylus*; since that is no help, we go to the next more general level: genus. Humans are genus *Homo*, siamangs, *Symphalangus*, so we go to the level of family. Humans belong to the Hominidae family, siamangs to Hylobatidae. Finally at the level of superfamily—Hominoidea—humans and siamangs come together, and from there through order (Primates), class (Mammalia), phylum (Chordata), and kingdom (Animalia) join together. Such a system allows us to hypothesize genetic similarities/differences and evolutionary links between us and siamangs.

The museological categories for quilts enumerated above cannot be ordered in a like systematic hierarchy because no single category is logically more general than any other. Date, for example, is not a category that subsumes regional affiliation, or vice versa. So you could not legitimately claim that the two sample quilts mentioned above are different at the "specific" levels of regional (Indiana versus Appalachia) and cultural (Amish versus Scotch-Irish) affiliations, but come together at the more "general" levels of name ("Lone Star") and date (1920s). At best these groups are parallel categories that add information to the general indexing that names provide. The knowledge thus acquired is extremely important in understanding everything a quilt has to tell us, but, like names, these data belong elsewhere and cannot serve as a reasonable basis for a taxonomy.

Despite the severe disadvantages of building a taxonomy on names (with or without added categories), there is an unquestionable need for a standardized naming system. Such a system would prevent confusion in writing about designs and would permit simple and rapid referencing. To avoid confusion,

this system should not be based on common or popular names but should be an entirely new vocabulary akin to the Latinate genus and species designations of the Linnaean system. The vocabulary should reflect a classificatory logic which will allow the researcher to place an individual specimen within the system without scanning or memorizing an entire field of names. Formal biological names have three clear advantages over common names: they are permanently fixed, they are unmistakably different from common terms (*Quercus alba*, for example, is obviously a scientific term), and they are linked to a rational taxonomy. Because the formal names of biological entities are an intrinsic part of a logical classificatory scheme, you can pick a flower in a meadow and, by following a series of well defined steps, identify it in a field guide. You do not have to check the flower with every diagram to find a match; the name is systematically associated with what you can observe.

At least one work purports to be a field guide to quilts: *Quilts, Coverlets, Rugs & Samplers*, in the Knopf Collectors' Guides to American Antiques series (Bishop, Secord, and Weissman 1982). The book is primarily intended for newcomers to antique collecting so they can haggle wisely over an overpriced item, but it claims to work like any natural history guide:

> The color plates and accompanying text are organized by basic types
> in a visual sequence, so that beginners can find a similar textile quickly
> without knowing its pattern name, method of construction, or date.
> (BISHOP, SECORD, AND WEISSMAN 1982:9)

The guide divides quilts into eleven groups (Bishop, Secord, and Weissman 1982:28–32):

1. Quilts with central motifs
2. Album quilts
3. Quilts with geometric designs
4. Log cabin quilts
5. Quilts with circular designs
6. Quilts with star designs
7. Patriotic quilts
8. Thematic quilts
9. Leaf, vine, and basket quilts
10. Representational quilts
11. Crazy quilts

These groups are further divided into subgroups, but, without going into the fine details, it is clear that the guide does not have an underlying rational

The Natural History of the Traditional Quilt

taxonomy to support it. If a quilt has a geometric design and a patriotic element, does it belong in group 3 or 7? The authors placed a "Goose in the Pond" (geometric) design made in red, white, and blue (patriotic) fabric in the patriotic section, but why does color choice override geometric construction in classification? A Hawaiian quilt called "My Beloved Flag" and made by joining four Hawaiian national flags—in good old red, white, and blue but bearing the British Union Jack emblem signifying Hawaii's historic status as a British colony—is listed not as patriotic but thematic. Is Hawaiian patriotism more "thematic" than the truly patriotic American version? The authors classify two album quilts with star motifs as star designs—why does star-ness supersede album-ness? The method of grouping, like Carrie Hall's naming system, is a jumble of different types of information—construction method, visual appearance, representative symbolism, cultural associations—that cannot rationally partition the universe of quilts into mutually exclusive groups.

Perhaps in large measure the guide fails because its purpose is not scholarly but monetary. Identification is the precursor to purchase for investment, and, in fact, the categories tell more about the culture of the collector than they do about the quilts themselves: presumably, the reason one category supersedes another has to do with a pricing structure which values, say, red, white and blue quilts above others (all things being equal). But at this stage the irrationality of the guide's classification becomes manifest because the pricing categories do not replicate those for identification.

For pricing the groups are (Bishop, Secord, and Weissman 1982:456–462):

1. Album and sampler quilts
2. Amish and Mennonite quilts
3. Circular geometric quilts
4. Crazy quilts
5. Crib and cradle quilts
6. Floral quilts
7. Hawaiian quilts
8. Log cabin quilts
9. Other geometric quilts
10. Patriotic quilts
11. Pictorial quilts
12. Star quilts

Some of the identification categories have disappeared or been conflated and others, based on cultural or regional associations (group 2 and group 7), and on size and function (group 5), have been added. So a Kansas baby quilt is

identified as a patriotic quilt (identification number 137) but priced as a crib quilt. Every quilt identified as a quilt with a central motif is priced as a floral quilt, as are almost all of those identified and grouped as leaf, vine, and basket quilts (including the basket quilts). Thus every imaginable way of indexing quilts piles together in an unsystematic tangle. There is still no way to go from unknown object through the steps of an identification process to a named item located in a fully developed taxonomy.

Carrie Hall's naming system of classification works best where the names refer to identifiable motifs such as stars or roses; and this leads us to consider briefly the possibility of using motif as a taxonomic base. One could, for example, replicate Hall's model by grouping together natural motifs subdivided into plants and animals and further subdivided into ever more specific taxons (see, for example, Rehmel 1986). This would satisfy the need for developing a hierarchical structure. But, like Hall's original scheme, this one could not distinguish between construction methods, such as piecing and appliqué. It would also rely on individual judgements concerning what motifs looked star-shaped versus cross- or rose-shaped. Furthermore, a residual category would be made up of a host of patterns whose motifs could not be construed as representing anything in particular.

At first it might seem possible to type designs or motifs according to the mathematical theory of symmetry in order to eliminate individual judgements. On the positive side such a system would be rigorous and objective, and one could infallibly get from object to taxonomic group by following a few basic steps. But the general theory of symmetry, worked out in exquisite detail by mathematicians over much of this century, is both absurdly powerful and largely irrelevant when it comes to the task of categorizing quilt designs (see Lockwood and Macmillan 1978; Shubnikov and Belov 1964; and Grünbaum and Shephard 1987). Perhaps few more than a dozen symmetry groups out of literally infinite possibilities are necessary to classify all traditional motifs. A system based on symmetry groups alone would, therefore, be unworkably reductive (all patterns that are commonly called "asymmetric," for example, would be lumped into one group). Dorothy Koster Washburn (Washburn 1977) has used symmetry analysis of ceramic patterns as the basis for associating stylistic variation with the interaction of social groups and with culture change, and she has applied her methods to other aesthetic forms (Washburn and Crowe 1991). Washburn's methods, however, do not point the way to an adequate taxonomy of design. Apart from the difficulties of reductionism, which apply equally to ceramic and quilt designs, an added problem is that symmetry analysis is as little relevant to the actual production of painted ceramic design as it is to the material realization of quilt pattern.

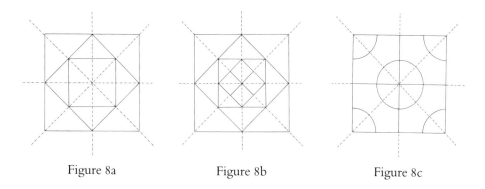

| Figure 8a | Figure 8b | Figure 8c |

Even if symmetry groups were less reductive, they would still serve more of an indexing than a truly taxonomic purpose. A taxonomy has to lead from the primary data to questions of analytic significance to the scholar. Take the three motifs illustrated in Figure 8: *a*, Beyer 1980:41; *b*, Beyer 1980:52; *c*, Beyer 1980:123. All three belong to the same symmetry group. In non-technical terms, each figure when rotated through 90° looks the same as if unrotated, and on each figure you can draw four lines (marked as dashed lines on the illustrations), that bisect the figure such that what is drawn on the left of each line is a mirror image of what is drawn on the right. (Technically they belong to the group 4mm.)

Grouping these three designs together might conceivably lead appropriately outward to questions of interest to quilt scholars, but it ought to be clear to the nonspecialist that 8*a* and 8*b* share important features that distinguish them from 8*c*. For a start, 8*c* involves curved seams, whereas 8*a* and 8*b* do not. More important, the complete designs in 8*a* and 8*b* are constructed in similar fashion and in a manner quite different from 8*c*. To make 8*a* you begin with the center square, sew a right triangle on each edge to make a larger square, then repeat the process to make the outer square (see Figure 9). With minor variations 8*b* is built up in the same manner. But to make 8*c* you make four squares and sew them together two and two (see Figure 10). Knowing this, we might hypothesize an evolutionary relationship between 8*a* and 8*b* or at least entertain questions concerning construction method and the creative process.

In short, symmetry analysis is based purely on visual design and pays no heed to mechanical construction. As such, it has great general value in comparing designs (for certain kinds of purpose) on quilts, pots, wallpaper, tiles, carpets, and baskets, but cannot be used by itself to address questions of fundamental importance to quilting alone. After all, the technical constraints on a tile maker, weaver, and quilter are quite different, so it is possible for each

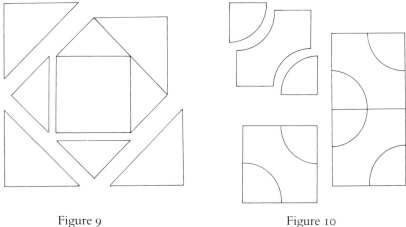

Figure 9 Figure 10

to arrive at similar designs through different chains in the creative process. Categories based only on symmetry groups are *descriptive* of the visual design of finished products and, therefore, end up being another indexing system, without showing how the maker solved problems of process unique to a particular medium.

Put in even simpler terms, symmetry analysis analyzes symmetry. Symmetry certainly constrains and prods the quilter, just as all construction techniques that build surfaces from geometric shapes must bow to the mathematical laws of patterns and tilings. But these laws are insufficient by themselves to explain how a quilter uses one pattern to invent another or how one construction method suggests multiple variations on a theme. If symmetry analysis is to be useful at all—as it will be—it must be subordinate to principles of construction and must not be the primary mode of classification.

Indeed, the problem with all of the classification schemes we have enumerated is that they are based on principles of likeness as defined by the individual analysts, and in most cases likeness does not reflect underlying process. As such, these schemes are analogous to pre-Linnaean schemes for classifying the natural world (see Boorstin 1983:420–476 for a succinct summary). Aristotle, for example, defined a species as a group of plants or animals that looked alike, and in fact the word "species" is derived from the Latin *specere*, to look at. The basic Aristotelian notion, which was followed for centuries, was to group all of the natural world into families of species on the basis of visual or apparent similarities. Before systematic biology, such classifications were sufficient. The needs of investigators were functional, descrip-

The Natural History of the Traditional Quilt

tive, or encyclopedic, and therefore any system that provided easy reference was enough.

Systematic biology, which became established during the Enlightenment, insisted that principles of organizing data be true to underlying biological realities. Linnaeus provided an answer to the problem by recommending that the mechanics of sexual reproduction form the foundation of a new type of taxonomy. By his lights, therefore, a species was no longer a group of plants or animals that *looked* alike, but a group capable of *reproducing* like individuals. In one fell swoop he revolutionized the field, because his system conformed to a fundamental biological process and not to the subjective observations of individuals. The scheme was so powerful that it could accommodate much later advances in biological theory, such as natural selection, evolution, and genetics. Simple systems based on likeness alone could not expand rationally in order to incorporate these advanced theories and might even have hampered their development.

What is needed for quilt analysis is a similar revolution: a new taxonomy based not on likeness but on the principles of production and reproduction. The taxonomy which we shall describe at length later in this section is based on the mechanics of construction of quilt tops. Using this taxonomy we will be able to demonstrate "genetic" relationships between patterns, the evolution of designs, the modes of conception and transmission of information and underlying structures, and a host of mechanisms that are fundamental to the creative process. As such this taxonomy is dynamic and processual and not static and archival: it elucidates active systems rather than cataloging forms. Moreover, the taxonomy is virtually infinitely expandable and therefore can incorporate new forms as they arise or come to light.

At first glance it might seem that such a taxonomy already exists. Jinny Beyer in *The Quilter's Album of Blocks and Borders* (1980) rationalizes a system proposed (in part, at least) by a number of people (Ickis 1949:223−252) and which may ultimately derive from traditional techniques. She has eight basic categories:

1. Four-patch
2. Nine-patch
3. Five-patch
4. Seven-patch
5. Eight-pointed star
6. Hexagon
7. Curved
8. Isolated squares (i.e., residual)

It is at once clear from her opening discussion that this system is founded on true taxonomic principles:

> Most designs fit into a grid, which can be defined as the number of squares into which a pattern block is divided. In the case of eight-pointed star and hexagon designs, the grid is not composed of squares, but of diagonal lines radiating from the center of the unit. . . . The ability to recognize the categories that patterns fall into . . . makes it much easier to . . . identify patterns you may want to look up.
> (BEYER 1980:29)

Examination of the first category, four-patch, will serve to expose the logic of her system. All designs in this category can be drafted on a square divided into four smaller squares (see Figure 11a, Beyer 1980:30; and 11b, Beyer 1980:36), each of which may be divided into four for a total of sixteen overall (see Figure 12a, Beyer 1980:30; and 12b, Beyer 1980:42), and again for sixty-four (see Figure 13a, Beyer 1980:30; and 13b, Beyer 1980:49). The other categories all have logically similar subcategories so that a rational hierarchy of types emerges. A design based on sixteen squares is logically subsumed under the more general rubric of designs based on a square divided in four, that is, four-patch.

A giant step forward though this system is, its fundamental purpose, the drafting of designs, makes it unsuitable as a fully developed and all-encompassing taxonomic system. At the most basic level it cannot incorporate appliqué designs, a substantial fraction of the quilt universe, because they are usually curvilinear and hence not based on gridded squares. It is as if Beyer had created a good classification system for plants but could not extend it to include animals.

More subtle and more vexing is the relationship between the *drafting* of a quilt and its mechanical *construction*. From the point of view of someone drawing a design on gridded paper, the pattern in Figure 14 most definitely belongs in the four-patch category, but from the perspective of someone assembling pieces of material, it is clearly *not* based on four squares unless you actually cut the material into smaller units. That is, if you cut the center square into four triangles (see Figure 15a) you could assemble it in four squares (see Figure 15b), as you would the pattern in Figure 11b. But this is not how it is made. The center square is a single piece of fabric and it is assembled by building out from the center (see Figure 16) in precisely the same way as the patterns in Figure 8a–b.

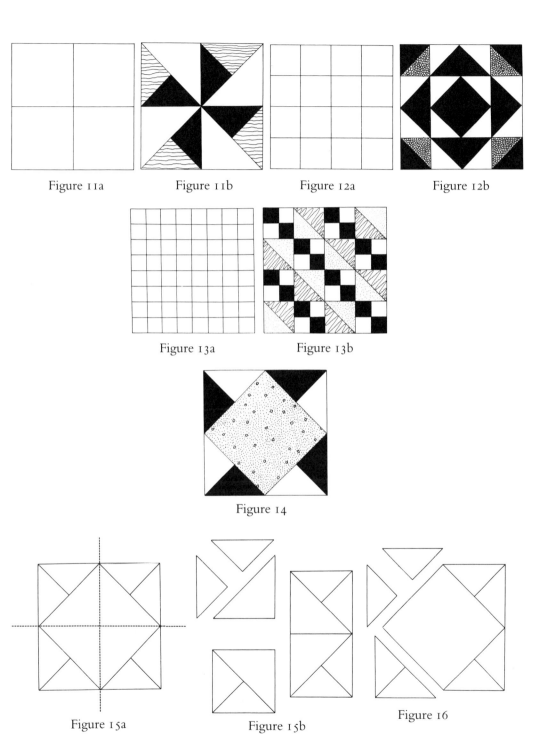

Figure 11a Figure 11b Figure 12a Figure 12b

Figure 13a Figure 13b

Figure 14

Figure 15a Figure 15b Figure 16

Figure 17

Well, it may be argued, let us simply have a refinement of the model by further subdividing drafting categories into assembly categories; the former is the genus, the latter the species. But soon such an attempt begins to break down the system. For example, Beyer classifies the pattern in Figure 17 (Beyer 1980:73) as a nine-patch design because its drafting can be comprehended on a 3 × 3 grid. Yet it is obviously constructed from the center out like those patterns in Figures 8a–b and 11b, all of which are drafted on a four-patch grid.

Is the nine-ness of Figure 17 more fundamental than its built-out-from-the-center-ness so that it is reasonable to type it as genus *Nine-patch*, species *built-from-the-center*, while including the others in genus *Four-patch*, species *built-from-the-center*? Or is it preferable to include them all in the genus *Built-from-the-center* and subdivide them into two species: *nine-patch* and *four-patch*? Or is neither suitable? The answer depends in part on the logical relationship between drafting and construction and in part on what you want the taxonomy to do for you.

It might seem that drafting is more basic than construction because it comes first, but this is not necessarily the case. In her first book on drafting patterns, *Patchwork Patterns*, Beyer begins by explaining:

> There are many quilt books which give *patterns* for geometric patchwork designs, but there seem to be none that go into detail or are devoted entirely to drafting one's *own*. Thus the constant question: "Does anyone have a pattern for 'broken star,' " or "I am looking for an eight inch block of the 'log cabin,' " and so on. . . .
>
> The whole concept of pattern drafting lies in the ability to be able to look at a geometric design and classify it into its proper category.

The Natural History of the Traditional Quilt

Once that category is identified, one can then fold a square of paper into the basic "grid" for that category. Once the paper has been folded, it is then possible, with the aid of a ruler and/or a few additional folds, to make all the pattern pieces necessary for that particular design.
(BEYER 1979: VII–VIII)

So it is not the drafting that comes first in this system but *other quilts*. The skeptic might object that the original quilt had to be drafted too, but there is no good reason to suppose that Beyer's system in particular—or any single one—was universally used, nor is it the case that a pattern need be drafted on paper at all.

As Mary Washington Clarke observes:

An experienced quilter can look closely at a quilt or even at a picture of one, analyze the structure into blocks and a block into pieces. Then she can take a square of cloth the size of the block she desires to make, fold it, and cut the needed pattern shapes for templates. She must, of course, have in mind or on paper a diagram of their arrangement and the number needed. Annie Chelf laughs at the labor she expended to "take off" a complicated pattern from a picture, only to discover the ready-made pattern later on. And Mae Young, who found she had lost her pattern for Jacob's Ladder when she got ready to make another one, said, "It won't be hard to cut another. It's just squares and half-squares." She had in her memory the structure of the block.
(CLARKE 1976: 36)

Note especially here that the quilters analyze "a block into *pieces*," which could be abstract drafting units, as in Beyer's scheme, or could be simply units ready to be assembled, such as the "squares and half-squares" that make up "Jacob's Ladder." Mae Young had mentally deconstructed the pattern into elementary units of assembly without the need of the intermediate step of a drafted grid explaining how to break the design first into nine-patch squares before being able to discern the basic units.

The ready-made patterns that Clarke mentions might come from magazines or be handed down through the family. They are essentially shape outlines from which to build templates out of some sturdy material:

Most quilters keep the pattern templates of cardboard (sandpaper in recent years) or some other durable material and pass them around

among their fellow quilters during their lifetimes. . . . The quilter needs for most patterns a diagram either in her mind or on paper indicating the number of pieces to cut for each shape (or color variations within the shape) and showing the arrangement of pieces into blocks and of blocks into a whole top.
(CLARKE 1976:36)

In the simplest terms a quilt design consists of a number of basic shapes—squares, right triangles, equilateral triangles, hexagons, and so forth—and an idea, on paper or in the head, of how they fit together to make a design. This is absolutely fundamental and, therefore, is the best place from which to start a taxonomy. Drafting schemes, such as Beyer's, may often capture the essentials of this process but they may also become abstracted from it and end up like symmetry analysis, describing a design accurately without being true to the fundamentals of construction.

So, to conclude the opening debate, we might say that Figures 8a and 17 are both part of the built-from-the-center group made up of a square and right triangles, and they differ in that the former involves five stages of building outward, whereas the latter involves only two. The fact that the former can be drafted on a nine-patch and the latter on a four-patch grid is an abstraction from the construction process that is superfluous knowledge from a taxonomic standpoint, just as is the knowledge that the uncolored patterns both belong to symmetry group 4mm. (Issues bearing on drafting as a preliminary to construction are taken up in Section 3.2.)

A taxonomy built in this manner also has the overwhelming advantage of being potentially complete and endlessly expandable to accommodate new designs. Every design (pieced or appliqué) is made up of definable shapes put together in a limited number of ways and following certain fundamental construction rules (e.g., wherever possible sew the pieces of a design together in an order that maximizes the number of straight seams and minimizes angular seams or "setting in"). No taxonomy could be closer to the elementary facts of quilt production and reproduction.

In recent years, scholars in the various branches of the study of material culture, particularly archaeology, have begun to devote serious attention to building typologies that incorporate data on modes of artifact production (Friedrich 1970; Glassie 1975; M. A. Hardin 1977, 1979; Longacre 1974; Stanislawski 1969) because of a shift in focus from general comparative investigation to specific theories concerning the relationship between social behavior and the production of particular artifactual forms (see Plog 1978 and Davis 1983 for a general overview).

Until the 1960s, as James Deetz observes (Deetz 1967:49–52), a simple *type* concept was good enough to deal with artifactual data from excavation sites (and for certain kinds of analysis still has merit). Potsherds, for example, could be divided into piles on the basis of distinct but arbitrarily selected visual elements with little concern for their relative social, symbolic, cognitive, aesthetic, or technological importance for the people who made and used the pots. The purpose of such groupings was simply comparative; they allowed the archaeologist to locate an assemblage temporally and spatially. Obviously, some interest in the manufacture of pots played a part in choosing elements for typing, in order to eliminate from consideration those features imposed on the pots by mechanical efficiency, function, or constraints in the medium. Such elements would be too general—and potentially the result of many independent inventions—to have any use as spatial or temporal markers.

These limited, and sometimes idiosyncratic, typologies began to give way to systems that more closely matched the material and psychological facts of production as Deetz and others attempted to use styles of pottery decoration from excavations to infer social information beyond the relatively simple facts of the location of an assemblage in time and space (Deetz 1965; Hill 1967, 1970; Longacre 1964, 1974; Whallon 1968, 1969). In some ways these new agendas of the archaeologists are related to our concerns in this book, so it is important to understand the ways in which their classification systems overlap ours and the ways in which they do not.

Although the "new archeologists" argue cogently for typologies based on the ethnography of artifact construction, they still end up relying heavily on the venerable, and often elusive, concept of style as the heart of their classifications. This choice is due both to the kinds of data archaeologists habitually find and the goals to which the typologies are directed. As Stephen Plog notes (1978:159), it is difficult to create rational taxonomies sensitive to the structural relationships between various design elements on pots and between style and mode of production when you are dealing with nothing but ceramic fragments. Rudiments of style and design inevitably become the objects of classification.

Dave Davis defines style as:

the formal similarities among artifacts that can be related to factors other than raw material availability or mechanical efficiency. . . . Archaeologists' definitions of style often emphasize the means by which stylistic similarities are identified as such or the interpretive goals to which the concept is applied or both. In the first instance,

style is usually regarded as a residual category, composed of formal variability that remains after "functional" variability has been accounted for (Chang 1967:112–114; Dunnell 1978:199–200). Under the second emphasis, style is regarded as the set of formal similarities that can be related to patterned interaction or communication among individuals or groups (Jelinek 1976:20; Whallon 1968:224).

(DAVIS 1983:55)

Style as a residual "nonfunctional" category is primarily an indexing tool and as such is not of much value to us, for the reasons given in our discussion of naming systems. On the other hand, formal properties that can be correlated with other social issues are of deep significance to us (and are discussed in due course in Sections 3.2, 3.3, and 4.3), but we feel that our taxonomy based on primitive elements and the mechanics of assembling them is logically prior to such a definition of style, and, therefore, better able to serve both our purposes and the express needs of the new archeologists.

Closer to our aims is James Deetz's use of the formal structure of artifacts for building typologies (Deetz 1967:83–101). Following a well established structural method ultimately derived from comparative linguistics (see Hockett 1958), Deetz decomposes artifacts into primitive units, called "factemes," which can be combined and recombined according to certain rules to make different kinds of objects or "formemes."

An elaborate working through of this method can be found in Henry Glassie's *Folk Housing in Middle Virginia* (Glassie 1975), where he constructs a typology of house types by speculating on the primitive units that traditional builders worked with and the structural rules that controlled the ways they assembled and reassembled these units. Following closely the linguistic analogy from which this structuralist approach derives, Glassie thinks of houses as "sentences" built out of the "words" of basic construction units according to the rules of "syntax" that represent the builders' internalized and largely unconscious architectural competence. "Sentences" (i.e., houses) that share that same underlying "grammatical" structure can be grouped together as a "type."

Glassie's approach has certain merits. His analysis does see beyond superficial and perhaps misleading aspects of house style to deeper levels of congruence or dissimilarity, driven by a desire not simply to classify buildings but to understand how the basic units and rules of the game influenced the development and evolution of certain types. His somewhat hierarchically, somewhat chronologically ordered series of rules for discriminating types—

running from the deeper/earlier (e.g., overall dimensions) to the shallower/later (e.g., existence of roof piercing)—allows us to see at what structural level/chronological point in building two types diverge.

But Glassie's system has trouble breaking free from the confines of his particular data-set, and it is doubtful whether it could be generalized sufficiently to accommodate all types of traditional housing, let alone be modified to suit other forms of material culture, such as quilts, without becoming unwieldy. Despite its overt attempts to get under the surface, it seems wedded to the detailed particulars of Goochland and Louisa counties. Unquestionably, house typologies must reflect house construction, but if a typology ends up being elaborately descriptive it loses much of its classificatory clarity and purpose.

Furthermore, Glassie prefers to infer his typological rules from the buildings without any intercourse with contemporary traditional builders:

> Artifacts are worth studying because they yield information about the ideas in the minds of people long dead. Culture is pattern in mind, the ability to make things like sentences or houses. These things are all that the analyst has to work with in his struggle to get back to the ideas that are culture.
> (GLASSIE 1975:17)

Yet, paradoxically, this agenda runs completely athwart the ethnoarchaeologists who feel that the artifacts themselves do not speak loudly enough or clearly enough and, therefore, seek out contemporary practitioners to guide them in their understanding of unfamiliar technologies. An investigator will not get the grammar of an unknown tongue from the lips of its native speakers, but the speakers will be able to correct the linguist in developing his or her own competence through trial and error. Otherwise a person would be just as well off trying to develop a grammar by studying sentences in a book.

Thus our taxonomy, while not determined by it, is informed by the ethnography of quilting past and present. The order of sewing together basic shapes, when used as a taxonomic principle, comes as a synthesis of knowledge derived from looking at quilts, experimentation with materials, and talking to quilters. And our taxonomy does not attempt to be completely descriptive, but rather deals only with those structural elements necessary to make classificatory decisions. We reserve the morphology of the whole for later study.

Partly in order to avoid the trap of being exhaustively descriptive at the taxonomic stage, we use only the construction of the quilt *top* for classifica-

tory purposes. Certainly there are ample precedents for this—no classification system of quilts we know uses anything other than top design—but even if there were not, the decision follows our general principle of being guided by the quilts themselves and the actions of their makers.

Both chronologically and conceptually, the top is prior to any other part of a quilt. It is made first and, therefore, is the basis for other decisions, such as the kind of backing and binding fabrics to be used on the finished quilt and the arrangement and complexity of quilting stitch patterns—it is the top that is quilted, not the quilt that is topped. When a quilt is named, the name refers not to the configuration of the whole object but to the top alone, so that a quilter may speak of making a "Snake Trail" or "Log Cabin" quilt, letting a part stand for the whole. When quilters speak of their quilt patterns, they are referring to templates for cutting out the tops. It is from the genotype of the top that the fleshed out phenotype of the finished quilt emerges.

The remainder of this section lays out our taxonomy in enough detail so that its key principles can be understood, and is divided into two broad categories—"kingdoms," if you like—that reflect the most basic decision of all: whether the top is to be pieced. Our first category contains all those tops whose basic structure is made up of small units of cloth pieced together. The second category deals with those tops that begin as a single piece of fabric. Smaller pieces may be attached to this base in some way to create patterned effects, or the base may subsequently be modified. But at the outset the base is an unseamed length of cloth. These are the foundational taxons because they represent fundamentally different modes of construction, which in turn have different implications for the evolution of designs. Besides these two major construction categories, there are a number of hybrid or anomalous types, which we discuss separately, following the sections concerning the main "kingdoms." Before examining the individual taxons in detail, we explore the notion of a *cell*, which lies at the heart of the whole taxonomy.

1.2. THE CELL

To build a rational taxonomy of any kind, it is necessary to consider carefully what criteria will be used to determine which items in the inventory to be classified are the "same" and which are "different." At the start it must be acknowledged that these notions of "same" and "different" cannot be absolute categories, but, rather, have meaning only within the universe defined by the taxonomy itself. Obviously, there is a sense in which every quilt is the same (basic morphology) and a sense in which every quilt is different (specific combinations of fabrics, colors, and techniques), but neither of these ways of

The Natural History of the Traditional Quilt

thinking is of much help taxonomically. We must find some middle ground that helps us place quilts into groups according to a limited set of rules, and—of fundamental importance—in so doing we should learn something about quilts and quilting that we would not ordinarily perceive without the taxonomy.

It is vital to the success of any taxonomy to limit the kind and amount of information that will be used to build groups of "like" objects. If all the observable data concerning an object were to be used in the classificatory process, then quite clearly every object would inevitably occupy a separate niche. Some information must, for the purposes of classification, be set aside. This is not to say that such information is unimportant; it is, however, unnecessary at this stage of analysis but it may be useful later. Classification is, therefore, inherently reductive, which is not problematic unless such reduction is the end point of analysis, instead of a well defined means to an end.

Both in making up categories and in assigning items to their respective places in a taxonomy, one has to consider the complexities of point of view. One could, for example, elicit information from quilters with the aim of discovering their own categories, or one could work independently of such "native" systems. Again, striking a balance between the two extremes seems appropriate to us. On the one hand, some of our analytic needs in a rational taxonomy lie outside of the conscious realm of many quilters, and, in any case, there is no reason to suppose that one system of categories would satisfy the wide range of perspectives and interests that quilters from Nova Scotia to Texas have. Yet building an abstract system of taxons without reference to the quilters would defeat our central purpose, namely, to stay as close to the quilt and its universe as possible and to avoid spinning off into the ether. Our taxonomy, therefore, must not do violence to native systems, but neither must it get bogged down in them or be limited by them.

All of these concerns can be subsumed under the question of what is to be the basic *unit* that will be the currency of the taxonomy. That is, what method of abstracting information from individual quilts will be suitable to handle overall designs made of shadow appliqué, miniature pieced squares, and everything in between, without losing itself in detail? For Linnaeus, the answer to a similar question in biology was simple yet ingenious. If two living things can mate to produce like, fertile offspring, they belong to the same species. Certainly quilts do not mate, but the Linnaean system gives us a lead, because quilts are built out of patterns that may be used to replicate forms. That is, quilts "replicate" through patterns, so that all quilts made from the same pattern can be thought of as belonging to the same "species."

All quilts are made from a pattern of some sort, even though not all pat-

terns are of the same type. Some quilters use templates made of wood, metal, or some durable material to draw outlines of basic shapes—squares, half squares, hexagons, diamonds—on material; others use commercially made or hand cut paper patterns. In some cases (crazy quilts, for example), the material can be cut by eye according to an overall aesthetic aim. In other cases, as with traditional Welsh wadded quilts, the "pattern" is the entire face of a piece of whole cloth, which is then quilted according to a design which may be the mental (and commercial) property of an itinerant specialist who traces it onto the top. The specific details of the process of pattern use we take up in Section 3.3, but now we wish to note only that regardless of what the pattern is like, physically or mentally, it exists somewhere in some form and represents a kind of genotype of a quilt.

Thus we might well build a taxonomy out of quilt patterns. Yet because patterns are potentially diverse and not all are mutually compatible, we need to proceed one more step in the abstraction process to find a common idea that underlies them all. A pattern for a quilt reduces the form under construction to a set of shapes that can be cut from basic materials and provides information on how to fit the shapes together to make the finished quilt. In the case of whole cloth quilts, the pattern is a simple matter, since it consists of a single piece and shape of fabric. Other types of quilts may be constructed of two or more lengths of quilts seamed together. The discussion in the remainder of this section will focus on the more complex taxonomic problems presented by the patterns in pieced and appliqué quilts; but it should be borne in mind that the taxonomy itself includes all types of quilts. Later sections will make clear the precise application of the taxonomy and its generative concepts to all varieties of quilts.

For many pieced and appliqué designs, the process of abstraction from overall pattern (and of creating design) involves constructing an intermediate unit which, when repeated a number of times, creates a whole quilt (Figure 18). These intermediate units may be thought of as *units of replication*—akin to a genotype—because they contain all the information necessary to produce whole quilts through basic repetition (and the application of some fundamental rules to be outlined later). We call this unit of replication a *cell*. (Note that the cell concept applies to whole cloth, medallion, Amish, strip, and other kinds of quilts as well, which will be evident from later discussion. In some cases, the cell is not an intermediate unit, but the only unit. It is a unit of replication in the sense that it is the only unit necessary for the replication of the pattern.)

To begin our taxonomy we may say that two quilts are the same if they are made up of the same kind of cell. But it must be borne in mind that cell is

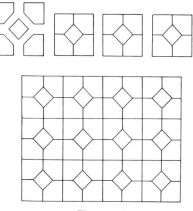

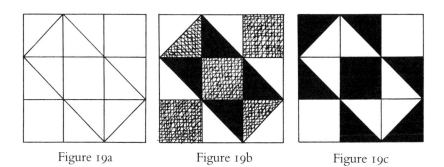

Figure 18

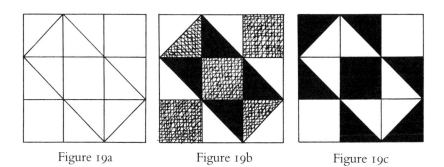

Figure 19a Figure 19b Figure 19c

primarily a *pattern* concept, not a material concept. The *shapes* within the cell and their *configuration*, not the ways that they are realized using specific color combinations of materials, define what a cell is. The pattern (i.e., cell) in Figure 19*a*, for example, may be realized in materials using different color values to produce the designs in Figure 19*b–c*, but the underlying configurations are the same. This mirrors the fundamental biological distinction between genotype (underlying pattern) and phenotype (physical variations produced from the underlying pattern). This does not mean that we consider color to be a secondary feature in terms of design, only that we are not using it as a taxonomic principle.

At the most specific level, one could, if desired, bring color into the description of pattern type. We do not carry the taxonomy out to this level of specificity, for a number of reasons. For one thing, color itself is not a simple issue. If one were to specify color, the dimensions of specification would first have to be clarified. Color theory recognizes such dimensions as hue, value,

and intensity. Which of these differences make a difference, and what degree of difference along each dimension is sufficient to create a new type? Add to these questions the matter of fabric variation, with distinctions of texture and structure, all of which are entailed in the phenomenology of color, and the picture becomes even more complicated. Simply put, the consideration of color as a taxonomic principle leads, ultimately, to the designation of each quilt as an individual class, thus destroying the aim of taxonomy.

Here, then, is a relatively concise, though not fully formalized, definition of a cell: a *cell* is the smallest unit of construction of a quilt that, when set together according to certain fundamental principles, produces a finished top. A cell may be assembled out of smaller pieces or it may be a single piece of cloth. Obviously, the simplest cell is made up of a single shape, such as a square, rectangle, or hexagon. Other cells are more complex. When a cell is assembled out of smaller pieces, it is important to realize that some or all of the pieces that make up the cell are *dissimilar* so that they cannot replicate as single units on their own to create a whole top.

In some cases the constituent subunits are dissimilar in shape; in others they are dissimilar in orientation. In Figure 20, for example, the cell has many like subunits in it, but they cannot individually replicate to produce the whole quilt. Figure 21 shows a cell made up of subcells that are similar in shape but dissimilar in orientation. The importance of relative orientation can be grasped immediately by contrasting this cell with that shown in Figure 22, where different orientation of the subunit produces a completely different visual object. By extension, two complete units which are constructed from the same constituent shapes using identical methods, but which are mathematical rotations of one another, represent two distinct, though very closely related, cells (see Figure 23). So we can add an important section to our definition of a cell: a cell is a unit that requires only *setting information*—that is, kinds of sashing, setting squares, borders, overall orientation (all cells oblique versus all cells straight, with respect to the quilt's edges), and the like—and not information regarding relative orientation of subunits or subcells, to make a finished quilt. (For further discussion of the notion of setting, see below, as well as Section 2.2).

It may be clear to the mathematically inclined that the cell concept as discussed so far is not—nor can it be made—formally rigorous. It is an idea that is to be grasped by working with it and by seeing all of its ramifications, intellectual and practical. It is what philosophers term an operational concept, that is, it is to be understood by seeing it used. There are many reasons for this state of affairs.

The Natural History of the Traditional Quilt

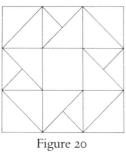

Figure 20

Figure 21 Figure 22

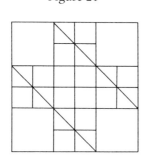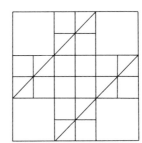

Figure 23

To begin with, the mathematics of tiling and symmetry already exists to handle whatever rigor is needed from a strictly design point of view (see Grünbaum and Shephard 1987 for an extensive technical discussion). But the making of a quilt is not a purely formal process; rather, it is the intersection of the formal (design and geometric constraints) and the nonformal (cognitive and cultural processes). Our taxonomy seeks to capture the essence of this intersection. Furthermore, as already articulated in the previous section, formal systems such as symmetry analysis, which have been created to handle enormously complex objects, end up lumping most quilt designs together in

a few simple categories that represent a minuscule fraction of the universe of possibilities, and so, ironically, end up being unworkably reductive.

Equally important, formal systems to be fully rigorous require a kind of abstraction that draws them too far apart from the basic mechanics of constructing an actual quilt. Tiling analysis, for example, relies on the basic geometric notion of the Euclidian plane. This is an ideal two-dimensional surface stretching infinitely in all directions. By such analysis, any particular quilt is the physical realization of a *segment* of this infinite plane. Figure 24 shows a tiling of a very common quilt pattern as represented in the infinite Euclidian plane. Highlighted within the plane are two cells that, when isolated, look quite different, but which produce identical tilings when replicated infinitely. From an abstract mathematical point of view the two are the same because of this fact. From a quilter's point of view, however, they are different because the quilter does not conceive of a quilt as a small fraction of an infinite mathematical object, but as a finite form made by piecing construction units together. What those units look like as individual entities makes a difference to the quilter, regardless of what happens to them when extrapolated infinitely in abstract space.

Figure 25 shows the two cells from Figure 24 made up into quilts. From the quilter's point of view these are *different* (though related) designs, whereas from the mathematician's point of view they are the same. They are different because the cells used to construct them are different, and such a difference ultimately affects fundamental choices in realizing the pattern in fabric, such as choice of color, materials, and possibly setting. Moreover, such a difference leads to potential differences in the creative variation of design and in the transmission of design. A taxonomy rooted in the practice of quilting must side with the quilters and against the mathematicians, and say that the two are different. The cell concept allows this, but in the process the notion of what a cell is becomes more heuristic (or operational), and less rigorous.

It must be remembered at all times that the cell concept is a practical construction concept, not a pure abstraction. Even though the cell concept takes no account of color—and hence could be termed abstract—such abstraction derives from the mechanics of quiltmaking itself. Using templates (standard shapes made of some durable material, such as wood, that can be drawn around onto fabric), for example, is the quilter's own traditional way of abstracting shape from color. The idea of "taking off" a pattern, as explored in the previous section, also makes it clear that quilters themselves conceive of patterns in terms of elementary shapes. A cell is, therefore, as much a *unit of construction* as a unit of replication. Given this fact, one might wonder why we do not use the common concept "block"—as used by many traditional

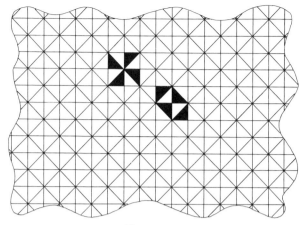

Figure 24

Figure 25a

Figure 25b

quilters—instead of cell as the starting point of our taxonomy. There are many reasons, and a comparison of the concepts of block and cell will both elucidate the cell concept more fully and explore its analytic usefulness.

Certainly the traditional term "block" as it is commonly used means a basic unit of construction, and our cell concept is ultimately derived from it. Characteristically a block is a square unit pieced together from basic geometric shapes. As such, like a cell, it is a unit of construction, but, even given the enormous number of blocks that are described in standard works (e.g., Beyer 1980 and Hall and Kretsinger 1935), the term falls well short of being general enough to serve as the basis of a complete taxonomy.

Many pieced quilts cannot be reduced to blocks, and attempts to do so have divorced the process of definition from the process of constructing actual quilts. Figure 26, for example, shows Beyer's conception of the "block"

for the classic design that is almost universally known as "Double Wedding Ring." But a simple inspection of an actual "Double Wedding Ring" quilt will show that Beyer's "block" does not exist as a construction unit. If it did, all "Double Wedding Ring" quilts would look like Figure 27*a*, that is, with the squared seam lines of the block running horizontally and vertically throughout, and with straight line borders. But they do not. They look like Figure 27*b*, with scalloped edges and no block seams. The mode of construction instructs us that there is a unit of replication at work here other than the block.

As normally defined, a single patch of unpieced cloth, such as a plain square or a hexagon, is not a block either, although it can be referred to as a "one-patch." Yet single patches are units of construction and units of replication. Although not blocks by standard definition, they are cells. The term "block" as applied in traditional quilting usually refers to a pieced unit, rather than an appliqué one. Analogues appear in appliqué work but they are not universally referred to as "blocks." Therefore, to expand the term beyond common usage requires special pleading and fresh descriptions. Even given adequate definitions, the expanded term could lead to confusion, whereas the introduction of a new term allows for a fresh start unencumbered by already existing frames of reference. However, such problems could be overcome were it not for more formal difficulties inherent in the idea of a block as currently understood.

Although the concept of the cell is not a fully formalized idea, the concept of the block is even less rigorous. According to Beyer, the two blocks shown in Figure 28*a–b* are different, but there is no formal reason why they should be classified thus. According to the cell concept, they are the same because at some stage in the construction process both involve the making of similar units. Admittedly, the block in Figure 28*b* may involve an intermediate construction step lacking in the other block, but the basic "genetic" identity of the two is clear.

It should be clear that the notions of block and cell overlap a great deal (and as our taxonomy is laid out the precise areas of conjunction will be clearer), but the cell concept is broader and more fundamental. Contrasting it with the block concept identifies several key ideas underlying the cell:

1. It is the *smallest* unit of replication.
2. It is based on actual *construction.*
3. It is a visual unit derived from *sewing*, not drafting.

But an important aspect of the block concept needs to be transferred to the cell concept to articulate it properly. A quilt may be constructed by sew-

Figure 26

Figure 27a

Figure 27b

Figure 28a

Figure 28b

ing blocks (or cells) together directly, but the relationship between block and top need not be so simple. A variety of other elements—borders, sashing strips, setting squares—may be added to the basic block to produce the finished quilt. Quilters have a clear sense of these other elements as extras of a

quite different order from the design of the block. That is, quilters regard the design of the two quilts in Figure 29 as the *same* even though one is set with and one without sashing strips. The block design is conceived as more basic to the categorizing of designs than the specifics of setting, so that if you look in standard compendia of patterns you will find arrays of blocks. To use the language of our biological analogy, the particulars of setting are part of the phenotype—what happens when the genotype (block or cell) is realized in fabric—and the pattern of the block is akin to the genotype. Our concept of the cell adopts the same usage and merely refines it in ways that allow our analysis to take account of all types of quilt. The cell is the unit of replication of the *basic pattern* (as conceived and transmitted by quilters), not of finished tops.

This distinction between the basic cell and "extras" is the ultimate reason why the formal rigor of tiling analysis—or any other mathematical system—is incompatible with the cell concept. Quilters know the difference between a block and a border, but a formal geometric description cannot be expected to skip over some aspects of a finished design in favor of others. A quilter can easily see beneath the "extras" and assert that the quilts in Figure 29 follow the same pattern, but *geometrically* they are different and require a different mathematical description.

Thus, the cell is as much a cognitive category as a physical one. Another way to express the idea is to think of the cell as the *unit of transmission*—that is, the smallest amount of information that enables the basic design idea to pass from one quilter to another (this being how designs are replicated). What passes from one to another is the genotype, not the phenotype. And, it is this basic notion that ideas pass from one quilter to another, through a kind of genotype, that underpins our whole taxonomy, for the taxonomy mirrors the ways in which ideas are transformed in the process of transmission (the basic folk process). The taxonomy is much less concerned with classification as a way of cataloging than with showing the historic and creative links between design ideas. It can reveal aspects of the process of invention, transmission, and modification that otherwise lie latent within the quilts themselves. The ensuing development of the taxonomy shows the process in action and, in turn, explores the cell concept more directly.

1.3. SEAMED BASE CATEGORIES

A rudimentary distinction can be made between those quilts whose tops begin as whole unseamed pieces of fabric and those whose tops are pieced from smaller units. These can be considered two "kingdoms," and represent a ma-

The Natural History of the Traditional Quilt

Figure 29a

Figure 29b

jor division of types. The cells that make up the taxonomic divisions in each are structurally sufficiently different, because of the nature of the base that they work from, that they can be treated separately. Thus, the unseamed taxons are described in Section 1.4. This section gives a thorough description of the taxonomic method for seamed base quilts, including a discussion of the hierarchical placement of taxons.

Although it is theoretically and technically possible, we do not give an exhaustive catalogue of cells here, nor draw out the taxonomy to its finest limits. Instead, we give enough of the basic working of the system so that it can be useful in subsequent sections. The taxonomy as it exists here will not differentiate between individual cells but only between broad families of cell types. In order to differentiate cells to the level of species, several additional layers of taxonomic distinction would need to be spelled out. We have indicated what these layers would specify, but we have not extended the formal taxonomy and its codes to include them here. The complete taxonomy and an enumeration of cells catalogued according to the system should constitute a reference work in its own right.

In essence, the cells of pieced base quilts can be classified according to the ways they are assembled, the number and shapes of the seams involved in assembly, and the number and shapes of the constituent pieces. The taxonomy is hierarchically arranged and is shown in graphic form in Figure 30. On the figure and in the text to follow, the taxons are designated by a code number that represents the tree structure of the entire hierarchy. Dots in the code represent points where the tree structure forks, and numbers after the dots represent the particular path taken. The exact derivation of these codes will be clearer as the description progresses. These codes are, however, simply a technical convenience and should not be dwelt on in themselves. The basic principles for producing the taxons are what matters.

S Seamed base cells

All codes in this section begin with the prefix S, which stands for "seamed base." The first fork divides into two branches—S1, those quilts made by many repetitions of a single cell idea, and S2, those that are constructed from more than one cell idea.

S1 Single cell

Those quilts made by repeating a single cell idea can be divided according to the shape of the cell—square, rectangle, hexagon, and so forth. There is one mathematical limitation here, however. Single cell quilts must follow the laws of tiling which determine what shapes can be sewn together without gaps. Thus, regular pentagonal and octagonal single cell quilts are geometrically impossible.

S1.1 Square cell

The square cell empirically represents the huge majority of seamed base patterns. It is, in a sense, the prototypic cell. As such it will be explored to the

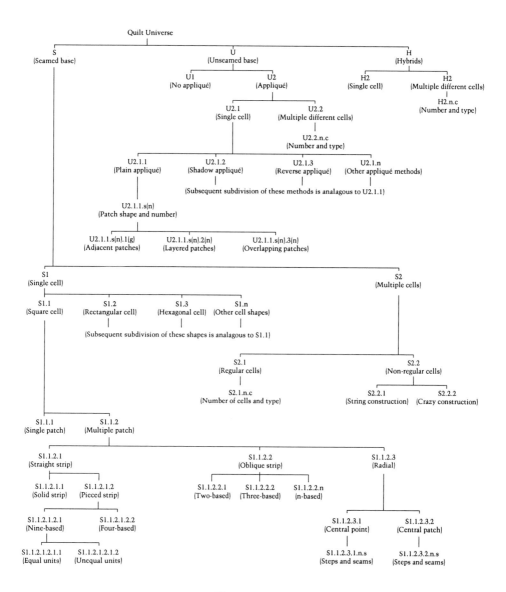

Figure 30

maximum depth that we intend to explore any taxon (stopping just short of cataloguing individual items). Other cell shapes we explore in less detail because the lower or deeper taxons are analogous to those of the square cell; they will simply be pointed to in outline fashion.

S1.1.1 Single patch

The simplest square cell quilt is made from solid, one piece squares sewn edge to edge. All other square cell patterns require piecing patches together.

S1.1.2 Multiple patch

The patches of a square cell can be sewn together in three ways—straight strip, oblique strip, and radial. These three modes are of fundamental importance in understanding the nature of cell construction.

S1.1.2.1 Straight strip

Patches sewn together in straight strips have main seams that run parallel to one of the edges.

S1.1.2.1.1 Solid strip

The simplest form of straight strip piecing involves sewing solid strips together to make the square cell (Figure 31). Lower taxons can be developed by specifying the number of strips and whether or not they are of regular width.

S1.1.2.1.2 Pieced strip

The straight strips themselves may, in turn, be pieced, and this method of cell construction is very well represented empirically.

S1.1.2.1.2.1 Nine-based

A nine-based pieced strip consists of three strips each made up of three units (Figure 32). This taxon includes many (but not all) of what are traditionally called nine-patch designs. The designs in Figure 33 can both be *drafted* on a 3 × 3 grid but they are *sewn together* differently. The design in Figure 33*a* is made into straight strips as shown, but the one in Figure 33*b* is sewn obliquely as shown. As such, the latter belongs in a different category, because our taxonomy is based on the practicalities of construction.

The fact that ours is a construction and not a drafting taxonomy also allows a useful economy in taxons. In many standard works separate sections are devoted to five-patch and seven-patch designs. These are drafted, respectively, on 5 × 5 and 7 × 7 grids (and so logically ought to be called twenty-five patch and forty-nine patch). Comparison of certain designs in, say, five-patch and nine-patch (Figure 34), though, reveals that, despite the fact that the subunits are of unequal width, many five- and seven-patch designs are

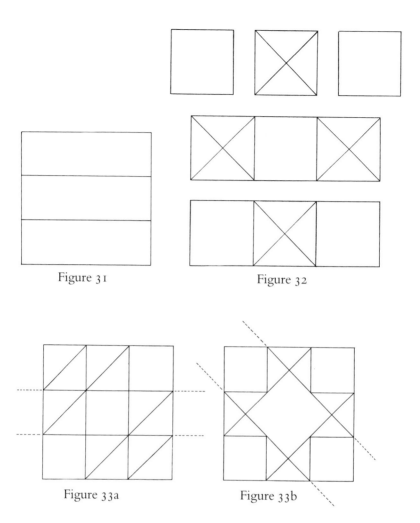

Figure 31

Figure 32

Figure 33a

Figure 33b

put together in three strips of three units. (Other modes of constructing five- and seven-patch designs are subsumed under taxons described below, such as oblique and radial, depending on basic mode of construction.) This leads to a further split into 3 × 3 designs of equal and of unequal subunits.

S1.1.2.1.2.1.1 *Nine-based, equal units*

This taxon represents the classic nine-patch, that is, nine *square* subunits arranged in three rows of three. For further subdivision the subunits can be described using the same system that we are using for the cells themselves (pieced versus unpieced, nature of seams, and so on).

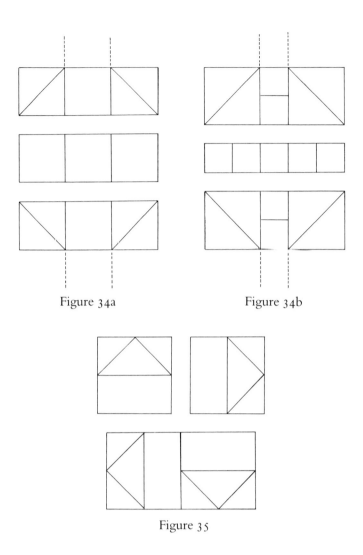

Figure 34a Figure 34b

Figure 35

S1.1.2.1.2.1.2 Nine-based, unequal units

This taxon includes those designs, such as those sometimes traditionally designated as five- and seven-patch, that are constructed in three rows of three subunits where not all the subunits are squares. It too can be further subdivided as its equal unit counterpart.

S1.1.2.1.2.2 Four-based

A four-based pieced strip design consists of two strips each made of two square units (see Figure 35). Most of the patterns in this taxon also fall under

The Natural History of the Traditional Quilt

<p style="text-align:center">Figure 36a Figure 36b</p>

the traditional rubric "four-patch" (but not vice versa). As with the categories nine-based and nine-patch, despite some overlap, the match between the categories four-based and four-patch is not complete because of the differences between drafting a pattern and constructing it. The two designs in Figure 36 (compare Figure 33) can be drafted on a 2 × 2 grid, but the design in Figure 36a is constructed in horizontal strips and that in Figure 36b in oblique strips.

From a taxonomic and general analytic point of view, it is interesting to note that the great majority of cells that can be drafted on a 2 × 2 grid (or square grid based on powers of two, such as 4 × 4 or 8 × 8) are *not* four-based in their construction. For example, almost all of the designs that Beyer classifies as four-patch are not four-based. The so-called four-patch block is primarily an abstraction based on drafting and is misnamed by modern analysts, such as Beyer, in that most such blocks are not reducible to four *patches*, or four of any other construction unit. The term "nine-patch" has some validity (and as such coincides quite closely with our term "nine-based"), not only because it is a traditional term, but also because the majority of nine-patch designs can be broken into nine construction units or patches in addition to being drafted on a 3 × 3 grid: drafting and construction frequently coincide. The wish to extend the obviously useful system beyond its limits to four-patch (and the even more anomalous five-patch and seven-patch) creates problems, because the use of drafting as the sole taxonomic criterion is both overly reductive and frequently unhelpful in showing how designs are "genetically" related (as already articulated in Section 1.1).

Like nine-based designs, four-based cells can be further subdivided and categorized according to the construction of the subunits. Note, however, that the subunits of all four-based cells are, of necessity, square.

S1.1.2.2 Oblique strip

As already noted, many designs that can be drafted on a 2 × 2 or 3 × 3 grid are actually put together in strips that run obliquely to the edge of the cell. This is most often done to avoid "setting in," that is, piecing patches into corners as opposed to sewing straight seams. So, for example, the design in Figure 33*b* could be made without oblique main seams, but the corner squares would have to be set in (see Figure 37), instead of simply sewing a succession of straight seams. Needleworkers avoid setting in wherever possible because of the difficulties of doing so accurately and quickly.

Some cells could hypothetically be made either by straight strip or oblique strip construction, and as such form an interesting bridge group between the two categories. In reality the choice rarely results in a dilemma for the quilter (or the classifier): straight strip sewing is to be preferred over oblique, mainly because the quilter can more easily keep angles square using a straight strip method.

Oblique strips can be further classified by the number of strips used to make up a square.

S1.1.2.2.1 Two-based

A two-based oblique strip involves two strips that are sewn together along the diagonal of the square (Figure 38). Further subdivision of the taxon can be based on the method of construction of the strips.

S1.1.2.2.2 Three-based

The great majority of cells constructed from oblique strips are made from three strips, with two seams running parallel to the diagonal of the cell (Figures 33*b* and 36*b*). They too can be further subdivided according to the method of construction of the strips.

S1.1.2.2.n n–based

For the sake of completeness, we include the logical extension of four-, five-, six-based, and so on, oblique strips. These can be subsumed under the general head *n*-based, where *n* represents any integer greater than three. Such formal possibilities exist, but empirically they are extremely rare, represented only in such designs as shown in Figure 39.

S1.1.2.3 Radial

Besides being constructed in strips, pieced cells may be made by building outward from the center (Figure 9). Because standard quilting works have

Figure 37

Figure 38

Figure 39

Figure 40

emphasized drafting over construction, this grouping of patterns has been ignored.

S1.1.2.3.1 Central point

The center of a radial cell may be a single point (Figure 40), or it may be a patch (pieced or solid). Beyond this difference the practicalities of classifying radial cells are the same.

S1.1.2.3.1.n.s Central point, steps and seams

The two construction factors that matter for the classification of radial cells are the number of steps outward from the central point, and the kinds of

seams used at each step to attach the fabric to the cell as it grows concentrically outward. The design in Figure 40, for example, has four steps outward from the center, and the seams are, in order from the center, straight, set in, set in, straight. This suggests a classificatory system that first identifies the number of steps, *n*, and then lists the type of seam used, *s*. To abbreviate matters the type of seam may be designated *l* (linear) for straight, *a* (angled) for set in, and *c* for curved. Thus the design in Figure 40 would be classified S1.1.2.3.1.4.l.a.a.l (see Figure 41).

S1.1.2.3.2 Central patch

Instead of a central point, radial cells may have a central patch. If needed this taxon can be further subdivided according to the construction of this patch.

S1.1.2.3.2.n.s Central patch, steps and seams

Central patch radial patterns follow the same system of classification of steps and seams as central point patterns. Thus the design in Figure 9 may be classified S1.1.2.3.2.2.l.l.

S1.2 Rectangular cell

Having explored the possibilities for square cells in some detail, we can examine other cell shapes rather less formally because after the initial difference of basic shape, all of the subsequent taxons can be brought to bear. So, for example, it is possible to split S1.2 into S1.2.1 (single patch) and S1.2.2 (multiple patch), and so forth. Thus the design in Figure 42 would be classified as S.1.2.2.1.1—rectangular cell, multiple patch, straight strip, solid.

S1.3 Hexagonal cell

In addition to rectangular, hexagonal is the other main nonsquare shape used for cells in traditional quilting. Like its rectangular counterpart, its taxons can be developed from the model of square cells.

S1.n Other cell shapes

Technically the geometry of tiling allows for virtually unlimited cell shapes, but very few beyond square, rectangle, and hexagon have been used in traditional quilting because of the difficulties involved in sewing the seams. The clamshell and axhead (Figure 43) are two possibilities found on occasion. Whatever new shapes need to be added can be classified as S1.4, S1.5, and so on.

Figure 41a

Figure 41b

Figure 41c

Figure 41d

Figure 42

Figure 43a Figure 43b

Note that the triangle cannot form a simple cell because, as discussed in the previous section, the orientation of units matters (see Figures 21, 22, and 23 and the discussion pertaining to them), and triangles cannot be sewn together without additional orientation information. Depending on the orientation of triangles, different cells emerge which can be assigned a place in the taxonomy above; the triangles themselves are simply subunits of these cells (see Figure 44). The point is worth reiterating: *the cell is a unit that requires only setting information (not orientation information) to make a finished quilt.*

S2 Multiple (different) cell

The cell concept starts from the premise that a quilter can fabricate a quilt top by simple repetitions of a single cell pattern. Fertile though this concept is, it should be clear that not all quilts can be described as the product of many repetitions of a single cell pattern. A sampler, for example, is plainly made from different cells. One way around this is to say that quilts of this sort are really one giant cell. The idea of quilts consisting of a single giant cell is at heart quite reasonable, the design in Figure 45 being a standard case in point. But there is something cognitively odd about extending this principle to samplers. Their makers are very clear that they are *sampling* different kinds of units, and our taxonomy ought to recognize this fact. Therefore, we must entertain the possibility of quilts consisting of many different cells. These can be divided into those patterns made from regular cells and those made from nonregular cells.

S2.1 Regular cells

The simple idea behind this taxon is that the cells that make it up are built out of regular shapes; that is, they are cut from templates or other forms of patterns that allow for the replication of certain identifiable shapes.

S2.1.n.(c) Regular cells, number of cells and cell type

The two factors to consider when fleshing out the taxonomy of multiple-cell quilts are the number of different cells, n, and the type of each individual cell (c).

A simple example involves octagons and squares (Figure 46a). At first sight one might be inclined to classify this as a single cell quilt, the "cell" being an attached octagon and square (Figure 46b). But this is not a unit of replication of such quilts. Quilters do not build stacks of these octagon-square combinations and then sew them together. Rather, the quilter starts with individual octagons and individual squares, and pieces each to an ever expanding form

Figure 44a

Figure 44b

Figure 45

Figure 46b

Figure 46a

as individual patches. Taxonomically, then, this quilt would be described as S2.1.2.(octagon).(square), where the names in parentheses could be substituted with cell descriptions of the pieces as individual cells from the section on single cells (that is, "square" = S1.1.1), with further taxonomic description in the case of pieced cells.

Perhaps the most complex of the multiple-cell forms are the group of related designs often called "Double Wedding Ring." As noted earlier, they are *not* composed of a single replicating unit, but, like octagons and squares, of multiple regular cells, growing ever outward.

S2.2 Nonregular cells

This taxon consists of those quilts that are made up of patches that are geometrically irregular and are all different from one another. Despite their seeming randomness of construction, two broad classes of design (as identified by quilters themselves) exist.

S2.2.1 String construction

A string quilt is made up of long irregular pieces of material, but, unlike in strip construction, the seams are not parallel to each other nor to an edge. Each strip is geometrically different. If necessary this group could be further subdivided into cells whose seams *on average* run parallel to an edge (see Figure 47a) and those whose seams *on average* run parallel to a diagonal.

S2.2.2 Crazy construction

A crazy quilt is the most irregular of all in that it contains multiple individual cells which are all different, not made from a regular pattern, and not formed into strips or any other discernible subunit (Figure 47b).

Discussion: An Initial Example

This system of classification is far from being simply a way of cataloging designs. Its main purpose is to provide ways of thinking about the relationship between construction and creativity. As such, the system is used and elaborated further in later sections. However, it is worth exploring an example briefly now to set the stage and give a sense of the importance of building a taxonomy on principles of construction.

The highlighted designs in Figures 48a, 49a, and 50a (constructed out of multiple cells and colored to reveal the larger figure), bear a certain visual similarity to each other, and it is not uncommon to hear quilters talk about them as related (see, for example, Hall and Kretsinger 1935:73). The accented elements in Figures 48a and 50a seem to make their constituent cells particularly closely associated, yet according to the cell concept these two are virtually unrelated, whereas those in Figures 48a and 49a, which do not look as alike as the other pair, are close relatives. This is a case where the pheno-

Figure 47a

Figure 48a

Figure 47b

Figure 48b

Figure 49a

Figure 49b

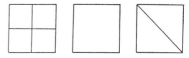

Figure 50b

Figure 50a

Figure 51

types (that is, the cells given color in finished tops), to some degree mask their foundational genotypes (that is, the principles of cell construction). Examination of the underlying method of construction of each makes the issue clear.

Scrutiny of the individual cell in Figure 48*b* following our taxonomic strategy shows that it is radial with a central point, radiating out in *three* steps, all steps involving straight seams (S1.1.2.3.1.3.l.l.l). The cell in Figure 49*b* is radial with a central point, radiating out in *four* steps, all steps involving

Figure 52b

Figure 52a

Figure 53b

Figure 53a

straight seams (S1.1.2.3.1.4.l.l.l.l). But the design in Figure 50*a* is not radial at all. In fact, it is not even made from a single cell but from three different cells, as shown in Figure 50*b*. Whereas the overall colored designs in Figures 48*a* and 49*a* are produced by assembling individual cells and stitching them together as single units to form the top, the design in Figure 50*a* is made by producing long strips of alternating cells and then sewing the strips together (Figure 51). In biological terms the cells in Figures 48 and 49 are alike because of homology (they involve similar structures), and those in Figures 48 and 50 are alike because of analogy (they involve dissimilar structures).

It may seem, at first blush, that making such distinctions is just a technical exercise, but there is much more to this process than academic curiosity: it bears profound implications for construction and creativity. A quilter making the design in Figure 48 could decide to produce cells that left off one radial step (Figure 52*b*). This would produce the design in Figure 52*a*. Likewise, a

Figure 54

quilter making the design in Figure 49 could decide to add a radial step (Figure 53*b*), producing the design in Figure 53*a*. Thus, the designs in Figures 48, 49, 52, and 53 are all genetically related, differing one from another by one "gene" only. (Likewise, it is possible to imagine the designs in Figures 48 and 49 as deriving from each other.)

The design in Figure 50 is not capable of mutating in the same way as these radial designs: it is not possible to make a simple construction change that will produce analogous equivalents of the designs in Figures 49 and 51. But the cell arrangement of it can be modified to produce new designs, such as that in Figure 54 (made by turning all of the oblique cells the same way). Thus, while analogous cells may look similar, modifying their structures or arrangements leads the creative quilter in quite different directions.

In addition, it should be noted that while the designs of analogous cells bear certain visual similarities, there are important differences. Most notably the seam lines are different, and such a difference is not trivial. Seam lines affect the dimensionality of a top and can be used as components in the quilting process, possibly producing counterpoints with the quilting stitch and at the very least influencing the quilting pattern. Seam lines are also junctures at which variation (intentional or unintentional) can occur, and as such are instrumental in the analysis of creativity, reinterpretation, and irregularity in quilt design.

Finally, the act of fabricating these cells in color points up further differences between analogous cells. Here it must be reiterated that a cell is an

The Natural History of the Traditional Quilt

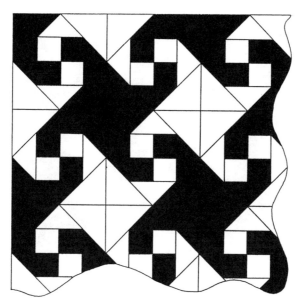

Figure 55

uncolored abstract. The addition of color does not change the nature of the underlying cell, but it may greatly change the appearance of the overall design. Further, the addition of color may open options of orientation of the *colored* cell, but analysis of the design will show no change in orientation of the underlying cell. In our analysis, geometric configuration and color operate on different levels and are differently reflected in the construction process. Our use of color here is simply for the purposes of emphasizing the differences between genotype and phenotype and anticipates the discussion of construction and color in later sections (see especially Section 3.3).

Figures 55 and 56 show the cells from Figures 48 and 50 respectively replicated in overall designs of two colors. Among other things, the *edges* of the two patterns are quite dissimilar. To mathematicians interested in the geometry of tiling, the differences in the edges do not matter because they imagine the two patterns extrapolated off into infinite Euclidian space where (barring the differences in seams, which they also ignore), the two patterns are congruent. But, to a quilter, *edges matter*. Borders may be added which must articulate in a pleasing way with the main design, and even if there are no borders except a binding strip, the way the edge looks is not a minor matter in terms of how the quilt looks draped on a bed. If for no other reason, a quilter is concerned with edges because she constructs them. An edge is a

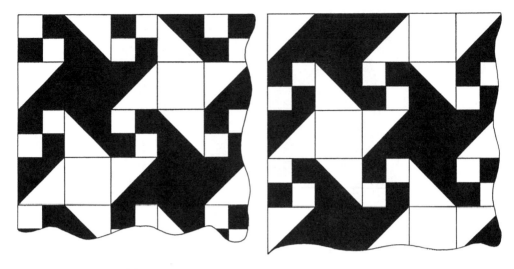

Figure 56a Figure 56b

functional reality: it is where the pattern of the quilt ends in an intersection with setting and finishing elements.

The way the edge looks for the design in Figure 55 is fixed because it is composed of *single* cells. The design in Figure 56 can vary depending on which strip of cells the quilter chooses to place along the edge (see Figure 56a–b). The quilt in Figure 57, adapted from a photograph in Carrie Hall's collection (Hall and Kretsinger 1935:154), shows how this freedom can be managed so as to create an interplay between pattern edge and border—the checkerboard cells at the corners of the pattern are echoed in the border corners. This relationship is not possible using the cell structure of Figure 55. (And, as a bonus, it should be noted that the seam lines are not visible in the photograph presented by Hall, but they can be inferred nonetheless using our method.)

The colored versions of the cells in Figure 55 may be manipulated in other ways, however. For example, they can all be set in the same orientation (rather than rotated through 90°), producing the pattern in Figure 58. Then, of course, there are the complexities of adding a third, fourth, fifth color, and so on. But these are all matters of phenotypic variation and, as such, we take them up, with a host of other issues having to do with quilt production, at greater length in later sections. For now it is enough to note that our taxonomy leads naturally into issues of construction, modification, and innovation because of its basis in the process of replication, rather than in visual similarity alone.

The Natural History of the Traditional Quilt

Figure 57

1.4. UNSEAMED BASE CATEGORIES

The second "kingdom" of quilt types comprises those that are made using an unseamed base, that is, a single piece of fabric that becomes the ground for further elaboration.

U Unseamed base

All codes in this section begin with the letter U, which stands for "unseamed base." The first fork divides into two branches—U1, those without appliquéd elements, and U2, those with appliquéd elements.

Figure 58

U1 *No appliqué*

Those unseamed quilts that have no additional fabric elaboration are conventionally called whole cloth quilts; they consist of a single piece of fabric for a top. In a sense they are composed of one giant, simple cell—be it a square or rectangle—and, therefore, make up an elementary taxonomic group.

U2 *Appliqué*

The use of various appliqué techniques creates a broad category of quilts that can be classified according to the cell concept. Admittedly, the taxonomy has a rather different character from the pieced base system, because the construction techniques involved are radically different. The mathematical strictures of tiling place limitations on piecing but not on appliqué; the latter technique does not necessitate gapless edge-to-edge construction, but rather lays shapes on top of one another. The primary freedom that appliqué introduces is the ability to create complex curvilinear designs that would be virtually impossible to replicate by piecing.

Notwithstanding the inherent freedom of appliqué, commonly found designs indicate the general applicability of the cell concept. Figure 59, for example, shows a well known pattern repeated as a series of cells. Clearly an object of construction is replicating here, albeit in very different fashion from

Figure 59

a pieced design. By following the principles of construction through in sequence, a cell based taxonomy can emerge.

U2.1 Single cell

As with seamed base designs, the possibility exists for the use of similar or dissimilar cells in a single quilt. In many cases appliqué quilts consist of a single giant cell, but the possibility of the repetition of like units, as in Figure 59, exists. It should be noted, however, that this repetition is qualitatively different from the repetition of pieced cells in that the appliqué cells have no tangible existence independent of their base. The *four* cells in Figure 59 are sewn to *one* unseamed piece of cloth, and until affixed to it exist only as individual pieces. For the cell concept to apply here, therefore, there has to be a clear sense that there is a well defined visual unit that is repeating (that is, a clear indication of repeated takes from a pattern or set of templates).

The next fork in the appliqué hierarchy concerns basic appliqué principles. We may identify various appliqué techniques, each having a different relationship between the cell and its base. This relationship between patch and base, as will be clear later, influences all other decisions concerning cell construction and so is logically placed high in the hierarchy. We give only sufficient details of the techniques here for classificatory purposes. Lengthier discourses occupy later sections on construction.

U2.1.1 Plain appliqué

The word appliqué means literally to "apply" or "overlay," and in its basic form this literal translation accurately represents the method. The quilter cuts shapes from a fabric and lays them on top of the base material, then sews them to this surface. The effect is quite different from piecing: the surface of an appliquéd quilt is *layered* and the appliqué seams look quite different from pieced seams. Different stitching techniques are used for appliqué as opposed to piecing—whether either is done by hand or by machine. And, of course, the background in appliqué is uniform. (For the case of appliqué worked on separate background pieces of cloth which are then set together to form a whole quilt, see Section 1.5 on hybrid and anomalous forms.)

U2.1.1.s(n) Patch shape (number)

From this point down in the hierarchy, the enumeration of the forks is the same for all appliqué techniques, so we will run through the descriptions for plain appliqué only.

Because of the infinite possibilities for cutting out appliqué patches, some method of reduction must be found that addresses key construction principles. One such is the identification of the *topological* shape of the patch. Simply, this requires identifying how many cut lines the shape involves— a cut line being a continuous line (no matter how convoluted) that can, in principle, be cut without stopping (see Figure 60a, one cut line; Figure 60b, two cut lines; and Figure 60c, three cut lines). A cut line is, of course, also a seam line, so that this classificatory method responds to two important construction elements, since for appliqué, as for piecing, placement of seam lines is a major visual factor.

A basic topological disk has one cut line, a flat "doughnut," two, and so on, and taxons can be numbered accordingly—U2.1.1, U2.1.2 . . . U2.1.n. Since a cell may use many patches of *different* topological shapes, these may be separated by a solidus, or slash, thus: U2.1.3/1 (with higher numbers preceding the lower). Finally, because a cell may consist of several patches of the *same* topological shape, this fact can be recorded in parentheses after the topological number. So, U2.1.1(4) represents a cell made of four patches all produced with one cut line (see Figure 61).

U2.1.1.s(n).1(g) Adjacent patches (symmetry group)

The equivalent of piecing a cell in appliqué work is the placement of the patches relative to one another on the base material; because in appliqué

Figure 60a

Figure 60b

Figure 60c

Figure 61

there are virtually no geometric constraints to this operation, the description of the placement of patches could be limitless. Nonetheless, certain general construction decisions can be noted. First, there is the issue of whether the patches are all adjacent on the base material or are built up in layers.

Those placed adjacently on the base can be categorized further by identifying their basic symmetry. (Although we showed in Section 1.1 the limitations of symmetry analysis as the *sole* mode of classifying designs, it is useful here both because it is used in conjunction with other principles, and because it reflects actual judgements made during construction.) The two kinds of symmetry that are important here are rotational and reflectional.

Rotational symmetry refers to the operation of rotating a figure about a fixed point and determining how many times it will fit exactly back on itself when turned through 360° (including a whole turn). So the design in Figure 62 has rotational symmetry eight. Reflectional symmetry concerns the ability to place a mirror on a figure in such a way that half the figure reflects exactly onto the other half. So the design in Figure 63 has one mirror line of reflectional symmetry, designated by an *m*. Multiple mirror lines are signified by repeated *m*'s; but note that mirror lines that can be rotated onto each other count as *one* only. So the designs in Figure 8*a–c* are classified as having

two mirror lines (i.e., *mm*) because the horizontal and vertical mirror lines can be rotated on to each other, and so can the diagonals. Asymmetrical designs are classified as group zero. (See Lockwood and Macmillan 1978 for a full discussion.)

Giving the rotational and reflectional designations for a cell in parentheses completes the taxonomic coding. So the design in Figure 64 can be given the code U2.1.1(13).1(4mm)—that is, thirteen topological disks arranged adjacently with rotational symmetry four and two mirror lines.

U2.1.1.s(n).2(n) Layered patches (number)

As well as being placed adjacently, patches may be placed on top of one another. This creates a series of layers, having a significant effect on the quilt's dimensionality. The number of layers can be coded as a number in parentheses.

Those cells that use both adjacent and layered placement can employ both methods of coding separated by a solidus, or slash: U2.1.s(n).1(g)/2(n). The design in Figure 65, for example, is U2.1.1(27).1(4mm)/2(3); that is, it is made from twenty-seven topological disks; the adjacently placed components have rotational symmetry four and two reflection lines; and the center piece is appliquéd in three layers.

U2.1.1.s(n).3(n) Overlapping patches (number)

Sometimes patches are neither adjacent nor layered but overlapping, so that part of a patch lies on another and part on the base material or underlying patch. These may be treated in similar fashion to the layered patch taxon above; where combinations of techniques exist, the coding is added after a slash mark.

U2.1.2 Shadow appliqué

Shadow appliqué adds another step to the plain appliqué process. Shapes are cut out and arranged on a base material, but then the whole base is covered edge to edge by a light, translucent material creating an effect of muted color. Each appliqué may be stitched to the base as in plain appliqué, or held in place by a running stitch through both the top layer and the base.

U2.1.3 Reverse appliqué

Reverse appliqué, as the name implies, is the opposite of plain appliqué. Fabric of the desired color is sewn to the *back* of the base material, and then the design is cut out of the base so that the material from the back shows through.

Figure 62 Figure 63 Figure 64

Figure 65

In addition, a variety of other less common techniques can be enumerated following reverse appliqué if necessary, but these three cover the majority of traditional quilts (and, in fact, plain appliqué far outstrips the other techniques empirically). The detailed coding of these appliqué techniques follows that of plain appliqué from here onward.

U2.2 Multiple (different) cells

By analogy with those made of multiple (different) pieced cells, quilts may, in principle, be made from multiple (different) appliqué cells all sewn to a single base. But care must be taken to discriminate between appliqué quilts made from multiple (different) cells and those consisting of a single cell, with many different subunits. There can be no rigorous test here; the correct taxonomic designation depends on an understanding of certain nonformalizable principles of construction. (This is true because one appliqué cell cannot be

clearly distinguished from another by straightforwardly identifiable construction elements such as outer seams when dealing with a quilt made on an unseamed base.) In essence, an appliqué quilt consists of multiple (different) cells when either (1) two or more design ideas are repeated in alternation or some other patterned manner on the same quilt, or (2) two or more design ideas on a single quilt are also found as separate items on other quilts (repeated or not). The point here is that certain common appliqué designs are well recognized by quilters and discrete patterns or templates exist for them. Therefore, the combination of two or more of these motifs on a quilt logically makes it, according to our system, analogous to a pieced sampler or the like. (By similar analogy, there are also appliqué versions of pieced setting elements such as sashing, fill, and borders.)

U2.2.n.(c) Number of cells and cell type

To complete this branch of the taxonomy, it is necessary to specify for each quilt the number of different cells, n, and the type of each (c), coded in parentheses separated by periods.

Just as with piecing, possibilities exist for homology and analogy, and it is even possible for analogies to exist across the two kingdoms. The image in Figure 66 (shown without seam lines) could be constructed in fabric in at least three fundamentally different ways: it could be cut from a single piece of cloth (with five cut lines) and appliquéd on a solid base; it could be appliquéd on a solid base using nine topological disks; or it could be pieced using a central patch radial method. Again, such relationships will be explored in detail in later sections.

1.5. HYBRIDS AND ANOMALIES

Because a taxonomy is a theoretical construct designed with certain analytic ends in mind, rather than a finely detailed descriptive catalogue of every object under study, certain forms are bound to slip between the cracks. This is a well known philosophic problem, and need not concern us long, except to note the areas of slippage.

H (S or U) Hybrids

The most straightforward problem is that there is some hybridizing between the "kingdoms": cells that are both pieced and appliquéd occur frequently enough to require some consideration. This mixture of systems may take three main forms.

The Natural History of the Traditional Quilt

Figure 66

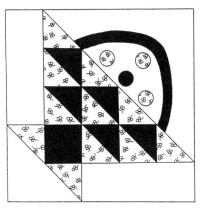

Figure 67

Figure 68

First, there is the relatively common practice of working appliqué onto separately cut pieces (usually squares, but conceivably some other shape) of background fabric, and then setting the finished cells together to make a complete quilt—often with setting elements added, such as sashings and borders. These can be coded as single patch (unpieced) cells with the appliqué code given in parentheses following the pieced code.

Second, there is the kind of cell that is pieced and then has appliqué laid over the top, usually to add a curvilinear element for figurative purposes (see, for example, Figure 67). These can easily be coded as pieced cells with the necessary appliqué code given in parentheses following the pieced code.

Finally, there is the more complex problem of appliqué patches that are pieced before they are appliquéd (see Figure 68). Here the best solution is to code the cell as an appliqué but to treat the pieced patch as special, giving its piecing code in place of, or as well as, topological information. This way analogies and homologies can be noted. Giving the piecing code for the de-

sign in Figure 68, for instance, indicates a basic homology between it and other cells where the entire square is pieced. In all three cases the code should begin with *H* to indicate the existence of two kinds of code.

Because the first type of hybridizing described above employs seamed bases, the possibility exists for the piecing together of similar or dissimilar cells. Therefore, this taxon must fork at this level in analogous fashion to seamed base categories, thus:

H1 Single cell

The quilt is made up of one giant cell or several cells cut and sewn in identical manner. Subsequently the coding follows as indicated above.

H2.n.(c) Multiple (different) cell

Where multiple cells are involved, the number of different cells is indicated by *n*, followed by the coding for each one (*c*); the codings appear in parentheses and are separated by periods, as with the kindred seamed base taxon.

A Anomalies

In addition to hybrid forms, there are a few construction methods that cannot be called piecing or appliqué in the strict sense. The primary example is that group of quilts made from folded or gathered units (as in the design commonly called "Cathedral Window," for example). Such techniques are well established traditionally, but there are very few individual designs (a variety has been spawned by the contemporary quilt revival and by art quilters). Other examples of anomalous forms include such types as biscuit and yo-yo quilts, in which individual stuffed or dimensional units are stitched together to form the whole.

It is possible to give folded and gathered units or stuffed units their own "kingdom" since, like the other techniques, part of the creative process is driven or limited by the practicalities of making individual units. Furthermore, the cell concept seems on the surface to apply here as well. However, for a relatively small number of designs it seems unnecessary to build a full blown taxonomic structure. Therefore, we simply note the existence of these techniques and move forward.

Given the vast array of quilt designs, we are generally satisfied that there are so few types that are hard to classify (far fewer than in all the methods described in Section 1.1). This suggests to us that we are using principles that lie close to the realities of fabrication, which leads us directly to consider in more detail the morphology of the traditional quilt.

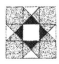 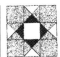

2. Morphology

2.1. INTRODUCTION

Perhaps of all aspects of quilts, their morphology has been most adequately detailed in other works. Naturally, therefore, much of what we have to say here will rehearse what has been documented before. In one important way, though, we go beyond the standard texts. Ours is a holistic morphology that takes into account all of the physical features of a quilt as they appear *through time*, and not only the ones it had when it was created. Our guiding principle here is that a quilt is a four-dimensional object. Texts conventionally give a great deal of attention to the two dimensions of a quilt top; rather less is given to the third dimension, even though it is the quilting stitch (the very process that defines quiltmaking) which helps add this sculpted dimension; and almost none is paid to the fourth dimension: time. A quilt has a certain morphology when it is created, but as an object which persists in time, it accrues additional or alternative morphological traits.

We divide morphology into three sections—general construction, materials, and pathology. In a sense these sections are strictly anatomical. They are meant primarily to add some physical form to the genotypes discussed in the previous section. Here we provide a set of orienting concepts and a vocabulary to get started with. We begin the evaluation of the quilt as a four-dimensional object in purely morphological terms. From there we expand in later sections to consider the life cycle and a host of physical and temporal factors that locate quilts in time and space.

2.2. OVERALL CONSTRUCTION

No simple definition or description of any object will do full justice to all of the conceivable variations it could assume. Quilts certainly manifest extreme variation—hence this study—but it is possible to identify a prototypic quilt morphologically and then work out from there to more unusual forms.

The prototypic quilt is a three-layered sandwich made up of the top, the batting, and the backing. This sandwich is held together by a quilting stitch

sewn through all the layers, and the edges are bound together. These four components of the prototypic quilt may be considered in turn, after considering a few general issues concerning overall size and shape.

General morphology

While quilted and patchwork objects in general come in a variety of shapes and sizes, the prototypic quilt is a bedcovering, so that its overall morphology in terms of size, shape, and orientation is limited by this usage. In consequence, the most common shapes for quilts are the rectangle and square, either with rounded or square corners. Less common, but frequent enough, especially historically, are the T-quilt and half oval (see Figure 69). The T-shape (Figure 69a) allows the quilt to fall square on the sides and bottom of a bed, and around the posts on a four-poster bed. Similarly, the half oval (Figure 69b) is designed to drape easily at the bottom of the bed.

When it is borne in mind that quilts are made for beds (often a specific bed), variation in general morphology makes perfect sense. Some quilts are made for baby cribs, others for huge four-poster beds, and every size in between. An inventory of traditional quilts might well come up with a statistical distribution with a mean point (much like height or weight samples in humans). But such a description has meaning only if it is taken in conjunction with the extreme possible range of variation.

Finally, under general morphology it should be remembered that many, perhaps most, quilts have a definite orientation. There is a real sense that one edge is the head and the other the foot. This is obviously true of T-quilts and oval quilts, but a square, although geometrically equilateral, may nonetheless have a specific orientation created by cells and borders. Issues of the relationship between quilts and beds are taken up in more depth in the ecology section.

The top

We have already begun the formal discussion of the top in the chapter on taxonomy. However, there we dealt only with the genotypes from which actual tops are produced. Now we can begin to move away from formal abstractions to practical examples (details of fabrication and conception are to be found in Section 2.3).

The top consists of the cells described in Sections 1.3, 1.4, and 1.5 fabricated in cloth, and one or more other elements—sashing, setting material, borders, and superadded items. To start, let us consider the cells in relation to their immediate surroundings and then move out to borders and super-

Figure 69a

Figure 69b

Figure 70

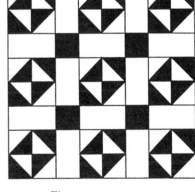

Figure 71

added elements. Partly because pieced quilts are the most common in the tradition (and therefore may be treated as prototypic), and partly because they present the most complex problems in terms of formal analysis, the remainder of the discussion of morphology is somewhat weighted in their favor.

The simplest top consists of cells pieced edge to edge as in Figure 70. But a variety of setting alternatives exist. Principal of these are the use of sashing and of plain setting squares. Sashing strips are a kind of internal border that encase and separate individual cells (see Figure 71), and plain setting squares

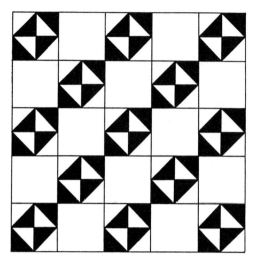

Figure 72 Figure 73

are unpieced units the same size as a cell and set in alternating checkerboard fashion with the cells (see Figure 72).

It is the isolation of the cells using these setting procedures that continues to illustrate how useful the cell concept is over formal mathematical systems. Were the design in Figure 70 drawn out infinitely in Euclidian space, it would be indistinguishable from the design in Figure 73. As we have already suggested in Section 1.2, the notion of Euclidian space bears little relevance to the quilter producing a finite object with edges; consequently, the edges of Figure 70 are decidedly different from those in Figure 73. But, more important for present purposes, the fact that the two cells could produce the same design according to geometric theory is a pointless abstraction. Sashing and plain setting squares underscore the design autonomy of the cells, regardless of what they are capable of doing when juxtaposed in certain ways. The cell from Figure 73 when set with plain squares appears as in Figure 74—the design equivalent of Figure 72 but visually utterly distinct. Under these circumstances the mathematical equivalence of the two cells is scarcely meaningful (except to the professional mathematician whose interests are not under consideration).

Mathematicians might complain that making a distinction between cells and setting squares is unfair, and from a purely geometric or visual standpoint they would be justified. But quiltmaking is a human process involving cognition: quilters know the difference between the design and its setting regardless of how irrational this may seem from an outsider's "objectified" frame of

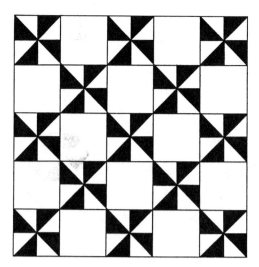

Figure 74

reference. Thus we may firmly assert that the top of a quilt is composed of cells and setting, the two complementing one another.

Other setting possibilities include the diagonal set (see Figure 75). At minimum this entails either cutting plain half squares to fill the edges (Figure 75a), or creating half cells for the purpose (Figure 75b). Combinations with other techniques are also possible: diagonal setting with sashing, or with alternate plain squares, or both, and so on.

A quilt top may or may not have one or more borders. It is quite possible to set the cells as desired and then leave it at that. On the other hand, some quilts are virtually nothing but borders. Medallion quilts, for example, are really no more than a large central patch concentrically surrounded by a series of decorative borders.

The possibilities for piecing and appliquéing borders are almost as numerous as those for the cells they contain, and, were it necessary, could be classified in much the same way. Figures 76–80 give some sense of the basic alternatives that a quilter can work with, including varieties of piecing and appliqué, mitered versus straight corners, rounded versus square corners, and scalloped versus straight edges. Clearly, then, the final shape that a quilt is to take is heavily determined by the choice of border.

But it is also true that the cells themselves may influence the shape of the edge of a top, and it should be remembered that borders are only one way of creating an edge that is other than straight with square corners. Quilts made on the pattern shown in Figure 27b, for example, commonly have a scalloped

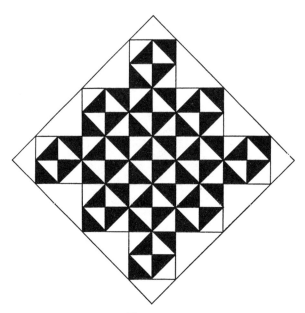

Figure 75a

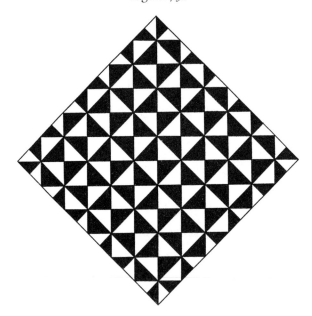

Figure 75b

The Natural History of the Traditional Quilt

Figure 76

Figure 77

Figure 78

Figure 79

Figure 80

Figure 81

edge because of the shape of the cell itself, and quilts made from hexagonal cells frequently have contours that follow the honeycombed edges of the hexagons (Figure 81). So the *border* of a top should not be confused with the *edge*, even though the one may create the other.

By itself a top is a three-dimensional object, whether it be pieced or appliquéd. Although in many diagrams and photographs in standard texts the top appears two-dimensional, the third dimension is always evident on the

actual article. On a pieced top the seams make clear ridges and furrows, so that even were a square, say, to be pieced from fabric made of a single solid color, it would, nonetheless, appear different from a square cut from whole cloth because of the dimensionality created by the seams.

The dimensionality of appliqué work is straightforward. In plain appliqué work, the appliquéd pieces stand a little above the base fabric, the dimensionality made more noticeable through layering. But with appliqué work a quilter can achieve an extra degree of dimensionality by stuffing the patches, a technique sometimes known as trapunto.

Not only are seams important parts of the dimensionality of a quilt in their own right, but also they play a major role in determining how and where to add other elements to the top, and they influence the arrangement and style of quilting stitch and its effect, when all the layers of the quilt are assembled.

Precision of piecing is a quality which is valued traditionally, but the weight placed upon it and the degree of technical imprecision which passes for precision in native terms varies. It may even vary within the works of a single quilter, according to her age and skill or depending upon what type of quilt she is making. Some traditional quilters are fastidious as to the intersections of points, the straightness and tightness of seams, and so forth. For others, an engagement with color or design might override overconcern with precision. It is worth noting that, among revival quilters, precision tends to be a more universal and compelling concern than it is within the tradition. Although traditional quilters express an imperative for neat and even work, examination of many traditional quilts often reveals that irregularity of seams is tolerated and in some cases may even be a part of the aesthetic.

Generally the seams in patchwork are made on the reverse of the top so that the needlework itself adds little prominent visual effect on its own. Of course, the quality of the needlework will have an effect on the overall integrity and appearance of the top, determining whether the seams are secure or loose, even or uneven in tension, and so forth. Machine and hand stitching are subtly different in their effects on the appearance of the completed patchwork top, the former generally producing a more regular and tight network of stitches than the latter. These variations in stitching will have an effect on the finished quilt, since the integrity and tightness of the seams will allow more or less of the batting to emerge, and varying degrees of visibility of the structure of the seam itself.

The needlework of appliqué seams, on the other hand, inevitably shows to a greater extent, and so the choice of stitchery and thread are more deliberate and obvious visual ingredients in the finished top. Slip stitch (Figure 82a), running stitch (Figure 82b), or buttonhole stitch (Figure 82c) are most

Figure 82a

Figure 82b

Figure 82c

common, with more fancy styles possible. Any of these types of stitching may be combined with embroidery.

It is quite common to have the seams of crazy patchwork embellished with embroidery stitches, these, again, adding texture, color, and dimensionality to the top. Patches may also act as backgrounds for elaborate figurative embroidery, and representational appliqués not infrequently have finer details embroidered in.

Further dimensionality can be added to a top through the use of cording. This requires backing the top with a second layer of material and joining the two together in designs made by parallel sets of stitches. Cords of cotton piping, candlewick, or yarn are then threaded through the channels created by the stitches. Such work is highly exacting because the channels must fit the cording exactly: if the channel is too narrow, the cord will not fit; if too wide, the dimensionality will be lost.

Another aspect of a quilt's dimensionality arises from the nature of the materials from which it is constructed. Each fabric has a dimensionality and texture of its own. Variations in weave, finish, dyeing or printing process, and orientation all create variations in dimensionality and surface effect. In the example above of a square pieced from a single type and color of fabric versus a plain unpieced square of the same fabric, some of the difference in appearance between the two could result from different orientations of the fabric in the former. The effects of grain on color and surface appearance may create an appearance of wholly different fabrics when the same fabric is oriented in different directions. Details of fabric structure are fully examined in Section 2.3.

The top may also bear signs of age, pathology, and anomaly to be discussed at greater length in Section 2.4 and in Chapter 3. For the moment it is sufficient to bear in mind that the top has a third dimension and a texture, and that both are anatomical traits of considerable significance in the overall morphology of a quilt.

The batting

The middle layer of a quilt is the batting. We will discuss the materials used for batting in Section 2.3. Here we consider the morphological variables and their effects on the overall qualities of a quilt.

The batting is a layer of fill material between the top and the back of the quilt, and, as such, is not directly observable visibly or tactilely. Even so, it has a vital visual and tactile role to play. Functionally the batting is the insulating layer that gives the quilt its warmth. To do an adequate job, it must be loose and fibrous, allowing insulating pockets of air to be created across the quilt. But those properties which the batting must have to perform its insulating job adequately come at a price. The looser the batting, the more liable it is to shift around inside the quilt, hence the need of a quilting stitch to hold it in place. The quilting stitch, in turn, creates textured and three-dimensional effects to complement the top, which are explored below under the rubric "quilting."

From an anatomical point of view, the batting has several qualities of its own to note, such as pliability, loft, weight, and texture (including natural particles or residues). Each of these features affects the general morphology of the finished quilt, particularly its drape, but also its general feel and warmth.

Although the prototypic quilt has a batting, there are cases of those that have none. If we were to follow a strictly formal method of defining quilts—say, something to the effect that a quilt consists of a top, batting, and backing held together with a quilting stitch—then those with no batting would logically have to be excluded. But, as we made clear at the outset, this work is rooted in the traditional quilt as a product of human behavior, and not as determined by logical or methodological abstractions. And the culture from which quilts arise recognizes objects without batting as quilts, nonetheless. Therefore we are impelled to do the same.

A lack of batting restricts the quilt in predictable ways. In particular it is both difficult and unnecessary to quilt something with no batting. Instead the top and back are held together by tying, tufting, or tacking (see our discussion of quilting techniques, later in this section); or else they are left unconnected except at the edges. It is possible for any kind of quilt to have no batting, but most commonly this is true of crazy quilts, perhaps because

the fabrics from which the tops are often made—including silks, satins, bro-cades, and velvets in the classic Victorian styles—cannot support extensive quilting. The lack of quilting in crazy quilts may also be due to the irregularity of the patches and the common use of embroidery to secure and embellish them. The surface of the quilt may not lend itself to the added elaboration of a quilting stitch, which interplays with the seam lines of the patches and adds its own dimensionality.

The backing

The backing is the bottom layer of the quilt, its main purpose being to hold the batting in place, and, along with the top, to support the quilting stitch. The backing is, therefore, approximately the same size as the top and consists of a whole piece of fabric, or two or more widths pieced together. Very occasionally the backing is more elaborately pieced, as in the case of reversible quilts pieced front and back; but such are rarities.

Quilting and binding

The three layers of a quilt are held firmly in place by the quilting stitch, passing through all three. This is normally a hand sewn running stitch. Anatomically, attention can be paid to the fineness and evenness of this stitch as well as to its overall elaborateness. The thickness of the three layers and the loft of the batting make the sewing of fine, even stitching a matter of skill and experience. Twelve stitches to the inch is considered fine work, eight plus is average, and anything less than seven is poor. Examining a quilt from end to end can, therefore, uncover historical details concerning its construction. For example, a quilt may exhibit variations in the fineness of the quilting stitch, suggesting that it was worked on by different hands (although evenness overall does not suggest a single quilter). Machine quilting is not unheard of in traditional quiltmaking, but a more common alternative to the normal hand quilting is the technique of tying or tacking at intervals. The three techniques create quite different effects in the finished quilt.

Of greatest morphological significance, frequently overlooked, is the fact that the quilting stitch sculpts the surface of a quilt, adding measurably to the three-dimensionality of the top. As such, the quilting stitch may either follow the dimensionality of the top itself, emphasizing and enhancing it (Figure 83), or run entirely counter to it (Figure 84). Or a compromise between these two poles may be employed in which the quilting runs counter to the seams within a cell, but stays framed by the main seams of the cell (Figure 85). Indeed, the use of *main* seams, that is, the outer seams of cells, setting pieces, or borders—as frames for quilt designs is common. Alternatively, a quilt may

Figure 83

Figure 84

Figure 85

Figure 86

be quilted for an overall effect without regard for cells or other seams (see Figure 86).

The top seams and the quilting stitch are, thus, inseparable as far as the design of the whole quilt is concerned, whether they work in unison or in counterpoint. They also require that a quilt be viewed from different angles and under different lighting conditions in order to appreciate the interplay. A low angled lighting will produce contours of light and shadow across a quilt emphasizing the hills and valleys of the quilting stitch, whereas a bright, direct lighting will show off the top and reduce the effect of the quilting. As

The Natural History of the Traditional Quilt

Figure 88

Figure 87

Figure 89

we discuss in Sections 4.2 and 4.4, such factors make the aesthetic of a quilt very much a product of its environment.

All quilting stitches give a three-dimensional texture to the quilt, but a reasonably fine line can be drawn between those designs that are figurative and those that are textural. The overall type designs are textural, creating rows or waves of geometric shapes (Figures 84 and 86). Likewise, the style of quilting that follows cell seams is primarily textural. But many designs are figurative and interact with the top in conventional ways. It is common, for example, to use a plain setting square as the base for a quilted image such as that shown in Figure 87. Borders and sashing strips may feature figurative designs (Figure 88) or textural (Figure 89). Certain traditional designs incorporate large unpieced patches along with areas of smaller patches, and the unpieced areas allow for figurative quilting if the quilter so chooses.

Appliqué tops may have large areas of plain cloth suitable for elaborate quilting, and because the appliqués themselves can be figurative, possibilities for the complex interplay of representational forms or the juxtaposition of figured patches and textured quilting, exist here. Indeed, when all forms of tops

and quilting are taken into consideration, numerous possibilities for inter-play or harmony exist. Both tops and quilting may be rectilinear or curvi-linear, figurative or geometric, overall or partitioned, plain or elaborate, and each of these variables may be set off against the others. An overall top design may have partitioned quilting, and a partitioned top may have overall quilt-ing; the plainest of tops—whole cloth quilts—conventionally have elaborate quilting designs.

To some degree the interplay between these variables is limited by physical factors. A multilayered appliqué cannot, in addition, be textured by quilting very easily because of the difficulty of getting a needle through so many layers of fabric. Likewise, a top that has superadded elements cannot easily sustain quilting across it. A patchwork quilt with many tiny patches cannot be elabo-rately quilted with any ease because of the difficulty of passing a quilting stitch through the layered cloth of the many seams.

To add to the dimensionality of the quilting design, certain elements may be stuffed with additional batting material, making them stand out boldly against the rest of the quilt. With a loose weave backing fabric, this can be achieved by separating strands of the material enough to insert the padding and then closing them up again. Otherwise the backing must be slit and resewn. In order for this technique to work effectively, the elements to be stuffed must be topological circles, so as to contain the padding compactly.

As well as quilting, other techniques exist for holding the layers of a quilt together, such as tying or knotting. Tying involves making a backstitch through all three layers of the quilt with yarn, or other suitably sturdy thread, and then tying a square knot on top using the two tails of yarn. Knots can be repeated at regular intervals or to form a pattern with the top (for example, in the center of every patch on a crazy quilt).

The raw edge of the quilt must also be held together. There are three main ways to do this; each affecting the overall look of the quilt. First, a strip of binding material may be sewn to the top and backing. Because this has the effect of creating a thin border, the quilter may choose the binding accord-ingly. Second, the backing material may be cut a few inches wider than the top, folded around the edge, and slip stitched to the top as a form of self-binding. This too creates a thin border on the top and requires that the back-ing fabric be compatible with the top. Third, the two raw edges of top and backing may be turned under and the resultant hems oversewn together. This technique creates a borderless effect and is useful if the quilter wishes the design of the top to extend all the way to the edge of the quilt, and it also saves on fabric. However, the resulting edge is not as sturdy and will wear more easily than an edge finished with binding or folded backing.

Other binding techniques involve the addition of new elements to the quilt, such as piping or frills. The two commonest choices for the latter are sawtooth (equilateral triangles) and clamshell (half circles), each piece consisting of two pieces of fabric sewn together and stitched to the back edge of the quilt or inserted and sewn between the turned-under top and back.

2.3. MATERIALS

Specific choice of materials for the various parts of a quilt is profoundly important and deserves separate treatment to mark all of its implications. For the sake of clarity and unity, we discuss materials following the order and division of the previous section, although clearly some of the discussion of the characteristics of yarns and fabrics can apply to all sections.

The top

The morphological nature of the fabrics used in making tops could be the subject of a major work in its own right, and certainly a monograph devoted to textiles should be consulted for detailed information (see, for example, Cowan 1962). Here we will present a general overview of these fabrics pointing out aspects of their anatomy that have a bearing on quilt construction and appearance.

Most commonly, though certainly not always, a quilt will be made up of fabrics which share a large number of features in terms of their makeup, thus giving the quilt an overall gross consistency in weight, texture, durability, and so forth. A quilter may have strong preferences as to what kinds of fabric are suitable for quiltmaking, and different traditions may tend toward somewhat different kinds of materials. A quilter's ability to select according to desire may depend on such factors as economic resources, location, and mobility. The following discussion provides a guide to the considerations of fabric characteristics which may inform the quilter's choices.

The first topics to consider are the origins and qualities of the fibers from which fabric is made. Basically there are three sources of fibers—animal, vegetable, and synthetic. The principal animal fibers are wool and silk. Wool may come in many grades depending on the breed of sheep and the part of the animal from which it is derived. Generally, however, it is a soft fiber, resilient and elastic. It shrinks when wet and is slow to dry. Silk is a strong, soft, continuous filament fiber. It is highly elastic and resilient and will not shrink. Traditionally, wool is used for certain types of quilt tops. The most common is the patchwork comfort made of scraps of wool suiting. This type of quilt is typically a utility quilt: it is warm but not fancy, the heaviness of

the wool not lending itself to elaborate stitching. In contrast, traditional quilts made of silk are generally fancywork and not intended for heavy use. Silk is not easily quilted because of its slippery and fragile quality, and the result is a quilt which is thin and decorative. Silk and wool are not as convenient to care for in terms of cleaning as are the vegetable fibers, which is another reason for their limited use in traditional quiltmaking.

The main vegetable fibers are cotton and linen. Cotton has a relatively short, medium strength fiber that is somewhat harsh feeling. It stretches very little and is neither elastic nor resilient. The fibers shrink significantly when first wet, but thereafter resist shrinkage. Linen has a long, smooth, lustrous fiber. It is stronger than cotton and rather stiffer to the touch. It is slightly elastic and nonresilient, so that both it and cotton, in contrast to animal fibers, wrinkle easily. Vegetable fibers and blends of vegetable and synthetic fibers appear most commonly in traditional quilts. Cotton is the most common due to its characteristics and its affordability and availability. Linen is far less common since it is traditionally a luxury cloth. Cotton fabric is easily stitched, readily available new and as scrap in a wide variety of qualities and colors, durable, and easily cared for by washing.

Cotton and linen are also found blended with wool in the fabric known historically as linsey-woolsey, the blend combining the advantages of animal and vegetable fibers. This fabric was frequently homespun and employed in whole cloth quilts. It was commonest in the eighteenth century and subsequently lost popularity so that now it is virtually impossible to find.

Somewhere between pure vegetable fibers and pure synthetics are the acetates, made by chemical and physical actions on high cellulose materials such as wood pulp or cotton linters. Acetate is not very strong, but lustrous and smooth, with a fine drape. It has low elasticity and resilience and can press or wrinkle permanently.

The true synthetics come in great variety, the two most important for present purposes being the acrylics and polyesters. Acrylics have as their basis long chain synthetic polymers made up largely of acrylonitrile units

$$(-CH_2-CH-).$$
$$|$$
$$CN$$

The fibers have a very high tensile strength, with moderate elasticity and good resilience. Polyesters are composed primarily of long chain synthetic polymers of esters of any dihydric alcohol and terephthalic acid

$$(P-HOOC-C_6H_4-COOH).$$

The filaments are strong and stretchy, both elastic and resilient. Quilters vary in their enthusiasm about synthetics. Some quilters happily use whatever attractive fabrics come their way. Others complain that the synthetic fabrics are difficult to stitch. Still other quilters construct entire quilts from such fabrics as polyester double knit, which is heavier in weight and springier in texture than the more commonly used cotton weaves.

The basic properties of the fibers themselves are enhanced or modified by the way in which they are constructed into fabric. All fabrics are made by one of three methods, weaving, knitting, or bonding, each producing characteristic qualities. Weaving involves the interlacing at right angles of two sets of yarns to produce a flat compact surface. The yarns are known as the warp (or ends), which run the length of the cloth, and the weft (or picks or filling), running back and forth across the width of the cloth. Thus the compactness of the fabric (a key element in the choice of quilting materials), can be expressed in terms of the number of warp and weft threads per inch—for example, 80 × 76 (that is, 80 warp by 76 weft). A quilter will look for fabrics which are compact enough to hold a seam and to contain the batting material, yet not so tightly woven as to be impenetrable to the hand held needle. The proportion of warp and weft threads, and the relative weights of the two yarns, have important effects on the qualities of the resultant materials and their suitability for use in quiltmaking.

Although there are almost infinite ways to weave cloth, there are really only three basic types of weave: plain, twill, and satin. Figure 90 gives a graphic representation of a plain weave. (Here, as in the other illustrations of weaving technique, every square represents the intersection of warp and weft threads: white standing for weft passing over warp and black standing for warp passing over weft.) Essentially the weft goes over and under each warp in one direction then alternates with under and over in the other. Common plain weave fabrics include gingham, muslin, calico, and chintz. Variations of plain weave are legion and form an enormous range of fabrics that are used in quilt tops.

The most straightforward variation involves altering the proportions of warp and weft threads. Percales are generally a balanced and compact 80 × 80, but print cloths are more usually 80 × 72, 72 × 80, 68 × 72, 44 × 36, or 65 × 56 (Cowan 1962:180). Slightly more complex is the doubling up of warp or weft threads, as in the case of oxford cloth made by passing a single (coarse) weft over and under two (fine) warps (see Figure 91). In this case the warp and weft are balanced because the doubled up warps are half the thickness of the wefts.

Figure 90a Figure 90b Figure 91

The use of fine warp and coarser weft, deliberately unbalanced to create a pattern, produces a rib across the fabric, such as on poplins and cotton broadcloths. The reverse, coarse warp and fine weft, produces a lengthwise cording, as on dimity. Blended ribs may be achieved by using different fibers for warp and weft, as in the case of ottoman, often made with wool or silk warp and cotton weft. Ribbed and corded fabrics are less durable than basic plain weave because the coarser yarns tend to pull away from the finer, resulting in tears. This quality is observable even as the fabric is being stitched into a quilt, as the hand held needle itself can sometimes produce enough stress on the fabric to separate the yarns. For this reason, and also perhaps because fewer used scraps survive, the use of ribbed and corded fabrics in quilts is less common than fabrics of basic plain weave.

Twill weave involves threading weft over and under warp in such a way as to create a stepped diagonal effect on the face of the fabric (see Figure 92). Common twill weave materials include drill, denim, and serge. As with plain weave, various effects can be achieved by manipulating the warp or weft count, and by varying the fineness of the yarns in each direction. Hand stitching twill weave can be somewhat tedious because a straight seam across fabrics cut on the grain will nevertheless cross an uneven run of yarns. The smoothness of the needle's action is thus impeded, adding extra time and the risk of irregularity to the work.

In satin weave the threads cross very sparsely so that the surface of the fabric is broken up as little as possible (Figure 93). This creates a lustrous appearance, but a material that is subject to wear and abrasion. As their names suggest, satin and sateen are satin weave. These fabrics are not well suited to use in quilts which are to receive daily use as bedcovers, because they are too fragile. If used in quilts which are to be quilted, the quilting stitch tends to disappear into the surface of the fabric, and the typical hill and valley dimensionality does not show up as well.

Figure 92a Figure 92b

Figure 93

The basic weave techniques may be combined and modified in a number of ways. Pile weave, for example, uses an extra warp or weft yarn, in either plain or twill weave, that is drawn up from the surface of the material in loops and then sheared, as in velvets and velveteens, or left unsheared, as in terry cloth. The fancy weaves—jacquard, dobby, and lappet—produce cloth with designs woven directly into the fabric. Jacquard, for example, is responsible for damasks and brocades. These fabrics are not commonly used for quilts

because of their thickness and obtrusive texture, and because many of them are relatively costly.

The second broad class of fabrics, the knits, differ fundamentally from woven goods in that their structure is built out of a series of loops in the yarns making them stretchable and resilient, even though the constituent fibers may be quite inelastic. The mechanical knitting process originally developed from hand knitting, but in more recent times mechanical knitting has developed techniques that cannot be replicated by hand. Knits are not commonly used in traditional quilts, though there are exceptions as mentioned above in the case of polyesters. Their stretchiness and susceptibility to runs and pulls make them relatively undesirable as quilt materials. A brief description of their structure elucidates the reasons for their scarcity in traditional quilts.

Hand knitting produces a series of loops that run across the fabric and so, following weaving terminology, is known as weft knitting. Mechanical weft knitting relies on two basic stitches, plain (see Figure 94) and purl (see Figure 95). Plain stitch (also known as flat stitch, jersey, or balbriggan) produces a fabric that has a different texture on face and reverse. The face shows a smooth arrangement of vertical loops known as wales, and the reverse, horizontal ridges or courses. Purl knits have marked courses also, but face and reverse are identical. Rib knits result from alternating plain and purl stitches in the same row so as to build up wales of plain and purl and produce a wavy cross section. These knits have a high degree of crosswise stretch.

Weft knits are particularly fragile because of their construction. Each loop in a wale is dependent on the next, so that a single broken loop will release the rest, causing a vertical run. Warp knits, in which the loops are created down or across the face of the fabric, produce less fragile materials. Warp knits are exclusively the product of machine construction and cannot be replicated by hand. For our purposes the most common warp knit is tricot (Figure 96), recognizable by its strong crosswise rib on the reverse side.

Finally, fabric may be created by bonding fabrics directly through the use of pressure or chemicals. For quilting, the most important bonded fabric is felt, made by subjecting wool fibers to heat, moisture, and pressure simultaneously. Because of such methods of production, bonded fabrics have no grain, or courses. This means that the edges will not fray or ravel, so they need no hemming, and patterns may be cut on them in any direction. They will tear under stress, however. This makes them convenient for appliqué rather than pieced work.

Some of the look, texture, and drape of a fabric is created by the mode of construction, and some derives from finishing processes. The type of finishing that can be used is, in turn, dependent on the nature of the original fibers.

Figure 94

Figure 95

Figure 96

The various possible finishing techniques lend distinctive characteristics to the fabrics, which when they appear in a quilt will present a particular surface appearance and drape. Scrap quilts containing a variety of materials owe some of their multiplexity of texture and look to the differences in finishing techniques represented in their constituent fabrics.

Calendering involves passing the fabric through heated rollers under pressure. The simple result of this action is to stiffen and flatten the fabric. When combined with an application of resin, glazing results. If the rollers have engraved designs instead of being flat, the fabrics become embossed, and if two fabrics are embossed together slightly off grain a moiré effect is achieved.

An alternative to calendering for cotton and linen is beetling, a mechanical process of beating dampened fabric to close the weave and flatten the yarns to produce a lustrous finish. The equivalent process for wool fabrics is fulling, the felting down by heat, moisture, and pressure of woven and knit fabrics. The result is a heavier material with greater body.

Napping involves the raising of short fiber ends by special wire teeth set on rollers, primarily from the weft yarns in such a way that the yarns themselves are not damaged. The raising of nap is dependent on proper construction of the cloth—long wefts producing fibers without loss of strength in the fabric. Brushing is similar to napping but involves raising long fiber ends.

Scroop is the term used to describe the rustling sound that silk characteristically produces when handled. Although it appears to be inherent in the fiber itself, scroop is created through a finishing process that involves treating the fabric with acetic or tartaric acid.

Dyeing and printing yarns and fabrics also create a great deal of the diversity seen on finished cloth. Dyeing can take place at any stage in the production of fabric. If the raw fibers themselves are dyed before spinning (stock dyeing) the result is a thorough penetration of color. Wool is often stock dyed. Or the fiber may be made into yarn and then dyed. Checks, plaids, stripes, and ginghams are often woven from yarn dyed goods. Most common of all is the dyeing of whole cloth (piece dyeing).

The printing of large quantities of fabric is most frequently achieved through roller printing of one sort or another. The design is engraved on a series of rollers, one roller per color used, and then attached to circulating drums. As the rollers turn, dye is spread across them and the fabric is fed over the face of each roller until all colors have been applied. Variations include discharge printing, by which a bleach paste, rather than dye, is transferred from roller to previously colored cloth in a design that, once the bleach has gone to work, produces a light figure on a darker ground; and resist printing, which applies the design in the form of a paste that resists dyeing. When the fabric is dyed the areas of design are undyed or lightly dyed.

Sharper registry of design and more colors can be achieved through methods developed from hand printing techniques. Transfer printing requires applying the print to paper first and then pressing the paper onto the fabric. Silk screening is an elaborate form of stenciling, once reserved for fine cloth, but now replicated mechanically.

Such is the morphology of the fabrics that go into the construction of the top. Every aspect of the anatomy of constituent fabrics—grain, hand, drape, color, resilience, and so forth—plays a part in the overall morphology of the top and of the finished quilt. But other cultural factors intersect with these basic physical features to create morphological variation and morphological types.

The top of a quilt can be made from fabrics previously used for or left over from some other purpose, or from fabrics bought with the express purpose of making the quilt. This distinction in sources of material for the top can be

used as a rough way of delineating two classes of quilts: best and scrap. These categories are most usefully regarded as prototypes or poles rather than mutually exclusive binary opposites. In practice, the two different sources for materials may or may not yield quilts of different formal and functional types. Moreover, while some local traditions may exhibit the two types as quite distinctive from each other, other traditions may not. Finally, many factors other than those strictly morphological play a part in determining the function of a quilt, whether it is initially closer to one or the other prototype. The complex relationship between form and function will be explored further in Chapter 3 on the life cycle and Chapter 4 on ecology. Concrete instances of the interplay between form and function appear in the case study presented in Chapter 5. For present purposes, it will suffice to indicate the ways in which the two types are morphologically distinct.

A prototypic best quilt can often be identified by its use of simple color schemes, and the repeated use from cell to cell of the same fabrics. This is possible because the quilter buys sufficient material at the time of construction for whatever overall effect she desires. Both pieced and appliqué quilts may be made from bought fabric, but the historical tendency is for more appliqué quilts than pieced designs to use purchased cloth. It is tempting to suggest that this dichotomy is an echo of the traditional roots of the two construction modes, but such must be speculation. That is, we might assert (as many have done) that patchwork arose out of the need to use up oddments of materials left over from other projects or salvaged from worn or discarded garments. Appliqué, on the other hand, requires a solid base of bought material, so that having spent money on the foundation it would be inconsistent to then sew scraps onto it as an economy measure.

These thoughts on the association of bought materials with appliqué and scraps with patchwork must remain simple speculations without strong documentary or other support; it would be erroneous in any case to attribute the aesthetic characteristics of quilt types solely to economic or pragmatic influences. Piecework is not inherently a scrap material occupation, even though it is a good use for scraps. It is logically possible for it to have developed using fine materials as a complex decorative process, and for it to have been adopted by scrap workers emulating fine work. Neither possibility is logically prior; equally old pieced tops of best and scrap materials exist. The oldest example of English patchwork is best work made in 1708 of fine chintz (Seward 1987: 30), but possibly older scrap work may not have survived because of its constant use and the relative fragility of the component materials due to previous wear. It is important, too, to keep in mind that geometric or patterned patchwork is not the most economical way in which to use scrap

materials, because of the wastage involved in cutting the shapes and allowing for seams. Then, too, there are scrap appliqués. The appliqué motif of a little girl in a gown and bonnet is a classic example of a design that is habitually appliquéd on whole cloth from scraps, although it must be conceded that it is usually appliquéd onto small squares of background, which are then pieced together.

Whatever the historical circumstances may be, it is the case that prototypic scrap and best tops fall into distinct categories with clear morphological differences. Care should be taken not to confuse "scrap" with "used," even though frequently scrap quilts are made from used materials. Scraps may come from a variety of sources, including the ends of bolts used for other projects, or remnants left from cutting out, which are oddments, that is, scraps, but new nonetheless. The real issue that divides scrap from best, then, is not the provenance of the materials that make up the top, but simply the limitation upon the *amount* available, requiring the scrap quilter to make numerous choices regarding the matching of types of fabric, color, and design. Of course, in some cases, a quilter may have a great deal of a certain scrap, which can give the finished quilt the appearance of a best quilt. Such a quilt may then be treated as a best quilt throughout its life. Sometimes a family may have purchased a large amount of a particular fabric which then appears in numerous scrap quilts, perhaps as setting elements for all of them. Often, too, quilters will exchange fabrics, and some traditions depend heavily upon this practice, so that material from a single large cutting may end up in dozens of quilts throughout a community.

Although the materials for a scrap quilt may be new, the use in tops of fabrics that have been used before does create a subcategory of scrap quilts with characteristic morphological features. Through age and wear the fabrics are softer and less durable, subject to tears and abrasion. It is also the case that scrap quilts are usually in more daily use, and therefore are handled and washed more often, further softening and thereby weakening the fabrics.

Because of the physical nature of the constituent materials, the morphology of the completed top is potentially complex. Some points to consider are whether the quilt is made from one basic fiber—all cotton, say—or whether they are mixed, and, if mixed, what the effect is on look and texture. Then there is the question of mixing fabrics made by different construction methods versus staying with one fabric type. Wovens and knits may be combined, but they require special assembling because of their differences in elasticity, and the combination produces tops with complex mechanical properties. The combination of styles of fabrication within a basic construction category may also occur. It is, for example, common to find satins and velvets

pieced together; both fabrics are wovens but are quite different in construction and, thereby, textural qualities. Along the same lines, tops may involve the combination of different weights of fabric, again presenting special construction problems if the weights are radically different.

Since all but the bonded fabrics have a definite grain, the direction in which pieces have been cut and sewn together makes a significant difference in the look and texture of the finished top. This is most obviously true for fabrics whose grain is a pronounced component of their texture, such as corduroy, but is no less true of tightly woven fabrics. If dyed woven fabrics are sewn without consideration for the run of the grain, two pieces cut from the same bolt will appear as different colors along the seam line. Grain line plays a major part in determining the look of a fabric (in much the same way that a newmown lawn appears striped because the mower has created a forward and back grain). A similar result occurs with the texture and look of pile fabrics. Velvets may be sewn with the pile all facing one way or various ways. The latter creates a shimmering, almost kaleidoscopic, effect.

By the same token, the way that designs printed on or woven into the cloth intersect is an important issue. As in the case of grain, the quilter may choose to align patterns and edges, or disregard any possible relationship between them. To some extent the ability to make decisions concerning the interplay between patch shape and fabric construction is a function of the amount of any one particular material available to the quilter. Thus a scrap quilt is more likely to exhibit patches cut out at odd angles to the grain or pattern than a best quilt.

The intersection of fabric color and pattern and cell structure is a lengthy subject that we deal with in some depth in Sections 3.2 and 3.3. Here we simply prefigure the main issues. Clearly, the way that a cell is realized in fabric has a major effect on the look of the cell itself and on the look of the finished top when the cells are put together. One primary concern is the juxtaposition of values, that is, of lights and darks. The use of value within a cell, and from cell to cell in a quilt, will determine the design which immediately appears to the viewer. Different uses of value in various fabric realizations of the same cell can produce radically different visual patterns.

At some distance the eye will always be able to detect the seam structure of a particular cell. Even if a cell is pieced entirely in one fabric (which is not uncommon in scrap quilts), grain, pattern, and texture all help to emphasize the seams close up. Farther away, however, colors can blend multiple patches into larger figures, allowing the eye to edit out seam information temporarily. The use of the same or similar fabrics together in a cell can create patterns that make seam information ambiguous. Figure 97 shows a basic cell struc-

ture, and Figure 98 shows some of the ways it might be realized in fabric (all drawn from a single quilt). It should always be remembered that seam versus figure ambiguities are ambiguities of *scale*. The degree to which seam information can be ignored at a distance is determined by the configuration of grain, color, pattern, and texture. If these all work together, the figure may stand out at quite close range; if they are set at odds, the figure may not appear except at a considerable distance.

Not only do the colors of fabrics create light and dark contrasts, the patterns printed on or woven into the material can create value differences, regardless of the particular hue of dyes used. Many factors combine to determine how a print will read as to value, and, of course, distance from the eye

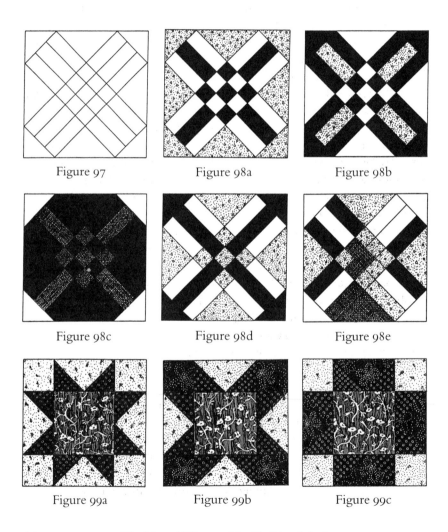

Figure 97 Figure 98a Figure 98b

Figure 98c Figure 98d Figure 98e

Figure 99a Figure 99b Figure 99c

changes the effects of each factor. At work are the scale of the printed design itself, whether large or small; the density of the design, meaning how close together the design elements are to each other regardless of the size of each individual element; the degree of contrast between the hues in a print; and the number of different hues within the print. Basically, prints that match in these factors will read as similar in value and can be used to blur seam lines if necessary (see Figure 99a–c, adapted from photographs in Horton 1986: 15–17). For an excellent discussion of the use of prints in fabric to create differences in value, see Horton (1986).

The relationship between seams and fabric designs is further complicated by the line characteristics of each. In essence, both seams and designs can be either rectilinear or curvilinear, making for many combinations—for example, straight line seams and straight line designs, or curved seams and a mixture of straight and curved designs, and so on. Furthermore, the seam line and design line may work in concert or at odds for different effects. The classic appliqué technique of *broderie perse* involves cutting around the figures from printed materials and using them as the appliqués. An analogous process may be used in patchwork where the patch acts as a frame for a centered design element. Or both appliqué and piecing techniques may ignore the lines of the fabric design.

The nature of the thread used to make the seams must also be considered in the quilt's morphological makeup. The two commonest fibers historically for thread are cotton and silk, with polyester and cotton mixes superseding pure cotton in recent times. Cotton thread is customarily made from fibers which have been mercerized, a process which involves treating them with alkalis. This treatment swells and shrinks the fibers, making them more lustrous, stronger, and more receptive to dyes. Pure cotton thread is made by twisting together three strands of spun cotton, the weight of the constituent strands determining the diameter of the finished thread, hence its strength. The main physical characteristic of cotton thread is that it has little stretch or give, and, therefore, is most commonly used with woven fabrics that do not stretch.

Medium diameter threads (size 50) are generally used for piecing and appliquéing tops. The color of the thread is relatively unimportant in piecework where the seam stitchery does not show very much. Traditionally, quilters most often use white thread for seams, which gives an underlying uniformity to even the most variegated scrap quilt. Thread color may be a definite element in appliqué work, chosen either to blend in with the color of the patch or ground, so as not to show, or to contrast.

In modern times the most common thread available is mercerized cotton wrapped polyester. It retains the basic look and feel of pure cotton because the outer wrapping of cotton is all that is exposed, but the core filament of polyester provides a degree of elasticity and reliance, making the combination more versatile than either fiber used alone. Silk thread may also be used for seams and other work on the top. It comes in many plies and weights, the finest (size A) used for general sewing. It is both strong and pliable with a lustrous finish for ease of working.

At the other end of the spectrum from silk are those threads used by quilters without the money to buy spool threads at all. Depression era quilts, for example, were sometimes sewn using yarn unraveled from sugar and flour sacks. These yarns were quite coarse and not very long. Therefore, fine running stitches were impractical, and, in consequence, seams would be open and tend to pucker.

Besides for sewing seams, threads are used on the top for all of the decorative functions, such as embroidery, mentioned in the previous section. Such specialty threads include filofloss, a loose twist of six strands of pure silk which can be separated into single or multiple strands, and various cotton threads, such as *coton à broder*, a single highly twisted strand with a shiny finish; pearl cotton, a single strand with a clearly defined twist and shiny finish; and embroidery cotton, a thick, soft thread with a matte finish. For special effects, some threads are made of linen or wool, and some imitate metals such as gold or silver.

The batting

Batting is usually made of the raw fibers discussed earlier in this section, the two oldest being wool and cotton. Both fibers go through similar processing before they are in a fit state for use as quilt fillers. Wool fleece is greasy when it is first shorn and so must be washed to remove most, but not all, of its natural lanolin. Then it must be treated, chemically or mechanically, to remove burrs matted into the wool, and then carded to align the fibers. Fleece is not a high loft batting, so the quilting stitch through it does not stand out in high relief. Furthermore, it must be quilted very closely—approximately every inch—to be sure that the batt will not wad up when the quilt is washed. On the other hand, wool is very supple and soft, giving a gentle drape and fine feel to the quilt, and it is warm.

Cotton must be ginned to separate the fiber from the seeds, hulls, and other foreign matter that cling together when it is picked. Then it must be carded to align the fibers. Older batts may show evidence of hand picking and hand carding, such as remnant seeds. Some quilters maintain that hand

picked and carded cotton produces a softer batt with a higher loft. In general, cotton has a higher loft than wool, making for more sculpted quilting, but it too must be closely quilted to avoid wadding. Cotton is less of an insulator than wool and somewhat stiffer.

When used in conjunction with loosely woven top fabrics, untreated wool or cotton batts may beard; that is, the fibers may work their way up through the top weave producing a linty fluff. This is a particular problem with dark fabrics. In recent years batts of natural fibers have been treated with a resin, a process called glazing, which acts to keep the fibers together, thus preventing individual ones from working loose.

Synthetic fibers, notably polyester, can be used alone or mixed with cotton in place of the all natural batts. They have good loft, like cotton, good insulating properties, like wool, and, unlike either natural fabric, do not wad when washed, thus allowing for a much looser quilting. Polyester batting may be quilted as far apart as every four inches and still retain its evenness and loft. Overall, synthetics are stiffer than wool, producing a quilt that has less natural drape.

Raw fiber batts allow for a variety of quilting possibilities because they are inherently flexible and crushable. The quilter manipulating a needle through top, batting, and backing can work speedily with raw fibers because they bend and move easily to the needle's passage. Other batting materials besides fibers present problems.

No end of materials have been used traditionally to fill quilts—corn shucks, newspapers, feathers—but apart from fibers the next commonest batts are flat fabrics, such as old blankets, flannel, and even old quilts. All of these batts provide some insulation, but they have no loft and are more or less impossible to quilt. Therefore they are usually knotted or tacked in place. Flat fabrics need not be quilted in any case because they will not shift or wad. However, quilting or tacking may be desirable for the purpose of adding integrity to the finished quilt, which otherwise would consist of loose layers. For a silk quilt a cotton flannel batt is common, where one is to be used at all, because it provides some insulation and, given that the top will not be quilted anyway, does not need to have any loft but does need to be stable.

The backing

Several considerations go into choosing a backing fabric. The first concern is looseness of the weave, which facilitates quilting. The tighter the weave, the fewer the stitches the quilter can catch in one push through of the needle, thus extending the job in time and effort. (Of course, for a quilt that will be

tacked this is not so problematic an issue.) Beyond this primary concern, other factors hold sway. A quilter may prefer to see the quilting stitch show up on the backing rather like the quilting on a whole cloth quilt, and so may choose solid, light colored fabric. Whether the quilter wishes the back to be unpieced, or pieced as little as possible, may dictate the fabric used at different historical periods based on what was available in wide widths. Sheeting, for example, is very wide, although the advantage of width is offset by the tightness of the weave.

After taking into account physical construction factors, the fact that the back will not be seen under normal circumstances affects choice for backing. Many traditions favor the use of a plain, unfigured fabric for backing, but there are other traditions in which prints are typically used. Economy may dictate the use of whatever fabric is cheapest. This does not mean that backing will always be inferior yardage, but rather it will tend to be made of goods that are held in relatively low esteem (in comparison to materials used on the top). This determination of low price and low esteem may be influenced by cultural, geographic, and historical circumstances. Therefore, it is of interest to note the relationship between the kinds of fabric used on top and backing, that is, whether they are in marked contrast or not, a contrast likely indicating the relative favor of fabrics. Whether the backing is to be used for self-binding may also influence kind of fabric and its color, since a thin part of it will become an integral part of the top once the quilting is finished.

Quilting and binding

Thread used for quilting must be heavier than ordinary cotton because it has to stand the strain of being pulled through multiple layers, several stitches at a time, and has to hold these springy layers solidly. Therefore a heavier gauge of thread than for regular piecing is common. Such heavy thread at one time came in limited colors (white predominantly), so that the quilting stitch itself, and not just the hills and valleys that it sculpted, might show up on darker fabrics. In any case an overall quilting pattern is liable to show up at some point, whether light or dark thread is used, because the quilting stitch will cross from light to dark fabric. Only quilting that stays inside seam lines can avoid this effect, and then would require the use of several colors of quilting thread, which is quite uncommon practice. Hand quilting thread may be coated with a resin or wax which makes it stronger and allows it to slip more easily through the layers of batting and fabric.

If a separate binding is used for the edges, it may be homemade or bought as a special item. At its simplest, binding may be any fabric cut from a bolt

with the grain or on the bias. Cutting with the grain allows for long unpieced strips (following the warp or weft), and little waste, but a straight grain binding cannot be used on curves and corners. A bias binding requires cutting at a diagonal to the selvage, producing relatively short strips that must be pieced and the possibility of wasted cloth, but it can be used on curves and corners, the bias grain yielding somewhat to accommodate them.

Making bindings allows the quilter to match top fabrics with the binding and to use whatever quality and style of fabric seems suitable. The use of purchased bias binding avoids the waste and effort of piecing. Generally, though, store-bought bindings are low quality coarsely woven goods. A piped or corded binding involves the same basic materials as a plain bias binding, except that the binding wraps around a length of cotton yarn.

2.4. PATHOLOGY AND ANOMALY

Conventional morphological descriptions of quilts take into account only the features of a quilt at one point in time, usually the moment of its completion. But a quilt exists through time, and over time its morphology can change. We deal with the circumstances that account for normal changes over time in the life history sections, but here we deal specifically with the morphology of change and, in particular, with aspects of a quilt that may be construed as "pathological." Furthermore, there is a tendency in descriptions of quilts to focus on what is perceived as normal and to eliminate anomalies from discussion as if they were either not there or not worthy of notice.

In pursuing the question of pathologies and anomalies, we should bear two points in mind. First, what may be conceived of as oddities are, nonetheless, part of a quilt. A patch over a damaged place may not be a trait that the quilter planned for a quilt when it was made. At some stage, however, the quilter or someone else has deliberately added it, and thus it becomes part of that quilt's morphology. Similarly, a stain may be perceived as a blight, but if the quilt is still in use it is not "fatal." Second, we must not jump to the conclusion that pathologies and anomalies are "wrong" or "bad." Fading or bleeding, for example, may change a quilt from what was originally intended in quite interesting and novel ways that the quilt's owner finds pleasing.

We must also make some attempt at preliminary definition of pathology and anomaly, although our intentions become more precise as this section proceeds. A pathology is an *accidental* flaw in a quilt's normal morphology— a rip, a stain—that would have been avoided if it had been possible. An anomaly is a departure from normal morphology taken deliberately by the quilter.

Pathologies may loosely be divided into three types: those built into the quilt as it is being made, those caused by historical events, and those brought about by deliberate changes or additions made once the quilt has been finished and used. Anomalies, by their nature, are usually constructed into a quilt as it is being fashioned.

It is impossible to talk about pathologies and anomalies built into a quilt from the outset without talking about the intentions of the quilter. Even so, this is not the time to discuss comparative aesthetics. We are not concerned with a pattern that did not turn out as expected or an infelicitous color choice. Rather, we are dealing with errors or changes in morphology that would be judged as outside the normal, not only by the quilter but by the wider community.

An adequate grasp of taxonomy and morphology should show that this is a relatively small and possibly controversial category, given what may be classed as normal. For example, we may not class cutting patches off grain as anomalous even though this act might be considered so by strict sewing schools. Needleworkers are conventionally taught to cut and sew with the grain because of the deleterious effects that off grain cutting and sewing have on the drape of a garment that must hang correctly on the body. This "law" of garment building does not apply to quiltmaking, however, so that what is anomalous in one sphere can be normal in another.

Sometimes in the constructing of a quilt an accident occurs at a point when it is too late to repair it invisibly. If a seam comes apart when the top is being constructed, for example, it would be possible to repair it by resewing, but if a seam comes apart when the quilt is being quilted, it would be an unthinkable operation to unpick all of the quilting to get at the offending place. Instead, the seam would be repaired in place with a slip stitch. Such a repair would be slightly noticeable on the finished article and would, by our definition, be a pathology. In fact, we may generalize from this to state that all visible repairs made during construction are pathologies that need not be named or described individually. Other pathologies include traces of construction that, under normal circumstances, would be eliminated or invisible. Thus, under normal circumstances, quilters use an ephemeral form of marking for laying out quilting patterns on the top; chalk, for example. But sometimes they use a pencil or marker that leaves a permanent line.

Construction anomalies are linked to the overall morphology of individual quilts, rather than to absolute notions. As a category whose members are potentially infinite, anomalies cannot be catalogued. Instead we can describe some common examples to indicate the general concept. Here it is important to note that the concept of anomaly does not refer to an aesthetic of irregu-

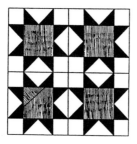

Figure 100 Figure 101

larity, which is quite common in traditional quiltmaking, particularly in scrap quilts. The tradition of irregular variation represents a rich and coherent aesthetic impulse, with results which often are both subtle and striking. Likewise, the presence of a morphological anomaly may also reflect the presence of an aesthetic impulse toward a certain kind of irregularity. The distinction lies in whether the unusual feature is judged so *in relation to the individual quilt as a whole*, and not simply in relation to an absolute or general standard. In the former case only can the feature be considered a morphological anomaly. The concept of deliberate overall irregularity will become more clearly articulated through the exploration of variation and innovation in Section 3.3.

The taxonomy and general morphology sections make it clear that seam lines are extremely important. The introduction of stray seam lines is, therefore, anomalous. Occasionally a scrap quilter needs just a little more material of one kind to make the final patch of a cell, but all the scraps left to her are too small. Rather than forego the fabric entirely, she may choose to piece that final patch, thus creating a seam line in the final cell that is anomalous (see Figure 100). The test for such an anomaly is to examine other cells on the same quilt. Only if the pieced patch creates an extra seam in comparison with the others is it an anomaly.

Highly regular quilts may display anomalies, either deliberate or accidental. Figure 101 shows a set of cells from a larger quilt with a single square turned around. This is an anomaly because the single turned square is at odds with all the others in an otherwise highly regular arrangement. Were the overall quilt execution not regular, or were many squares in different cells set at odds, then it would not be anomalous. Such small isolated oddities may be caused by deliberate plan, as in the often posited (but rarely documented) case of the quilter who believes that attempts at perfection challenge God; they may be the result of a strictly aesthetic choice; or they may be genuine errors.

A similar anomaly occurs through the use of a single piece of fabric in a best quilt that stands out as not related to the mass of store-bought materials represented. Such anomalies usually strike observers as puzzles, because fabric regularity is the hallmark of a quilt cut from new cloth, and some planning of needed yardage precedes purchase. Again, the use of an odd fabric is anomalous only if the rest of the quilt displays strict uniformity in fabric chosen.

Pathologies that develop as a quilt ages can be divided into those that are limited by the quilt's basic morphology and those that cut across it. Those in the first category are relatively few and are largely determined by the materials used in construction. For example, some colors can fade more quickly than others, creating substantial changes in the value relationships in the cells. Patches that once provided a dark background or helped create a dark figure may fade to the point where they no longer serve this function. Although the appearance of the cells has changed, the fading of patches does not transcend or alter the cell structure. Likewise, some materials are less durable than others, so that as a quilt wears these fabrics tend to fray and rip before the others. Thus it is quite possible to have whole patches worn away, or even the whole of one particular color throughout the quilt, while the rest of the cell structure remains intact.

Most pathologies that occur during the life of a quilt, however, cut across the basic morphology, many causing changes in a quilt's function, as is detailed in Section 3.4. A stain, for example, is no respecter of seam lines, but instead spreads raggedly in all directions. Akin to stains are the results of nonfast colors bleeding onto adjacent patches during washing. Old reds were particularly susceptible to bleeding, causing pink stains to spread in light areas. Many other indications of wear are also independent of basic morphology. Keeping a quilt folded for too long in storage can result in stress lines on the top corresponding to the folds. Similar marks may result from hanging, particularly when drying. Moths or mice may eat holes anywhere in the body of a quilt, and mildews and molds affect the quilt wherever they happen to grow. Pathologies arising from use and age may lead to new pathologies due to changes in the quilt's basic function. A stained quilt, for example, may be removed from service on a bed and used as a draft excluder on an attic window, say. Subsequently it will bear the marks of being nailed or pinned. Or it may be put to service in a location where getting dirty is normal, such as in a shed or barn, and thus it acquires further pathological marks.

To prevent further deterioration due to pathologies, elements may be added to quilts during their lifetimes. Most common are patches applied to

the top to cover over rips or worn places. These are easily recognized be-cause, in addition to being generally made of colors different from the others on the top and of newer fabric, their seams show and they interrupt the flow of the quilting stitch. Sometimes an entire edge may be enveloped in a sleeve of cloth which reinforces and protects the original portion of quilt which has received excess wear: a quilt edge which is pulled up under a sleeper's chin or is tucked under the foot of the mattress often wears out before the rest of the quilt. More unusually, a quilt may be widened or lengthened by the addition of an extra quilted section after the original has seen some service. Or the reverse may occur; a section—perhaps worn or stained—can be cut off and the raw edge rebound. This latter kind of pathology is difficult to spot unless some basic symmetry or balance in the overall morphology is disturbed, or if the new binding is noticeably different from the old.

3. Life Cycle

3.1. INTRODUCTION

It is customary in aesthetic theory and the history of the arts to distinguish between the performing and the static arts. This distinction places particular emphasis on static arts items as objects or commodities, with the role of curator and conservator being to maintain such objects in *static* condition, that is, as unchanging as possible. This attitude, via the (bare and grudging) acceptance of quilts as art objects and (less grudging) awareness of their potential as commodities, has spilled over into the analysis of quilts. We cannot digress and explain why we think this opinion hinders appreciation of fine art works (see Forrest 1991), but we shall consider at length alternative ways of looking at quilts.

If one's only glimpse of quilts is in a museum display or the glossy pictures in books, it is easy to believe that they are static forms. But those who live with them know how radically they change in the course of a day, a season, a year, a lifetime. Not only *do* they change over time, in traditional settings such changes are seen as, if not always desirable, at least inevitable. Cotton tops soften with multiple washings; batts lose their loft. These changes associated with the passage of time can be hastened or delayed, but not stopped.

Permanent changes in a quilt's morphology do not happen overnight; they take considerable time, sometimes even generations. Hence they are rarely given much prominence in the analysis of quilts. The making of a quilt is dramatically fast compared with the almost imperceptibly slow texturing of a cotton fabric. Quilts metamorphose over literally hundreds of years, whereas humans are restricted to their threescore and ten. Perhaps it is this fact more than any other which has caused the nature of the life histories of quilts to be overlooked. Whatever the reasons for the general omission, it has led to an inadequate picture of the existential and functional character of quilts. Through an understanding of the life cycle of traditional quilts, their powers of interaction with humans and with other aspects of the environment are at last brought to light.

When a quilt is considered a static object, distortion occurs as to its physical, social, and aesthetic nature. A further indication that a quilt is more usefully regarded as having a kind of life, or active existence, is the fact that quilts are so closely associated with narrative. The showing of a quilt almost inevitably brings forth a narrative from its owner, as is discussed in more detail in Section 4.3. The narrative may be extremely short, but in our experience it is a recognizably performed piece (see Hymes 1975 for a discussion of the emergence of performance in the course of ordinary discourse) containing narrative and poetic structure. This is not the place to examine the character of performed narratives associated with quilts, but it is important to note their existence. Neither is it possible to expound upon the theoretical significance of the close association between some physical objects and performance forms; but it is interesting to note that if this kind of connection is taken seriously, as it must be by researchers true to the data as they occur, then the rigid distinctions among genres and between "art forms" and "everyday life" disappear.

While the narratives associated with a quilt draw upon aspects of its life history, they are not coterminous with it. A quilt's life history encompasses more than any one owner or maker is likely to know. In the following sections, the components of a quilt's life history are explored in terms of a general life cycle. The life cycle of the traditional quilt may be broken into four somewhat discrete phases: *conception*, when the ideas for its making are synthesized; *birth*, when the ideas are realized in fabric; *life span*, when the quilt undergoes changes in response to its functions and the environment; and *death*, when it ceases to exist as a single artifact.

3.2. CONCEPTION

A quilt consists of an idea, which we can call a "pattern"—even if it has only mental existence—translated into physical form. The process of converting the pattern into an actual quilt we call "gestation"; coming up with the pattern we call "conception." The conception of a quilt is an opportunity for creativity, and it is at this time that new design ideas can be produced. But new ideas do not come out of a vacuum; they are responses to, or combinations of, ideas that already exist in the tradition. How "parent" ideas produce "offspring" is thus the central theme of this section and is intrinsically related to our discussion of genotype in Section 1.2 on taxonomy.

Probably all traditional quilters rely on preconceived patterns for some or all of their quilt tops, except for those quilters working in traditions which rely solely upon designs freshly inspired (e.g., some African-American, Poly-

nesian, and Native American traditions). In the latter case, new patterns arise according to traditional canons, and the techniques used to create them in cloth are derived from preexisting forms. Patterns are available from a host of sources—books, magazines, pattern companies—so that there is no absolute necessity for a quilter to make up her own. But probably every quilter has had the experience of seeing a design for the first time and knowing that she is inspired to copy it, yet not knowing where to find a ready-made pattern. She may search bookstores, ask friends, subscribe to new magazines. But if she is yet unsuccessful and still driven to make the quilt, some aspect of the process we describe here will come to bear.

A pattern for a top can at any time take one of three related forms. Let us imagine that a quilter sees a quilt she likes and wishes to reproduce. She may take home with her the pattern in the form of a *mental image*, which she may then convert into a *drawing* that becomes the basis for a set of *templates* from which to cut out fabric for a top. The top turned into a quilt may then be the inspiration for another quilter, making the process entirely cyclic. Of course, not every pattern must go through all the stages defined here. A quilter may, for example, make a drawing directly from another quilt. It is important to understand, however, that these three kinds of pattern exist, because different kinds of creativity can arise due to the nature of each and the kinds of transitions that take place from one to the next. We begin by considering the use of templates, the process closest to the fabrication of tops. (Our discussion at the outset focuses on piecing, but an analogous process applies to appliqué also and is described more briefly at the end of the section.)

To produce the infinite variety of patterns possible in patchwork and appliqué would require a storehouse of infinite templates. But it is surprising how many different patterns can be produced from a limited stock. It is common for traditional quilters to have templates of a few basic shapes made out of highly durable materials, such as pasteboard, plastic, wood, or metal. The quilter can draw around these templates time and again to produce the patches from which cells can be sewn. Here lies the first possibility for creativity, because such basic shapes can be recombined in a staggering number of new ways.

Figure 102 shows the patches produced from a quite rudimentary set of templates (undoubtedly fewer than in any actual set), consisting of nothing more than three squares of different sizes and three right triangles made by cutting the squares on the diagonal. The smallest square is a quarter of the size of the largest and the medium one has a side as long as the diagonal of the smallest. Figures 103 through 112 represent a mere sampling of the pos-

sibilities produced by just six templates. It is easy to see how the addition of just one more shape, a half rectangle, say, would multiply the design possibilities enormously, such that a collection of perhaps a dozen templates would be the source of endless innovation.

One major limitation on this kind of creativity is scale. If for simplicity we say that the smallest template square in the set in Figure 102 is one unit by one unit, then the designs in Figures 103 to 108 are all 4×4, those in Figures 109 to 111, approximately $4\frac{1}{4} \times 4\frac{1}{4}$ (the length of the side is actually $3 \times \sqrt{2}$), and in Figure 112, 5×5. But suppose the quilter would like all the cells in her various quilts to be the same size or thinks that one design would look better a little larger. This necessitates drafting the pattern first and then using the drafted designs as temporary templates from which to cut more durable ones that, in turn, can be used to mark fabric.

It is also true that creativity using standard templates might be unlikely to arise without the use of some drafting. But there is a difference between drafting with specific templates already in hand and drafting as a means of producing the shapes for the templates. In the former case the size and shape of existing templates control the process to a degree, whereas in the latter the drafting itself is the driving force.

Take the pattern in Figure 105, for example. The quilter working with the set of templates described above, and not intending to make extra templates, must draft the pattern out of half squares as shown in Figure 113. This turns the whole construction enterprise into a matter of making identical subcells of diagonally cut squares. The quilter with no templates already made can draft the pattern, and has the option of deciding to make two templates, one a half square and one a parallelogram, as shown in Figure 114. Using two templates saves sewing and material by eliminating four seams. This is not to imply that the quilter who already has a set of templates cannot draft the pattern and then decide that she needs a new (parallelogram) template. But if she already has enough templates to do the job in some fashion, the existence of these templates may narrow her decision on how to cut out the material, or even influence the way she interprets what she has drafted.

Furthermore, the intermediate steps in the cell construction process in Figures 113 and 114 may themselves result in different kinds of innovation. With a pile of identical subcells available to her, as shown in Figure 113, a quilter could decide to experiment with alternate configurations, such as the one shown in Figure 115. This possibility is not open to the quilter using the subcells shown in Figure 114. But this innovation occurring when the pattern is being fabricated is, strictly speaking, part of gestation and is discussed at greater length in the following section.

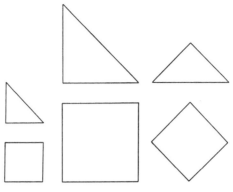

Figure 102

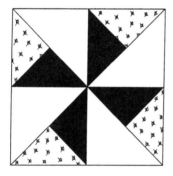

Figure 103

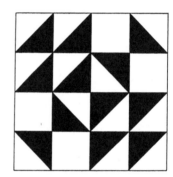

Figure 104

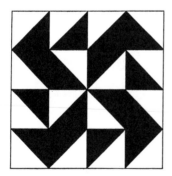

Figure 105

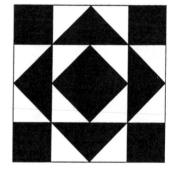

Figure 106

The Natural History of the Traditional Quilt

Figure 107

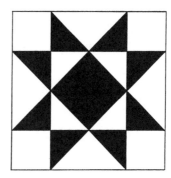

Figure 108

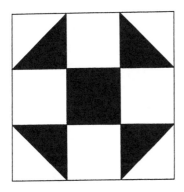

Figure 109

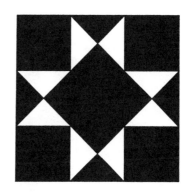

Figure 110

Figure 111

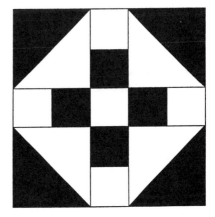

Figure 112

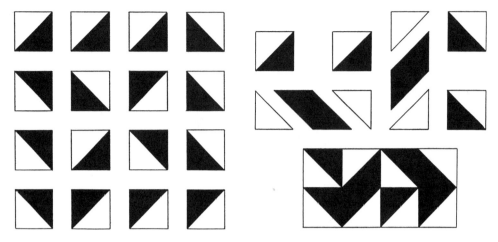

Figure 113 Figure 114

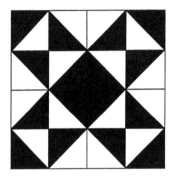

Figure 115

Such innovation also reminds us of a crucial discussion in the taxonomy section: although the *drafted* patterns of the designs in Figures 113 and 114 are the same, the resultant cells, one that uses only half squares and one that uses parallelograms as well, are *different* because *seams matter.* The process of moving from drafting to template can result in innovation and difference, which may, in turn, affect later decisions.

Understanding how creative changes can occur in the shift from drafting on paper to making up templates is of critical importance in grasping how certain innovations come about. It cannot be emphasized sufficiently that drafting is not isomorphic with construction. The process of drafting has its own rules and limitations that overlap with, but are not identical with, the rules pertaining to construction. Most importantly, drafting can be done be-

fore considering where seams should be, what the order of construction should be, or even if it is feasible to work the design in fabric. Drafting is an overall *gestalt* process, where construction is piece by piece and *linear*, and proceeds according to rules of ease and economy, given the nature of fabric and needlework.

The choice of drafting technique itself may influence how templates are subsequently made. Perhaps the commonest traditional method of drafting is to start with a plain piece of paper the same size as the intended cell and to fold it such that crease lines indicate the chief drafting divisions of the cell (see Ickis 1949:223–252). A design that is drafted on a 4 × 4 square, for example, can be replicated by folding a piece of paper in half and then in half again, unfolding it, turning it a quarter turn, and repeating the process (see Figure 116). The following is a description from a standard source on how to use this method to draft the pattern shown in Figure 117:

> After block is folded to form 16 squares, divide each outside square
> into 2 triangles. The 4 center squares are also divided into 2 triangles.
> Arrange light and dark triangles according to design.
> (ICKIS 1949:235)

The interplay of the crease lines and drawn lines thus suggests that the template for this pattern be a simple half square, even though a parallelogram template could be employed and might be suggested by other drafting techniques.

A second common way of drafting is to use graph paper and then find some way to enlarge the scale drawing to full size. One possibility is to have a square sheet of paper the same size as the finished cell ruled to match the squares on graph paper. Then when the smaller design is completed, it can be transferred square by square to the larger sheet. This is in some ways a similar process to creasing the larger sheet, except that there is an additional step—the use of scale drawing first. And because the full scale sheet does not have crease lines on it, which are physical analogues of seam lines, a different layout of templates may be suggested to the quilter. That is, construction lines drawn on a plan to enable the transfer of scale drawings can be erased when the desired design has been achieved. Crease lines are permanent, influencing the way a design is perceived even after it has been completed and the crease lines are no longer necessary.

It should be noted that these two common methods of drafting do not rely on arithmetic calculations. They are analogue systems that are based on shape and form, not on principles of analytic geometry. Of course it is possible, but

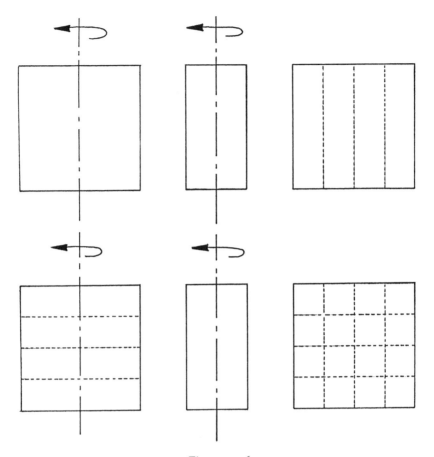

Figure 116

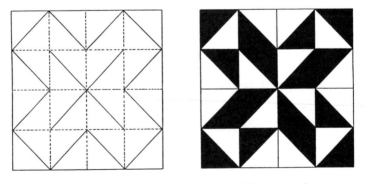

Figure 117a Figure 117b

The Natural History of the Traditional Quilt

not especially practical, to convert scale drawings on graph paper to full size templates arithmetically. Not only is it easy for mistakes to creep in, but unwieldy calculations may result in impractical measurements. If the quilter were to desire the small square template in Figure 102 to have 2″ sides, then the length of the side of the middle sized square template would be the same as the smaller square's diagonal, namely, the square root of 8—that is, $\sqrt{(2^2 + 2^2)}$, by the Pythagorean theorem, or 2.82842712475. Simple folding of paper eliminates such monstrosities, and is likely to be more accurate for the purposes of the finished product because it is physically closer to the construction process. Cartesian geometry represents a considerable abstraction from the practicalities of quilt construction.

So far our discussion has been concerned with the interface between drafting and templates. But of great importance is the relationship between a pattern as an idea and the same pattern as subsequently drafted. Enormous possibilities exist for deliberate and accidental innovation at this juncture. Before considering what happens when the quilter takes away the pattern as an idea and then drafts it without the original quilt in front of her, however, let us first consider the simpler but related process of drafting directly from another quilt.

Much of the time seam lines act as guides in the drafting process, making it straightforward to reconstruct a cell on paper from which templates can be made. But innovation can occur in this process, through a number of deliberate and accidental means. Take the quilt section represented in Figure 118, for example. Even a careful inspection of all the seams leaves doubt as to how the cells should be drafted. One possibility is the cell shown in Figure 119. But a diagonal setting of the cell shown in Figure 120, alternated with a plain square, is as plausible a way of achieving the design, and the latter is certainly a likely way for the overall look of the quilt to be perceived at first glance. Two quilts made up according to the above specifications, using the two different cell structures shown, would appear all but identical—but the similarity would be an example of formal analogy rather than a reflection of genetic identity. That is, the two quilts would share a surface or phenotypic appearance arising from different underlying genotypes.

If the cells were set with sashing (Figures 121a–b), the ambiguity in interpretation of the cell structure of the quilt in Figure 118 would be cleared up. Likewise, poor seamwork might show the cell structure via corners that meet imprecisely. And, naturally, if the whole were made from scraps, each cell worked in two or three colors only, and the colors of each cell different from the others, then the structure would be as clear as if sashing had been used. But in the absence of these indicators, the ambiguity remains. It might also

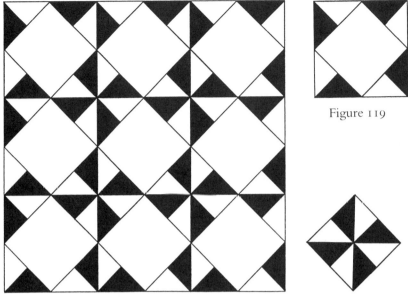

Figure 119

Figure 118 Figure 120

be argued that the cell of Figure 119 is a more likely choice because the edges of the quilt (which would be made of half cells and quarter cells set at the diagonal, if the pattern were conceived as whole cells set diagonally), are more easily explained given such a structure. But this is not an ironclad argument. Cells that are unambiguously diagonally set are often traditionally set with half cells and quarter cells to finish up the edges. Thus the drafting process, even with a quilt in front of a drafter who has every intention in the world of copying the pattern exactly, can lead to unexpected change.

Intentional change may also occur at the drafting stage. The drafter may see quite clearly the seam structure, but choose another method of working out the design, nonetheless. Figure 122a shows a section of a quilt that has a clearly defined cell structure. The cell is unambiguously as shown in Figure 122b. But an innovative drafter might look at the quilt and decide that it would save seams and cloth to use a different cell structure, setting the cell shown in Figure 123a diagonally, with alternate light and dark solid squares (Figure 123b). This is a conscious change in how to reproduce the design resulting in different seam lines, hence appearing different on the finished quilt—but in drafting, the two look the same. This also underscores that drafting is a two-dimensional process, whereas sewing is always three-dimensional. (Creasing paper may give an analogue feeling of three-

The Natural History of the Traditional Quilt

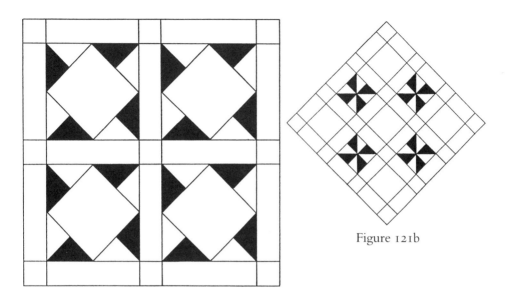

Figure 121a

Figure 121b

Figure 122b

Figure 122a

dimensionality to drafting, making the process closer to sewing, but many of the crease lines may be irrelevant to seam lines in the finished cell.)

Once the drafter has created a different cell structure from that of the original quilt, then as the drafted pattern is made up other innovations can occur that were not possible using the original cell structure. The new cell structure could be set straight instead of diagonally, for example (see Figure 124), or the quilter could choose colors other than a simple alternation of light and dark for the setting squares (see Figure 125a). In addition, the new cell structure opens a different set of possibilities for error and for color and value variation within the cell. In Figure 125b, for example, all the pieced cells are set with the same value orientation because the larger figure/ground created with only two values, as in Figure 123, is now lost, thus eliminating the need for setting the colored cell in alternating 90° value rotations, as in Figure 125a. Such possibilities are frequently sources of creativity for the traditional quilter, as will be demonstrated below and in Section 3.3.

The process of drafting a pattern from a finished quilt becomes vastly more complex if the drafter looks at a finished quilt, takes away an idea in her head, and then has to reconfigure it on paper without further reference to the original. Figure 126a shows a section of a quilt top made up using the cell indicated in Figure 127. But the gestalt image taken away from the quilt may not be one that involves that cell at all. It could be that the drafter recalls the pattern in terms of the cell shown in Figure 128 (also highlighted in Figure 126b), or, more radically, the remembered image could be as simple as the forms shown in Figure 129. Without going back and checking edges and seams, any one of the three patterns in Figures 127 to 129 could emerge on the drafting sheet.

Perhaps the best way to see how gestalt image and drafting work together to produce innovation is to examine a case study in detail. It should be borne in mind at all times, however, that this case study postulates hypothetical formal links between drafting and images, not actual historical connections. Clear understanding of the case study will reveal that our description might reverse the actual course of history, or influences may have come from outside the quilting realm, as we discuss later. The purpose of the case study is to convey a general set of ideas that can be applied to a wide variety of patterns. We have used a limited set of values to facilitate comparison among the figures that illustrate the study, but we have occasionally manipulated them (consonant with traditional practice) to emphasize the visual ideas we are expressing. The cells are, thus, not uniformly colored from start to finish.

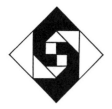

Figure 123a

Figure 123b

Figure 124

Figure 125a

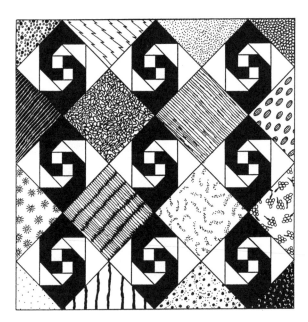

Figure 125b

The Natural History of the Traditional Quilt

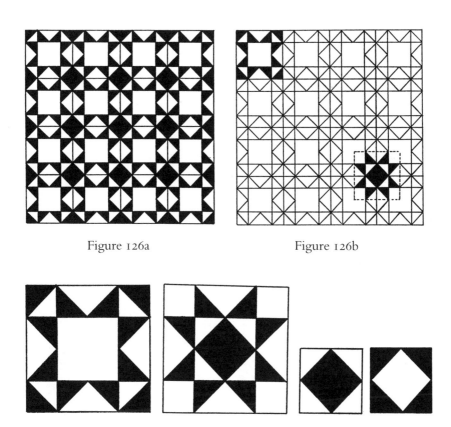

Figure 126a

Figure 126b

Figure 127

Figure 128

Figure 129

Figure 130*a* shows a section of a quilt and Figure 130*b* its constituent cell. With the quilt in front of her, the drafter has the ability to isolate the original cell and draft it, and she may make an exact copy. But this particular design takes a good deal of experience and ingenuity to draft accurately. One reasonable way to begin drafting is to break the cell down into repeated units, in this case the four quadrants separated by the central cross. Figure 131 shows an isolated view of the top left quadrant of the design with construction lines to indicate one way of drafting it. The basic grid used here is 10 squares × 10 squares, not easy to achieve by creasing paper since at full size the quadrant may be only 4″ × 4″, and ten is not an obvious number to count out when planning the design on graph paper. As drawn, this quadrant requires four different templates—a diamond, a small half square, a large half square, and a whole square.

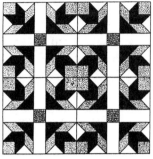

Figure 130a

Figure 130b

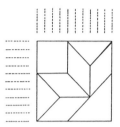

Figure 131

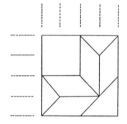

Figure 132

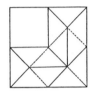

Figure 133

Figure 134

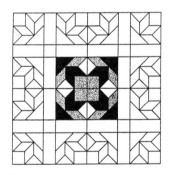

Figure 135

The Natural History of the Traditional Quilt

Deliberately or unconsciously, a drafter can change this quadrant into a pattern that is much simpler to conceive and draft. By working on a 4 × 4 grid—easy to crease and quite common as a pattern foundation—the design in Figure 132 can emerge. The relative scales of the patches have changed and the diamond shapes are slightly altered to become parallelograms, but the design idea is much the same. What has changed drastically, however, is the ease with which this new drafting can be turned into templates. Figure 133 shows how the basic design can be decomposed into half squares (with a single whole square in the top left corner). A quilter might not choose to construct the pattern in this way if parallelogram-shaped templates were available to her, or if she had the expertise to produce them; but a quilter who was impelled to make the pattern and could not procure or produce parallelogram templates could easily make the pattern using the half square and square scheme shown. When the quadrant pattern in Figure 132 is made up into full cells, analogous to the original cell as shown in Figure 130a, and then into a whole quilt, an overall design emerges that is akin to the original but by no means identical (see Figure 134).

Thus far we are assuming that the drafter is concentrating visually on the cell as it was conceived in the original. But the *look* of the finished quilt suggests other possibilities. Where the quadrants of the cells meet, a new visual gestalt image is formed. For the cell in Figure 130, this is shown in Figure 135 (and for the cell in Figure 134, it is shown in Figure 136). What may appear to the eye—when a viewer momentarily disregards information from seams and edges—is a completely different pattern surrounded by sashing strips. These apparent sashing strips are in reality part of the original cell, but by focusing visually on the design in a different way they can be made to look like setting pieces surrounding a different species of cell.

As a tantalizing side note, we can hypothesize from this part of the exercise that the use of sashing as a setting element could have developed originally as a misreading of the way that cells of this nature (with narrow central crosses) are constructed. As with all such historical speculation, however, very little evidence can be brought to bear that definitively proves one idea (cells with central crosses) preceded or led to another (sashing strips): the absence of examples of the later pattern in the earlier period may simply mean that examples did not survive the ravages of time. It is also likely that all pattern ideas were individually reinvented, through a kind of convergent evolution, many times. After all, the principles we are exploring here are pushed upon us by the mechanics of drafting and the laws of geometry. For these principles of innovation and creativity via drafting to have the kind of general validity we require of them, they must have been noticed by numerous quilters.

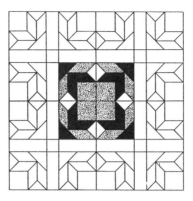

Figure 136

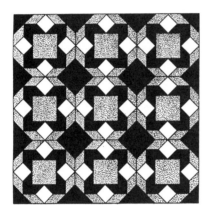

Figure 137a

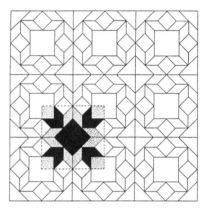

Figure 137b

A drafter can choose then to take this gestalt image (from Figure 135), strip away what she supposes to be sashing pieces (but are actually part of the cell), and draft a new cell. When this new cell is set into a quilt, it looks like Figure 137a. This in turn might suggest yet another gestalt image to a drafter (as highlighted in Figure 137b), which in turn could be set as a whole quilt (see Figure 138), and so on, indefinitely.

Alternatively, the gestalt image from Figure 135 might be set diagonally with plain setting squares as in Figure 139. This suggests another kind of image (highlighted) which may, in turn, be set square, as in Figure 140. Similarly a new image can be created from the diagonal setting of the cell in Figure 138 (Figure 141), until the possibilities seem infinite. And this is just the extension of the original cell from Figure 130. The same process can be

The Natural History of the Traditional Quilt

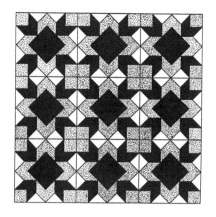

Figure 138

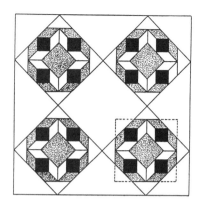

Figure 139

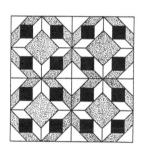

Figure 140

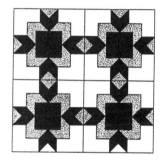

Figure 141

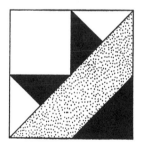

Figure 142

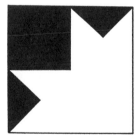

Figure 143

used for the alternate cell in Figure 132, producing analogue changes and creating extraordinary complexity. And, lest it be thought that such geometric manipulation is simple academic playfulness, we should make it clear that every one of these designs can be found traditionally.

We must also make it clear that this innovative process is not the result of drafting alone. That is, what we have done so far may appear on paper to be a creative pencil and paper process, but the purpose and result of each newly drafted pattern is the construction of a quilt top. The finished quilt, or the process of finishing it, then inspires a new round of drafting, perhaps by the same quilter or perhaps by another. Construction provides the impetus for each new drafted design. What is more, construction is completely interactive with drafting, because, of course, the purpose of drafting is construction, and not vice versa.

To illustrate the interdependence of drafting and construction, and to prefigure some issues covered in depth in the next section, we can go back one more time to Figures 131 and 132. The diamond shapes in Figure 131 cannot be constructed out of smaller shapes in such a way that the construction of the cell thereby is made easier. But, as shown in Figure 133, the analogous figures in Figure 132 (here parallelograms), can be constructed from half squares. This construction process, which introduces extra seams, may suggest different ways to color the quadrant (see Figures 142 and 143). Without going through all of the steps, it should be clear that these patterns ultimately can give rise to the designs in Figures 144 and 145, respectively. The same process of removing new images from quilts, as described above, can continue here also. Figure 146a shows a gestalt image taken from the area in Figure 145 where four cells meet, and Figure 146b shows this same image set straight with dark and light values reversed. If this image is used as a colored cell then the quilt shown in Figure 147 is produced. Once more, a new gestalt image may emerge from this pattern, as highlighted in Figure 148. This cell is genetically very close to one that is extraordinarily fecund in producing new images and which is the subject of our discussion of gestational innovation in the next section.

The study of creativity in drafting leads us to another form of design innovation, namely, the concatenation of elements where a construction process used to develop one cell suggests ideas from other cells. Let us take for the basis of this discussion the cell shown in Figure 149. The central square shape in this figure is an unpieced patch and might suggest to a quilter possibilities for piecing. That is, since many cells are square, it is possible to piece a small square subcell on the pattern of any chosen square cell and fit it into this space in place of the plain square patch. Figure 150 shows a standard

Figure 144

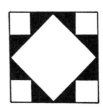

Figure 145

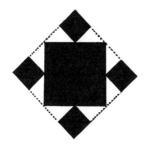

Figure 146a

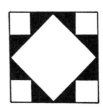

Figure 146b

Figure 147

Figure 148

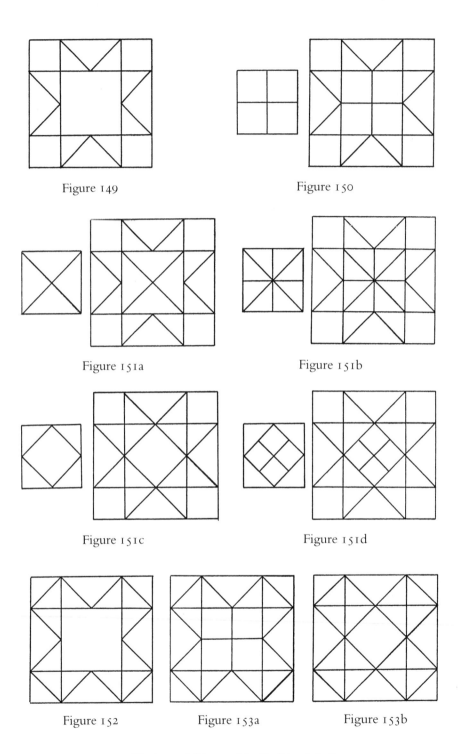

Figure 149

Figure 150

Figure 151a

Figure 151b

Figure 151c

Figure 151d

Figure 152

Figure 153a

Figure 153b

The Natural History of the Traditional Quilt

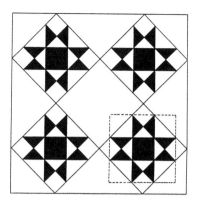

Figure 154

four-based square cell (inset), and the new cell which combines the two ideas. Obvious extensions are pictured in Figure 151. Or the original cell could be modified as shown in Figure 152, with the corner squares cut diagonally. This new cell can take modifications in the middle square, akin to the modifications of the original cell, some samples of which are shown in Figure 153.

When this kind of innovation is combined with the other drafting possibilities outlined above, it is easy to see the scope for endless variation. One hint at the potential should be sufficient. Figure 154 shows the cell from Figure 151c colored and set diagonally. If a quilter looking at this setting has a gestalt image of cells set straight (outlined figure), then the cell in Figure 171, which is the basis of a vast series of variations discussed in Section 3.3, is the result. It should also be obvious, without going through the steps, that if the same permutation were performed on the cell in Figure 149, the gestalt image from Figure 148 would emerge, thus indicating one way in which the cells in Figures 148 and 154 (and 171) could be related.

Two points of general interest emerge from this admittedly limited exploration of the possibilities for innovation in pieced cells at the stage of conception. First, multiple paths of cellular mutation can lead to the same or similar designs. This may be considered the design analogue of convergent evolution, whereby distinct species move toward a common pattern. That is, there is no reason to suppose that any particular cell design is the result of a unique conceptual process, but, rather, the cell design is likely to have been discovered repeatedly as quite different lines of mutation and innovation are followed. Second, it should now be evident that cells are not discrete, immutable entities, but are subject to constant mutation via the evolutionary

processes discussed above. These processes continue and are a vital aspect of the tradition—they may even be considered definitive of traditional quilting.

Appliqué work is not quite as amenable to this kind of variation at the drafting level as pieced work, but the act of conception is, nonetheless, important and similar in some respects. Clearly the act of drafting pieced work is contained within the laws of geometry, and many of the innovations of conception discussed are attributable to those laws. Appliqué does not require that all seams meet exactly, because the background material takes care of gaps in the design, and, therefore, allows for infinite variation of shape. Just as with pieced designs, however, the three basic kinds of pattern—idea, drafting, and template—are of equal importance and provide the impetus for innovation.

Drafting appliqué designs in preparation for the making of templates can often be a close analogue of cutting out the patch itself. Take the so-called Hawaiian appliqué method, for example. This technique requires first cutting out a paper template that acts as an exact analogue of the patch to be cut, as follows (see Figure 155). A sheet of paper the exact size of the needed appliqué patch is folded over into quarters and then diagonally. Next the design is drawn onto the exposed surface of the paper and cut out. At this point the paper may be unfolded to reveal the design as it will appear when cut out of fabric. If the design is satisfactory, then one-eighth of the design is cut from the paper (shaded in Figure 155e), as the cutting template. The fabric to be used is then folded in the same way that the paper was and cut out around the paper template.

But this drafting technique itself suggests alternative modes of drafting that will alter the cutting out process and therefore the genetic nature of the finished cell. For example, the one-eighth template could be used on *unfolded cloth*, the quilter cutting eight identical shapes, but each a separate patch, so that she has eight patches from which to make the design instead of one. This allows for the use of different fabrics (see Figure 156).

Highly complex appliqué designs may be drafted as single units or as multiple templates. The design in Figure 157 (adapted from a photograph in Ickis 1949:141) can be cut from a single piece of cloth using the folding technique, or it can be broken into smaller units, the templates for which are shown in Figure 158, adapted from Ickis 1949:142. Thus an appliqué pattern may be conceived in template form as a whole, in a way that a pieced pattern cannot, or in parts, with individual templates for each part, much as piecework is cut.

Because designs for appliqué cells may come in units that fit together, the process of conceiving them may in some ways resemble the conception of pieced cells. There are, for example, certain fundamental appliqué ideas, such

Figure 155a Figure 155b Figure 155c

Figure 155d Figure 155e Figure 155f Figure 156

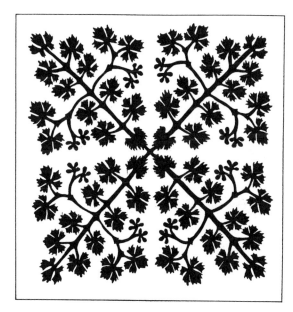

Figure 158

Figure 157

Figure 159 Figure 160 Figure 161

Figure 162

Figure 163a Figure 163b

Figure 163c

as the "wreath" idea. The basic cell entails a circular strip on and around which are appliquéd patches representing a particular motif. Figure 159 (adapted from Ickis 1949:59) shows the wreath idea expressed using leaves and old-fashioned roses. A simple change in templates produces a wreath of grapes and grape leaves (Figure 160, adapted from Ickis 1949:57), a wreath of leaves only (Figure 161, adapted from Ickis 1949:61), or whatever the quilter wishes. Templates from other designs can be co-opted for this process, analogous to the concatenation of ideas described above for piecing. Also akin to piecework innovation is the novel arrangement of basic shapes. The

Figure 164a Figure 164b

shape in Figure 162 (adapted from Ickis 1949:254) is common in appliqué work and may be put together in new ways to create new cells, as illustrated in Figure 163.

Drafting appliqué patterns represents a different order of drawing technique from that of piecework because of the use of complex curves in appliqué patches. Piecework, by and large, can be drafted on folded or graph paper with little difficulty. Of course, some pieced designs are curved, but the curves are mostly arcs of circles. With or without circles, patchwork cells can be constructed readily on a few basic graph paper layouts. Appliqué designs, however, have no such simple limitations. The use of graph paper may be little more than a guide to drafting a pattern. This means that a certain degree of variation is inevitable in the process of translating an image from idea to draft or template. A basic feather shape, for example, can change significantly from the drafting of one quilter to another, and such variation is allowable because there is no geometric need for the seams of the feather to interlock or butt up against each other tightly.

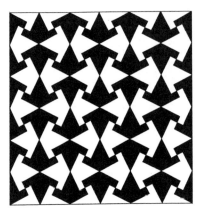

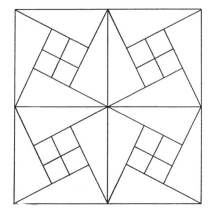

Figure 165 Figure 166

One answer to this problem is to trace a complicated patch and transfer the tracing to template material. Or a design can be marked with a gridded overlay to act as a line guide for transferring and enlarging the pattern, copying its edge square by square (see Figure 164). These techniques, like most of the conception procedure for appliqué work, keep the process of drafting and template making physically close to, and isomorphic with, the models from which the images are drawn. It is even possible for an object that is to be converted into an appliqué idea to become the template itself: one may draw directly around a hand or a leaf without drafting first.

The last example reminds us that both appliqué and piecework take conceptions for cells from outside of the world of quilting; in the process their drafting techniques may become somewhat more convergent. That is, a quilter may need to overlay a gridded model on a design that may end up pieced, for example, to enlarge it or to get some idea of how to break it down into smaller units. Without the model of another quilt, a certain amount of manipulation of the desired image is necessary to make it amenable to cutting out and stitching in fabric. Fewer decisions may have to be made if the design is to be appliquéd, but the translation to fabric always requires compromise. And, of course, certain basic decisions have to be made, including whether the design would work best pieced or appliquéd.

Media that are in some ways morphologically analogous to patchwork are obvious sources for new ideas, because the translation process is relatively straightforward. Ceramic tiles, for example, are common cradles of inspiration because the geometry of fitting tiles and fitting patches of fabric together without gaps are kindred systems. The pattern in Figure 165 almost certainly

Figure 167 Figure 168 Figure 169 Figure 170

comes from tilework. An identical design can be found in the Alhambra, sketches of which were popularized by M. C. Escher in the 1930s (see Grünbaum and Shephard 1987:3); appropriately enough, the design is often found under the name "Arabic Lattice." Notice here the method of adapting from one medium to another. The Alhambra tiles are made as one piece stamped out with the ceramicist's equivalent of a cookie cutter (another source of inspiration, incidentally), but the patchwork "tiles" are pieced to avoid tricky multiple set-in seams (see Figure 166).

At a farther distance than tiles from quilts morphologically are the repeated motifs of wallpaper or other patterned materials, but their regularity (and two-dimensionality) makes them tractable in the drafting process, even if a certain amount of alteration must be effected. But even though such sources may be common because of the reasonably mechanical method of converting them into templates, there is no limit to where inspiration derives. John Rice Irwin, for example, reports of a quilt top made according to a pattern seen in a dream (Irwin 1984:168).

So far our emphasis has been on the top itself, which is an empirically justified treatment of the process of conception. Quilts are tops that are quilted; the conception therefore begins with the top. In many cases the actual quilting designs are not considered and marked out until the top has been made and basted to the batting and backing. As such, quilting design generally belongs in the gestation section. But it must be acknowledged that some quilts are conceived with the quilting in mind. Whole cloth quilts, for example, are almost exclusively concerned with quilting, and so are conceived with the quilting design foremost.

The conception of such quilts falls naturally in line with the procedures outlined above concerning appliqué patterns. As in appliqué work, quilting patterns may be drawn from curvilinear templates. The fundamental difference between an appliqué and a quilting template has to do with the fact that quilting ultimately comes down to the sewing of *lines*, not *patches*. In conception, therefore, it is one-dimensional (even though it creates two- and

Figure 171

three-dimensional shapes). Quilting also responds to different physical limi-
tations. It is concerned with keeping the batting in place and may, therefore,
have to be as close as one quilting line per inch of batting, in all directions.
Large designs must, in consequence, be filled with cross hatching or smaller
motifs, to combine decorative form with practical function (see Figure 87),
making the template a pierced rather than a solid form.

Given the basic differences between appliqué and quilting conception, the
systems have much in common. Certain basic template shapes and ideas can
be recombined to form new patterns. The teardrop (Figure 167), for ex-
ample, has multiple manifestations (Figures 88, 168, and 169). Or the basic
idea of laying out a template repeatedly around a central point or motif can
be repeated using different templates or different numbers of repeats (see
Figure 170).

Because quilting is one-dimensional, it is liberated from the topological
rules that control the shapes of appliqué patches. As part of the conception
process, therefore, a quilter may decide that a pattern idea is best worked in
the quilting and not in fabric. Various one-dimensional line patterns, such as
spirals, are geometrically feasible in quilting only. Thus the nature of the
quilting may play a role at the stage of conception. But its biggest part usually
comes during the gestation stage.

3.3. GESTATION

The conceiving of a quilt as an idea or as a drafted form leads naturally to its
fabrication. But it should not be thought that the creative process ends at
conception. Conception provides the genetic foundation of the quilt, yet the
way that this underlying pattern becomes realized is itself subject to almost
endless variation. In this section we outline the methods for making a quilt
according to a pattern, following the order of construction chronologically.
It would, however, be quite unimaginable to show the kinds of variation

The Natural History of the Traditional Quilt

possible at the construction stage with even a handful of the cells from our taxonomy. Instead we pursue one extended example, showing how a single cell can be transformed myriad ways in the construction process, and we use it to typify variation in the others.

The basic cell for this exercise is depicted in Figure 171. It is made up of a total of twenty-one patches, cut on only two templates—a square, and a triangle that is a quarter square. These are arranged in the three rows of three squares that constitute the classic nine-patch (taxonomically = S1.1.2.1.2.1.1). There is, therefore, nothing extraordinary or particularly complex about this cell; it is perfectly common and well known. Its absolute ordinariness makes its many manifestations in fabric truly amazing—but typical.

When cutting out the patches for a pattern, a quilter may use any color fabric she cares to for each patch. So, at one end of the scale, she may decide to cut our chosen design in twenty-one different colors; or, at the other extreme, she may cut all the patches from the same color. Both of these polar opposites may seem unlikely choices, but they are known. More likely, though, are arrangements of patches in two or three colors. Even so, the alternatives for ways to place the colors in the cell can amount to staggering numbers. To keep the mathematics relatively straightforward, we can express the possibilities for arranging colors in the form of a general equation:*

$$P = c^n$$

where P stands for the number of ways to arrange colors in a cell, c for the number of colors used, and n for the number of patches in the cell. In our case, $n = 21$, so c is the primary variable. If we choose to make the cell out of just two colors, then, we may arrange them in the cell in 2^{21} (or 2,097,152) different ways. Over two million possibilities with just two colors seems like a lot, but it is peanuts in comparison with the kind of alternatives that exist with more colors. Just three colors yields 10,460,353,203 (around 10.5 billion), and the possibilities using more are too heady to contemplate.

*Actually, this equation takes no account of rotations of the cell and is something of an overestimate in a cell such as the one chosen because of its high degree of rotational symmetry. A more precise formula accounting for a cell with fourfold rotations would be:

$$P = c^n - c^{\left(\frac{n}{2} + 1\right)} - \left(3 \times c^{\left(\frac{n}{4} + 1\right)}\right)$$

Nonetheless, the possibilities with three or more colors still represent huge numbers.

Even more astounding, we must remember that these calculations represent the ways to arrange two or three colors without considering what those two or three colors are. So there are two million possibilities using white and green, another two million using blue and red, another two million using magenta and scarlet, and so on. So even in concentrating on the fabrication of a single cell, articulating all the creative possibilities is beyond our scope. To make the discussion manageable for the moment, therefore, we will limit our descriptions of arrangements of colors in the cell to relative values. To be even simpler we will use only three values, a light, a dark, and a medium, represented in the figures by white, black, and shading dots respectively. In cloth, these three values might be three colors, two colors and white, three tints of the same color, combinations of colors and prints, and so on.

Figures 172 to 211 show some of the permutations of the cell possible using two or three values, taken in large part from traditional quilts and pattern books (see especially Risinger 1980:51). There are several points to notice about these different uses of value. Some permutations emphasize the seam structure of the cell while others cut across it. Figures 172 to 181 show fabrications of the cell in which *every seam* joins fabrics of a *different* value (like values meet only at points). Even so, the figure/ground relationships in these interpretations are strikingly different. In most of the other fabrications illustrated, one or more seams in the cell join fabrics of the *same* value. This has the effect of de-emphasizing the seams that join fabrics of like value—especially at a distance. Fabric choice may, therefore, expose or disguise underlying cell structure.

But the seams are still there; even if some of the permutations resemble other cells, the (in all cases identical) construction process is, nonetheless, different from that used in those other cells. A quilter using the cell in Figure 171 could come up with all of the variations shown (and many more), and might easily create them (perhaps even accidentally), in her experimentations with piecing. This is especially likely in the case of scrap quilts, which in some traditions exhibit a wide ranging and fanciful play with color, value, and figure/ground relationships from cell to cell. It is worth reemphasizing that all of the variations on the cell in Figure 171 are created according to the same construction process. That is what identifies them as manifestations of the same underlying cell structure. All of these manifestations of the cell are phenotypical variations of the same underlying genotype. It is true that having created a particular color scheme which obscures seam lines in the cell in Figure 171, a woman might, in conceiving her next quilt, choose to draft templates which would follow the color scheme rather than the original seam lines, and thus she would be creating a different cell for the subsequent quilt.

The Natural History of the Traditional Quilt

Figure 172

Figure 173

Figure 174

Figure 175

Figure 176

Figure 177

Figure 178

Figure 179

Figure 180

Figure 181

Figure 182

Figure 183

Figure 184

Figure 185

Figure 186

Figure 187

Figure 188

Figure 189

Figure 190

Figure 191

Figure 192

Figure 193

Figure 194

Figure 195

The Natural History of the Traditional Quilt

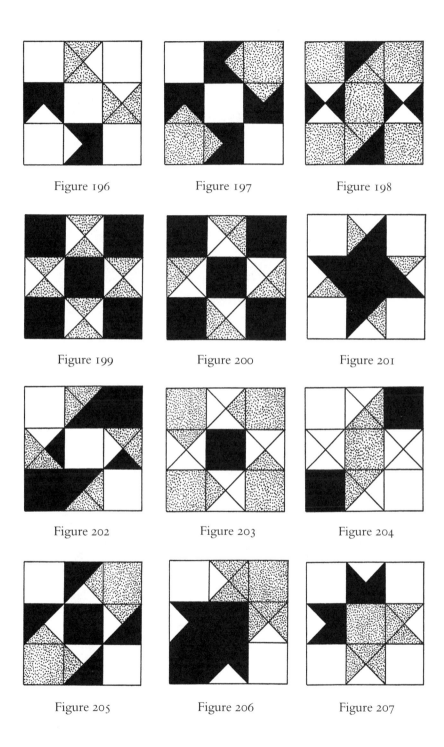

Figure 196

Figure 197

Figure 198

Figure 199

Figure 200

Figure 201

Figure 202

Figure 203

Figure 204

Figure 205

Figure 206

Figure 207

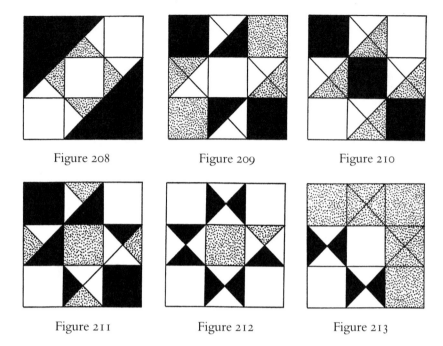

| Figure 208 | Figure 209 | Figure 210 |

| Figure 211 | Figure 212 | Figure 213 |

The variations shown for coloring the cell in Figure 171, however, come prior to that step.

It should also be noted that the variations we have illustrated, whether they emphasize seam structure or not, tend to be symmetric, either rotationally or reflectively, or both. Empirically it is common for the fabrication of a regular cell to be regular also, but the genotype does not preclude asymmetric interpretations, or interpretations that reduce the symmetry of the genotype. Figure 212, for example, emphasizes every seam yet has neither lines of reflectional nor points of rotational symmetry, and is quite consonant with traditional modes of scrap patchwork. Figure 213 shows an asymmetric fabrication where seam structure is de-emphasized, and which is also consonant with the scrap tradition, though much rarer.

The coloring of each cell may appear to produce endless variety, but this is merely the first step on a long trail. The next step is to piece multiple cells and unite them into a quilt top. A whole different order of decisions comes into play at this level, leading to a giddying kaleidoscope of possibilities. As we have already discussed, the top may be set in numerous ways with sashing, borders, setting squares, and other materials apart from cells. But we begin our discussion of assembling tops with the simplest case, namely, piecing cells edge to edge without any added setting elements.

The Natural History of the Traditional Quilt

Figure 214 (183)

Figure 215 (189)

Figure 216 (190)

Figure 217 (192)

Figure 218 (193)

Figure 219 (195)

Figure 220 (197)

Figure 221 (198)

Figure 222 (201)

Figure 223 (211)

Figure 224 (191)

Figure 225 (191)

The Natural History of the Traditional Quilt

Figure 226 (204) Figure 227 (204)

Figure 228 (196) Figure 229 (196)

Obviously, the simplest choice involves piecing all of the cells in the same way in regard to value and stringing them together. Even so, the lattice arrangements thus created can be quite surprising. Figures 214 to 223 give examples using single colored cells taken from the sample gallery (the original cell figure number is given in parentheses, as it also is in Figures 224 to 229 and Figures 231 to 233). As we have demonstrated in the previous section, the piecing of cells edge to edge often produces figures that appear distinct from the original cell that created them, inspiring further creativity. Many such "counterpoint" figures can be seen in the lattices in Figures 214 to 223.

Yet more diversity is added to an already complex picture by using different value arrangements for the constituent cells of the top. We admit that not all of the alternatives elaborated here are especially common with the cell

we have chosen, but the general principles are the issue. It is easier to see how the different ways of arranging cells produce designs if we concentrate on one cell. One possibility is to reverse the values in alternate cells, with the rows jogged (see Figure 224), or to reverse the values in rows (see Figure 225). In these examples the basic relationship between value and seams is preserved from colored cell to colored cell, but in alternating colored cells the values lie in different locations.

Various symmetry operations may be performed on the colored cell, without changing values. Note that the symmetry operations which we illustrate here are possible without changing the underlying structure of the cell in Figure 171 because it is both rotationally and reflectively symmetrical. The cell itself is not being rotated or reflected: according to the original definition, a cell is a structural constant which contains all orientation information necessary to produce a finished quilt, exclusive of setting elements. It is merely that the coloration of the original cell can be varied so that the visual pattern which emerges appears to have been rotated or reflected. A cell structure which is not rotationally symmetrical will not permit the emergence of apparent rotations of the colored cell, and one that is not reflectionally symmetrical will not permit coloration shifts which make it appear to have been reflected. The cell proper, the genotype, is nothing more than the arrangement of seams without respect to the colors or values of constituent patches. The rotations, reflections, value changes, and so forth described here act on *colors* and so do not alter the geometry of the underlying cell at all. Take away the colors in Figures 224 to 233 and the cells all look the same. It should also be added that the permutations we illustrate here in terms of symmetry operations and variations for putting together colored cells are a mere fractional representation of all the possibilities.

Rotations of a selected colored cell, for a first example, produce larger design elements out of the constituent cell, provided that the coloring of the cell does *not* have rotational symmetry (even though the underlying basic cell *does*). A colored cell may be rotated through 90°, 180°, or 270° in a number of combinations and permutations. Some of the more obvious are: similarly colored cells rotated at 0° and 90° set alternately in rows with the rows jogged (Figure 226); similarly colored cells rotated at 0° and 90° set in rows of the same rotation with rows alternating (Figure 227); and the same two ideas using alternations of 0° and 180° instead of 0° and 90° (Figures 228 and 229).

A colored cell may also be rotated around one of its corners through 0°, 90°, 180°, and 270°, and the resulting unit of four colored cells can be repeated in a lattice. Depending upon the symmetry of the colored cell, rotations about each of the four corners may produce different designs. Figure

Figure 230a

Figure 230b

Figure 230c

Figure 230d

Figure 230e

Figure 230f

Figure 230g

Figure 230h

Figure 230i

Figure 230j

230 shows one colored cell taken through rotations about each of its four corners (labeled *i*, *ii*, *iii*, and *iv* in Figure 230*a*), with the resulting units used to construct lattices. Figure 230*b* shows a rotation around point *i*, and Figure 230*f* shows a 2 × 2 lattice of the resultant unit. Figure 230*c* shows a rotation around point *ii*, and Figure 230*g* shows the lattice. Figure 230*d* shows a rotation around point *iii*, and Figure 230*h* shows the lattice. Figure 230*e* shows a rotation around point *iv*, and Figure 230*i* shows the lattice. A comparison of the lattices in Figure 230*f* and 230*h* shows that the patterns are mathematically identical. However, since quilts are not mathematical abstracts, and edges and the placement of emergent motifs matter to the overall design of the quilt, the two lattices represent different possible choices on the part of the quilter.

The Natural History of the Traditional Quilt

Figure 231 (203)

Figure 232 (203)

Figure 233 (177, 187)

Figure 230*j* shows another common possibility in scrap quilts, namely, the irregular placement of rotations of the colored cell to produce a seemingly random (but usually carefully planned) overall effect. In fact, our attempts to draft this figure helped elucidate this point. At first we simply used a random number generator to come up with the placement of each individual cell in the overall design, but each placement so produced did not appear entirely plausible. So we resorted to choosing the rotation of each colored cell, as if we were piecing them together.

Reflections of a basic colored cell can be carried out using analogous permutations, that is, alternating mirror reflections in jogged rows (Figure 231), and alternating mirror reflections in repeated rows (Figure 232). Of course, symmetry operations of this sort can be combined endlessly—you could

have, for example, a setting involving the rotation of the colored cell about a point coupled with mirror reflections—and all of these operations can be made more complex by the use of value changes as well. Figure 233 shows yet another possibility, in that two wholly different colorations of the cell can be combined into a single lattice—in this case, in alternation and with rows jogged.

The permutations described so far represent possibilities that require and preserve a degree of regularity in the finished top, and can be described according to simple mathematical operations. But scrap quilts, in particular, often have little regularity of this sort. The most complex of scrap quilts are composed of individual colored cells with no intention of preserving uniformity of value, seam relationships, or symmetry overall (Figure 234). Others preserve some regularity without being completely beholden to it. It is common, for example, to construct a scrap top paying attention to value relationships across seams, but without concern for uniformity of value relationship from cell to cell or orderly placement of like cells. Figure 235, for example, shows a top in which all seams join patches of different value, but the placement of the colored cells in relation to one another does not conform to any simple mathematical operation.

There is also a middle ground between utter regularity and utter lack of it. A basically regular orientation of colored cells with one or two breaking the regularity is well enough known on both prototypic best and scrap quilts. Or a basically irregular arrangement may have points or centers of regularity. For example, a scrap quilt may exhibit an overall irregularity of color anchored at regular intervals by the use of a single recurring color.

Before widening our discussion from an exclusive concern with value to other aspects of fabric, we should consider value as an overall attribute of a top. Some tops may be made with solid concentrations of darks or lights, others with high contrast between the two. This choice has a considerable effect on the finished quilt, because it determines how the top will create and display shadows under different lighting conditions. The lighter the values, the more easily shadows show, adumbrating seams and quilting stitches, especially under sharply angled lighting. Darker values mute these shadowed three-dimensional effects. Overall value characteristics of a quilt will also affect how the quilt shows soil and wear, and may correspond to the season in which the quilt sees regular use.

So far the discussion has reduced the role played by fabric choice to a question of value only (and the illustrations have been limited to the three most basic values). But, as explorations in previous sections have made clear, fabric choice can work with or against seam structure in a number of creative

Figure 234

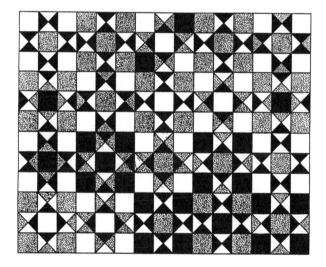

Figure 235

ways beyond value. A checkered material, for example, can be cut in such a way as to make it seem, if seen at a distance, that square patches are constructed out of smaller squares. Or striped materials can be cut and sewn in such a way that the seams stand out, emphasized by the abrupt halt or change in direction of a regular grain or print.

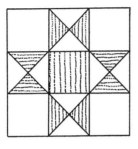

Figure 236 Figure 237

Our sample cell can be diversely affected by the choice of fabric. The question of the densities of prints inasmuch as they create value can be passed over, but there are numerous issues to consider beyond value. Prints and weaves may produce rectilinear or curvilinear designs. Depending on the contrasts of hues used to create these designs, their geometric properties may influence their use in fabricating a cell.

The sample cell is completely rectilinear, emphasizing squareness and oblique lines parallel to the main diagonal. Rectilinear fabric designs can be used to reinforce these cell lines by running parallel to them (Figure 236), or by working obliquely against them (Figure 237). Rectilinear designs on fabric can also be created in more subtle ways than simply through the use of straight lines, as in stripes and plaids, and can be used to create similar, though more discreet, rectilinear effects in the construction process. A small scale print, such as a polka dot, may be repeated in straight lines, or the overall effect of, say, a twining vine—locally curvilinear—may be rectilinear. In fact, all prints made by repeating individual motifs in what are technically known as frieze or wallpaper patterns, depending on whether the repetition is along one or two axes respectively (see Lockwood and Macmillan 1978: 11–35), have straight line elements, namely, the axes of translational symmetry, that can be exploited by the quilter.

On the other hand, the curvilinear nature of fabric patterns may reduce the overall rectilinear effect of the cell's seam structure. This is particularly true if the print is made up of strongly contrasting hues, so that the pattern's curvilinear nature is as marked to the eye as the cell structure. However, these effects are greatly influenced by the size of individual patches in relation to the scale of the print.

It is common to speak of small, medium, and large prints as if these were absolute values. Undoubtedly in the fabric trade as a whole there is some uniform agreement regarding these terms. But, from the point of view of

cell structure, what matters is the scale of the print in proportion to an individual template. The main question is whether a motif in the pattern is small enough to be contained entirely by the boundaries of an individual patch template. By this relativized definition a small pattern is one where many motif repetitions can be contained within one template, a medium pattern is one where a single motif can be framed by the template, and a large pattern is one where the template is too small to contain more than a portion of a single motif.

Relatively small, medium, large prints can be juxtaposed to emphasize or de-emphasize cell structure. A large print inherently emphasizes the seams of a rectilinear patch because its motif structure is abruptly truncated at the edges. But this effect is downplayed if all the patches in a cell are cut from fabrics of a single scale. Conversely, the effects may be magnified by juxtaposing fabrics with patterns of markedly different scale. In this latter case the selective positioning of the large scale prints can radically alter the visual focus of the cell.

Choice of hues (that is, what is commonly referred to as "color"), is, of course, neither a minor nor simple matter. As we have already suggested, the choice of a few versus many is the most obvious distinction between prototypic best and prototypic scrap quilts. So the most basic question facing a quilter preparing a top is how many hues to use overall. Then there is the issue of the relationship of the various hues to one another. In the field of color theory, the usual way to discuss this relationship is through use of the color wheel (Figure 238). Colors are arrayed on the wheel to convey a sense of physical relatedness or distance. Strictly speaking, the areas on the color wheel are made up of infinitely small gradations from one part to the next, but it is more usual to refer to main sections: the primaries (red, yellow, blue), the secondaries (orange, green, purple), and the tertiaries (colors each lying between a primary and a secondary color and taking their names by compounding the names of these hues, e.g., yellow-green).

For our purposes the use of the sections of the color wheel, and their attendant names, is a descriptive convenience only and not a complete analysis of how quilters choose and use hues (see Hilbert 1987 for a discussion of crucial methodological issues). Quilters in many parts of the tradition refer to "darks and lights" in describing the aesthetic for which they strive, or the way in which they conceive a particular pattern. Though the terms would seem to indicate an interest solely in value, an operational definition would most likely turn out to involve considerations of hue as well. Quilters are aware of the potential for hue to influence the visual perception of a pattern, in terms of dimensionality, for instance. Many traditional patterns—the de-

Figure 238

sign frequently called "Baby Blocks," for example—rely on the judicious use of hue for the dimensional effects which would be less striking when brought about through the use of value alone. Native categories may or may not include some version of such concepts as "cool" versus "warm" hues and hues which "advance" or "recede." The study of color categories as conceived by quilters is a useful endeavor yet to be accomplished in detail.

The use of one hue only or hues that are so close that they fall within a single marked section of the color wheel results in a *monochromatic* quilt (the neutrals, white and black, may be used in addition without counting as hues). Otherwise, a quilt is *polychromatic*. It is in the latter category that the color wheel is a useful descriptive device, distinguishing those quilts made from colors close together and those made from colors far apart. Combinations of hues that cover less than half the color wheel are said to be *analogous* whereas those diametrically across from one another are said to be *contrasting*.

Polychromatic quilts may, therefore, be described in terms of the distribution of analogous and contrasting hues. The polychromatic nature of a quilt may exert itself at any level. That is, a patch may be polychromatic,

made of a print using several hues, as may a cell, as may the whole top—and at each level hues may be analogous or contrasting. The main issue concerns the conscious juxtaposition of these hues at the various levels. For example, a quilt may contain contrasting hues but they may be kept spatially distinct, so that the effect on the eye scanning the top is of moving from one analogous hue to the next—perhaps red through orange through yellow to green—so that at no point on the top are contrasting hues directly adjacent. Or the opposite may be true. Contrasting hues may be deliberately abutted. And this may be true on the level of the cell as well.

The relative area covered by different hues is also of significance. A quilter may choose to balance the amount of space occupied by contrasting hues, or, as is quite common, have analogous hues predominate, with a small area of a contrasting hue—perhaps no more than a single cell or patch—standing out in high relief against the rest.

Color may also be classified according to *saturation*, or chroma, the pigment equivalent of brightness in colored light. All of the variations and decisions described concerning value and hue apply equally to saturation. However, saturation is not entirely distinct from value in that lights and darks cannot physically be as saturated as middle values. Thus, playing with brightness of necessity involves some consideration of values; brighter, more saturated colors must come from the middle of the value range. The reverse is not true. Less saturated colors can have any value.

It is abundantly clear, then, that even with a single well defined cell structure there are infinite possibilities for elaboration. It is also possible for creativity to creep in because of a dislocation between the process of conception and the process of fabrication, resulting in an alteration of the cellular structure, as already intimated in the previous section. That is, it is possible to draft the cell structure, cut out the patches, begin sewing up subunits, and then, by accident or design, change the construction process. Figure 239 shows a cell and its constituent subunits, and Figure 240 shows ways that these subunits can be pieced as alternatives to the original design. These are *not* different colorings of the basic cell but new cell configurations: the underlying seam structures of all these cells are different, even if very close taxonomically.

We do not mean to suggest that these variations are inevitably produced in this way, or even that any of these in particular were thus devised. Rather, we simply mean to show that new cellular structures may arise because of the nature of the construction process, as distinct from drafting. But certain kinds of cells are more susceptible to this process than others. Straight strip constructed cells with many like subunits seem to be the most fruitful for vari-

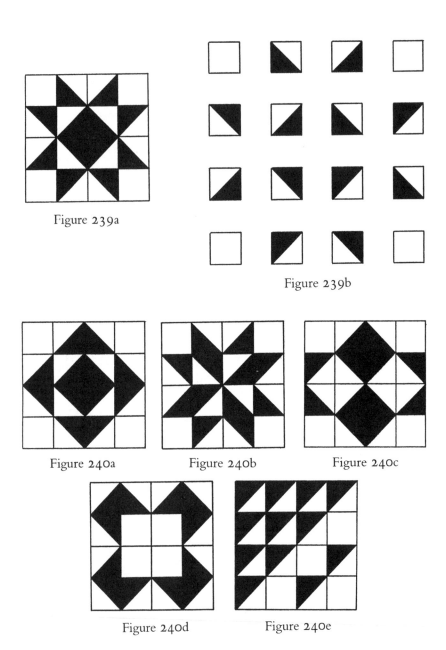

Figure 239a

Figure 239b

Figure 240a Figure 240b Figure 240c

Figure 240d Figure 240e

ation of this kind. Oblique and from the center constructions place more limits on which subunits can be interchanged and still preserve the cell's basic shape. In addition, it is best if the subunits have little rotational sym-

metry. Otherwise not much manipulation is possible that would make cellular differences.

We have already discussed the elements of the top which are not part of its cell structure—the materials for setting the cells—in our morphological descriptions. What remains is to examine the fabrication of these setting elements. To review briefly, the cells may be set using any or all of the following techniques which depart from the simple process of sewing cells edge to edge:

- Cell edges may be set at 45° to quilt edge.
- Cells may be set jogged a half a cell in width in alternate rows.
- Cells may be alternated with plain squares.
- Cells may be set with sashing strips.
- The entire mass of cells in a quilt may be surrounded by one or more borders.

Plain setting squares and sashing separate the cells from one another, thus emphasizing individual cell structure at the expense of multicellular structures. By so doing, certain possibilities explained above are of necessity excluded. Cells end up directly complementing or contrasting their setting rather than each other and the cells cannot work together to form larger figures. Figure 241 shows an example of a cell that traditionally may be used to create larger forms (see Figures 121 and 122) set with sashing, so that the way the cells work together overall is obscured. Sashing may also be used as a framing device if the colorings of the individual cells in the top are all radically different, producing a sort of gallery effect. Both of these setting techniques have the potential to create overall visual effects, because they are not confined to any single area of the top. Thus, a top may be made of cells composed of polychromatically contrasting scraps but be set with plain setting squares, all of the same hue and value. In this way the diversity of the cells is balanced by the uniformity of the setting. Sashing may be used to similar effect.

It is not necessary to repeat in detail all of the aspects of value, hue, and saturation choice with respect to the setting elements. But because the setting pieces work with the cells, some consideration of key issues is warranted. Of prime importance is the question of whether setting squares, sashings, and borders are to be cut from one bolt of cloth or from scraps. In plain physical terms there is often a simple answer to this question. That is, setting elements often must be cut from a bolt because they require so much fabric in total

Figure 241

and each piece is substantial in itself. This decision, then, can create a balance between cells made from scraps and setting pieces cut from store-bought cloth. Apart from the aesthetic effects of such a decision, there may also be benefits regarding the durability of a scrap quilt, which may have a greater structural integrity if the setting elements are of strong, new cloth.

Sashings and setting squares may be cut from scraps, but this practice is much less common than creating a scrap border. In the main this decision has to do with the fact that borders are often pieced, so that the techniques that apply to pieced cells apply to pieced borders also. Setting squares by

definition are not pieced (except in anomalous cases), and sashing lies somewhere between borders and setting squares—it can be pieced, and, if so, can be made of scraps, but commonly is cut from whole cloth.

Color decisions are tied to these decisions concerning the provenance of setting materials. That is, when setting elements are cut from whole cloth, it, of necessity, has a unity of color that may complement or contrast with the cells. When setting elements are cut from scraps, there is more potential for variation across the top of the quilt.

Choice of setting may also prefigure decisions about the way the top is to be quilted. The sample cell we use at the beginning of this chapter has no really large areas on which to quilt elaborate motifs without quilting over the top of seams. Thus, the desire to create fancy quilted motifs may move a quilter to set this cell with alternating plain squares. Likewise, sashings and borders can be the ground for linear motifs, such as trailing vines. But the use of plain setting elements is not a determinant of motif style quilting. It is perfectly possible to set a cell with sashing and then quilt the top in an overall pattern.

In the great majority of cases, the conception and fabrication of the quilt top is the work of a single individual. But group process at this stage is possible, even though a jointly made top must be classified as a special case, and the resultant quilt will usually have special social value. Perhaps the commonest of such group products is the friendship quilt, each cell being constructed and possibly signed by a different person. Other types of group quilts include various kinds of commemorative or gift quilts, quilts to be raffled or sold for some community cause, and quilts made for emergency or charitable purposes.

Group process at the stage of fabricating the top presents special problems because the piecing or appliquéing of the individual cells is almost inevitably done privately. Yet all of the decisions explored above still hold sway. The quilters may decide to buy fabric and then split it among themselves, or they may use scraps. They may decide on an overall color scheme or leave the choice to the individuals. They may cut all the pieces on one template or on several.

When it comes to quilting the top, the decision as to who quilts it and how many quilters there are is a critical decision with many ramifications, morphological and social. The three basic possibilities are as follows: the quilt may be quilted by the same woman who made the top; it may be quilted by one woman different from the one who made the top; and it may be quilted by a group of women, including or excluding the one who made the top.

Although popular tradition asserts that quilting by groups is typical, empirical research suggests that the picture is more complicated. Quilting alone may be the norm traditionally, with past and present quilting bees constituting exceptions occasioned by particular social circumstances (such as those mentioned in the discussion of group fabrication of tops) or by the influence of the revival. Certainly the quilting bee has achieved a kind of mythic status, and no doubt it was in some eras and locales an important activity with multiple social functions beyond getting tops quilted. But many sources indicate that quilting in groups produces an uneven finished product and so is not suitable for better quilts, as the following citations from different parts of the United States indicate.

Southwest:
I belonged to this club out in Hamilton. It was just a quiltin' club. Everybody taken a covered dish and we just quilted. Whoever had the club put up a quilt, and we quilted it out. Sometime we'd quilt two a day. Some days they would be fifteen or twenty of us all over that quilt. Some of 'em didn't do too good a quiltin'. When it come my time I didn't put up no fancy quilt. I just put up one I didn't care how was quilted.
(COOPER AND BUFERD 1978: 102)

I never like to quilt with a group, only with my mother when I was young. She taught me to quilt and we liked it to always be right. I don't like somebody else working on my quilt. You know, maybe they didn't learn the way I did.
(COOPER AND BUFERD 1978: 140)

Pennsylvania:
Contrary to popular opinion, most of these quilters as well as their older relatives, had quilted alone all their lives or with just one family member or interested neighbor. Although some were now quilting in groups, such as the New Berlin, Laurelton, or Pennsdale women, they were recent exceptions. When group quilting had occurred, it was usually connected with a fundraising event for a church, library or civic organization. Many felt strongly that the results were usually better when one quilted alone.
(LASANSKY 1985: 29)

The Natural History of the Traditional Quilt

Southern Appalachia:

A number of women interviewed about quilting bees knew
grandmothers whose memories went back as far as the pioneer period.
Most of the women never participated in any kind of gathering for the
purposes of quilting except in the 1920's and 1930's, when quilting was
enjoying a healthy revival. Little evidence exists to indicate that
quilting parties were a universal practice in the pioneer-frontier era.
(IRWIN 1984:15)

The themes that run through descriptions of group quiltings are that the
functions of the events are neighborliness, relaxation, and perhaps also char-
ity (making quilts for the needy, for example), but high quality quilting is
rarely the product:

I've always belonged to some quiltin' club or church bee. When I was
raising my kids the club was always my time to get off and get some
relief. I ain't happy doing nothing. But if I can take my relaxation with
a needle and have some fun talkin', then I think it's all right.
(COOPER AND BUFERD 1978:103)

Sometimes I quilt for other folks. They say 'Miz, you got to do this
one for me. Can't no one quilt like you.' And I do it for them, but
even before I start I'm thinking about getting back to my own work.
I do all my own quilting and piecing, you know. I know it ain't
neighborly, but I can't let no one else touch it.
(COOPER AND BUFERD 1978:125)

Group quilting is liable, then, to produce uneven stitching. In addition, it is
not a process congenial to highly elaborate quilting designs, because each
quilter is working on a limited area and is not easily able to follow the intri-
cacies of a complex pattern over the quilt's surface. Of course, even the sim-
plest design requires one woman to pick up where another has left off, but
this aspect of the process can be minimized.

Sending a top out to be quilted for a fee has been routine practice
throughout the twentieth century. Despite Carrie Hall's romantic visions of
the quilting bee (which culminate in a long excerpt from Harriet Beecher
Stowe's *The Minister's Wooing*), she, nonetheless, concludes her description of
making a quilt with the advice, "When you have finished your 'top' turn it
over to an experienced quilter, for a beautiful quilt may be made or marred by

the quilting. Most professional quilters charge per 'spool' with an extra charge for marking, also a charge for binding" (Hall and Kretsinger 1935:46). The process of sending out a top to be quilted for a fee can make the construction process discontinuous depending on the desires of the person who made the top. That is, she can turn the top over to a professional quilter, leaving all judgements on quilting design and execution in the professional's hands. Or she may mark the top with designs before handing it over, thus retaining control of design decisions and relinquishing physical execution only.

Although relatively uncommon, there are other ways in which the making of the top and its quilting may be carried out serially by different people. For example, a woman may find a top pieced by a forebear and decide to finish it herself. Or through sickness or some other infirmity the woman who began a quilt may not be able to finish it and may have it completed by a friend or relative. And, indeed, the transition from one maker to the next need not happen only at the point that the top is ready to be quilted: the top may be half pieced or the quilt may be half quilted.

Continuous control and execution are ensured when one woman works from beginning to end on a quilt. Proceeding in this way also allows a woman to work on a quilt when and where she can, without the necessity of co-ordinating activities with other women. It is certainly easier to snatch half an hour from other tasks for quilting than it is to gather together with other women at a fixed time and location, requiring time for preparation and travel as well as the time actually spent quilting.

In laying out a quilting design, several key decisions must be made at the outset before the specific questions of what designs to use are addressed. These decisions may be made at the time of conception, or they may be deferred until the top is completed. As should be clear from previous explorations, quilts are subject to continuous change throughout the execution process. It is possible to have a quilt planned out from piecing to binding before a single patch is cut or a seam is sewn. But traditionally inventiveness can change original conception at every step. Thus it is common practice to hold off decisions concerning quilting until the top is made and the quilter can have a physical sense of what she is working with.

She may decide to use an overall pattern (Figure 86), in which case all that is left to her is to lay it out in chalk or some other ephemeral medium on the quilt top. If she decides, on the other hand, to follow the seams, she may not need to lay out the design at all, particularly if she is working by herself—the mental image of the system of working is sufficient guide. But not marking the top is possible only if she is executing a straightforward design, such as

outlining each patch or following the lines of sashing strips. Complex representational motifs require laying out even though they may be contained within seam lines.

Binding generally is an individual occupation and is, again, an opportunity for a final decision, although certain methods of binding must be decided upon earlier. If the backing is to be folded over as the binding, for example, the decision must be made when the backing is cut. But if a separate binding is used, color and fabric choices (and whether to add cording or ruffs), can be left until the quilting is finished. Naturally, however, if a quilter intends to use fabric in the binding which she has also used in the top, some advance planning will be necessary to insure that enough fabric exists for both uses.

Thus the gestation process can be seen as a series of steps beyond conception that each give physical form to ideas, and which can open and close possibilities at later stages. Most important, the stages need not be planned in advance. Rather, the process of traditional quiltmaking can be seen as one of continuous and active decision making, and not simply the mechanical carrying out of a preordained order.

3.4. LIFE SPAN

From the moment of birth (even from conception), each quilt is destined for a radically distinctive life. But certain uniformities are easy to identify, based largely on decisions made in the construction process. The most obvious distinction is between the common scrap quilt and the so-called best quilt, whose life destinies are quite predictably separate. We follow here the paths that quilts of these types take, mindful that we are focusing on general trends, and that individual articles may diverge from the common path. In this regard it is important to remember that the categories "scrap" and "best" are prototypic and not necessarily mutually exclusive. The following descriptions pertain to these prototypes. Many issues concerning the genesis, distribution, and functions of quilts are explored in Chapter 4 on ecology; our purpose here is primarily to consider the *transitions* that quilts undergo in their lives.

The primary functional distinction between prototypic scrap and prototypic best quilts is that the former are for everyday use, whereas the latter are for special occasions only. The following are typical identifying statements:

> . . . Mama was interested in pretty patterns, but when she'd make one she would put it away. She wouldn't use it. Oh, she may have got it out

and put it on the top of a bed for Sunday. But she'd never use it for
every day.

(IRWIN 1984:138−139)

I keep my best quilts put up for special occasions, or just to bring out
and look at, put on the bed once in a while. I'll pass them on to the
kids of course. They each have an heirloom picked out. But in those
busy days before Doc passed away, I had lots more everyday quilts
made of outing and feed sacks and wool suitings. We used them for
pallets for the kids to crawl around on. And we wouldn't think of a
picnic without a pallet. We used to take a pretty quilt out to the
mesquite thicket for a special picnic when we was courtin' and put an
old quilt under it. Lord, was that pretty on a spring day.

(COOPER AND BUFERD 1978:110)

Thus, a best quilt may be most painstakingly and lovingly made and then
spend much of its life stored. In fact, any type of quilt may begin its life in
storage, as when a young woman furnishes a "hope chest," or when a quilter
creates a store of quilts for purposes of future giving or use. But scrap quilts
are constructed to be used, so it is most likely that when they have been
finished they will be placed in service.

The first and primary use for traditional quilts is as bed clothes. Whatever
other functions they serve throughout their lives, this is their definitive pur-
pose. Traditionally, beds might have no other cover for warmth. Quilts might
be used singly in summer months, or stacked high on top of the other during
the cold of winter. The pressure of layers of quilts, in time, compresses the
batting if it is made of a lofting material, such as cotton or fleece. Otherwise,
serving duty as bedding in itself may not be harmful to the quilt's structure,
but depending upon the habits and hygiene of the sleeper, bed quilts can
receive some heavy wear. Body oils and soil may deteriorate a quilt, particu-
larly at the edge which the sleeper pulls up around the shoulders or face; and
all edges are subject to wear if tugged or if tucked into bedsteads which have
sharp or abrasive sections. Any household which includes cats or dogs may
also sacrifice the pristine quality of its bed quilts to the pull of claws or the
shedding of fur.

Scrap quilts may serve many other functions besides bed coverings:

This particular time Papa and Frances came back from the crib with
the corn. Renda went to the quilt shelf and got a clean quilt. After
sweeping the floor and moving everything out of the way, she spread

The Natural History of the Traditional Quilt

this large quilt on the floor, and Papa poured the corn on top. Father and the older girls placed their chairs around the corn, close enough so that they could pull the edges of the quilt up over their knees, somewhat like an apron. Then they began to shell the corn, letting the grains fall onto the quilt. . . .

By this time all the corn was shelled. My father made a three-cornered opening by catching the edges of the meal sack with his teeth and both hands. Renda got a plate from the shelf and using it as a shovel, she scooped the corn up from the quilt and placed it into the sack. Then she folded the quilt and put it back in the shelf.
(SLONE 1979 : 109, 111)

And, as articulated in citations at the beginning of this section, quilts may be used as pallets on the floor or ground, best quilts being protected from contact with the ground by older quilts. This treatment is likely to be more abrasive than use on beds and leads to more soiling as well. However, under any conditions, except storage, a quilt will inevitably become soiled enough that it must be washed. The following is a common description of the traditional washing process:

We'd take and put them in a big tub of water and in plenty of home-made soap and rub 'n rub. The we'd lay them out on a bench an' paddle 'em. Had a paddlin' stick, they called it, and just come down with all the power in both hands, and everywhere you struck that quilt you'd make a clean place.
(IRWIN 1984 : 140)

Obviously this treatment over time wears the fabric thin, leading to tears and rends. Even less harsh washing will eventually cause deterioration of the fabric, particularly if it has come from clothes that have in their own lifetimes been worn and washed many times. And some stains are so firmly set that they cannot be removed with even the roughest treatment.

Continuous washing and general use of quilts cause most of their major transformations. The first transition is not an easily definable step, but rather a process, although the before and after qualities are well known. After numerous washings, the top fabric softens and the whole surface texture becomes relatively homogeneous. But this transformation to maturity comes at the expense of the strength of the cloth, so that at some point the quilt tears irreparably.

Either physical breakdown of the fabric or severe staining can cause a quilt

to pass through a critical transition point and be designated an "old" quilt. An old quilt is not necessarily of any particular age, but rather is no longer suitable for use as a bed covering. Clearly this transition is most likely to occur in scrap quilts because of the treatment received early in their lives; they are washed more often and used in more demanding service. A best quilt that becomes fragile and liable to damage is most often permanently stored away before further physical harm can come to it.

Verna Mae Slone describes some of the many uses old quilts can be put to:

When quilts had outgrown their usefulness for the beds, they made saddle blankets, covers for a chicken coop, a dog bed, or they were hung over the opening of the outhouse or barn in place of a door shutter, or placed on the floor as a pallet for the baby.
(SLONE 1979:52)

My father's generation had no glass jars, so they did not can fruits or vegetables. They filled large crocks or churns with applebutter. When boiled down very stiff and sweetened with molasses, it would keep fresh for many weeks. Big barrels were filled with smoked apples; a few holes were made in the bottom of the barrel so the juice would run out, then filled up a few inches with apples that had been pared and sliced, with the core removed. On top of these a dish was placed in which a small amount of sulfur was slowly burned by placing a heated piece of iron beside the dish. A quilt over the top kept the smoke from escaping. Next day, another layer of apples and more sulfur was burned and so on, until the barrel was full. The sulfur gave the apples an "off" flavor that took a little getting used to, but was supposed to be good for you.
(SLONE 1979:63)

We "bedded" our sweet potatoes in a "hot bed" made from shucks, manure, and dirt, and covered with fodder and an old quilt. After they began sprouting, the fodder and quilt were removed. When large enough, the plants were then transplanted to hills or ridges.
(SLONE 1979:67−68)

Old quilts may also be nailed over door and window openings to stop draughts, or tacked to walls and ceilings as temporary screens and room dividers. Or their cushioning qualities may suit them for use as furniture pads, bedspring dampers, and the like.

Whatever use old quilts are put to, little or no care is taken for their physical integrity or their cleanness. The boundary of physical breakdown or dirtiness that they pass through to be designated "old" in the first place is what fits them for these functions. There is, thus, no turning back. A quilt used to cover horse manure in a cold frame or keep sulfur dioxide contained in an apple barrel cannot be used subsequently on a bed.

Naturally such harsh treatment as an old quilt receives continues the degenerative process and it may not be long before the quilt has lost its usefulness as a whole object. Then the quilt is deconstructed or destroyed in some manner, or it deteriorates completely as a natural condition of its use.

3.5. DEATH (AND REBIRTH)

Some quilts achieve a kind of immortality by being preserved as heirlooms, works of art, or financial investments. But many others have a natural end to their lives. They disintegrate or are deliberately dismantled or destroyed. We discuss both courses here, with emphasis on the second as empirically more likely.

Any quilt is hypothetically capable of exiting the traditional life cycle and achieving a degree of immortality, but certain types of quilts are more likely to gain this status than others. Disproportionately high numbers of prototypic best quilts, friendship quilts, and album quilts exist as heirlooms and "collectibles." These are all types of quilts made with preservation in mind; they are deliberately special. Prototypic best quilts are made from new material, used rarely, and washed infrequently. Therefore, they can be expected to last a long time, whatever else is special or prized about them. And longevity in itself can be a reason for continuing to preserve a quilt. That is, once a quilt has survived intact for one or two generations it acquires a family history that makes its continuing preservation more likely.

Yet any quilt, scrap or best, can, in theory, survive long enough to achieve what we may call "historic" status. A scrap quilt might even suffer the ravages of time but be preserved, nonetheless, because it was "the first quilt that mother made," or the like. Or else accidents of time and place can confer special status on a quilt, making it worthy of preservation—a quilt that survives a notorious fire or flood, for example, or one used by a person subsequently famous.

Some quilts have a kind of historic preservability built in at their conception and birth. A friendship quilt, for example, in which cells are constructed and signed by different people as a corporate memento, is inherently worthy of preservation because it is designed as a keepsake, not as a utilitarian object.

Or a quilt may be made or given to commemorate a special event such as a wedding or anniversary. Whether or not the event or the maker is recorded in the design of the quilt itself, the circumstances of its origin confer special status on it.

Even events not related to individual quilts can engender a desire to preserve specific ones. Various quilt and craft revivals throughout the nineteenth and twentieth century periodically raised public consciousness concerning quilts, prompting a growth in the demand for quilts as commodities in the arts and crafts market. These, in turn, created a recurrent desire on the part of buyers and entrepreneurs to preserve a wide variety of quilts, because as commodities their resale value rests in their capacity to be conserved.

The above activities are common enough that they cannot be designated as atypical or anomalous, but they are, nonetheless, special. Fieldworkers can be led to believe that the objects of such preservation represent a higher percentage of the total quilt universe than is actually the case because, first, they are not able to count or document the quilts contemporaneous with those preserved that have been destroyed, and, second, informants tend to bring out their special quilts for documentation in preference to others which they consider more ordinary or unworthy of an outsider's attention. Likewise, books and museums tend to emphasize the special over the everyday, giving the general impression that preservation is the norm. But preservation is only one "normal" track for quilts to take, and a minority one at that.

Some quilts end their lives by being quite literally buried in coffins:

Dora Bell Taylor bathed and dressed the body. Some of the children remembered that their mother had expressed a desire to be put away wearing her favorite black satin dress. Over this dress was put a white shroud made by Sarah Reynolds. Preacher Billie Slone made the coffin from seasoned wood, lined it with white cloth, and covered the outside with black cloth. The edges were trimmed with lace. Some folks used cotton to pad the inside bottom, but Sarah had a beautiful quilt she had made herself for this purpose.
(SLONE 1979:57)

When I was about four years old the neighbor's baby died, and all the women was called in to help. Mama knew what her part was because right away she took some blue silk out of her hope chest. I remember that silk so well because it was special and I got to carry it. When we got to the neighbors some of the women was cooking and the men was making the casket. Mama and three other women set up the frame

and quilted all day. First they quilted the lining of the casket, and then they made a tiny little quilt out of the blue silk to cover the baby.
(COOPER AND BUFERD 1978:49)

In both these cases the quilts were made with the express purpose of being used in caskets, thus effectively conflating birth and death (an especially appropriate symbolic association in the latter case), and also contributing affectively to the sense that the dead are only sleeping. But it is also possible for a quilt to be selected for this service that has not been specifically made for it. Likewise, animals may be buried in the old quilts that have been their beds.

Apart from this obvious connection with death and burial, quilts may be utterly destroyed or deconstructed to take on new form. Complete destruction is an extreme measure often associated with extreme situations:

One time a big tornado struck the county and some of those little towns was leveled. Lord, it was a sad mess. I went along with Doc to nurse. I had a stack of quilts in the wagon ready right then for the emergency, and I was cutting up them quilts for bandages before the day was over.
(COOPER AND BUFERD 1978:107−108)

A quilt may also be cut up for rags, toweling, or some other purpose that ultimately annihilates it.

Otherwise it is perhaps more common for old quilts at the end of their useful lives to be reused in some fashion. They might, for example, become the batting for a new quilt, thus retaining a degree of unity. Or an old quilt might be cut in appropriate strips to cover an ironing board, line a coat, or form the backing for furniture upholstery.

4. Ecology

4.1. INTRODUCTION

Up to this point, we have stayed relatively close to the quilt as an object that contains meaning inherently in its physical makeup. As a starting point, this is appropriate and right, but it is by no means the end of investigation. Quilts, indeed all artifacts, acquire functions and meanings in relation to their environments. Hints of the interaction between quilts and their environments have been given in previous sections, but we discuss what we may call the *ecology* of the quilt in more detail here. For analytic purposes we may divide the quilt's environment into three arenas: artifactual, human, and natural.

Quilts in daily use react with artifacts in their immediate environment. The commonest interaction, one surprisingly little discussed, is between quilts and beds. The same quilt draped on a double and a twin bed looks different because different portions of it are displayed horizontally and vertically and because different parts of it are exposed to light and shadow. We consider here not only the more obvious relations, such as those between beds and quilts, but also more subtle interrelations between quilts and environmental factors, such as window placement and natural lighting, and shadows cast by objects in the room. We also consider the quilt as an artifact that is fabricated using other artifacts, ranging from large scale items, such as frames and hoops, to the tiny, such as sharps and brights. Such analysis can be extended ever outward by considering the rooms, houses, farmsteads, communities, regions, and so on, in which quilting is done.

The section on the human environment treats, on the one hand, quilts and individuals, and, on the other, quilts and social groups. Under the first heading we consider the multilayered relations that exist between each quilt and the people who make and use it. Points for discussion are so numerous that they can only be hinted at in a list. Topics include quilts as the embodiment of personal memories and narratives, quilts that tell a story, quilt names and their meanings, quilts as gifts, quilts as mementos, quilts as heirlooms,

quilts as aesthetic objects, quilts as art, quilts as functional objects, and so on.

Under the second heading we consider quilts in their larger social contexts. For example, the ethnic heritage of the makers and users of quilts plays a significant role in design and use. Similarly, religious and regional affiliations play their part. We also consider the effects of a wide range of social facts, such as kinship, friendship, neighborhood, economic conditions, and community structure.

Because quilts are artifacts for warmth and comfort, they have an obvious relationship to the natural realms of geography and climate. But they are found from Alaska to Hawaii. Quilts in these quite diverse natural environments serve different functions. In cold climates quilts not only warm beds but can be found keeping drafts from rooms, protecting young seedlings in hotbeds, or preventing stored apples from freezing. Also quilts live cheek by jowl, as it were, with a range of nonhuman animals. Cats sleep on them, or they may serve as horse blankets. In the end, the effects of just such activities often lead to the wear and ultimate demise of quilts.

4.2. INTERACTION WITH ARTIFACTS

So far we have discussed the quilt primarily as the product of the intersection of human decisions both in its conception and gestation and in its functioning. But a quilt is also in constant interaction with other artifacts during its fabrication and for the rest of its life. Any quilt in its very existence implies the existence of a vast technology and a system of values and meanings, which, if explored systematically, can eventually reveal the whole culture in which the quilt resides. We may divide the artifacts that a quilt interacts with into three groups—those that produce the raw materials from which the quilt is assembled, those used in the fabrication process, and those of importance once the quilt is finished.

The history of the technology of fiber and textile production are, of course, worthy of major works in their own right, and there is no question that the history of textile manufacture is wrapped up in many of the most significant events in world history—Britain's Industrial Revolution, the War between the States, the Edict of Nantes, the independence movement in India, and on and on.

Even following one historical thread leads in ever expanding circles of complexity. For example, the development of factory methods of spinning (James Hargreaves' spinning jenny, Richard Arkwright's water frame, and

Samuel Crompton's mule) and weaving (John Kay's flying shuttle and Edmund Cartwright's powered loom) were at the cornerstone of the Industrial Revolution in England and Scotland, spurred initially by a desire for self-sufficiency because of the Napoleonic Wars, but ultimately leading to a period of mass production and export of cloth, thus securing Britain's prosperity for a century or more. However, mass production required raw materials, which meant colonization (cotton from India, wool from Australia, silk from China) and enforced trade relations (for example, with the American South during the War between the States). Latent within every quilt, therefore, are the political economies of nations.

Each stage of the fiber production process has an associated technology of considerable complexity, but for simplicity's sake we can divide the processes into *hand* and *mechanized* methods. Basically the distinction concerns the source of *energy* that powers the process, not whether machines are used or not: hand processes use human energy; mechanized, nonhuman energy (water, steam, electricity, and so forth). Thus the cotton fabric for the top of a quilt could be hand picked, hand sorted and carded, hand spun, hand woven, and hand dyed. Or mechanized processes could be used at every step.

The differences in hand and mechanized technologies are manifold, both in terms of the physical product and the cultural values attached to them. It is unusual for a traditional quilt to be the exclusive product of hand methods, but certain stages in fabrication may more easily be worked by hand than others. The choice to use hand technologies at different stages of quilt production are tied to cultural as well as material needs, often of profound import.

A very few quilts are the end product of exclusively hand technologies. The eighteenth century linsey-woolsey whole cloth quilt, for example, has a top made from homespun fabric—a mixture of wool and linen or cotton—hand dyed, and filled with hand shorn fleece or hand picked cotton, before being hand quilted. But this type represents an extreme, now connoting pioneer craftsmanship and self-sufficiency. Indeed, all of the hand methods evoke the symbolism of the sufficiency of the individual. Yet it is the economic circumstances of the wider culture that influences the degree to which this self-sufficiency is viewed positively or negatively.

In the case of the linsey-woolsey quilt, it is important to note that it is made as a whole cloth quilt. If one has the technological resources, it is obviously much more economically efficient to weave broadcloth and use it whole than to weave it and then cut it up to make patchwork. Or one can weave a woolen coverlet, working designs directly into the fabric, more economically than piecing. Hand technology for tops, therefore, is more likely

to restrict choice for the quilter in traditional economies. Store-bought fabrics, on the other hand, as well as used fabrics from a number of sources, greatly expand choices for top design.

The main advantage of hand fabrication of material is control over the stages of production. The quality of the raw materials can be checked, the precise nature of the spun threads assured, and the exact weave chosen as desired. But such control comes at the expense of maintaining an elaborate home based technology, including at minimum a spinning wheel and a loom, representing an investment not only of space and money but also of experience. Such technologies, where they exist in addition to that necessary for quilt construction, imply a degree of settled prosperity.

Certain hand processes may be introduced without encumbering a small household with equipment. Hand making a batting, for example, is quite common. For cotton, all this entails is the knowledge of how to hand pick the cotton so that as little boll as possible gets into the fibers, hand picking the seeds (or using a homemade gin), and aligning the fibers and evening out the batting with carding combs. According to several sources (Clarke 1976: 28; Cooper and Buferd 1978:117), hand production of cotton batting has persisted in many parts of the South to the present day. For a best quilt, a woman may choose to hand dye some fabrics to achieve the match she wants. Again, the technology needed is simple and takes up little space. In both these cases, the principal reason for choosing hand methods (besides the economic) is control over the process in order to make a component for the finished quilt in a way that cannot be replicated by mechanized methods:

> You can't hardly buy good cotton no more. I take it right from the
> field and card it to get the very best. I can't find it good enough in the
> stores any more, and I certainly don't need to go north to buy cotton.
> I like it long and silky, and it should press down smooth and flat.
> (COOPER AND BUFERD 1978:117)

When it comes to fabricating the quilt itself, the choice between hand and mechanized technologies still exists but is more limited. Cutting out the top is perforce a manual operation, although the exact nature of the technique used is subject to continual debate. The main issue is how to assure that pieces when cut out will fit together accurately and with the right seam allowances (or hem allowances for appliqué) and still produce the pattern as desired. Some templates are used to mark the size of the patch as it will appear in the design, so that the seam allowance must be accounted for in the cutting out stage, either by eye or by adding a line after the template line is drawn.

Other types of template take the seam allowance into account, and require a second line to be drawn on the patch within the template line marking the seam lines. Similarly, templates and rulers of different sorts can be used to mark the quilting designs onto the finished top. Some are solid shapes to be drawn around, others are of a stencil type, and still others are pierced and require the use of a pouncing powder which is sprinkled and rubbed through the holes. Thus, the technology of templates carries with it a level of knowledge concerning how they are to be used.

The making of the templates themselves also involves other technologies, depending on what the templates are made of. In some cases the quilter can make the templates herself, as when they are made of paper, cardboard, or another material that can be cut in a similar manner to cutting fabric. Otherwise, she may turn over the template making process to someone else: a woodworker or a metalworker, for example. But the further away from her ambit the template making process goes, the less control she has over the product, in turn influencing the ways in which she is capable of fabricating quilts.

Such artifacts may also in themselves create and maintain social bonds. Quilters frequently speak of saving and exchanging templates. Thus it is possible for a community as a whole to have at its disposal a wide variety of patterns, without any one individual owning more than a few. But this requires social cohesion and cooperation. Availability of the artifacts of design implementation determines the possibilities open to individuals. Paper patterns have long been available for purchase through quilt magazines and the like, but the construction of sturdy templates is still required for multiple usage. In recent years, plastic templates have become available in craft stores or by mail order, thus enabling the quilter to work in greater independence and isolation from her immediate community if she so desires or if she has no accessible community connections.

Other required artifacts for cutting out include marking instruments and fabric shears. The degree of sophistication in these tools represents the quilter's ability to pay for them, the perceived need for them, and the degree of concern for accuracy in cutting out. One could, for example, own a battery of rules (dressmaker's rule, rotary rule, meter rule, tape measure), marking tools (colored pencils, chalk pencils, tailor's chalk), and shears (dressmaker's shears, pinking shears, paper scissors, embroidery scissors). Ownership of an array of equipment may lead to a highly specialized artifactual division of labor, at this and all other stages of fabrication.

The making of the top is the chief area where hand and mechanized technologies compete. It is possible to piece or appliqué tops using a sewing

machine or with needle and thread. As with all home mechanized proce-
dures, a certain degree of prosperity is assumed by the use of a sewing ma-
chine, but construction issues are also at stake. Some quilters claim that the
accurate meeting of points in pieced designs is more easily accomplished with
hand than machine sewing. Certainly in the hands of a skilled operator a
sewing machine can be used very accurately. But the issue concerns the rela-
tive degree of experience necessary in hand and machine methods to produce
the desired results.

In at least one notable instance, the use of machine methods for patchwork
led to the invention of an entirely new tradition, though the technique is not
ordinarily used in quilts. Seminole patchwork, created by sewing and cutting
and resewing repeatedly in long, straight strips, produces intricate patterns
which are then used as decorative borders or pieced to form whole cloth for
skirts. This method is highly labor intensive, however, and impractical for
the creation of pieces large enough to be used as bedcovers, although en-
larged versions of Seminole-like patterns have recently appeared in revival
and art quilts. The quiltmaking revival has also spawned an array of special-
ized methods for piecing by machine which are intended to save time while
maximizing accuracy. Some such methods may appear in the tradition as
well, particularly within a specific family or community, to be passed along
by example where a quilter has a proclivity for machine work.

Certain historical factors are apparent in the decision to construct tops by
machine or by hand. The sewing machine was not patented in a form that
had fully practical applications until the 1840s and was not readily available
for domestic use until considerably later. Furthermore, these early machines
were hand powered (usually with a kick treadle) until the 1930s and 1940s,
when electric motors were attached. So the sewing machine has a slightly
ambiguous role in our terminology. It has been for much of its history a hand
powered tool, only becoming fully mechanized in recent decades.

Machine sewing is very fast, the stitches are even, and the seams are strong.
In addition, complex stitches such as zigzags can be used to accommodate
difficult fabrics like the stretchy knits. Hand sewing, by contrast, is slower,
the seams are looser, and the stitches are relatively simple. Yet one clear ad-
vantage of hand sewing is its eminent portability:

> I had to drive one of them big wheat trucks during harvest. I would
> just take my piecin' or crochet to the truck with me in the morning.
> Then that way when I had to wait for the men to load or unload the
> truck, I would just be piecin' on my quilt top.
> (COOPER AND BUFERD 1978:76)

Handwork can be carried to whatever location is most comfortable, or to the place where the quilter's presence is desired or needed: at the sickbed of a relative or neighbor; in the yard, while the baby plays; on the porch on a hot summer evening. Hand piecing can also be picked up and put down around the house at any moment, without encumbrance. A sewing machine imposes physical constraints on its user in terms of space and location, and it also makes noise, which may restrict its use temporally and in relation to other activities. Handwork is silent and can be done while other family members sleep, read, or talk. Some quilters like to work on hand piecing while watching television, an activity which is curtailed by the din of a sewing machine and sometimes also by its static interference with the sound and picture.

The effects of handwork as opposed to machine work on the creative process are somewhat more difficult to pinpoint, but there are clear differences between the two techniques. For one thing, the relatively greater time it takes to piece a quilt by hand means quite simply that the quilter lives more of her life with the quilt in progress. More personal experiences become attached to and have an effect upon the quilt's construction—but these matters are best left for the discussion of a quilt's interaction with its human environment. More pertinent here is the fact that the prolonged process of hand piecing lends itself naturally to longer contemplation of the design and to a greater elapsed time between stages of aesthetic decision making. Such meditation on the design as it is being constructed may lead more readily to innovation on one or more of the levels discussed in Section 3.3 on gestation. A quilter who works by machine is likely to have planned her process carefully before she sits down, since her moments of stitching limit her movement and presence elsewhere in her home. Moreover, because a sewing machine is most useful for making long seams, a quilter piecing by machine may wish to maximize these through careful advance consideration of the order and method of construction. Indeed, some quilters have devised special methods for use in machine piecing. In order to be temporally economical and procedurally practical, machine piecing must be methodical to a degree which is unnecessary in handwork. Thus handwork is likely to lead to a more processual approach to piecing.

The physical differences between hand sewing and machine sewing are fundamental. The hand sewer can release the needle and grasp it again either on the reverse side of the fabric or on the same side, the needle having passed through and back. But a machine does not release its needle at any point. Instead, it has an eye in the point of its needle and thrusts the thread through, which is then locked on the underside by a second thread wound on a bobbin that is independent of the needle. A hand sewer may sew a running stitch

in which only half of the line of thread (or less) is visible on the surface of the material. But the line of thread is always visible on the surface of machine stitching, and a running stitch is impossible. A significant concomitant of the difference between hand and machine stitching is the relative difficulty of picking a seam apart in case of error. Hand stitching is generally more easily undone than machine stitching, which means that a quilter working by machine is under greater constraint not to make mistakes.

For piecing of tops the differences in stitches per se may scarcely matter to the quilt's finished appearance. It takes a close inspection, perhaps even pulling at the seams on a finished quilt, to detect the difference between a running stitch and a lockstitch, the seams all being on the reverse. But on appliqué and other surface work, the differences are visible and evident. Aesthetic and cultural issues then begin to make an appearance. Some quilters may prefer the even look of machined stitches, others may like the evidence of hand crafting.

In cutting, piecing, and quilting, many of the artifacts employed can be homemade if the need or the desire exists. But some—mostly worked metal—must be bought: shears, a clear example; an iron, if it is important to the quilter to press hems and seams; and needles and pins. This inability to produce needles at home often creates problems for the home needleworker. Many different types and qualities exist, and she is dependent on commercial manufacture and distribution for what she wants. For general piecing this is not an issue (except for the most isolated households), a range of sharps being available readily enough. But for quilting the situation is rather more critical.

Hand quilting involves a running stitch that penetrates all three layers of the quilt. The simplest way, but one that is extremely time consuming, is to push the needle through to the underside, turn it around, and push it back up to the top. To make the going faster, quilters usually wiggle the needle up and down through the layers from the top, gathering many stitches at once before pushing or pulling the needle all the way through. To do this requires a small, very sharp needle, which is subject to considerable stresses and so may eventually blunt and bend or even snap. The smaller the needle, the smaller the stitches that are possible; but very small sharps are often hard to procure and may become valued items in the quilter's tool inventory.

The process of quilting many stitches at once also requires other artifacts, most notably some type of thimble to help push the needle through so many layers of fabric without the eye piercing the pushing finger. (Little or nothing can be done for the fingers that feel for the passage of the needle on the underside; protection would prevent them from doing their job.) Quilters use a variety of types of thimbles, the most common being a regular metal

sewing thimble. Thimbles or sheaths made of leather are also used. Not all quilters use thimbles, however, and some have special techniques of pulling the needle through the layers which do not involve pushing the eye portion with the finger. "Quilting with the thread," for example, is a way of pushing the needle through by using pressure on the part of the thread which runs through the eye, and then pulling on the tip of the needle with the fingers.

Machine quilting is possible but much less common than machine piecing, in large part because of the quality of the stitches that machines produce. Hand quilting with a running stitch creates a balance between the thread and the surface material showing on the top, but machine quilting creates a solid line of thread that is highly visible. And the line that the machine needle follows is very tightly held. Because these visible effects are so noticeably different from hand quilting, the choice of one over the other is quite different from piecing, where the effects are different but largely hidden except to close inspection. Machine quilting is noticeable at a great distance. In addition, hand quilting lends to the finished product the characteristic puckered texture traditionally associated with quilts, whereas machine quilting causes the quilted lines to lie flat. Finally, machine quilting requires that a very large quantity of thickly layered fabric be passed under the sewing arm in an order which produces the desired quilting design. This is no small feat, in terms of both planning and sheer physical technique, and machine quilters, like machine piecers, tend to use specially developed methods. For this reason, machine quilting is often much simpler in design than hand quilting.

Hand quilting requires that the fabric sandwich be held tightly enough that the quilter can work the needle through the layers easily, but not so tightly that it is difficult to gather up several stitches at once. The commonest way to do this is to use a frame that holds the whole quilt at once. The most basic frame consists of four lengths of wood, two for the ends and two for the sides. The end pieces have some kind of fabric tacked along their length so that the quilt can be basted on to them. The side pieces are stretchers clamped or pegged to the end pieces so as to keep the whole quilt reasonably taut. The advantage of this kind of frame is that many people can sit around it at once, and the whole quilt is accessible from a variety of angles. But it takes up a great deal of space.

To use such a frame requires not only having a room big enough to hold it but also additional room to hold the chairs if several quilters are to sit around it. Then there is the question of what to do with it between quilting sessions. A common solution in some regions is to suspend the frame from the ceiling and hoist it up away from the living space between times. But this means that quilting and other activities are mutually exclusive in a substantial

part of the house, so many quilters use other ways of coping with the problem. For example, some quilters have a special porch, arbor, or outbuilding built to keep the frame set up in at all times.

More modern quilting frames take up less space. Instead of having long side stretchers, they have the quilt rolled on the two end pieces with a working length of quilt only two feet or so between the rollers. As the quilter finishes the open area, she rolls it onto one of the rollers, thus exposing more unworked space from the opposite roller. This kind of frame is as wide as the older kind but takes up considerably less space in length, while allowing a number of quilters to sit at it, if desired. Such an artifact is a good deal more difficult to make than the old-fashioned frame, and, although homemade versions are possible, they are more often store-bought.

It is also possible to quilt using a large embroidery hoop. A quilter using a hoop must baste the three layers of the quilt together before quilting, since at no time will the entire quilt be held in the frame; basting itself requires space and effort. The use of a hoop solves the space problem caused by a large frame, but, in turn, reduces to one the number of people who can quilt at any given time. Although any design can be quilted with a hoop, this method is more suited to quilting designs that stay within the borders of cells, so that the hoop can frame each cell in turn. Otherwise several threads may have to be kept going simultaneously to keep a pattern going across the quilt face. Hoops are not particularly successful in holding the quilt's edges firmly, although a traditional frame does not hold the sides of the quilt taut either.

A quilt may be made to go on a specific bed, but all quilts end up interacting with beds and other artifacts in their immediate environment whether they have been made specifically for a bed or not. We have already stressed that quilts are three-dimensional objects in that their surfaces are sculpted by piecing, appliqué, and quilting. But they are also three-dimensional in that they drape over beds.

A quilt may lie completely flat on a bed, or it may drape over the edges and around pillows. The same quilt looks different on two different beds because of this fact. Not only does it make a visual difference whether part of a pattern is seen in a horizontal or vertical position, but also the positioning of the lines on the top where the horizontal and vertical intersect, created by the edges of the bed, can have an impact on how the whole is viewed. A quilt made, therefore, for a particular bed may give a completely different impression on another where a different proportion of the quilt appears flat and horizontal.

Note also that a quilt that drapes over a bed cannot be seen in its entirety from any one vantage point. A viewer must move around the bed to see it

completely, which causes different relationships of horizontal and vertical to come into view. And, of course, a quilt is seen at a quite different angle by a person *in* the bed, the contours of the body further sculpting and shaping the quilt. Thus, even though quilts may have a top and a bottom (that is, the sides that go at the top and bottom of the bed), there is no single privileged viewpoint with regard to such an orientation. The top of the quilt does not have to be at the top of one's visual field (as in the viewing of a painting); it can be closer than the bottom if one is in the bed, or farther away if one is at the foot of the bed—and neither is the "right" or best way to view the quilt.

In the course of its life, a quilt may be sculpted in a variety of ways—laid flat on the ground at a picnic, folded away on a shelf, wrapped around a barrel, pinned up over a window—each position having an effect on what can be seen of the quilt at any one time and how the parts are shaped in relation to one another.

Added to this complex three-dimensionality are the many aspects of the play of light. The houses in which quilts reside are also artifacts, and window placement (as well as the location and type of artificial lighting) in relation to beds can play a significant role in viewing quilts thereon. After all, the vertical and horizontal parts of a quilt look different in part because of the changes in location of light and shadow. A vertical edge hanging over a bed away from the light source will be considerably darker than the horizontal surface on the bed having the benefit of brighter lighting. (Perhaps reverse effects will occur at night, with angled bedside lamps lighting the sides more than the top.)

Lighting also affects the way that the juxtaposition of top design and quilting stitch are seen. A strong overhead light shows up the pieced or appliquéd elements on the horizontal surfaces of the top and de-emphasizes the quilting, because the light fills all the crevices and casts few shadows to highlight dimensionality. In contrast, a strong angled light casts many shadows, highlighting the dimensions of the quilting and de-emphasizing the top motifs.

The play of light on a quilt in a naturally lighted room during the daytime, thus, is slowly changing, at one time showing up the quilting, at another the hues and values of the top, and so forth; the whole interplay is complicated by the possibility of light relations being reversed on horizontal and vertical surfaces. Gradual changes also occur as the seasons of the year change, strong summer lights producing more dramatic changes than winter.

Other objects in the room can create additional effects by casting their own shadows over the surface of the quilt, hard edged in bright light, softer in subdued. As the sun moves, so too do the shadows, so that any particular

image is ephemeral, even though it may replicate itself in subtly changed ways from day to day.

Neither should we rule out the fact that quilts interact with other quilts. This interaction may also have a temporal quality. Quilts may be stacked up high in the winter and stripped off in the summer. Parts of the designs of some may show under others, and the weight of those on top compresses those underneath. Quilts on top are exposed to light and to any soil or wear from items, people, or animals which rest on them; they also protect the quilts underneath. Likewise, the quilt at the bottom of the stack receives the wear from bodily contact with the sleeper and protects those quilts which lie on top of it. And the choice of which quilt to use is made in relation to other quilts—the lifetime use of a quilt is affected by the character and significance (which may change over time) of the other quilts in its environment.

4.3. INTERACTION WITH PEOPLE

It is convenient to start with the most basic human interaction with quilts—the use of the five senses—and build outward from there (see Forrest 1991 for an extended discussion). Because we have already focused attention on sight, we shall pass over this sense temporarily, to give the other senses more prominence.

Touch is a complex sense that could be considered under various headings—feelings of warmth, texture, weight, and so forth. Without discussing the neurophysiology of touch, though, we can get an idea of the complexity of this sense by considering the various ways in which people come into physical contact with quilts on a regular basis. They touch the surfaces with their fingers, they lie on and under them, they pick them up and hold them or spread them out.

Regardless of how they are juxtaposed, all fabrics have a characteristic feel, or "hand" as it is generally known in the textile industry. The fibers themselves, the weaves and other construction techniques, and the various finishes and processes all contribute to the hand of a cloth, producing a range of tactile possibilities—silky smooth, coarse, nubbly, hairy, grainy, and so forth. A quilt can be heterogeneous or homogeneous to the touch depending on the fabrics employed and their relationship to each other, and the textures can be simple or complex. A plain pieced cotton top, for example, presents a relatively simple texture to the fingers, but a top of mixed silks, satins, and velvets provides rich contrasts. And the construction differences between

piecing and appliqué can be felt as well as seen, the fingertips easily finding and following the seams on appliqués because of their raised nature.

Some of these tactile qualities are related to vision. The tactile qualities of silk and velvet, for example, can be appreciated visually without touching them, and these materials may be put together as much for the visual effect as for any other reason. But unlike a collage, or montage, quilts in the normal course of things are touched, so it cannot be said that the visual is in any way more important than the tactile. The tactile nature of quilts is well evidenced in the tradition by the fact that many quilters continue to quilt, some even more prolifically as time goes on, after they have lost their sight to old age. The feel of the fabrics and the tactile nature of stitching lead the quilter along without the necessity of acute vision.

The texture of the top may change over time due to constant washing and handling. This is especially true of cotton fabrics where heavy use ultimately blurs tactile distinctions between grades, finishes, and so forth, creating a gently napped softness. Whereas some owners might value a quilt less in visual terms because of such wear (although there are also those who would appreciate the visual softness), others might favor such a quilt as the most comforting of bedcovers because of its lack of stiffness and abrasiveness.

Touch may also be used to indicate relative warmth. Certain fabrics, because of radiating or insulating properties, feel warmer than others to the fingertips. Satin, for example, presents a cool surface to the fingers, whereas worsteds are warm. There is obviously an ambiguity of sensation here, because, of course, quilts are designed to keep bodies warm. Yet a quilt can simultaneously feel cool to the fingertips *on* it, and warm to a body *under* it.

Different fabrics and fibers used in the parts of the quilt create varying degrees of warmth for the body lying beneath it. Clearly the nature of the batting is a significant factor in overall insulating properties, thicker, higher lofts being better than thinner, and wool being warmer than cotton. But these properties can be enhanced by heavier top and backing materials, such as flannel and woollens.

Lying under a quilt also provides the tactile sensation of weight or pressure, coupled with feelings of pliability (or lack of it) related to the drape of the quilt. These sensations of weightiness and pliability extend to the daily general handling of quilts. Shaking out and spreading quilts on a bed transmits feelings of heaviness or lightness to arms and shoulders, and incidentally creates momentary mobile visual effects, as well as the dispersal of the characteristic smell of the quilt.

All quilts have an aroma, partly indicating usage and care. Quilts habitually used for beds may smell of soaps and detergents, of having been aired in the

sun, or of odors carried from the room and the bed. Those kept in storage may carry fragrances of mothballs, camphor, cedar, or must. Although not all of these scents fall within an agreeable category, they are all part of the normal variation for bed quilts. Thus a quilt that is to be used on a bed would not be assigned to a task that would leave it unusually odoriferous, such as retaining the sulfur dioxide in an apple barrel or covering bedding plants in a hot bed dug with horse manure. Only old quilts would be assigned these duties. Thus, under most circumstances, a quilt must *look* a certain way—ragged, torn, stained, or faded—before it can be allowed to smell strongly.

Taste is closely allied to smell, so that the general principles concerning the one apply to the other. It may seem odd to consider taste in connection with quilts, given that in the natural run of events people are not likely to taste them. But quilts are used to collect and carry foods that will be eaten, so the issue is rather a matter of what a quilt does *not* taste of, or will not impart to the taste of edibles. Shelling corn into a quilt, for example, where the quilt acts as a large catchment for several workers, requires using the cleanest of bed quilts to avoid tainting the corn. Reciprocally, the corn will not impart a flavor or smell to the quilt. Foods that have a strong taste are gathered and carried in old quilts. We have seen a woman carrying oysters, for example, in a quilt whose top was threadbare and torn. It is also worth noting in this regard that during the Depression certain foods, particularly flour and sugar, were routinely sold in sacks printed with floral material that women then turned into quilts (and other items). Although this is a historically particular relationship between quilts and food, it is clearly marked. "Flour sack" or "sugar sack" quilts are now being preserved as special artifacts.

There are two different ways to think about quilts and hearing: first, concerning the sounds the quilts make, and, second, concerning the ways they block or transmit sounds from other sources. Fabrics make characteristic sounds, some, like the scroop of silk, sufficiently desirable to be created and enhanced by special finishes. Thus, moving a quilt, by sleeping under it or by arranging it in some way, naturally produces these fabric sounds as the textures rub against each other, and as the multilayered whole rumples and flexes.

Old quilts are frequently used as window and door coverings or temporary room dividers, their thickness and mass playing a part in their ability to screen out or keep in sounds. They are not especially effective acoustic barriers, yet sounds heard through them are muffled and distorted. In addition, a room using quilts as door, window, floor, and bed coverings—as was, and is, usual in country attics and lofts used as bedrooms—has noticeably diminished echo and reverberation.

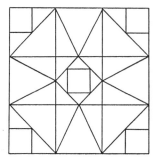

Figure 242a

Figure 242b

These sensual qualities of quilts are an important starting point for considering the interactions between quilts and individuals, because they make it clear that the appreciation of quilts, even on the most basic level, is far from monolithic. The sensual qualities of quilts interact in interesting ways. It is often the *look* of a quilt, for example, that determines what ranges of *smells* it is acceptable for it to emit. Look and touch are also related in complex ways, in that looking at a quilt may tell the observer much as to how the quilt feels, but this interpenetration of the senses relies on the observer having at some point actually touched similar fabrics and textures. Moreover, a quilt may be

made of fabrics which the observer knows to have particular tactile qualities, such as velvet, but which the observer is forbidden to handle because of their delicate qualities.

There is also possibility for ambiguity and paradox. We have already mentioned the fact that a satin quilt can feel simultaneously cool (to the fingers) and warm (to the body). In part, these are questions of *scale* and *time* that have general relevance to the senses. That is, the satin quilt is cool on a small scale, but warm on a large scale, these scales being relative to the size of the human body. This quilt is also cool for short periods, but warmer for longer; the cool feel is of short duration because the insulating properties of the fibers soon warm the area around the fingers.

In Section 4.2, we considered how the passage of time was a critical component in the *look* of a quilt, as, for example, when light from a window traversed its surface. Scale is also an important issue in this regard. Depending on how close one is to the surface of a quilt, it may appear smooth or coarse. At close range different features catch the eye from those at a distance. Close up, for example, all the seams are readily apparent, and even slightly different hues and values are detectable. At a distance, the seams can blur where two fabrics of like value are sewn together displaying larger figures. So overall design is an aspect of distance and individual construction an aspect of close range. This scalar differential lies behind many designs named "So-and-So's Puzzle"—the puzzle being whether the observer can infer the small scale construction from the large scale design (the design in Figure 55 is a classic example sometimes called "Indiana Puzzle"). There are also rectilinear cell designs that give a curvilinear effect on a large enough scale (Figure 242).

Paradox and ambiguity are not confined to single senses but may cross two or more. Take, for example, a quilt that *feels* warm but is executed in colors that *look* cool. Or a cell may be built out of values that give a sense of depth where none exists to the touch. Such possibilities open us out into the broad field of sense and symbolic meaning, because such ambiguities do not reside strictly within the physiological facts of optical or tactile neuroanatomy. Looking cool or dimensional are qualities of vision as interpreted from a particular cultural perspective, as it were. Cool colors do not look cool because they are inherently so, but because of long-standing cultural associations—even though those associations may have some basis in physical reality. The ambiguity of a warm quilt in cool colors is, therefore, as much a crossing of sensual and symbolic values as of two different types of sense data.

Once we include the symbolic in the analysis of human interaction with quilts, the vistas open up endlessly before us. But in the process of exploring

these many avenues, we must not lose track of the sensual, because the symbolic arises from sensual experience, and the conscious manipulation of sensory values is a key aspect of the symbolism in quilts.

One general question, of major import to the study of the symbolic world and material culture, is the degree to which *language* specific to a particular process influences technical and aesthetic decisions. The old-fashioned view of folklore, largely superseded, was that folk culture was oral culture, by which was understood "nonliterate," that is, not relying on *written* sources. By this definition, therefore, a folksinger learned songs from other singers, not from texts, and a folk quilter learned quilting techniques from other quilters. What is not really taken into account in the debate of the oral versus the literate is the degree to which, for certain skills, language is an issue in the first place. Singing, after all, is intrinsically *linguistic,* but quilting is not. It is quite proper to expect language to create and change song texts, and for written texts to be more rigid than oral ones, because songs are built out of linguistic entities. But it is not obvious if or how language influences the construction of a quilt, because a quilt is not a linguistic object.

Nonetheless, we know empirically that language is one of the principal ways in which people interact with quilts—they name them, tell stories about them, discuss their aesthetic merits, and so on. Often the relationship between language and quilting is subtle, and it is still poorly understood. One obvious place to start the investigation of the linguistic in quilts is to examine the practice of naming designs: Until this point in our analysis, we have avoided using names for designs as much as possible because we have been concerned primarily with the physical mechanics of construction and not with the symbolic and social meanings that the names add (as well as wishing to avoid the confusion involved in using a naming system that is not precise or universally agreed upon).

We may begin by considering the fact that quilt designs have names at all. From the point of view of curators of exhibits, writers, and other people interested in conveying information to the public at large, the practice has its benefits, allowing as it does a straightforward, although hardly rigorous, cataloging system, as discussed in earlier sections. It is an easy, but false, leap of logic, therefore, to imagine that naming patterns is a universal practice, simply because it is impossible to open a quilt book without seeing every design neatly labeled (or in extremes labeled "name unknown"). Lost in the analyst's chronic desire to label things is the fact that some people do not use names for their patterns (see Forrest 1988:78). The idea that all individuals give their quilt patterns names may prove to be as romantically misguided as

the now discredited notion that most quilts were traditionally quilted at quilting bees.

So the first question to ask is not, what do quilt names signify, but, why do some women use names and others not. No definitive answers can be given at present because the question is a new one, and the field data do not exist. But some suggestions based on what is known can guide future investigations. A name is many things, and just as it can serve as a label to a curator, so can it to a quilter. But a quilter must have a reason to need to label designs. There is no obvious reason why a *visual* object should have a *linguistic* tag to identify it. Quite the contrary, it is almost certain that practiced needleworkers think of designs primarily in terms of the spatial arrangement of shape and color, rather than via linguistic descriptions. But if quilters need to communicate with one another about a pattern, then a label is useful.

If names are solely what we might call "transactional," that is, if they serve the purpose of transacting business between individuals rather than having a function for individuals alone (they are a kind of medium of exchange), then we would expect two things to follow. First, names would tend to have at least local currency. That is, the welter of names that proliferate around certain designs (the cell illustrated in Figure 148, for example, is variously labeled as "Mosaic Patchwork," "Eight Point," "Flying Crows," "Ohio Star," "Happy Home," "Lone Star," "Texas Star," and "Variable Star") might be unlikely to exist on the local level, since the communicative function of the names would be complicated through use of multiple names. Similarly, the same name would be unlikely to be used within a specific region for two different designs. Two quilters must have the same pattern in mind when talking about "Lone Star" for their conversation to make sense. Second, where quilters are working in isolation from one another, names should tend to be of little importance and be easily dropped if once known or used at all. Instances of quilt names persisting in isolation, or existing in multiplicity within a tradition, might be taken as evidence that at least in those sectors of the tradition, quilt names serve additional purposes beyond the transactional.

In considering quilt names as transactional, there is also the implication that having names means that *talking* about patterns (as opposed to, say, explaining by showing) is important to the people who use the names. How common this is traditionally is unclear. Certainly women do not say, for example, "My mother *told* me how to quilt," but instead, "My mother *showed* me how to quilt." Names might not be necessary in such a manner of teaching, although their use would not be precluded. A quilter who does not *talk* about her quilts may nonetheless have occasion to *refer* to them, in which

case the use of a name may be helpful. On the other hand, of course, she could simply refer to a quilt in terms of its colors, the place in which it is normally used, the person it was made for, or some other attribute.

When exploring the transactional nature of names, it is informative to consider what it is that is actually being named. In some cases, or according to usage by some quilters, a pattern name refers to the uncolored cell; it represents the abstract design, not any particular realization of it. In other cases, the name refers to a specific use of values to highlight forms within the cell. These two kinds of naming may be used by the same community of quilters, but the kind of name attached to a particular design may vary from community to community or from individual to individual. Here is one source of the confusion of names. One quilter labels a set of designs "Jacob's Ladder" (Figure 13), "Underground Railroad," "Stepping Stones," and "Tail of Benjamin Franklin's Kite," because she is focusing on the value relations within the cell, whereas another calls them all "Jacob's Ladder," because she sees they are all constructed in the same geometric manner regardless of values. (For a full discussion, with illustrations, of this group of designs and associated names, see Forrest 1988:85–86.) If kinds of naming do not have general local currency which is universally understood, confusion may be the result, and possibly even innovation arising from that confusion. Because the practice of naming has been so taken for granted, and therefore understudied, it is not known to what degree confusion or clarity prevails in particular communities in regard to the relationship of name to pattern.

Another issue is at stake here besides that of clarity of communication. The quilter who names value relations, rather than underlying geometric relations, may consciously or unconsciously limit her creative manipulation of values in a scrap quilt by the thought that she is making "Underground Railroad" and not "Stepping Stones." That is, she may tend to preserve the value relations summed up in the name that names values. The quilter who uses names to name underlying geometry is not constrained in the same way. Thus a name whose purpose was communicative can develop into a controlling factor in the construction process. Yet there are ways for names to limit or guide creativity whether names name geometric patterns or value relations.

Some names can be said to be "graphic" and others "arbitrary." That is, some names refer to what the cell represents visually, while others have no direct relationship to the visual nature of the cell. Within the graphic category there is some variation, and the two broad classes are not entirely discrete from one another, as discussed in Section 1.1. But it is the general distinction that matters here.

The cell used in Section 3.3 in the examination of permutations of coloration is often traditionally called "Ohio Star." As we have seen, the cell can be made to represent a stylized star design using appropriate values, or the star element can be obscured. If the quilter uses the name "Ohio Star," she must decide at some point whether a particular realization of the cell is going to have "starry" elements or not. The name acts as a guide concerning expectations for the fabrication of the cell. This does not mean that the name forces her to make her designs star-like, but the name is an element in the conception and execution of the pattern. However, if she calls the design "Mosaic Patchwork," she has no such graphic guide (and this is true whether she uses the name to name geometric configurations or value relations). The same argument applies to the case of a woman who names all her designs versus a woman who has no names. Not having any names for designs means not having to consider the semantic import of the names *at all* when choosing values to fabricate cells.

The semantic import of a pattern name may influence the quilter in more general ways. The very name itself might be sufficient stimulus to make (or avoid making) a pattern whatever the design itself looked like. It is asserted that the pattern often called "Rose of Sharon" is traditionally a common bridal quilt design because of the biblical reference "O that you would kiss me with the kisses of your mouth! For your love is better than wine . . . I am a rose of Sharon . . ." (Song of Sol. 1:2, 2:1). And Carrie Hall records:

As the 'Wandering Foot' was supposed to have a malign influence,
no child was allowed to sleep under one, else he would grow up
discontented, unstable, and of a roving disposition. No bride would
have one in her dower chest. Later the name was changed to 'Turkey
Tracks' to break the curse.
(HALL AND KRETSINGER 1935:75)

That is, the cause of all the trouble was the *name* and not the design. By changing the name, the problem was resolved; brides and mothers could then use the design without scruples.

Even though there may be little or no direct relationship between a pattern name and its graphic design, the name can still exert an influence on the construction of cells. A quilter familiar with British history might, for example, choose to execute a design called "Nelson's Victory" featuring navy blue, or, more generally, she might have in her mind a color symbolism to match the symbolic content of the pattern name. However, even given all of these possible relationships between quilt names and decisions concerning

the execution of patterns, we must emphasize that these represent influences, not necessities.

Regardless of the effects of naming on construction, there are a number of social and symbolic factors to explore concerning the names themselves, although many of the important issues have been adequately documented elsewhere and need not be repeated at length (see Hall and Kretsinger 1935:18–20 and 49–127, and Clarke 1976:101–111). The poetic value of names to traditional quilters is a matter which has not been sufficiently explored, although there is evidence that some quilters cherish pattern names as an aesthetic component of quilts. The poetic and symbolic attributes of quilt names as interpreted by collectors, curators, and other writers cannot be assumed to be those traditionally recognized as significant. Whereas the linkage of a visual object with a linguistic form is not a necessary connection in terms of identification, it may be the case that the aesthetic whole comprises both visual and linguistic aspects; a full study of the interrelation of linguistic and material forms is lacking.

It is commonly noted that quilt names are not immutable within the world of traditional quilting, suggesting that where names are used at all they are used consciously (by some women at least), and not as a slavish labeling system. In other words, the semantic import of the names carries at least some weight of its own, otherwise it would scarcely be worth changing them. In the case of the pattern called "Wandering Foot," the implications are straightforward, but many other factors are at work besides superstition. Take, for example, the names associated with the cell in Figure 243: "Broken Plate," "Churn Dash," "Double Monkey Wrench," "Greek Cross," "Greek Square," "Hole in the Barn Door," "Lincoln's Platform," "Love Knot," "Puss in the Corner," "Sherman's March," and "Shoo Fly." The associations represented here are numerous—manual work (men's and women's), farming, religious affiliations, national heritage, political activities, historical events, personal relationships, children's games, and so on. Each designation is likely to have a vogue based on such associations, which would change with time and location. The name "Churn Dash" would mean one thing to a nineteenth century farm woman and another to a twentieth century townswoman; the name "Lincoln's Platform" would have different implications for Northerners and Southerners.

But we must bear in mind that this example is a design with a multiplicity of traditional names, and it is not the case that all designs have anywhere near as many names. In fact, the existence of multiple names can be considered a fact of interest by itself. Those designs with numerous names appear to be those that are most widespread historically and geographically. Many less

Figure 243 Figure 244 Figure 245

common designs have only one name. And some designs have several names, but one is almost universal, while the others have a restricted historical or regional usage.

Multiple names for a cell can also indicate that different traditional color or value interpretations exist with stable and definable form. As mentioned above, the cell underlying the design often called "Jacob's Ladder" (Figure 13) can be used to create designs called "Underground Railroad," "Stepping Stones," "Tail of Benjamin Franklin's Kite," and others. Generally these names refer to specific value orientations that are sufficiently stable, identifiable, and distinct from one another to allow the existence of separate names. However, this kind of naming is not consistent, because only some quilters use names to name value interpretations.

Also of interest, in this regard, are names that have been attached to several different designs. Sometimes this is merely a matter of graphic reference, as in the case of the two so-called "Snowball" designs in Figures 2 to 4, each producing an overall pattern vaguely resembling a snowball. But using the same name for different designs can also indicate the kinds of structural relationships that quilters perceive between designs. The name "Churn Dash," for example, is traditionally used for the design in Figure 244 as well as that in Figure 243. The basic structural relationships are clear. In other cases, such as the two designs known as "Lincoln's Platform" (Figures 243 and 245), the relationship is apparent but more distant. Kinds of likeness, as perceived by quilters, can therefore be indicated through naming. In some cases the likeness is iconic, in others structural (or a combination of the two), and there is no particular rigor in the process.

Carrie Hall's somewhat haphazard breakdown of quilt names into categories is revealing in terms of the kinds of semantic (as well as graphic) associations that exist between quilting and the world at large. A substantial number of quilt names, more than half of Hall's total collection, refer either

to stars or flowers, simply because a majority of quilt patterns are graphic abstractions or representations of those forms. In general this is noteworthy because it points up a strong association between quilts and the natural world (if stylized stars can be considered "natural").

Investigation of the star names themselves, which Hall does not undertake, proves instructive regarding the general semantics of names. They can be divided into two major groups and several minor ones. Many of the names continue to be graphic at the specific level ("Geometric Star," "Pieced Star," "Hexagonal Star"), forming a large category. The bulk of the remainder refer to regions of the United States ("Texas Star," "Missouri Star," "Ohio Star"), or, to a lesser extent, other parts of the world ("Mexican Star," "Arabian Star"). Lesser themes such as biblical subjects ("Star of Bethlehem") and the political world ("Dolly Madison's Star") make a showing, but not to a great extent.

In some ways this classification from the star names is indicative of naming as a whole. The graphic, or descriptive, is very prominent, but underlying it are regional or local associations primarily; other interests, such as the political, biblical, or historical, being of rather less importance. As a whole, quilt names show a marked agrarian or rural character. Certainly the regional affiliations are primarily to agrarian states, but even in their specific associations the references are overwhelmingly to the farmyard ("Hens and Chickens," "Ducks and Ducklings," "Hole in the Barn Door"), the garden ("Peony Patch," "Wind Blown Tulips," "Grandmother's Flower Garden"), or to the natural world of the country in general ("Bear's Paw," "Wild Rose," "Autumn Leaf"). And the emphasis is on the living world beyond the house, not on the artifactual or the domestic (though references to these are not unheard of).

Naming quilts is merely the tip of the iceberg, however, when it comes to considering quilts in their linguistic context. As indicated in earlier sections, a small but important technical vocabulary is connected with quilting that defines and classifies construction and usage and that varies somewhat regionally. The use of language specific to quilting is one of the many aspects of quilting that has so far been only sketchily investigated yet could yield significant results in the study of material culture as it is understood by its practitioners. For example, we have distinguished between what we call prototypic scrap and best quilts, and there is no doubt that this is an empirically valid distinction. Nor is there any doubt that the distinction is demarcated by some quilters through linguistic tags such as "scrap" and "best." But the terms themselves are not universal, and the semantic connotations of the different labels used suggest subtle variations in the classification itself.

In many parts of the country scrap quilts are called "everyday" quilts, implying a temporal dimension and an ordinariness to their use. Sometimes the term "everyday" is contrasted with "pretty" instead of "best," but by "pretty" quilt a woman can also mean any quilt made from a formal pattern (whether using scraps or store-bought materials) as opposed to crazy or rudimentary pieced designs, such as pieced squares. Using the terms "everyday" and "pretty" as contrastive labels connotes a temporal alternation between the ordinary and the aesthetic, mirrored, perhaps, in the actual practice of using "pretty" quilts for a special day, such as Sunday, and using "everyday" quilts the rest of the time. But it is important to note that the contrast is not "everyday" versus "Sunday" or "pretty" versus "plain." The implicit meaning of the "pretty"/"everyday" dichotomy is that these terms are cognitive opposites for the people that use them.

The term "old" quilt, a quilt that is no longer used on beds because it is worn or stained, is not, like "pretty" or "scrap," a term of binary contrast, but a simple demarcation of a subset. That is, "old" quilt is not contrasted with "new" quilt or "clean" quilt or any other well defined group label. There are quilts as a whole, and then within that whole there are "old" quilts. Certain functional contrasts are inherent in such labeling, it is true; "old" quilts are used for dirty jobs while others are not. But the fact that there is no term for the "others"—the ones that are not "old" quilts—shows that "old" quilts are a special category that performs functions out of the ordinary. They are a marked case.

Before continuing with other issues concerned with language and narrative, the existence of the "pretty"/"everyday" dichotomy in at least one quilting region prompts a brief digression into the theory of aesthetics (see Forrest 1988: 19–33 for a more extended analysis). To put it rather simplistically, one could try to separate the objects in a culture into two groups: those that are purely aesthetic, that is, those that are appreciated for their formal, sensory, and affecting qualities without regard for any other functions; and those that are purely utilitarian, that is, those that have a job to perform and are never viewed dispassionately or independently from this function. Unfortunately, these two categories would be rather small. The former would contain what is often designated "art for art's sake"; the latter, a medley of everyday objects. The great bulk of objects in every culture would belong in a middle category, sometimes viewed in a utilitarian manner, sometimes aesthetically.

What applies to objects in general applies to quilts in particular. Rarely is a quilt made, traditionally, for the sole purpose of being looked at. One may *acquire* such status over time, as in the case of aged heirlooms that are too

precious to be used on beds and so are retired from functionality to be brought out intermittently for admiration. In André Malraux's terms, these can be called "art by metamorphosis" rather than "art by designation" (1967).

It may be rather more common for some quilts to be made as purely utilitarian objects, but this idea is hardly ever taken up in the quilt literature because one of the prime motives for studying quilts in the past has been aesthetic (as has been the motive for collecting and displaying in museums and catalogues). Thus, one whole aspect of the ecology of quilts has been slighted because of the premises of intellectual inquiry. If scholars treat quilts a priori as aesthetic objects, then when surveying the quilts of a particular area they will pay little or no attention to those that appear to them, or to their owners, as having little aesthetic value. They may, in turn, come to believe that all quilts by definition have aesthetic value even though it is the process of documentation itself and not the quilts that has created this opinion.

The survey technique of fieldwork of the kind common in quilt scholarship may be the single biggest reason why utilitarian quilts have been largely ignored in the past. When an investigator pops into an area for a day or two asking to see and possibly photograph quilts, it is unlikely that their owners are going to bring forward purely utilitarian ones: because they are purely utilitarian they are not for show. To discover such quilts it is usually necessary to live with a group of people long enough that the fieldworker can see everyday objects in use, that is, to engage in extended participant observation. At the very least it is essential to ask the right kind of questions to ensure that informants realize that the fieldworker is interested in *all* types of quilts, and not just those that display obvious aesthetic values to their owners' eyes.

Certainly narratives from quilters give every indication that some quilts may be made without emphasis on aesthetic values:

We only had time to quilt for cover in those days settlin' in. They weren't pretty.
(COOPER AND BUFERD 1978:90)

We just made [quilts for ourselves] out of old heavy clothing. . . . They didn't have no pattern, ner no quilting. They was just made out of big pieces of old wore-out coats, pants and so forth. And we'd use feed sacks and flour sacks. . . . We just stuffed them with any old rags that couldn't be used for anything else.
(IRWIN 1984:121)

The Natural History of the Traditional Quilt

Another problem is that people are unlikely to save such quilts when they have ceased to serve their function because they do not have aesthetic qualities to plead for their survival. Thus they are commonly disposed of at the end of their lives, leaving no trace for the fieldworker.

Within the middle category of those objects that are *both* aesthetic and utilitarian, some quilts have more aesthetic values, and some, more utilitarian. Rather than classifying quilts into one of three groups—aesthetic, utilitarian, or both—it is perhaps more legitimate to think of all quilts as existing on a continuum from the two absolute poles of purely aesthetic and purely utilitarian. And, as already suggested, a quilt may move further toward one pole or the other as part of its life cycle. One might also think of these poles as centers of gravity pulling unevenly on quilts over their life span. Those that begin life more toward the aesthetic pole may be pulled more in that direction over time, and the utilitarian pole may have a similar effect on those that start their life courses more in that direction.

A slightly more subtle problem that complicates this simple spectrum concerns the possibility that different, although occasionally overlapping, domains of the aesthetic exist. In our own fieldwork, for example, we have discovered that the distinction between best and scrap quilts, although overtly a difference based on the provenance of the constituent materials—the former store-bought, the latter from the scrap bag—is just as much a difference in the kinds of aesthetic that are at work (see Forrest 1988).

In one community the best/scrap distinction was in part a matter of public versus private aesthetic values (Forrest 1988:96). Both kinds of quilts had easily identifiable aesthetic properties, but these were quite disparate for those quilts that were destined to be seen by people who lived outside the household and those that were strictly for use by the people within it. The quilts that outsiders saw were generally regular and symmetrical in their geometric and color arrangement, with quite limited ranges of colors and fabrics, whereas those for insiders tended to be irregular and asymmetric, based on a kaleidoscopic variety of hues and materials. Their makers found both aesthetically pleasing, but for different reasons. The aesthetic of the best quilts had a kind of devotional quality to it; they were often admired for the painstaking, puritanical effort involved in their construction. The scrap quilts, by contrast, were enjoyed for their freedom and exotic gaiety—better kept for private consumption in a Protestant community.

It would not be correct to say that the best quilts in this community were "prettier" than the scrap quilts or vice versa. Both kinds existed in their own noncomparable, aesthetic domains. Nonetheless, the life cycles of the two

were different, the best quilts frequently ending up as purely aesthetic and the scrap quilts as purely functional. The private aesthetic was disposable. This analysis, in turn, suggests the existence of a myriad of social, religious, and ethnic values embodied in quilt aesthetics, which is discussed later in this section, and demonstrates the magnitude of the ethnographic and theoretical discoveries which follow from serious attention to the linguistic component of the traditional material culture of the aesthetics of different communities.

To return to the linguistic aspects of quilts, Mary Washington Clarke (1976: 109–110) notes that there are phrases peculiar to the activities involved in designing and making a quilt, but a complete lexicon and regional variations in the technical vocabulary of quilting have yet to be documented. She notes that, in Kentucky, "taking off" means copying a design, "stripping" means using sashing between the "blocks," "laying out" the quilt is marking it for quilting, and quilting "by the piece" involves following the seams on every patch. The fact that these processes have special terms indicates both their importance in the overall construction of a quilt and the need for a degree of verbal precision in discussing them so as to avoid ambiguity or misunderstanding.

It should also be noted in passing that the act of quilting in groups is itself legendary as a *linguistic* activity. Quilting and talking are co-partners:

> We used to quilt up there at the Methodist church. You know, making quilts to sell to get money for the church. I just went up there and helped them some. Everybody would take a dish and I really enjoyed it. Lots of talkin' goin' on. We just talked about everything.
> (COOPER AND BUFERD 1978: 105)

> In the summers we'd put up the frame on the screened porch, and when the work was done, Mama would say, 'O.K., girls let's go to it.' That was the signal for good times and laughin'. We'd pull up our chairs around the frame and anyone that dropped in would do the same, even if they couldn't stitch straight. Course we'd take out their stitches later if they was really bad. But it was for talking and visiting that we put in quilts in the summer.
> (COOPER AND BUFERD 1978: 76)

The historical origin of this association probably has its roots in well known cultural proclivities—certainly well known in the South—notably, the social force of the Protestant work ethic. "Talking and visiting" by themselves are

forms of idle pleasure, and, hence, sinful. But talking while gainfully occupied is generally considered acceptable practice. The work at the quilting frame justifies the leisure of talking. Other religious and ethical considerations traditionally associated with quiltmaking will be discussed later in this section.

Some documentation of the structure of the talking around a quilting frame exists (Cooper and Buferd 1978:110–117, 137), but there is scope for development of ideas. Obviously the structure of discourse is likely to be punctuated periodically with technical discussions of the quilt at hand because people working at close quarters on the same object have to communicate as sections they are working on overlap. Beyond such practical necessities, probably little of general consequence can be said without more data. It is of interest to consider, though, to what degree the process of quilting defines the mode and structure of discussion.

Sitting at the quilting frame easily provokes discussion of other quilts, but it has been our almost unfailing experience that the showing of a quilt evokes a story about it. These narratives vary greatly in complexity, length, and subject matter, but, whatever their form, they are readily elicited at even the slightest provocation. These narratives may be quite short—no more than a sentence or two—or considerably longer. The main thrust of such narratives is almost always an explanation of why the quilt is special, memorable, or otherwise unique, as the following examples indicate:

My mother had a table cloth with a pretty rose on it, and she got the idea of making a quilt using that pattern. She just drew this pattern, the Satin Stitch Rose, she called it. Then she embroidered it, and then quilted it.
(IRWIN 1984:155)

Now this one was made by Daddy's Aunt Lareu Lawson. She made it out of salt bags. Back then they sold salt in cloth bags and she saved them up and finally got enough to make herself a quilt. She called this the "Quiled Rattlesnake" quilt.
(IRWIN 1984:157)

Mother had a sister named Martha who died at the age of 19 of typhoid fever, about 1885. Well she had a nice dress made out of what they called madris cotton, but it was customary to bury people in new clothing; so they made, or had made, a new dress to bury her in. But

her mother, that was my grandmother, took that cotton dress, and made it into this quilt.

My grandmother, Sarah Oaks Stooksbury made the quilt from her daughter Martha's dress after she died. She had eight children, and Martha was one of the eight. When my grandmother died in 1914, she gave the quilt to my mother, who kept it all these years, and then she left it for me. You can see that it's been used a lot somewhere along the line, but I don't think mother ever used it after she got it.
(IRWIN 1984 : 158)

From this sampling it is evident that quilts often have personal or family memories attached to them, oftentimes in the form of their constituent materials:

This is one also my grandmother made. This is a "Single Wedding Ring." . . . It was made with old scraps. A lot of these pieces were my grandfather's pajamas, you know, and aprons and old dresses that my grandmother wore. In that sense it's kinda dear to have a quilt made of those things because you see those materials and you recognize them and say, "That was Gramm's dress," you know, or "That was my hat."
(AUTHORS' FIELD TAPE: BONNIE SHEARD, CALKINS, PA.)

Or their value may stem from their being made for special occasions, by special people:

It's tradition in our family for the grandmother to make a quilt for a wedding present for each grandchild. And before any of us were married she had every quilt made for every grandchild. And, of course, as the new grandchildren arrived she made quilts right away as soon as they were born. That way she had it made, and if she wasn't around when they got married, they had it.
(AUTHORS' FIELD TAPE: BONNIE SHEARD, CALKINS, PA.)

Then there are quilts that seem to inspire or embody a more lengthy story. The following is a long excerpt from an even longer narrative concerning a quilt in the form of many red crosses on a white background, each cross signed in ink, that is now used for display at the Red Cross bloodmobile during blood drives in Port Jervis, New York:

The Natural History of the Traditional Quilt

Aunt Catherine had this quilt in 1917. The ladies of Port Jervis wanted to establish a Red Cross, they thought it was time that this town had a chapter. They devised this quilting bee, and they made the quilt, and in order to raise money to establish the chapter they asked people to sign their names and donate money. I guess, because all the squares are filled, they got a very good response on it. I don't know why Aunt Catherine took it home, but she did. To the best of everyone in the family's knowledge, the Red Cross didn't do anything with the quilt after that. Aunt Catherine took it home, kept it for safe keeping at her house. And then she died, and her daughter took it, Aunt Betty took it; and Uncle Bob, who was married to Aunt Betty, was Elsie's [brother]. . . . They moved to Reading, Massachusetts—Aunt Betty and Uncle Bob, that is. And then Aunt Betty died. And when she died, Uncle Bob sold the house, found the quilt, that had been stored in the basement (not the attic), and gave it to Elsie. And said, "Do what you want with it." He said, "I think it belongs to the Red Cross, will you take care of it." And she did. She gave it to a board member, who donated it to the Red Cross. But then the town historian got hold of it. I would guess it was ten years ago when all this took place. Then this historian took a course on the preservation—not the restoration, but preservation—of quilts, in which he got the idea of storing it in an acid free container, and subsequently held it for the Red Cross. And that's when I decided it was dumb to keep it in a container when it could be used. It's a symbol of giving, that's what it was made for. So I decided to use it at bloodmobiles as a logo—a symbol of donating. When it was first made, the people of the area gave to the committee in order that the Red Cross be established, and I feel that symbol ought to be re-enacted, instead of just sitting in limbo. It's terrific, because they come up and say "Oh, I know that person" or "that's a relative of mine." They do, they really do, because they're all people of the area.

(AUTHORS' FIELD TAPE: SUE PANTLEY, PORT JERVIS, N.Y.)

Such narratives also indicate the wealth of social relations that are, in part, symbolized by or given form through quilts. At the heart of these social relations is the fact that quilts are intimate household objects, whose principal, although not exclusive, domain is the bedroom. So, to say that quilts are commonly given as wedding presents, for example, is really telling only part of the story. It is important to discuss who gives quilts to whom, what social

relations are being manifested through the gift, and what else is being symbolized. In the example cited above, the grandmother gave quilts to all the grandchildren. Traditionally it is also quite common for *mothers* to make quilts for *daughters*. But these are quite different gifts in the sense that mother/daughter relationships are of different social consequence from grandmother/grandchild relationships.

When looking at quilts as gifts, therefore, one immediate question concerns the kinship or other relations between giver and receiver. What follows is a series of suggestions as to some of the more obvious possibilities for the symbolic significance, in terms of social relations, of quilt bestowal. Particular communities should be investigated for confirmation (and elaboration) or disconfirmation of these hypothetical ideas.

The gift of a quilt from mother to daughter can be seen as a confirmation of bonds along the female line. Because quilts are almost exclusively made by women and the skill is often passed on from mother to daughter, such a gift's symbolic and social value is reasonably straightforward in this regard. But knowing that quilts are for beds adds meaning to the gift at wedding time. In this case, the mother is bestowing her labor on the wedding bed of her daughter, signaling not only the moving on of fecundity in a biological sense, but also in the sense of general creativity. The new household is expected to bring forth babies *and* quilts to cover them. The gift of a quilt is a starting point from which the new bride can expand. In addition, the presence of her mother's quilt on her bed is a constant reminder of her connection with and debt to her mother. The wedding quilt makes the mother a participant in and influence on her daughter's life, even in the bridal chamber.

A rather different, although related, symbolism is concerned when young women make quilts for bachelors, not an uncommon practice traditionally. Perhaps all of the eligible women in a community will get together and jointly make a quilt for all of the eligible young men. The symbolism here is still connected with the bridal bed, but it is more flirtatious, because it crosses gender boundaries and because the gift is from young women.

It is also of importance that these gifts are *new* quilts made expressly for the purpose. Weddings, engagements, and births require new quilts as symbols of the beginning of a new enterprise. Old quilts are gifts on other occasions. In fact, the gift of an old quilt at a wedding could be judged a deliberate insult, meaning that the couple have already slept together (symbolically long enough to wear out quilts). The circumstance under which old quilts are most often given away is at the death of their owner. This act confers heirloom status on a quilt, perhaps removing it from general use, at least adding symbolic value to its existence.

The Natural History of the Traditional Quilt

Quilts are also given as gifts in times of adversity, indicating their status as household necessity. Incidentally, in the example below, the quilts are also the indirect bearers of a missionary message that Baptists are industrious and charitable:

They took all the pretty quilts to the Baptist Church. They was for the poor people and the foreign missions. And sometimes if somebody lost their house to a fire or a twister, the women would all go with a stack of quilts and say, 'These is a gift from the ladies of the First Baptist Church.'
(COOPER AND BUFERD 1978:29)

All of the above discussion indicates that quilts and quilting embody and symbolize the values of communities of people, not simply individual tastes and needs. This is the implicit justification for the wealth of books written on the quilts of particular social groups—ethnic, religious, and regional. There is no need to dwell on this topic given the abundance of published materials, but it is legitimate to raise a few theoretical questions springing from the foundational principles we have elucidated, and to point out critical lacunae.

Good anecdotal and heuristic evidence points to the existence of regional and ethnic quilting styles in America. For example, Jeanette Lasansky describes the quilts of the nineteenth century from central Pennsylvania:

It was the appliqué patterns, many of them distinctly individual in concept, that flourished in the mid-nineteenth century, and they continued to be made until near its close. Red and green calicos placed on a field of white, occasionally accented by touches of yellow, orange, or pink, made up the dominant palette. Those few worked on a solid color field seem to be out of place and are felt to be examples of isolated occurrence or of a maker recently arrived in the area from the more solidly "Dutch" counties, Dauphin, Berks, or Lancaster. . . .

Flower motifs such as the *Whig Rose*, the *Tulip* or *Rose Wreath*, the *Peony* or *Pomegranate*, the *North Carolina Lily*, and the *Cockscomb* were the most popular but they are repeated only as general types, rarely as identical patterns. Most often they were laid out in quadrants but they were also arranged in blocks, sometimes within a rake, and usually with an elaborate border or borders to frame the *tour de force*.
(LASANSKY 1985:10)

On a similarly local level, Joyce Joines Newman has compared the piecing traditions of three regions of North Carolina. She describes the style in the northern Tidewater:

> The quilts of the Perquimans-Chowan area might be characterized by the word *elaboration*. We found many quilts there with complex geometric block patterns, small units of construction, and highly patterned strips and borders. The block patterns are strongly geometric; in fact, we found only a few appliqué quilts, mostly twentieth-century interpretations of simple patterns such as "Dutch Doll."
> (NEWMAN 1978:9–10)

Although a decent smattering of works gives some space to the vagaries of local style, virtually no theoretical discussion appears anywhere of *why* these styles exist or what, if anything, they signify. Why should central Pennsylvania be dominated by appliqué quilts, whereas coastal North Carolina is practically devoid of them? In part, the lack of theoretical depth and rigor results from a lack of comprehensive data. Without a serious historic/geographic survey of traditional quilting styles in the United States, it is impossible to say anything about how style may correlate with other social and material variables.

There is also the perennial question of what constitutes a "style." No one has trouble recognizing a central diamond quilt executed in black and solid brights as Amish, but what general features combine to make up the Amish style? Style, it must be conceded, does not reside in one or two morphological variables, but arises out of the intersection of a number of construction processes (see the discussion in Section 1.1). For the Amish, for example, the style is the result of the intersection of a limited subset of cells from our general taxonomy, a special group of construction principles for turning these cells into tops, and a recognizable palette of fabrics and colors. But these three processes do not carry equal weight. The palette is a major ingredient and the other two are secondary to it. The style of Tidewater North Carolina, however, is less determined by palette than by construction principles, and that of central Pennsylvania is a balance of palette and construction.

To alleviate this problem, and to engender more rigor, it would be profitable to break style into the component parts described in this work and to document them separately over the United States, creating a descriptive atlas of quilt features. Then these individual features could be correlated with one another to indicate the intersections that create recognizable styles (as well as

The Natural History of the Traditional Quilt

intermediate forms), and correlated with other factors to indicate possible causal relationships.

In this enterprise it is vital to consider what the actual choices of the quilters in different historical periods were, and not to just document the variation in absolute terms. It would not be strictly true, for example, to say that eighteenth century quilters *chose* muted colors for their palettes when modern dyes with their vibrant hues were not available to them. Only when the range of choices is fully understood can a set of aesthetic values be imputed to a community. But in the absence of a comprehensive descriptive study, all that we can do at present is point out some of the social issues suggested by existing data.

One of the factors frequently mentioned in connection with choice and aesthetics is the economic, but the literature in the field less often explores the extent to which quilts are economic objects. One well known economic stereotype should at the outset be examined and brought into question. Quilts are frequently represented as the offspring of necessity or poverty. They are touted as symbols of the pioneer spirit that led women to use and reuse precious materials thriftily, giving worn-out garments, for example, a new lease on life in a different guise. No doubt this stereotype contains some truth, as our sections on morphology and life cycle indicate, but it is not the whole truth. Quilts have always been made by all economic classes in America, with economic necessity a prime but not exclusive motivation.

The majority of prototypic best and appliqué quilts are products of neither necessity nor poverty. They are made out of store-bought materials and constructed in ways that could be considered wasteful. For example, because of seam allowances, a pieced pattern reduces the overall surface area of a new piece of cloth. The idea of patchwork from new cloth being wasteful (while patchwork from old cloth is good economic sense) is frequently commented on by ladies' journals in the nineteenth century:

> In an economical point of view there is great saving in patchwork
> quilts, if they are made from pieces of cloth already in the house which
> are useless for anything else; but if as I once knew a lady to do, you
> buy the finest, highest priced French chintz to cut up into inch pieces,
> it is not perhaps so great a saving as it would be to buy the quilt
> outright.
> (LINDSAY 1857:166)

> I must allow it is very silly to tear up large pieces of cloth, for the sake
> of sewing them together again.
> (ELIZA LESLIE, *THE GIRL'S OWN BOOK*, CITED IN LASANSKY 1985:50)

How many a callous 'lord of creation' has scoffed and laughed at his toiling wife, sister, or daughter, for 'cutting cloth up into little bits of pieces for the sake of sewing them together again!' (*GOOD HOUSEKEEPING* JUNE 1894:263, CITED IN LASANSKY 1985:58)

The frequency of such comments, making them almost proverbial, is instructive. As well as the obvious puritanical call for avoiding waste of cloth and time explicit in these statements, there is also the strong implication (validated empirically through quilts that survive) that many women did indeed buy yards of expensive cloth expressly to turn it into fine patchwork.

Following this line, we can isolate certain quilt types whose construction entails the diametric opposites of both necessity and poverty. Chief among these is the silk crazy quilt, a popular item with young women of leisure of the Victorian era. These are not only made from expensive fabrics but also are typically covered in complex embroidery work. In a number of ways these quilts are impractical as everyday functional objects and contain the hallmarks of a moneyed pastime. The fabrics by themselves, being delicate and difficult to clean, set such quilts apart from mundane usage. In addition, the embroidered elements not only increase their delicacy, but are in their own right a luxury, because unlike quilting stitches they perform no functional duties for the artifact as a whole. Oftentimes the embroidery was the exclusive or principal raison d'être of the silk crazy quilt, the patchwork merely serving as the ground for the stitchery.

The seeming paradox of these elite artifacts is that they are luxury and leisure in the guise of necessity and thrift. The patchwork is an emulation of the arts of expedience but without the economic motivation (although, to be fair, patchwork using fine materials may follow in some cases from nostalgic impetus, and thus it may represent an economy of memory or emotion). The same may also be said of best patchwork quilts, pilloried in the first citation above. The need to make small patches, because all that the quilter has at her disposal are oddly shaped scraps, is absent, yet the aesthetic endures. That is, the geometric aesthetic endures; the aesthetics of color and design are quite altered by having ample fabric. Whereas the scrap quilter must choose a pattern to suit the size, shape, and color of the materials at her disposal, the best quilter may choose a pattern for its formal qualities alone, knowing that she can buy whatever she needs to fabricate it. This is also true for a great many appliqué designs.

We can, therefore, return to Newman's observations concerning stylistic variations in regions of North Carolina and draw a few tentative conclusions,

which may be tested further through more comprehensive historic/geographic data. Of the Rowan-Cabarrus region she notes:

> Of the three areas we visited, the Rowan area is the most industrialized and urbanized. Many women work in the area's industries, a factor which has apparently contributed to the decline of quilting in the area since the mid-twentieth century. The prosperous economy is also reflected in the fact that the median per capita income and the average years of education are higher than in the other areas visited.
> (NEWMAN 1978:8–9)

Of the style of the region she says:

> We found a surprising number of appliqué designs among the older quilts of this area, many of them simple but charming interpretations of a familiar floral motif. This is in striking contrast to the other two areas where we found almost no appliqué quilts made before 1900.
> (NEWMAN 1978:9)

Several economic components are clear here. Newman herself suggests that industrial wage earning and quiltmaking are inversely correlated—as the former increases, the latter decreases—although she takes the surmise no further. Several factors, not necessarily separable, could be at work here. One could be the lack of time for quilting; another could be the availability of alternative commodities, such as blankets, for ready cash. It could also be that for people rising in economic standing, quilts have a "homemade" connotation, which they may wish to get away from.

When these people, or later generations, have established their socioeconomic bona fides, however, this same homemade quality may become desirable, emblematic of an economic status that can allow time for sewing as leisure. For quilts to fulfill this role, they must be clearly distinct from those made because of necessity. Hence, in this region many of the quilts are appliqué designs requiring yards of expensive store-bought materials. Such quilts cannot be mistaken for plain utilitarian objects. It is also unlikely that a large number of them will be made, in comparison with the quantity produced for utility alone. Families who have "risen" from a poor rural background may, once they are secure in their new social position, use such items as quilts to indicate a connection with a long heritage of gentility. For them, quilts can be emblematic of a romantic past, provided the designs chosen are

consonant with the kind of quilts most often seen preserved in museums, namely, prototypic best quilts which have survived because they have not been used.

Another related economic issue, also understudied, is the practice of paying women to quilt finished tops. Certainly matters of class are involved here, too, but this procedure indicates more than the simple existence of strata in society. To create a top and then pay someone else to quilt it suggests that in some women's minds these are distinct tasks with a separable ethos or social meaning. What these separate meanings are cannot be determined accurately without extensive fieldwork, but some preliminary speculations can be made.

It seems likely that some women who pay others to quilt think of the activity involved in designing and fabricating the top (and even planning the layout of the quilting across it) as creative work, whereas the actual quilting they conceive of as pure labor. This surmise is supported by the fact that quilts made as fancies by wealthier women, such as silk crazies, are frequently not quilted at all. There is no question that historically the mode of paying for quilting indicates that, to at least some extent, the work was thought of as routine piece labor, because the quilter was paid by the spool of thread used and at a rate that showed this was not highly valued employment, at least in economic terms (see Finley 1929:95 and Hall and Kretsinger 1935: 45). The practice of paying to have a top quilted does not mean that a woman conceives of quilting as having no intrinsic value, otherwise she would scarcely bother to make quilts at all and would not care how the quilting was executed (which has never been the case). It is certainly true that some women are renowned for their skill as quilters, in the strict sense of the word, and that their work is considered more beautiful than that which the maker of the top could do. However, it is a significant fact that some women who can afford to have tops quilted by others do make a clear distinction between what they want to do and what they are content to pay someone else to accomplish for them.

It should also be mentioned in this regard that it is not entirely unknown, though perhaps less common, for women to pay others to make up quilts entirely from materials and patterns supplied. The economics and social philosophy of this practice are rather different from the previous example, because here the woman with money is handing over the entire process, aesthetic and otherwise, to someone else. Again the precise meanings built into this practice cannot be determined without more data, but we can at least indicate the critical questions.

To begin with, we need regional and historical comparative economic data to determine why a woman would have quilts made, as opposed to, say, buying blankets. Was it cheaper in certain areas at certain times? Or do some women prefer to have quilts because of their attractiveness and versatility? We also need oral testimony, because some questions are quite complex. Why, for example, would a woman go out to work to make money to pay someone else to sew and quilt for her when she might work less and quilt for herself? One obvious answer is that she is paying less per hour for quilting than she is making in her job, therefore further aiding in the stratification of society and, perhaps unwittingly, devaluing home work.

Farther afield, but still tied into this debate, is the practice of buying whole quilts (that is, buying quilts that have already been made up without any input from the buyer), which also reveals certain aspects of regional and community values. To a certain extent the issues are the same as those outlined in the case of paying to have a quilt made. People who buy new quilts may buy them for the same set of reasons that they would have one made up. But there are some broader implications as well, because people trade old as well as new quilts. An abbreviated case study here will serve to indicate the range of issues.

David Pottinger has bought a large number of quilts from Amish women in Elkhart and Lagrange counties in Indiana and in *Quilts from the Indiana Amish* (Pottinger 1983) records some of the details of his transactions as well as some information on the quilts themselves. One of the captions reads:

Rabbit's Paw, Honeyville, 1901. 75″ × 75″. Made by Mary (Mrs. Manas) Hochstetler at the time of her wedding. The quilt is initialed "M.H." and dated "1901," the year of her birth, and "1919," the year she was married. The quilt was purchased from Mary Hochstetler in 1981 at her home, which is the first farm west of the Honeyville store. (POTTINGER 1983:64)

At first this description (which is typical) may seem a little surprising, because in other communities such a quilt might well become a prized heirloom. But Pottinger makes the case that, since around 1940, community aesthetics have changed, making the older quilts unappealing to their owners. The key, he suggests, was the increasing availability after 1940 of blended fabrics and batting that were more durable and warmer than the older cottons. That is, the change was initiated because of utilitarian considerations, but attendant changes affected aesthetics. First, synthetic batting has a greater

loft than plain cotton, which means it cannot be quilted as tightly. Second, the colors of the new fabrics are generally brighter than the old, somber tones for which Amish quilts are noted.

The new fabrics made the older style quilts obsolete functionally, and, equally important, outdated aesthetically, so that their owners felt quite comfortable about selling them. After all, the older quilts took up space and the money could be put to other uses. Thus, selling old quilts is, for the Indiana Amish, an indication of loss of interest in them. As their functional and aesthetic value declines, their exchange value becomes increasingly important. (And, the cynical observer would note, as their exchange value mounts, so does the interest of outsiders.) Because demand for "typical" Amish quilts has outstripped supply, some Indiana Amish women have taken to making new quilts in the old style, that is, with a heavy use of black and dark hues combined with brighter accents and pastel shades. These quilts are of no interest to their makers, who prefer the newer style, but are made exclusively for sale to the "English," that is, the non-Amish public.

Several general points that arise out of this case study are worth emphasizing. First, it is evident that economics, aesthetics, and functionality may be complexly intertwined, and the particular relationship of these three social variables may respond to local, regional, ethnic, or religious idiosyncracies. Second, Pottinger's book makes interesting viewing, but the quilts on display there, attractive though they may be to outsiders' eyes, are Amish *discards*. They are not representative of an enduring or static traditional aesthetic, but of the concerns of a finite time period, now past. They cannot even be taken as representative of pre-1940 aesthetics, because there may be many other quilts of this era in Amish homes that Pottinger and others have not seen. As Pottinger himself notes, the Amish do not show quilts to outsiders unless they are for sale.

This discussion raises a crucial issue, frequently misrepresented in the popular mind: traditions change. Commonly, "traditional" is used as a synonym for "unchanging," or "fixed in form," whereas it is well documented that all traditional practices change over time due to the very nature of the oral transmission process. Therefore, regional, and other, quilt styles need to be studied with respect to time. Apart from the changes wrought by the advent of new materials, little analysis of change over time has been carried out.

As always, it is essential when studying regional styles not to superimpose values and correlations that derive exclusively from the eye of the outside beholder, although quilt studies seem particularly prone to this error. Rachel

and Kenneth Pellman in *The World of Amish Quilts*, for example, show a picture of an Amish farmer harvesting side by side with a photograph of a "Diamond in Square" quilt, with the caption, "The suggestion of quilt designs are found all around the farm. Here the standing wheat creates the Diamond in Square, the sheaves the quilting stitches" (Pellman and Pellman 1984:12–13). If this were a direct quote from an Amish farmer or quilter it would have some merit, but as the judgement of an outsider, looking with a completely different eye, it merely confuses analysis by imputing a relationship that probably has no validity and only serves to obscure the true picture.

This discussion has centered on quilts as economic objects, but before leaving the issue entirely it ought to be said that while economic variables may play a part in shaping styles of fabrication, they are not exclusive determinants. Scrap and best quilts are what they are, in part, because of economic conditions. But, as we have seen, a best quilt does not have to be rigidly regular in its design and execution just because it is made from store-bought materials (although many are). Nor does a scrap quilt have to be jazzy and irregular in its juxtaposition of colors and shapes. A woman putting together a scrap top is limited in certain ways, but the finished design is still her conscious choice; it is not forced on her by the nature of the materials at her disposal. Aesthetic values may always transcend economic limitations.

Another influence on quilt style, which closely and intricately interacts with functionality, aesthetics, and economics, is the general ethos of the quiltmaker and her community. Often this ethos is embodied in particular religious beliefs and practices, some of which have a direct impact upon the activities and attitudes of the quiltmaker at work. A correct understanding of traditional religious beliefs can contribute to the appreciation of a quilting tradition if aspects of religious beliefs can be seen in the quilts themselves or the process of making or living with them. On the other hand, it is possible that an examination of the aesthetic of a community's quilts may reveal something of their religious ethos.

Certain religious ideas appear repeatedly in works about quilts, with little in the way of ethnographic or other evidence to support an assessment of them as traditional. Under this rubric, it is appropriate to consider the frequently cited belief among quilters that perfection in quiltmaking is to be avoided because it represents a challenge to God. It seems likely that this putative belief may be another of the myths which revivalists and collectors have attached to quiltmaking, in this case to "explain" the irregularities and variations which distinguish so many traditional quilts. One reason for presuming that this belief is not rooted in tradition is the fact that no quilter

would be likely to assess her quilt as "perfect," whether or not it had irregularities. Any woman who has sat at work over a quilt knows where its flaws are and where she would like to have done a better job.

A possible source for the idea that the pursuit of imagistic perfection is a challenge to God is the Islamic belief which pertains especially to rugmaking. Islamic rugmakers, while they traditionally incorporate an irregularity into their rugs, are nonetheless at pains to devise clever ways of concealing or disguising the "flaw" so that the rug becomes the visual equivalent of a riddle. Islamic law, unlike Christian doctrine, is filled with prohibitions concerning the creation of visual images, which accounts for the Arabesque aesthetic of nonfigurative, geometric patterns. At least one Islamic pattern, found in the tilework of the Alhambra, has found its way into quilt pattern books, usually under the name of "Arabic Lattice." It is possible that the idea of a prohibition against perfection was picked up at the same time as the pattern itself, and then used as a rationalization for the variations in traditional quilts. Once such an idea has been adopted by the revival or by those who trade in quilts, it may indeed be fed into the tradition, and the notion may be perpetuated in some instances. This mechanism is a well documented aspect of the folk process; but it is nonetheless legitimate to recognize a distinction between those practices and beliefs arising within a tradition and those imported to it.

Another religious idea which has been associated with quiltmaking is that of predestination. An often quoted passage from Eliza Calvert Hall's *Aunt Jane of Kentucky*, a fictionalized and romanticized vision of a Kentucky mountain woman, expresses the relationship between Calvinist notions and traditional quiltmaking practices:

> How much piecin' a quilt is like livin' a life! You can give the same
> kind of pieces to two persons, and one will make a "nine-patch" and
> one'll make a "wild goose chase," and there will be two quilts made
> out of the same kind of pieces, and jest as different as they can be. And
> that is jest the way with livin'. The Lord sends us the pieces, but we
> can cut them out and put 'em together pretty much to suit ourselves,
> and there's a heap more in the cuttin' out and sewin' than there is in
> the caliker.
> (CITED IN HALL AND KRETSINGER 1935:83)

Without evidence from traditional sources, this sentiment cannot be assumed to reflect the beliefs of any group of traditional quiltmakers, although the description is an accurate enough picture of the traditional aesthetic process.

We do have evidence from our own fieldwork that religious attitudes influence the attitudes and practices of traditional quiltmakers in the Appalachian mountains of Kentucky, where Aunt Jane supposedly lived. The interplay of religious ethos and aesthetics in Eastern Kentucky will serve as an example of how the two spheres can be interrelated generally. Among traditional people in Eastern Kentucky, judgements about secular aesthetics are often stated in terms which imply religious values. Regarding secular music, for example, Kentucky mountain people hold attitudes which range between the two extremes of active disapproval and passionate devotion; these different attitudes correlate with the individual's religious affiliation. The patchwork quilt, however, provokes no such religious controversy: in no case is quiltmaking deemed unfit for enjoyment by the righteous. The quilt is not neutral with regard to religious values. Formal features, process of production, and affective associations are all positively and explicitly bound to religious themes and ideas.

Kentucky mountain women do sometimes refer to quilt patterns by traditional names, many of which are Biblical or religious in reference. Mountain women are articulate about the ways in which the making of quilts puts into practice the virtues valued within their Protestant ethic. Quiltmaking is a domestic activity which can be construed as productive of functional items. As such, the aesthetic component of quiltmaking is to that degree culturally forgiven or overlooked, because the expenditure of aesthetic energy occurs in an arena appropriate to the concerns of a godly woman. Appalachian quilts are seen by their makers as representing a tradition of thrifty industry. Quilts are made by using scraps of fabric and stray bits of time, by women who abhor idleness and waste. The positive value of quiltmaking is therefore diminished if a woman neglects other necessary activities in order to quilt. Some evidence suggests that since quilting, as opposed to piecing, is considered a chore, the woman who pieces copiously and does not do her own quilting may need a good excuse, such as poor eyesight, in order not to be considered "ornery."

Quilts in Appalachia may come to have affective associations with the sacred, often through the circumstances of their making and use. Quilts are commonly made in association with critical junctures in life, such as birth, marriage, and death—all occasions marked by religious rites as well as social observances. Fabrics used in scrap quilts may be remembered garments of a relative or friend, so that the quilt may take on a hallowed aspect as it becomes a memento of those presumed to be in heaven. The same may be true to some extent of any quilt made by a deceased kinswoman. It is imbued

with her energy and care, and becomes a perpetual reminder of her virtues and a testimony to the belief that she has gone to a heavenly reward.

Many Appalachian women never sell the quilts they make, but only give them away, principally to family members. These women express the attitude that there is something not quite right about selling their quilts, though the same women will sell other products of their labor. At least one Appalachian woman suggested that her quiltmaking grandmother's aversion to the notion of selling her quilts stemmed from her assessment of the practice as in some sense sacrilegious. Questioning alone may not be sufficient to disclose the inner complexities of Appalachian women toward selling quilts, since those who do not sell dismiss the inquiry itself with some measure of horror or disdain. There is, however, evidence enough to suppose a connection between religious ethos and attitudes toward the sale of quilts made by individuals.

The fact, however, that quiltmaking displays virtues and principles of Protestantism makes it particularly suitable as a means of raising money for ecclesiastical purposes, such as fundraising for the church or for charity. The handcraft revival, begun early in this century and having a heavy impact on traditional quiltmaking in Appalachia, has been in large part fostered by churches and accepted by mountain people on that basis. Quiltmaking and similar activities are encouraged for the qualities that their practice is thought to promote, and for the spiritual improvement which theoretically follows from the capacity to exchange handcraft for cash. The success of the handcraft revival in Appalachia is directly related to the degree to which its principles intersect with traditional attitudes toward work and aesthetics (as well as to the need for acceptable additional sources of income).

Thus, on a number of levels, quiltmaking in Appalachia is connected with traditional religious beliefs and values; a correct understanding of the latter can shed light on the former. In some instances, too, an examination of the quilts made by members of a religious community can illuminate aspects of their religious attitudes. For example, the Amish are frequently stereotyped as a stolid people who eschew beauty and pleasure. Their quilts are therefore seen as paradoxically elegant and gay. If the presence of the quilts, however, is taken seriously as a component of traditional Amish life, the stereotype of the joyless Amish farm family is belied. Quite evidently, Amish belief has ample room for truly lush examples of material beauty—and the fact that the quilts are used as bedcovers would suggest that beauty may be acceptably allied with pleasure and repose.

Similarly, the Baptist prohibition against certain kinds of fleshly indulgences has created a stereotype of rigid opposition to aesthetic embellish-

ment. The following story provides evidence quite contradictory to this received image:

> My daddy was a Baptist preacher. I reckon you can tell that by how ornery I am. We didn't have much luxury, I can say. But I remember the funniest day one time when I was still a young girl.
>
> Mama was goin' to help me start my quilts for my hope chest. She had got the old scrap bag out. We spread 'em all out on the bed and tried to kinda put the colors together right. But the scrap bag was really low. We sure hadn't got anything new in a long time and it seemed at that time everybody in the church was usin' all their own scraps and none had come our way.
>
> Mama said, "Come on into town with me Saturday, and we'll pick up a few pieces of brighter calico to spruce 'em up a bit."
>
> Well, come Saturday, true to her word, we went to town with Papa. Soon as he tied up the team he went over to the feed store and we went to the dry goods. We had picked three pieces of remnant blue and was just fingerin' some red calico. We was jest plannin' on enough for the middle squares from that.
>
> Just then Papa come in behind us and I guess he saw us lookin'. He just walked right past us like he wasn't with us, right up to the clerk and said, "How much cloth is on that bolt?"
>
> The clerk said, "Twenty yards."
>
> Papa never looked around. He just said, "I'll take it all!"
>
> He picked up that whole bolt of red calico and carried it to the wagon. Mama and me just laughed to beat the band. Twenty yards of red. Can you imagine?
>
> A Baptist preacher, jest like any other man, likes that red. We had red for a long, long time.
>
> (COOPER AND BUFERD 1978:57–58)

Besides saying something about Baptist aesthetics, the above story contains hints about other aspects of certain Baptist norms and practices. For instance, it is clear that the woman speaking felt that it was to be expected that a preacher's family would not have much in the way of material wealth or comfort. At the same time, there may be an implicit criticism of the church members who might have had more but did not share fabric scraps with the preacher's wife and daughter. Then there is the father's exhibition of largesse at the dry goods store, which runs counter to the relative modesty in which his family was accustomed to live. The anecdote offers a tantalizing glimpse

of what might be learned about the relationship between aesthetics, attitudes toward material wealth, and religious principles through considering the practices of the quiltmaker.

This discussion of quilts and their interactions with their human environments is intended to be no more than suggestive of the directions of inquiry which make up a comprehensive understanding of the traditional quilt and its world. In the following section, we turn to the final aspect of the quilt's environment, those features of the natural world with which the quilt interacts.

4.4. INTERACTION WITH THE NATURAL ENVIRONMENT

Previous sections have touched on the quilt's relation to the natural world. The growth and manufacture of the materials which are used to make quilts relate to natural climates and cycles. Imagery appearing in quilts and names associated with them reflect a connection with nature. Kinds of fabrics available as scrap may have to do with regional climate. The particular wear a quilt receives, and the deteriorating factors it faces, differ according to natural climate and conditions. In this section we discuss briefly a few other kinds of interaction between quilts and their natural environments that have not been explored in previous sections.

Quilts in diverse natural environments obviously serve different functions, and climate may have a significant effect on the entire life cycle. Cold climates may influence both quilt production and use. Where winters are severe and people use quilts as the primary bedcovering, they need a large number for warmth. Although this kind of factor cannot absolutely determine modes of production, it may limit or direct production in certain ways. The need for a relatively large number of quilts may, for example, mean that the quilter has less time to be concerned about the nature of the design of the top, particularly since in a great stack of quilts only the topmost one shows. The quilting, also, may tend to be more practical than elaborate.

Quilts, because of their good insulating properties, may serve a multitude of functions in colder regions, which, in turn, may cause them to wear out faster, leading to an increased need for yet more quilts. As already discussed in Section 3.4, quilts may be tacked over window and door openings to keep out drafts, spread over young seedlings in hotbeds, wrapped around stored apples to prevent them from freezing, and the like. All of these functions draw quilts away from beds, and eventually destroy them, so that the supply for beds must be constantly replenished.

The Natural History of the Traditional Quilt

Quilts may serve all of these purposes in warmer climes, but fewer are needed for shorter periods of time. Thus, fewer quilts cycle through the system, at a slower pace. Hence, quilters in these regions may have the comparative luxury, should they wish to take it, of taking longer over the fabrication of utility quilts (and also the possibility of having some extra time to make fancier ones).

General climate could, therefore, be a component in the development of regional styles, and it would be worthwhile to see if any correlations exist between climate variables and quantifiable aspects of quilt production. The principle contenders for the former could include mean low winter temperatures, average number of frost-free days, average winter precipitation, and all the factors that are amassed to produce the general climatic regions of the United States; and the latter, absolute number of quilts per capita per household, ratio of utility and best quilts, average time to construct a quilt, and so on. It would also be profitable to see if similarities in overall quilting style exist between regions with similar climates, whether or not those regions are culturally similar.

It should be remembered, however, that many cultural and historical factors can influence or skew these correlations to the point that it might be difficult to gather appropriate data, or the data may need to be weighted to take account of these other variables. For example, a family living in a log cabin needs a large number of quilts to cut down drafts as well as to keep beds warm, but the same size family living in a frame house with tightly fitting ceilings and walls needs fewer, even though the two are located in the same climate. Similarly, the development of a variety of building and heating technologies (and changing human expectations) in the twentieth century have all left their mark on the need and desire for quilts. At least, therefore, the attempt to draw correlations would need to take account of the passage of time as a variable, and not simply lump all quilts from one region together.

The effects of climate may also be indirect or subtle. It is possible, for example, that the long winters of the north have a tendency to foster more group activities to battle cabin fever, and, hence, it would be more common to find quilting bees in colder regions and individual quilting in warmer. Our own fieldwork tends to support this conclusion but more widespread documentation is needed for confirmation. Certainly the quilting bee is not the common tradition across the United States that it was once thought to be, nor is it entirely a poetic figment of romantic imaginations. If climate is indeed a component in the decision as to whether to quilt alone or in company, then there should be an attendant effect on style because certain quilting

designs are better done alone and others more suited to group work. Also, no matter how carefully women quilt, there are always differences in their stitching, which will be seen on close scrutiny.

The seasons of the year are generally reserved for different sets of tasks, particularly among people living close to the land. The job of quiltmaking, with its different components, may be carried out according to a seasonal round, though the apportionment of tasks according to season may vary from region to region. Summer's longer evenings may afford light and breeze for the quiltmaker piecing outdoors after supper, while winter's chill may make quilting a more appealing activity than it would be in the heat of summer. Or it may be the other way around. African-American quiltmaker Arbie Williams, originally from Texas, traditionally pieced in the winter and quilted in the summer when it was too hot to do anything outdoors (Collins 1992).

Besides covering people in their beds, quilts also serve the needs of non-human animals, especially those that are in some ways part of the household. In a sense, providing a quilt for the prime or exclusive use of a cat or dog, for example, is a way of drawing that animal closer into the human sphere. The quilt humanizes the animal by imputing to it needs and interests that resemble those of humans:

> This was one of mother's old quilts; all wore out but it does all right fer a dog bed. That's Grant's old dog, and the last thing he ever said to me before he died was, 'Luther, take care of my dog.' He thought the world of that ole dog. That's about all he had—no children, ner no property. . . . I've took care of his dog. Got that old quilt fer him to sleep on. He don't want for nothin.
> (IRWIN 1984:20)

In this way quilts have the capacity to transform the natural world, bringing it closer to the orbit of human affairs.

It is also surprisingly common to find reflective quilters relating the natural world to quilts, as if the quilt were a human remaking of the natural world:

> The many colors of the autumn leaves remind me of my 'crazy quilts,' such a blending of colors that the absence of any scheme or pattern makes a beauty or system all its own: a picture you will never forget if you have seen it once.
> (SLONE 1979:72)

This Appalachian woman comes from a tradition which finds spiritual import in the manifestations of nature, an attitude which she shares with quiltmakers from a variety of traditions, including Polynesian, Native American, and African-American traditions. Inspiration from nature is connected with an experience of the spiritual world, and quiltmaking becomes at once an acknowledgement of the natural and an embodiment of the spiritual.

The study of quilts brings the investigator full circle, again and again, connecting the realms of the material and the ideational; the sacred and the secular; the natural and the cultural; the cognitive and the perceptual; the historic and the sociological; the aesthetic, the economic, and the technological. Yet without a central focus on the quilt as living object, this complex picture becomes a muddle of prejudice and caprice. Our work has been to lay out a system by which the quilt can be seen at the center of its own nexus of relationships. Only with such a comprehensive view of traditional quilts and quiltmaking can any particular aspect be understood.

The decision to stay with the quilt, letting it generate its own method of investigation through the facts of its existence, yields a final image of traditional quilts and quiltmaking which is as free as possible from distortion. A natural history of the traditional quilt opens the way for a full understanding of the intimate and rich interweavings of all of the realms of nature and culture as seen in the life of the traditional object. A quiltmaker imbues her quilt with life. In the method we have outlined, that life is taken seriously, celebrated, and lifted up for appreciation through informed contemplation.

It remains to put the method into practice in talking about a body of real quilts, made by a flesh and blood quilter and used and cherished by her kin. In explicating our mode of study, we have necessarily picked apart the interwoven strands for the sake of analytical clarity. In the case study which follows, we hope to present the quilts, their maker, and their other owners in all of the integrity and complexity of life, for such results are the only test and justification for our method.

5. Case Study

5.1. INTRODUCTION

The aim of the case study is to pull together the analytical strands which have been teased apart in the expositions of the preceding sections. Such a study has as its guiding purpose the humanization of the subject matter—the quilter and her quilts. The programmatic discussion of a natural history of the traditional quilt is necessarily abstract, at some remove from the realities of fabric and flesh which motivate it. The concepts may therefore easily appear dehumanized and detached. But if the focus of the research program is the construction of a natural history, the results of its method should above all be natural pictures of the totality of the subject. If the method yields a comprehensive view of quilts in their natural totality, then it must be seen that the component concepts, however technical and theoretical, are derived from and lead back to a deep engagement with the quilts and the quilter. The same issues appear in the case study which have been expounded upon throughout previous sections, only here they appear in specific, humanized form.

For the purpose of a case study, the examination of the works of a single prolific quilter has several advantages. First of all, the quilter's life can be seen in its entirety in relation to the quilts, and vice versa. In this regard, the present approach differs radically from the hit and run technique characterized by documentation of a quilt and its particulars without an adequate grasp of the entire life structure which surrounds it. In fact, the documentation of the life and entire extant oeuvre of a traditional artist is extremely uncommon in the literature. One justification, therefore, for choosing such a task lies in the fact that until such works are accomplished in number, there is no way of knowing what insights will be revealed concerning the production of traditional artifacts.

There are, however, a number of goals to be gained in the study of a single corpus which are quite evident at the outset. One is a view of the developmental sweep of the artisan's technique and aesthetic. Looking at a lifetime's

work reveals changes over time which correlate with changes in the quilter's age and circumstances. At the same time, stylistic variation at any one moment, through time, and within the corpus as a whole, can all be assessed in terms of known influences. Moreover, the place of a quilt can be understood relative to the places of other quilts by the same maker—for each quilt exists both on its own and in relation to a universe of quilts. Correct analysis of the quilts in relation to one another can indicate overall trends and moments of innovation within the aesthetic process of the quilter. Serious consideration of the aesthetic process of the traditional artist, based upon a work by work analysis, is the necessary starting point for any theoretical advances in the understanding of the role of aesthetics in traditional life.

The place of the quilts in the life of the family is seen clearly through the consideration of an entire oeuvre. Native categories of form and function can be ascertained as the life histories of quilts are gathered. Changing attitudes within subsequent generations can be assessed, and the aesthetic and technical skills and interests of family members can be explored. All of these kinds of information can flesh out an understanding of the life of the traditional artisan and the lives of the artifacts she produces and bestows.

Close examination of such issues sheds light on questions of major importance in cultural anthropology, sociology, folklore, history, and ethnoarchaeology—such issues as: the place of the artisan in society; the relation of age and gender to production; the significance of the distribution of artifacts in terms of kinship, marriage and residence, and use; the relation of style to social and cultural facts; patterns and correlates of change in tradition over time; the effects of social mobility on tradition and on domestic production; and the modes of transmission of traditional culture. The quilter and quilts of the case study were selected for the richness of available data, the synthesis of which speaks to the above issues as well as presents a complex human picture of a traditional artist, her life, and her work.

Anna Butcher Mayo was a prolific, lifelong quilter whose quilts continue to be used and treasured by her descendants. Mrs. Mayo was born and lived most of her life in the mountains of Eastern Kentucky, and her work arises out of a longstanding and still viable tradition of Appalachian quiltmaking. The quilter and her works were pointed out to one of us (Blincoe) over thirty years ago, and the corpus later suggested itself as a topic for detailed research. At the time of the fieldwork on which this case study is based, Mrs. Mayo had been dead for more than a quarter of a century. Nevertheless, the quilts themselves are testimony to her ways of working and to the uses which the fruits of her labor have served. Scrupulous and rigorous attention to Mrs. Mayo's quilts reveals much in the way of her aesthetic preferences and

technical methods and skills. Interviews with her relatives provide abundant data concerning the social and historical facts surrounding the quilts and their life stories, beginning with the life story of their maker.

A full case study of the quilts and the quilter would constitute a book length work in itself, and therefore is beyond the scope of the present volume. It would include, in addition to an examination of the entire extant corpus, a listing of all known quilts no longer extant. All the quilts which were not made by Mrs. Mayo but which live in the same households with her quilts would also be documented and compared. The quilts made by her quiltmaking descendants would be documented and analyzed for their relationship to her work. Other kinds of handwork practiced by Mrs. Mayo and other family members would be noted and investigated as part of the context of the quiltmaking. Narratives regarding all the quilts would be collected and analyzed for linguistic and aesthetic structure as well as informational content. Religious attitudes toward traditional aesthetics, including quiltmaking, would be fully explored. A complete social history of the family would be pursued, and relevant facts would be included in the account of the passing of the tradition through the generations. These areas and more would form portions of the complete account of Mrs. Mayo and her quilts. The present case study can be construed as a thumbnail sketch for the whole, with an emphasis on the presentation of a wide range of issues.

Section 5.2 presents a quilt by quilt description of the available extant corpus, followed by a general discussion of the issues and insights that a material examination uncovers. The descriptions focus on the physical facts as embodied in the quilts, and on the speculations, questions, and conclusions which arise from a consideration of these facts. Issues of taxonomy and general and specific morphology prevail in the descriptions and discussion, with references to what can be learned and what questions arise about the conception, gestation, life span, and ecological interactions of the quilts simply from close examination. In this descriptive section, the humanistic value of the taxonomic principles for understanding the quilter's aesthetic and technical process becomes clear. Likewise, considerations of taxonomy and the physical appearance of the quilts lead to the formulation of hypotheses and queries regarding the lives of the quilts, their maker, and their owners.

In Section 5.3, information gathered in interviews with the quilter's descendants, principally her two daughters, is the focus of discussion. The interview questions are shaped by observation of the quilts and by the holistic view of quilts and quiltmaking as detailed in the preceding sections of the present work. This portion of the case study attempts to draw together all of

The Natural History of the Traditional Quilt

the seemingly disparate facts of the quiltmaker's life and of the history of the quilts into a coherent story comprising her identity and activities as a quilter. In addition, a description is shaped of the quilts as living entities and of the entire corpus as a kindred of quilts.

Section 5.4 presents an analysis of the relationship among three genetically close quilts in Mrs. Mayo's corpus and places the group in a larger traditional context. The three quilts are examined for their method of construction, and the process of determining the cell structure is discussed and illustrated in detail. Formal oddities in the quilts are related to facts of their life histories. In this section a departure is made from exclusive consideration of the corpus, as comparisons are made with related designs documented in the literature. Working back and forth from Mrs. Mayo's quilts to those of other quilters results in a deeper and clearer understanding of all of the quilts.

Section 5.5 concerns the analysis of an anomaly in one scrap quilt which is taxonomically closely related to several others in the corpus. From a detailed search through the construction methods entailed in each, a conjecture is built as to the emergence of creative innovation in the use of a traditional pattern. A picture develops of the quilter as active, imaginative artisan—a woman repeatedly drawn to particular kinds of designs and fascinated by the potential shapes and colorations latent in the patterns she used.

Concluding remarks about the case study and about the work in general make up the final chapter of the book. Section 6.1 takes up the issues raised in previous sections and relates them to issues current in the fields of anthropological aesthetics, ethnoarchaeology, folklore, and other disciplines. The natural history method at work produces a complex picture of a traditional aesthetic form. This picture can then be referred to as a test of ideas in fields concerned with domestic and traditional production, and the value of the model for other forms of material culture can be assessed.

5.2. EXTANT QUILTS OF ANNA BUTCHER MAYO (1874–1965)

Preliminaries

Anna Butcher Mayo created at least one hundred quilts, perhaps many more, in a lifetime of work. The life of the quilter and the distribution and life histories of the quilts will be discussed in Section 5.3, but it is relevant to note here that all of her quilts still belong to family members. Charting and tracking the extant corpus, therefore, is relatively straightforward in theory. However, the task is complicated in actuality by the far-flung migrations and attenuated family connections of recent generations. Geographic and social

distance make access to the outlying quilts difficult, but a more serious problem lies in determining for certain whether a particular quilt belongs to the corpus.

The quilts presented in the case study represent the available extant corpus of Mrs. Mayo's work, namely those quilts belonging to descendants who have kept relatively close to family and the ancestral home. The nature of the case study corpus may reflect patterns of family relationship in ways which are not clear without access to the entire extant corpus—but the pattern of availability of the quilts is in itself part of the social data connected with them. That is, these quilts became available for documentation because their owners maintained strong geographic and social ties to kin and the homeplace. Thus the quilts themselves form a kind of intimate kindred in which their outlying "siblings" do not take part at present. This division within the body of quilts mirrors the social realities of family mobility.

The quilts which form the basis of this case study are owned by Mrs. Mayo's two daughters, a granddaughter, and two great-granddaughters. The descriptions of the quilts are presented in groups according to owner. The order of discussion reflects the way in which they appeared in the course of fieldwork and underscores the fact that ownership is a significant aspect of a quilt's life history. Within these groupings by ownership, the descriptions of the quilts are arranged in no special order. Each series follows the actual order of display of the quilts by the owner: quilts were shown as they were pulled out of closets, drawers, and chests, or as they lay on beds. No order of presentation in terms of aesthetic value, age, or other principle was discernible. Rather, the quilts were brought out in a manner suited to convenience based upon where they were used or stored.

Twenty-six quilts make up the corpus for study. For ease of reference, each is designated by the quiltmaker's initials and a number, e.g., AM1, AM2, and so forth. AM1–AM14 are owned by Mrs. Mayo's younger daughter. AM15–AM21 belong to Mrs. Mayo's elder daughter. AM22–AM26 are owned by other descendants. The corpus includes one unquilted top, AM22. Each designation is followed by its taxonomic code, but it is important to note that, as discussed in Section 1.3, the taxonomy has not been carried out in the present work to the level of cell species. The taxonomic codes listed here indicate broad types only, not particular cells. Because the taxonomy as it stands does not include an exhaustive coding for cell shapes, in a few instances the shape of a cell is provisionally indicated by letter (e.g., x, y, z) rather than by assigned number, and the shape which the letter indicates is given in brackets following the letter. In the completed taxonomy, these shapes would be indicated by numbers.

Each quilt is illustrated by a figure showing the constituent cell or cells. In some cases, subunits and mode of construction are also illustrated, as are quilting motifs where they are not easily described in words. The illustrations are meant to convey something of Mrs. Mayo's technique and aesthetic. The drafting is not executed with mechanical accuracy. The shadings are hand drawn to represent aspects such as hue, value, and fabric design. At the same time, no attempt has been made to present actual pictures of the quilts in the form of drawings. The illustrations represent somewhat regularized, stylized diagrams rather than slavish recreations of every formal fact found in the fabric. That is, in the drawings, seams meet in straight lines; measurements are generally regular and normative; shapes tend to conform to geometric ideals. The quilts, of course, show much more variation.

No attempt is made here to provide an exhaustive description of the formal features of the quilts. Such a study is too large an endeavor to include here. The descriptions are as detailed as possible in terms of cell structure and overall morphology; however, it should be emphasized that all measurements are normative rather than exact. Within each quilt, the precise measurements differ from cell to cell, and so an average measurement is given. The quilt's overall dimensions as given in the description of it will not necessarily accord with those which would be derived from the simple addition of average cell measures. A full description of the quilts would include many more details than are given here. Exact measurements would be given for each unit of each quilt; each fabric in each quilt would be catalogued and its distribution charted—both in individual quilts and in the corpus; exact locations of worn spots and stains would be mapped; quilting designs would be measured and mapped cell by cell instead of described generally; and so forth. In the present discussion, the aim to present a sampling of issues raised in preceding sections of this book is balanced with an attempt to characterize each quilt in terms of at least some of its outstanding features. Even these simplified descriptions should suggest the enormous formal complexity of the traditional quilt, as considered by quilter as well as scholar.

Mrs. Mayo's quilts are not exceptional formally, an important point to bear in mind when working through the description and analysis of their formal features. The corpus is representative of the tradition generally and of the Southern Appalachian tradition specifically. The work does not tend remarkably toward regularity or irregularity, elegance or plainness, skillfulness or crudeness, relative to other examples of traditional quiltmaking. Therefore, discussions of intricacies, oddities, and variation are not reflections of an idiosyncratically complex style. Any body of traditional quilts when subjected to similarly methodical scrutiny would undoubtedly reveal as great a range

of puzzles and surprises and would raise an equal number of significant issues in the analysis of traditional aesthetics.

The value of the present method of description and analysis lies in its capacity to provide otherwise unavailable insights. Like anyone else, we are prone to see at first glance those attributes which we *think* are present in the quilts. Detailed examination according to the methods previously described frequently leads us to revise our first assumptions. The quilts frequently turn out to be more complex and less regular than they had appeared at first. Sometimes the construction method of a design is found to be quite other than that which would suggest itself from a consideration of the finished pattern. Most importantly, looking again and again at the formal features of the quilts reveals a picture of the quilter at work, and of her aesthetic principles. Her finished products affect the viewer in particular ways, and accurate and detailed formal analysis tells why.

Before embarking on the description of the individual quilts, it is useful to point out a few morphological generalities. This will save repetition of similar information throughout the discussion of single quilts. Any deviation from the general morphological characteristics detailed here will be listed under the rubric of the individual quilt. All of the quilts could be used on a double bed with a small overhang or on a twin bed with a larger overhang. All quilts are of cotton fabric, almost entirely of plain, relatively close weave. (The two exceptions are AM7, which contains scraps of flannel pajamas, and AM22, the unquilted top, which has some patches of corduroy.) Backings are generally of fine muslin, unbleached or white, with one exception being AM2, which is backed in blue cotton. Fillings are of store-bought cotton batting. All quilts are seamed and quilted with white thread. The quilting is handwork on all of the quilts, with the single exception of AM10, which has been raggedly quilted on a machine. All quilts are bound with a homemade binding strip. Beyond these morphological similarities the quilts take on their own characteristics, which are detailed below.

Quilts owned by the younger daughter of Mrs. Mayo

AM1 S2.1.2.(S1.1.2.3.1.2.l.a).(S1.1.2.3.1.2.l.a). This red and white quilt appears at first inspection to be created through the straightforward replication of a single cell, executed in regular fashion in terms of color, though there is an anomaly in one of the cells. This anomaly is discussed fully in Section 5.5 and illustrated in Figure 294a–d. Close attention to the pattern, however, reveals that the quilt is actually formed of two different cells, the

construction of which are discussed below. The sashing strips are of the same red fabric as the cells, and the intersecting squares are white. The square cells are oriented parallel with the quilt's edges. AM1 is backed in unbleached muslin and bound in red. The character of the piecing and the quilting do not match: the former is uneven, with points not meeting and patches showing irregularity of shape; the latter is intricate and neatly executed. The fabric is new and the quilt is unused.

The two constituent cells which make up AM1 are shown in Figure 246*a*–*b*. The dark central portion of the pattern is oriented in one direction in 246*a* and in the other direction in 246*b*. Each cell is made of the same number and same shapes of patches, but the construction of each is different. The piecing method for each is radial from a central point, with two steps out from the center. Each cell is composed of diamond-shaped patches of two sizes, which make up the central motif, and squares and half squares, which are sewn with inset seams to the central shape to form a square cell. The difference between the two cells is in the placement of the squares and half squares in relation to the central motif (Figure 246*e*). For the cell in 246*a*, the odd-numbered sectors are squares and the even-numbered sectors are triangles. For the cell in 246*b*, the odds are triangles and the evens are squares. Note that turning either cell through 360° will not at any point allow one to be laid congruently over the other. The two cells are mirror images of one another, and the difference is in the underlying cell structure and not simply in the coloration. The two cells are taxonomically very closely related, but distinct.

The red (dark) patches of the colored cell form a central motif, with the white patches forming a background. The seams in the white portions of the cell are barely discernible, and tend to disappear at a distance (Figure 246*c*–*d*). Each cell measures approximately $13\frac{1}{4}''$ × $13\frac{1}{4}''$. The cells are set straight and a red and white sashing is used in setting the top. The red sashing strips are $4''$ wide. The intersecting squares are white. The quilt has a $4''$ red unpieced border. AM1 is four cells in width and five in length. The quilt measures $72''$ × $88''$. The quilting in the red motifs of the cells is by the piece. The white squares in the cells are quilted by the piece and with an internal X shape. The sashing strips are quilted in a double chain motif, and the intersections are quilted by the piece and with an internal asterisk shape (Figure 246*f*). The work is neat and regular, and moderately fine.

Diagram 1 is a setting diagram indicating the positions of the two kinds of cells in the quilt. The cell shown in 246*a* is labeled *a* and the cell shown in 246*b* is labeled *b*. The anomalous cell, which is a version of the cell shown in 246*a*, is labeled *a'*. The orientation shown is arbitrary, since no information is available as to which might have been intended as the top and which

Figure 246a

Figure 246b

Figure 246c

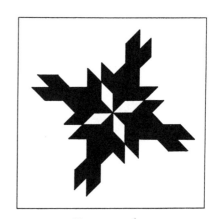

Figure 246d

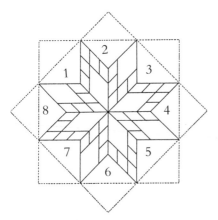

Figure 246e

Figure 246f

The Natural History of the Traditional Quilt

a	a'	b	a
a	b	b	b
b	a	a	a
b	b	a	b
a	b	a	a

Diagram 1

the bottom edge (if such a distinction was indeed intended, which it may not have been).

AM1 is a fascinating example of a quilt which appears entirely regular and ordinary (except for the anomaly), but which on examination reveals itself to be much more complex. The question which suggests itself with respect to AM1 is the degree to which the quilter herself saw the two cells as distinct, and the possible reasons for the existence of the two cells. These questions are addressed in the general discussion at the end of this section, with formal data from other quilts considered as well. Another obvious question presented by AM1 concerns the disparity between the quality of needlework in the quilting versus the piecing. Another portion of the puzzle is that the goods were apparently purchased new and the quilt is unused. This would appear to be a prototypic best quilt in all respects except for the incongruously uneven piecing.

A most intriguing feature of the quilt is its anomalous cell. Visual examination reveals the way in which the anomaly came about in terms of construction. Section 5.5, which explores the characteristics of this and related quilts in detail, contains a complete exposition; but the question remains as to why the anomaly is incorporated into the finished quilt. AM1 is very closely related to AM15, its taxonomic twin, and to AM26. More distant but still related quilts in the corpus are AM9, AM14, AM19, and AM20. The formal relationships among all the quilts are discussed in Section 5.5.

AM2 S2.1.2.(S1.1.2.3.1.l.l).(S1.1.2.3.1.l.l). AM2 is another quilt in which apparent regularity turns out under close examination to be illusory. The variation in its two constituent cells is even more subtle than that between the cells in AM1, so that the visual impression is one of high regularity. The quilt is blue and gold backed in blue cotton. The blue of the pieced cells is slightly different from that of the plain setting squares and the backing. The binding is the same dark blue as the backing and setting squares. The work is

fine, precise and regular throughout, in both piecing and quilting. The quilt has not been used or laundered. The fabric of the backing and setting would appear to have been purchased rather than scrap material. The fabric of the cells appears unworn.

Figure 247*a* shows a section of AM2. The cells and setting squares are at a diagonal to the edges of the quilt, with setting squares alternating with pieced square cells. The illustration shows that the yellow (light) portions of the pattern form a pattern of continuous lines across the face of the quilt, even though the pieced squares are interspersed with plain squares. Figure 247*b–c* shows the two constituent cells. As with AM1, the two cells are very closely related. In AM2, however, the difference is not one of construction. Instead, a conceptual distinction of orientation differentiates the two. The unit in 247*c* is the same as that in 247*b* except that it is turned 90°. Because relative orientation information is part of the definition of the cell, and because the structure of the two cells looks different, the two cannot be considered to be the same cell, even though as units of construction they are identical. Here is a case in which the concept of the cell operates on a very abstract level, somewhat distant from the actual construction process.

A close look at Figure 247*a* shows that the cells are arranged according to the pattern shown in Diagram 2, in which setting squares are labeled *s,* cells as in Figure 247*b* are labeled *b,* and cells as in Figure 247*c* are labeled *c.* A setting diagram for the entire quilt appears in Diagram 3, with half cells and half setting squares labeled *b′, c′,* and *s′,* and quarter setting squares labeled *s′′.* It should be noted that the orientation of the quilt for purposes of illustration is arbitrary: no information is available as to the originally intended orientation (if any).

The quilt measures 81″ × 91″, and each cell and each setting square is 16½″ × 16½″. The piecing is extremely smooth and even throughout. Equally exact and elegant is the quilting. The cells are quilted by the piece, creating a curvilinear pattern of stitching which is echoed to a degree by the curving quilting design used in the setting squares. The latter are quilted in a pattern similar to that shown in Figure 43*b* for patchwork.

It is unknown to what extent the quilter regarded the two constituent cells as distinct, even more so in the case of AM2 than in AM1, since the difference between the two cells in AM2 is one of orientation rather than construction. Part of the mystery of AM2 lies in the difference between the blue of the cells and that of the setting squares. Its piecing and quilting, and the regularity of color use, suggest the prototypic category of best quilt, as does the use of new fabric and the quilt's condition. Yet the two colors of blue do not match, which suggests an unusual twist of some sort in the quilt's life

Figure 247a

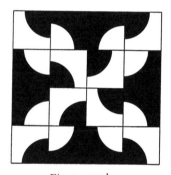

Figure 247b

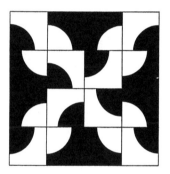

Figure 247c

```
                                    s"   s'   s'   s'   s"

                                     b    c    c    c

                                    s'   s    s    s    s'

                   c                 c    c    b    c

              s    s                s'   s    s    s    s'

         c    c    b                 c    b    c    b

              s    s                s'   s    s    s    s'

              b                      c'   c'   b'   c'
```

Diagram 2 Diagram 3

history. Another unusual feature is the quilt's backing, which is the only colored backing in the corpus. This also suggests some special aspect of the quilt's conception or gestation or both.

AM2 is closely related to two other quilts in the corpus, AM3 and AM18. The formal connections among the three, as well as the group's relationship to other closely related examples elsewhere in the tradition, are discussed fully in Section 5.4.

AM3 S2.1.2.(S1.1.2.3.1.l.l).(S1.1.2.3.1.l.l). AM3 is a red and white quilt which shows very little wear, but it has been washed, as evidenced from the character of the puckering of the fabric along the lines of quilting. The use of color is regular throughout the quilt, without variation or anomaly in piecing. It would appear that the quilt was not made from scrap fabric, since there is a large amount of only two colors. The piecing is remarkably ragged, given the fact that apparently new fabric was used, and a pattern was chosen which would require expertise in needlework. The quilting is exceptionally fine and close. The quilt is backed in unbleached muslin, which is exceptionally fine in comparison with that of other quilts in the corpus, and bound in white, which matches the white fabric of the top. The quilt has no borders or sashing.

Figure 248 shows a section of AM3. The two constituent cells are the same as those in AM2 (Figure 247*b–c*). The values are the same as in AM2, with the dark representing the red in AM3. The two cells are set in alternation, with rows jogged, to create the pattern. The orientation of the cells is parallel with the quilt's edges. A full discussion of the cell structure of AM3 and related quilts appears in Section 5.4, where alternative analyses are examined and the arguments laid out in favor of the analysis presented above. Each cell is $14\frac{3}{4}''$ square, and the quilt's overall dimensions are $62'' \times 75''$. AM3 is quilted overall in close, fine rows of hand quilting, with vertical rows running through the white areas and diagonal rows running through the red. Rows are approximately $\frac{1}{2}''$ apart.

Observation of this quilt raises questions about its life history. The quilt has been lightly used, but is very well preserved, and the question arises as to how the quilt's condition relates to the attitude of its owner or owners. The apparently new goods used in its construction are incongruous with the relatively inept piecing. On the other hand, the piecing is at odds with the fine quilting.

AM4 S2.1.2.t(four point star #1) = (S1.t.2.3.2.1.l).u(diamond) = (S1.u.1). AM4 is a multicelled scrap quilt, with one of the two constituent

The Natural History of the Traditional Quilt

Figure 248

cell types cut from purchased plain pink fabric. The possibility that the fabric was originally white, and its present pink color is the result of the quilt's reds bleeding during washing, is ruled out by the fact that the quilt's binding is white. If the reds had dyed the fabric of the quilt, they would have colored the binding as well. It is unlikely that the quilt was rebound in white to replace a stained binding, because the white binding shows a degree of wear comparable to that of the fabric of the rest of the quilt. The backing is unbleached muslin. Irregularity in piecing is built into the design. The quilting is neat but very plain. The quilt is worn but clean.

The two cells which make up the design of AM4 are evident in Figure 249, which shows a section of the quilt. They are a four point star (pieced) and a diamond (unpieced). The four point star shape is made up of irregularly shaped scraps pieced into four elongated isosceles triangles joined to a central square made of four triangles. The star shapes are oriented with the central axis of their points running at a diagonal to the quilt's edges. The central square shape in each of the four point stars tends to be made of two colors, with opposite triangles being the same color and adjacent triangles being different; however, the two colors chosen for the central square vary throughout the quilt. The scrap selection is very mixed in color and kind (e.g., prints, solids, ginghams, etc.). Red gingham, black, blue, and bright yellow stand out. The shapes of the scraps which make up the points of the

Figure 249

star shapes are quite irregular. The quilt is five star-shaped cells wide and six star-shaped cells long. The star-shaped cells measure 17″ from point to point, and the overall dimensions of the quilt are 56″ × 68″. There are no borders or sashing. The quilting is an overall pattern of horizontal rows.

The condition and materials of AM4 are consistent with the characteristics of a prototypic scrap quilt. The quilt has been well used; it remains only to discover how, where, and by whom. The scraps may have particular associations because of their original sources (e.g., dresses belonging to the quilter), and this possibility invites investigation. Also, AM4 is built out of the same cell as another quilt in the corpus, AM25, with which it should be compared.

AM5 H2.2.(S1.1.1(U2.1.1(16)).1(16)).(S1.1.1(U2.1.1(16)).1(16)). The only quilt in the corpus of hybrid construction type is AM5. The coloration is regular: brown and yellow pieced units appliquéd on white squares. AM5 appears at first glance to be created from the replication of a single cell, but examination reveals the presence of two different cells. The apparent uniformity is an illusion. The edges of the square cells are parallel with the edges of the quilt. Sashing and borders are brown and yellow. The source (scrap or store-bought) of the goods cannot be determined for certain due to the aging of the quilt from use. A fair guess is that the white was purchased new, due to the quantity required and the fact that the squares are relatively large to be cut from scrap. Perhaps the yellow and brown were purchased also, since the colors are regular throughout. Also, there is generally an association with regularly colored appliqué work and purchased goods. The needlework

throughout the quilt is precise. The quilt is backed in unbleached muslin and bound in yellow. The quilt has been well used but is not overly worn.

The two cells for AM5 are shown in Figure 250*a–b*. Each cell is a square with a pieced unit appliquéd onto it. The pieced unit consists of sixteen pointed and angled blade-shaped patches joined radially to form a topological doughnut, with the patches alternately colored brown and yellow. In 250*a*, the blades are pointing in a clockwise direction; in 250*b*, they are pointing counterclockwise. The patches which make up the blades in 250*a* are mirror images of those which make up 250*b*, and therefore cannot have been cut from the same template. A close look at the blades suggests that, in fact, no template was used, since they are of many different, slightly varying shapes. Further, it would seem that the quilter may have cut patches for different cells at different times, since they are of different shapes. The setting diagram shown in Diagram 4 labels the clockwise cells *a* and the counterclockwise cells *b*. Note that the quilt is set with sashing, which is not indicated in the diagram.

The sashing strips are 2″ wide and cut from brown fabric which matches that of the cells. The intersecting squares are yellow, also matching the fabric of the cells. A pieced border in brown and yellow, $2\frac{1}{2}''$ wide, runs along both lengths and one width of the quilt. It is pieced from elongated trapezoidal patches, alternately reversed in orientation and alternately colored. Each square cell is $12\frac{1}{2}'' \times 12\frac{1}{2}''$, and the quilt consists of four cells in width and five in length. The quilt's overall dimensions are 61″ × 74″.

The quilting is neatly done and creates a counterpoint pattern which crosses from cell to cell (Figure 250*c*). The quilting pattern is quite simple, but its relationship with the pattern of the cells results in a complex interplay of lines. The quilting is by diagonally oriented squares which cross at the centers of the intersecting squares of the sashing and at the centers of circular space at the center of the pieced motif. The squares are quilted alternately in horizontal or vertical rows. Although the eye immediately perceives the quilting pattern as regular, the number of rows actually varies from square to square. An even number of rows in all of the squares would result in rows meeting at right angles at all of the edges of the quilted squares, but since there are unequal numbers of rows, they do not necessarily meet. Nevertheless, the eye smooths the pattern to regularity unless very particular attention is given to the formal features.

In terms of form, AM5 would appear to fall into the prototypic category of best quilt, due to the regularity of coloration and to the use of appliqué. Its well used condition, therefore, is of interest, and raises questions as to its

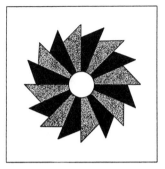

Figure 250a

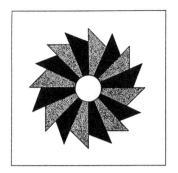

Figure 250b

Figure 250c

a	a	a	a
a	a	a	a
b	b	a	a
a	a	a	a
b	b	a	a

Diagram 4

The Natural History of the Traditional Quilt

category at birth and its subsequent life history in terms of use. Also curious is its status as the only quilt in the corpus featuring appliqué, suggesting perhaps special circumstances surrounding its conception. The free-form nature of the patches, evidently created without templates, is a further oddity in a prototypic best quilt. The shapes of the patches reveal much about the quilter's way of working, but also raise questions as to when patches were cut in relation to the task of piecing. The quilter may have cut patches for each cell as she went along, or she may have cut patches for groups of cells. Either of these procedures would easily account for the mirror image variation in the shape of patches from cell to cell. The other possible explanation, of course, is that the quilter deliberately varied the cells.

The quilting design is notable, since it is one of only two quilting patterns in the corpus (see also AM8) which is directly related to the cell in term of its placement, yet operates beyond the confines of the cell. The presence of a border on three sides is of interest and suggests a definite orientation with respect to a bed, perhaps with the unbordered edge at the head and the bordered edges lapping over the sides and foot.

AM6 S2.1.3.w(convex lens) = (S1.w.2.3.2.1.c).w(convex lens) = (S1.w.2.3.2.1.c).x(concave diamond) = (S1.x.1). The condition of AM6 is good. The quilt is unworn, though it has been lightly used and laundered. The pattern is made up of various colors (prints and a few solids, many light in value, probably scrap) and a quantity of white, which appears to have been purchased new. Solids in lavender and salmon recur regularly in the design at the points where cells meet, and these fabrics also may have been purchased, particularly since the binding is of the same salmon fabric. In a very few of the cells, there are matching sequences of fabrics on opposite sides of the cell, but for the most part the sequences of colors follow no simple pattern. The quilt is without borders and its edges are scalloped, following the circular shape of the design. Small triangles of white have been added to the edges of the quilt at the points where the indentations are the deepest, making the scallops more nearly straight. The backing is unbleached muslin. The handwork, both piecing and quilting, is precise and fine, with the latter being somewhat fancy relative to other scrap quilts in the corpus.

Figure 251*a* shows a portion of AM6. The quilt has three constituent cells: one is a curving diamond-shaped cell (Figure 251*b*), and two are convex lens-shaped cells (Figure 251*c*). The convex lens-shaped cell is pieced of a central patch of lens-shaped white enclosed by segmented strips terminating with diamond-shaped points at either end. In one type of cell, there are

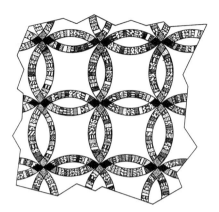

Figure 251a

Figure 251b

Figure 251c

twelve segments per strip, and in the other type there are thirteen. We surmise that the quilter did not use a template to cut her segments, but estimated their width by eye; thus the variation. A similar kind of variation is seen in AM21, which is extremely closely related.

Throughout the quilt, the diamond-shaped points are salmon and lavender, with opposite points colored the same and adjacent points colored differently. All of the lavender diamonds are oriented in one direction, and all of the salmon diamonds are oriented in the other. The segments of the strips of the lens shapes are cut from scraps. The curved diamond-shaped cell is cut from white fabric. The quilt is approximately 86″ × 100″, with each ring measuring 17″ in diameter. The design consists of five rings in width and six in length.

The quilting of AM6 is neat and close. Each strip section of each ring is quilted with three parallel lines of stitching running lengthwise through the strip. The convex lens-shaped white patches are quilted by the piece, and then with a triple interlocking ring motif. Each diamond-shaped cell is quilted with a motif of a four convex petal shapes surrounding a central

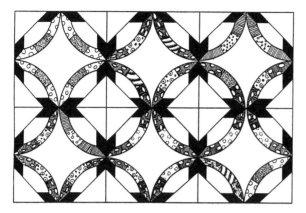

Figure 252b

Figure 252a

circle, with the points of the petal shapes oriented in the same directions as the points of the patch.

Despite the use of scraps of various colors, the quilt has an appearance similar to that of a prototypic best quilt, because of the intricacy of the work and the quilt's condition. The uses and circumstances of construction of the quilt are issues connected with its category in the minds of the maker and the owner, with the quality of work and excellent condition of the quilt being visual clues. Another point of interest is the quilter's apparent choice not to use templates for the segments of the ring shapes, which is a choice also apparent in AM5. AM6 bears a close relationship with AM21, with which it should be compared formally and in terms of its life history.

AM7 S1.1.2.3.2.3.c.c.l. This quilt is made from scraps in various colors and presumably purchased white, with the possibility that the solid red, which recurs regularly in the pattern, is also purchased. AM7 contains an assortment of scraps which appear to have come from the flannel pajamas of a little boy. The prints are of rockets, airplanes, parti-colored spots, and other boyish designs. The overall impression given by the quilt's coloration is one of white and light colors, with plenty of light blues, set off by reds. The quilt is well used and softened with age, but not excessively worn. AM7 has no borders. It is backed with unbleached muslin and bound in white.

The design of the quilt is a series of segmented rings with two diamond-shaped patches together pointing inward into each ring at each of four quadrant points (Figure 252a). The rings do not overlap. Although the pattern appears as rings, the cell is a square shape (Figure 252b), oriented parallel with the quilt's edges. The cell structure requires intricate piecing and curvilinear

seams. Each ring segment is pieced of three scrap patches. Often the scrap segments follow a color sequence of *a-b-a,* with the two colors markedly different in value. The diamonds are all of solid red fabric. Other patches are white, forming a background to the rings. AM7 is six cells in width and seven in length, with each cell measuring $9\frac{1}{2}''$ square. The quilt is $57'' \times 72''$. The quilting is neat and fine and follows an overall curvilinear design similar to that shown in Figure 84. In AM7, the series of curves in the quilting begins at both top and bottom of the quilt, so that the design is mirrored on either side of a horizontal line.

The design is interesting because of its appearance as rings versus its underlying square cell structure. The cell structure accounts for the fact that the edges of the design are half rings, since the ring shapes only emerge at the points where cells intersect. The half rings, along with the location of seams, are a visual clue to the structure of the cell. The piecing of the design requires skill and patience, but the quilt is made of scrap and has been well used. It is interesting that a quilt so intricately made was apparently intended for use, presumably by the little boy whose pajamas feature in the design. The relationship of the quilter to the boy and the circumstances of the quilt's creation are questions raised by the quilt's form. The quilting design is also interesting and relates the quilt to other quilts in the corpus with a similar design: AM13, AM14, and AM25. The quilt is also very closely related to its taxonomic twin, AM17.

AM8 S1.1.2.3.2.3.c.c.c. The dark green and white solid fabrics of AM8 are undoubtedly store-bought. The quilt's design is completely regular in color and piecing, and the green is vivid due to the fact that the quilt has not been used. The quilt is backed with fine grade white muslin and bound in white. The piecing is precise and the quilting is neat. The green patches which make up the circular motifs of the cells do not intersect anywhere, but the gaps between them are regular and appear to be part of the design.

The cell of AM8 is a square, radially pieced around a central patch with three steps out from the center (Figure 253a). The pattern appears as circular shapes, each made up of four convex lens shapes centered around a small, dark curving diamond centered in a light curving diamond. The cell's sides are parallel with the edges of the quilt. At the points where four cells intersect, another circular shape emerges, this one without the dark curving diamond shape inside (Figure 253b). Each cell measures $10\frac{1}{2}''$ square, and the quilt's dimensions are $61'' \times 84''$. The quilting is somewhat intricate, and crosscuts the cell structure (Figure 253c). The patches are quilted by the piece. In addition, each lens shape is quilted with a curving line parallel to

Figure 253a

Figure 253b

Figure 253c

the curve toward the inside of the cell, so that emphasis is placed on the circular shapes which emerge at the cells' intersections. The white diamond shape where the cells intersect is quilted with a six point asterisk stitched in double lines.

AM8 falls squarely into the prototypic category of best quilt, by virtue of its materials, its needlework, and its condition. The quilting pattern is interesting in that it runs counterpoint to the cells, as in AM5. The cell structure bears a relationship to that of AM7 and AM17. Though the latter two quilts are based on a cell structure which requires more complicated piecing, they are made of scrap. The fact that AM8 is made of purchased fabric and has not been used, not the intricacy of work involved, sets it apart from the other two. The reasons for the distinction in category would appear to lie in the quilt's life history and ecology.

AM9 S1.1.2.3.1.2.l.a. The fabrics of AM9 are vivid solids and large areas of white, all of purchased material which has retained its intensity of hue because the quilt has not been used or laundered. The eight colors of the

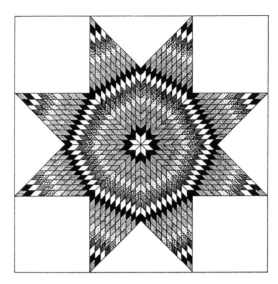

patches which make up the giant star shape repeat regularly, from the center: yellow, dark olive, blue-green, red, medium blue, pink, lavender, dark maroon. The piecing is precise and the great white areas of the quilt display fancy quilting motifs, exquisitely worked. The backing is fine grade white muslin. The square shape of the cell makes up the main body of the quilt. White $4\frac{1}{2}''$ borders run along two lengths, widening the finished quilt, which is bound in white.

AM9 is an example of a quilt which is composed of a single large cell, rather than made up of repetitions of a cell or cells. The cell structure is shown in Figure 254a. The design is pieced radially from a central point, with the large squares and half squares set in after the central motif is constructed. The central star-shaped motif is constructed from a series of eight pieced diamond shapes, each of which contains smaller diamonds. Each larger diamond-shaped subunit is sewn from one hundred small diamond patches arranged in a 10 x 10 grid and pieced in strips which run parallel to two opposing edges of the larger diamond, that is, the assembly of the diamond shapes requires no setting in. Nevertheless, such a large number of seams and acute angles in the shapes of the patches magnifies the possibility of error. Thus, the exactitude of the piecing is noteworthy. Large white squares and half squares complete the cell's square shape. The cell measures $63''$ square, and the quilt with its borders is $63'' \times 72''$.

The quilting of AM9 is elaborate. The central star shape is quilted in rows along two parallel edges of each strip of small diamond patches. The large square and half square patches are quilted with a combination of overall quilting and figurative motif (Figure 254b). Triangle shapes filled with a diamond

Figure 254b

grid are quilted into the corners of the square, in the center of which is a double feathered oblong wreath motif. The borders are quilted in a pattern of tessellated triangles, each quilted in rows (Figure 254*b*). The effect of the quilting in combination with the white binding and white background is that the central pieced motif stands out against a gently sculpted field.

There is little doubt that AM9 falls into the prototypic category of best quilt. Its intricate design and quilting, its regular colors, and its condition all attest to its status. A best quilt may have particular significance due to the occasion for which it was made or the person who received it as a gift; or there may be other significances to be discovered. The quilt stands out as the only example in the corpus which contains large, intricate quilted motifs. The question as to why AM9 should feature such quilting may find its answer in the source of the pattern (if purchased, it may have come with specifications and templates for quilting), or in the identity of the quilter (a professional quilter may have completed the quilting), or there may be other explanations.

AM10 S1.1.2.1.2.1.2. AM10 is an exceptionally vivid quilt, pieced in scraps of bright fabric and set with bright purple setting squares which are cut from new fabric. The pattern is one which is pieced with ease, particularly when compared with the designs of much of the rest of the corpus. Color use is somewhat regular: within subunits, opposite squares are the same color and adjacent squares are different colors, and the central cross shapes are all of the same pink and white print fabric. Overall, however, there is much variety. There are no borders. The quilt is backed in unbleached muslin and bound in white. It is quilted all over by machine, with a large zigzag stitch. Wildly wavering rows of stitching cross the entire quilt diagonally, the white thread standing out sharply against the purple setting squares and predominantly bright scraps of the cells. The quilt has never been used.

The cell structure of AM10 is based on a straight strip nine-based method of construction, with the nine units unequal in dimensions (Figure 255). All patches are relatively large, and all seams are straight. There is little in the way of complexity as far as assembling the overall design of the cell. Each pieced subunit of the nine follows its own color scheme, so that there can be no obvious error in placement (although, of course, a quilter can decide whether or not the choice of colors in closely placed subunits is suitable). The cells are oriented diagonally in relation to the quilt's edges, alternating with plain setting squares. Each cell measures $11\frac{3}{4}''$ square. The quilt is four cells in width and five in length, and measures $64'' \times 78''$ overall. As described above, the quilting is raggedly executed in machined diagonal rows.

The character of the work in AM10 is remarkable in comparison with that in the rest of the corpus. Its colors are by far the most bright, and the needle-work is much more irregular and uncontrolled. The most obvious questions associated with this quilt concern the reasons for the quality and character of the work in relation to the corpus as a whole. It is quite interesting that the quilt has never been used, since its formal characteristics are those of a pro-totypic scrap quilt. Possible reasons, to be explored, would include the owner's or maker's aesthetic valuation of the quilt (too pretty or not pretty enough to use), the lack of necessity for the quilt as a bedcover, and special significance of the quilt.

AM11 S1.1.2.3.2.2.l.a. AM11 was in use on a bed at the time of fieldwork. Though obviously used, the quilt shows little heavy wear. The cells of the quilt are made up of various scraps and white, with coloration regular within each cell but various throughout the quilt. Value relations remain the same throughout, so that the same design emerges in each cell. Much medium blue print is used, as well as some light blue and very light green prints. Toward the edges of the quilt, some golds and pinks appear, and near the center is a cell with patches in a red, green, and yellow print. Sashing is dark blue with white intersecting squares, and the same sashing forms a border. Sashing and cells have straight edges running parallel with the quilt's edges. The quilt is backed in unbleached muslin and bound in white. The piecing is adequately precise, but not exceptionally so. The quilting is plain and neat.

Radial piecing produces the cell of AM11, shown in Figure 256. The cen-tral diagonally oriented square patch receives four diagonally oriented strips pieced of right triangles, and then four larger triangles are inset to form a square cell. All the work is straight sewing except for the setting in of the final triangles in the cell. The design has a simple appearance, but is relatively intricate to piece. The quilt is five cells wide and six cells long. Each cell

Figure 255

Figure 256

Figure 257

measures 11″ square. The sashing is 4″ wide, and the overall quilt is 80″ × 94″. The quilting is simple and neat, with the cells quilted by the piece in the smaller colored patches, the central square patch, and the inset larger triangles. The sashing is quilted in a diagonally oriented square grid with diagonal squares quilted in the intersecting squares of the sashing.

Of interest is the quilt's use on the owner's bed, and the reasons for and significance of its use are the questions raised. Another point of interest is that the quilter has chosen a pattern which is not utterly simple, while the quilt has been executed in scraps. That is, the economy of materials is not echoed in an economy of time and labor. The indications would seem to be that necessity has not taken precedence over aesthetics in the case of this quilt, and that possibly the quilter took pleasure or pride or both in her skill as a needleworker.

AM12 S2.1.2.y(four point star #2) = (S1.y.2.3.1.1.a).z(octagon) = (S1.z.1). A great quantity of purchased white fabric gives AM12 an overall appearance of lightness and brightness. The colored cells each use one light and one dark fabric, presumably scraps, though some may be previously un-used fabric (possibly left over from another project). The needlework of quilting and piecing is precise and the quilting is neat and fine. AM12 has

been lightly used and is not worn. The quilt has no borders, is backed in unbleached muslin, and is bound in white.

The pattern in AM12 is made up of two constituent cells (Figure 257). The four point star shape is pieced from colored fabrics and the octagon is cut from white. The result is the appearance of a series of star-shaped images against a white ground. The points of the stars are oriented diagonally to the quilt's edges. Star shapes made from a yellow print and a dark green solid of new material recur in two loose groupings, and the colored cells are oriented in both directions. A group of star-shaped cells in blue plus grey and blue plus various oddments appears along one length, with all of the blue points oriented in the same direction. There are several star-shaped cells made of grey and a very light or white fabric, so that the white points are undemarcated from the adjacent octagonal cells.

The quilt is eight star-shaped cells in width and ten in length, each star measuring $5\frac{1}{2}''$ from point to point. The overall quilt measures $55'' \times 71''$. The star shapes and octagon patches are quilted by the piece, with a motif of crossed rectangles quilted inside each octagon. Figure 257 shows the quilted motifs marked in dashed lines inside the octagonal cells. Two different orientations of the motif appear, randomly distributed throughout the quilt.

A point of interest lies in the orientation of the darker points of each star. There is no fixed rule as to which direction the darker patches point, although there is a tendency for more of them to point in one direction than the other. The quilter has chosen irregularity where a more regular pattern would have been possible, given the same materials and the same construction method. The irregularity may be presumed, therefore, to have been a choice at some level. The two orientations of the quilting motif echo this choice of irregularity.

AM13 S1.1.2.1.2.1.2. Irregularity of piecing and coloration is built into the design of scrap quilt AM13. The cells are built of an array of brightly colored and dark scraps, prints, and solids. A central cross element in each cell tends to be cut from light blue or pink scraps with an intersection of one or another kind of red fabric, print or solid. The quilt features lots of red gingham, various red prints, pink, and a dark yellow solid, and some cells have a quantity of white. Setting squares are of presumably purchased white fabric. The quilt has a thin white border on each of two opposite edges, $2''$ on one edge and $3''$ on the other. Without the borders, the quilt would be square. It is backed in unbleached muslin and bound in white. The character of the piecing is deliberately irregular—a quality which is built into the pattern. The

Figure 258

quilting is elegantly fine and neat, and appears as a rich texture in the large white setting squares.

Figure 258 shows the cell structure of AM13. Orientation of the seam lines within subunits varies. The shapes of patches in the pieced subunits are highly irregular, in keeping with the concept of the pattern. The cells are oriented at a diagonal to the quilt's edges and set alternately with plain white setting squares. Each cell measures roughly 11½″ square. The quilt is four cells by four cells, and its finished dimensions are 67″ × 67″. The quilting follows an overall pattern similar to that seen in AM7 (see Figure 84 for an approximation). The circular design begins at opposite edges of the quilt, meeting in a line across the center of the quilt as it lies on a bed.

Although AM13 is a scrap quilt, the quilting is quite fine and the condition of the quilt is excellent. It bears a relationship with other quilts in the corpus which feature a similar quilting design: AM7, AM14, and AM25. All of these are scrap quilts, and AM25 is built on a cell concept which incorporates many various irregularly shaped patches.

AM14 S1.1.2.3.1.2.l.a. AM14 is a scrap quilt in which elements of the cells are echoed in the light blue sashing and white intersecting squares. A border of light blue extends all the way around the quilt. The cells are pieced of various scraps and white. A large number of cells are pieced in a beige print and green and white stripe. The piecing and quilting are neat. The quilt was in use on a bed at the time it was documented. It is in good condition.

The cell for AM14 is created through strip piecing (Figure 259a). The cell is nine-based, with five of the nine subunits forming a kind of internal sashing

Figure 259a

Figure 259b

of light blue with a white central intersecting square. Each of the remaining four subunits is radially pieced, with two steps from the center. The diamond shapes of the central portion of the cell are pieced in two alternating colors. Squares and half squares are white. A large number of the subunits are pieced in a beige print and a green and white stripe. In these, the striped patches are cut so that the stripes run parallel to opposite edges of the diamond, giving a twisting, scintillating effect. The stripes do not always run the same direction, and the striped points may appear either top left or top right.

Figure 259*b* shows a 2 × 2 cell section of AM14, including the border. The light blue sashing strips are of the same width as the shorter internal light blue strips, and the white intersecting squares of the sashing are identical with the central white square patch of the cell. The result is a counterpoint pattern of light blue crosses made up of the light blue sashing strips and the internal light blue strips. The white intersecting squares of the sashing demarcate the crosses, while the central white patch within the cell marks the center of that internal light blue cross.

The quilt measures 66″ × 79″ overall, including the sashing and borders, which are all $3\frac{1}{4}$″ wide. It is eight cells wide and nine cells long, with each cell measuring $12\frac{1}{2}$″ square. The cells' edges are parallel with those of the quilt.

AM14 is quilted overall in a pattern similar to that in AM7 and AM13 (see Figure 84 for an approximation). The circular design begins at opposite edges so that the circular patterns meet along a vertical line down the quilt's center.

The quilt is related to AM7, AM13, and AM25 by virtue of their similar quilting designs, and to AM1, AM9, AM15, AM19, AM20, and AM26 because the radial piecing of the subunit of AM14 is related to the radial piecing of the cells in the other quilts. Its use on a bed regularly slept in marks it as a utilitarian quilt, but its condition attests to special care.

Quilts owned by the elder daughter of Mrs. Mayo

AM15 S2.1.2.(S1.1.2.3.1.2.l.a).(S1.1.2.3.1.2.l.a). AM15 has been lightly used. The quilt is pieced in lavender and white. The lavender in the cells is a slightly different color from the lavender of the sashing. There are no borders, and the quilt is bound in white. The piecing is precise, and the quilting is elaborate and finely executed, giving the quilt a lacy appearance. As with AM1, the apparent uniformity of the cells proves illusory upon examination. The quilt is actually composed of two cells.

The two cells for AM15 are the same as for AM1 (Figures 246a–b), and the emergent pattern is the same (Figures 246c–d). The setting sequence for AM15 appears in Diagram 5, with cells as in 246a labeled *a* and cells as in 246b labeled *b*. The quilt is four cells wide and five cells long. The cells measure $12\frac{1}{2}''$ square and the sashing is 4″ wide. As with AM1, the cells and sashing have edges parallel with the quilt's edges. The finished quilt measures 63″ × 80″.

The patches in the cells of AM15 are quilted by the piece. In addition, cells and sashing are quilted with a selection of curvilinear motifs, shown in dashed lines in Figure 260. The cells have heart shapes quilted in double lines in white areas, in some cases crossing seam lines. The sashing strips are double lines of stitching in the form of a chain motif. The intersecting squares are quilted by the piece and have a tiny feathered wreath quilted into the center. The quilting in AM15 is by far the most elaborate and elegant of any quilt in the corpus.

The curiosity of AM15 is the use of two colors of lavender. It is reminiscent in this respect of AM2, in which two very similar shades of dark blue appear. The fact that, in each case, the cells are of one fabric and the setting elements of another suggests the possibility that the quilts were made in two stages; though, of course, another possibility is simply that the quilter had insufficient fabric of one type to complete the quilt. In both AM2 and AM15

a	b	a	a
a	a	a	b
b	b	a	b
b	b	b	b
a	a	b	b

Diagram 5

Figure 260

the piecing is exceptionally skilled. In comparison with AM1, built using the same cell, AM15 is by far the more precisely cut and pieced. The extremely decorative and complicated quilting makes the use of two colors even more interesting. If the quilt is made of scraps or oddments, the elaborate quilting is somewhat incongruous in terms of the prototypic best quilt that the regularity of color use suggests. Of further interest is the use of two mirror image cells, as in AM1.

AM16 S2.1.2.(S1.1.2.1.2.2).(S1.1.2.1.2.2). This quilt is made of scraps in various medium and light value fabrics. A green and white print and a pink and white print recur, each pieced with white patches within the cells. Two

cells near the quilt's center contain a darker fabric of purple and gold on white print. One cell near one edge is irregular in color, in that only one of the large triangular patches is a medium green solid, while the other colored patches are of a light green print. The quilter has used a medium blue print for the setting squares for AM16. Setting squares and cells are oriented with edges at a diagonal to the quilt's edges. Two cells are used in AM16, though they are identically constructed. The binding is white, and there are no borders. The quilt is in good condition, though used. Piecing and quilting are plain and neat.

The two constituent cells of AM16 are illustrated in Figure 261. Diagram 6 shows the setting sequence for AM16. In the cell in Figure 261*a*, labeled *a* in Diagram 6, the larger triangle shapes are toward the top and bottom of the quilt. In the cell in Figure 261*b*, labeled *b* in Diagram 6, the larger triangles are toward the quilt's sides. Diagram 6 shows that the distribution of the two types of cell follows no regular pattern. Half cells are indicated by *a'* and *b'*. Setting squares are labeled *s*, half squares are labeled *s'*, and quarter squares are labeled *s''*.

The quilting is very plain. The cells are quilted in rows running horizontally across the quilt. The setting squares are quilted in rows running diagonally across the quilt. The rows of quilting are about $1''$ apart. Each cell and setting square measures $10''$ square. The quilt's dimensions are $71'' \times 77''$.

The two cells of AM16 are identical in construction but have a conceptual difference in that they are oriented differently (and are therefore different cells by our definition, which identifies the cell as that unit of construction which requires only *setting* information and *not* orientation information to produce a finished quilt). In this respect the cells of the quilt resemble those of AM2 and AM3. Examples such as these make it clear that the cell concept, while attempting to follow principles of construction as closely as possible, is ultimately analytic in purpose, and, therefore, sometimes makes distinctions that a quilter might not (or casts them in terms that a quilter might not), but which are, nonetheless, significant to an academic inquiry. In this case it is not immediately clear whether the maker saw the two cells as the same or different, and, if different, how different, and how much the difference influenced overall construction choices.

AM17 S1.1.2.3.2.3.c.c.l. AM17 is the taxonomic equivalent of AM7, and, like AM7, it is constructed of scraps plus white. The scraps used are a variety of prints such as would be seen in dresses: dark blues, a blue and red, and a medium blue-green; in addition, a solid red is used. The diamond shapes in the cell are all of lavender. There are no borders, and the quilt is bound in

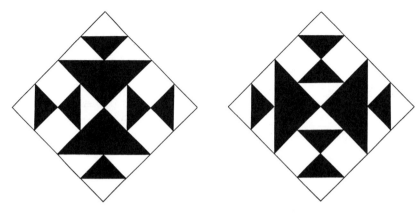

Figure 261a Figure 261b

```
s"   s'   s'   s'   s"

  a    a    b    b    a

s'   s    s    s    s    s'

  b    b    a    a    b

s'   s    s    s    s    s'

  a    a    a    a    a

s'   s    s    s    s    s'

  b    a    b    a    b

s'   s    s    s    s    s'

  b    a    a    b    a

s'   s    s    s    s    s'

  a'   b'   b'   b'   a'
```

Diagram 6

The Natural History of the Traditional Quilt

lavender and backed with unbleached muslin. The cell is 12″ square and the quilt measures 85″ × 97″. The piecing is precise, and the quilting is intricate and very fine. AM17 has been lightly used. In comparison with AM7, the quilt has a softer look in terms of its colors, which are much less bright and dark than those of AM7.

The cell structure of AM17 can be seen in Figure 252b. The quilting design follows the pattern of rings which emerge when the cells are set together (Figure 252a). The patches of the cell are quilted by the piece. Three parallel rows of quilting through the white area inside each ring connect each adjacent pair of diamonds (four sets of three rows per ring). The curving diamond shape at the center of the cell is quilted with a small central circle. Double lines of quilting cross at the center of the white space inside each ring.

A different selection of fabrics and a different approach to the quilting distinguish AM17 from AM7. The quilts are identical in genotype, but phenotypically unique. The pattern is quite well suited to the use of scraps, but its complicated piecing might conceivably place a quilt made from this cell in the prototypic category of best quilt. AM7 and AM17 appear to partake of both prototypic categories. They have been used, but are not overly worn.

AM18 S2.1.12.(S1.1.2.3.1.l.l).(S1.1.2.3.1.l.l).etc. Upon first sight, the pattern in AM18 appears to be a simple color and value reversal of that in AM3. Closer inspection reveals subtle differences and numerous anomalies in piecing. The quilt is made up of twelve different cells, placed together according to no regular pattern, yet the overall effect is one of regularity. The red and white fabric is new. The piecing of AM18 is more regular than that of AM3, but not nearly so smooth as that in AM2. The quilt has two borders, an interior 2″ border in white and an outer 1″ border in red. The quilt is backed in unbleached muslin and bound in white. The quilting is neat but not very close. AM18 has never been used.

Figure 262a shows a section of AM18, with examples of cell variations shown in Figure 262b–e. The central portion of each cell is identical, as are the central portions of the outer strips. The subunits of the four corners of the cells are variously oriented from cell to cell, creating the differences in cell structure. The cells measure $12\frac{1}{2}″$ square and the finished quilt is 88″ × 104″. The quilting of AM18 is an overall pattern of vertical rows of double lines, with the rows 4″ apart.

The main question in relation to AM18 lies in the way in which the anomalies occurred and were incorporated into the quilt. The regularity of color, the purchased fabric, and the quilt's unused condition would seem to

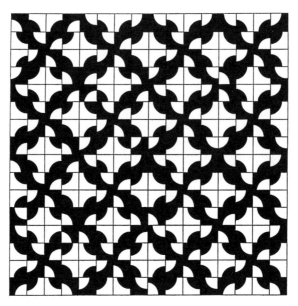

Figure 262a

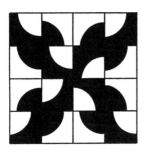

Figure 262b

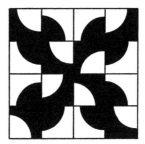

Figure 262c

Figure 262d

Figure 262e

The Natural History of the Traditional Quilt

place it in the prototypic category of best quilt, despite the anomalies. The quilt's relationship with AM2 and AM3 is of interest, and the entire grouping is discussed in Section 5.4.

AM19 S1.1.2.3.1.2.l.a. This scrap quilt is pieced in shades of red, pink, white, and blue. The quilt has been well used, and portions of it are ragged and full of holes. Notably, the red fabric (but not the white) in the borders along two sides is worn through in many spots. The red in the borders on the top and bottom edges is a different fabric, sturdy and vivid in color, and was apparently new when the quilt was made. The central portion of the quilt shows a regularity of color use in that all small diamonds at the same level in the larger diamond shapes are of the same fabric; but there is no regular repetition of fabrics within the rows of small diamonds from center to outer points of the large diamonds. The pieced square subunits show much variation within and between squares. AM19 is backed in unbleached muslin and bound in white. Piecing and quilting are structurally adequate but not overly precise.

Figure 263a shows the cell structure of AM19. It is closely related to AM9 and AM20, but the diamond grid on which the large diamond shapes are constructed is 8 × 8 patches in AM19 and 10 × 10 in the other two quilts. Unlike the other two quilts, AM19 has square subunits which are pieced rather than plain. Each subunit is differently colored, and there are three sets of value relations in all. The uncolored subunit is shown in Figure 263b. The quilt has a border which extends all around the quilt. Along the lengths it is 6″ wide, and along the widths it is 4″ wide. The border is pieced of red and white tessellating, gently trapezoidal shapes, with the narrow ends of the red trapezoids nearest the quilt's edges. The quilt's central motif is quilted along the rows of the small diamond patches. The half squares and pieced squares are quilted in horizontal rows. All rows of quilting are about 1″ apart. The quilt measures 69″ × 74″.

The intricacy of piecing and the irregularities, as well as the unusual feature of the pieced corner squares, make AM19 interesting. The difference in fabrics in the pieced border is also curious. This quilt is discussed further in Section 5.5.

AM20 S1.1.2.3.1.2.l.a. AM20 is similar to AM19 in many respects. It is a scrap quilt built on a very similar cell to that of AM19. Its grid of diamonds, however, is 10 × 10 instead of 8 × 8, and its squares and half squares are of plain white fabric instead of being pieced. The mixture of scraps in AM20 includes many prints, mostly of medium and light values. There is no pattern

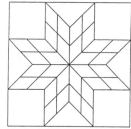

Figure 263b

Figure 263a

of repetition in the sequence of colors of rows of small diamond patches, but analogous rows in the larger diamond shapes are of the same fabrics. The inmost small diamond of each larger diamond, the eight of which form a central shape, is dark red. Where the small diamonds form a continuous band around the center of the larger diamond shapes, the patches are dark blue. About halfway between the dark blue band and the outer tip of each large diamond shape is a row of dark green solid patches. A narrow border is pieced of the same dark green solid and a light print. White fabric is used for the other borders. The quilt is backed in a fine grade of unbleached muslin and bound in white. The piecing is precise and the quilting neat and fine. A20 has been lightly used and shows heavy fold lines.

The cell for AM20 is shown in Figure 264. It is the same as the cell for AM9, but the coloration makes for a striking visual difference. The quilt has a series of three borders top and bottom and two along the sides. From the inside out, the top and bottom borders are: a 4″ white border, a pieced border of narrow rectangles each 2″ wide by 4″ long, and another 4″ white border. From the inside out, the side borders are: the same pieced border as along the top and bottom and a 2″ white border. The pieced motif of the cell is quilted in rows along the strips of small diamond patches. The large white square patches are bisected and then quilted in rows set at 90° to the bisecting

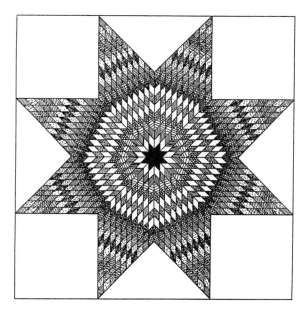

Figure 264

Figure 265

line, with the quilted rows running all the way through all borders to the quilt's edges. The white half squares are quilted in rows running perpendicular to the nearest edge of the quilt, all the way through all the borders. AM20 measures $72'' \times 83''$.

The relationship of the three quilts AM9, AM19, and AM20 is of particular interest and is discussed in Section 5.5. It is evident that the patches of AM19 were cut using different templates from those used in AM9 and

AM20. The reason for the different sets of templates, and for the other differences among the quilts, are issues to be explored. Although AM20 is a scrap quilt and the quilting is not fancy, it has received a certain kind of attention from its owner. It has seen some use but has been stored for long enough that fold lines are evident. A change in the quilt's status or function at some point in its life history may be indicated, and questions arise as to the reasons for the change.

AM21 S2.1.3.w(convex lens) = (S1.w.2.3.2.1.c).w(convex lens) = (S1.w.2.3.2.1.c).x(concave diamond) = (S1.x.1). AM21 is a scrap quilt which is similar to AM6 in its cell structure and use of color. It is not possible to tell what the original colors of the scraps were in AM21, because the quilt is extremely faded and worn, and all fabrics are now very light. The selection of materials is exceedingly various, and a quantity of white is used for portions of one constituent cell and all of another. Lavender print and yellow diamond-shaped patches recur at the points of the lens-shaped cells. There is no border. The quilt is backed in unbleached muslin, and the deeply scalloped edge, which follows the curves of the pieced design, is bound in pink. The piecing is neat and the quilting is relatively intricate and close.

A portion of AM21 is shown in Figure 265. The two constituent cells are similar to those in AM6 (Figure 251*b–c*). In AM21, however, the cell which is similar to that shown in Figure 251*b* has nine or ten segments per ring section instead of twelve or thirteen. As with AM6, it would appear that the quilter did not use a template for the patches making up the ring sections. It is possible that in each quilt she used an arc-shaped template from which she cut segments by eye, and then mixed the patches cut from one arc with those cut from others. This would account for the differences within and between the quilts.

Three parallel rows of quilting run along the pieced ring sections through all of the patches and the intersections at the points. The white lens shapes at the center of the lens-shaped cells are quilted with two concentric lens shapes. The curving diamond-shaped cell is quilted by the piece and with a motif similar to that described for AM6, except that in AM21 the lines of quilting which make up the motif are doubled. The quilt measures 71″ × 89″ overall.

The piecing in AM21 is less intricate than that in AM6, but the quilting is somewhat more elaborate. AM21 is much more worn than AM6, which has been used but is still in good condition. AM21 is ragged and faded. Nevertheless, it has been kept, and it maintains its integrity as a whole quilt. A

comparison of the two quilts points to the evident importance of other factors beyond the formal in an individual quilt's life history. It should also be noted that AM21 was not brought out for documentation by the owner, and its presence was revealed only when the authors were helping the owner put her quilts back into the closet in which they are kept. Thus, the owner's regard for the quilt may be supposed to be based upon sentiment rather than on formal appreciation. Also, she may have feared negative judgement. She expressed knowledge that the quilts are worth money to collectors, and she may have felt that outsiders would consider her treatment of the quilt to have been wasteful or abusive. Her reason for neglecting to show the quilt initially was that it was in such poor condition. Differential display of quilts by their owners can lead to a skewed perspective on the nature of the tradition or of a particular corpus. The fieldworker should be alert to the possible existence of quilts which the owner does not deem worthy of documentation.

Quilts owned by other descendants

AM22 S1.1.2.1.2.1.1. AM22 is an unquilted top. The hand sewn seams are open to view on the reverse side of the top, and the stitching is moderately coarse. The top is pieced of bright red purchased fabric (used for borders and setting squares) and a small selection of scraps: red and white gingham, a red and white houndstooth weave, a gold cotton solid, and a dark gold print corduroy. Color use is regular within the bounds of available scraps: each cell has four patches of red and white (either the gingham or the houndstooth) and five of gold (either the solid or the corduroy print). From a distance, the gingham and the houndstooth are very similar in appearance. AM22 contains anomalies in the form of several patches which have been pieced of small bits of red and white houndstooth and of the gold solid. Because the top has not been quilted, it of course has not been used as a quilt.

The cell structure of AM22 is simple, as shown in Figure 266. Pieced cells alternate with plain setting squares, and all are oriented at a diagonal to the top's edges. There are two side borders which are each 4″ wide. Cells and setting squares measure 8″ × 8″, and the top's dimensions are 67″ × 71″.

Evidently, the quilter had a particular color scheme in mind but not enough suitable scraps to make up her top without some variation. The hint is in the pieced patches. Apparently, the quilter was trying to eke out a small amount of material before resorting to an alternative fabric for completing the design. Since this is the only unquilted top in the corpus, the obvious question is why AM22 alone should have remained unquilted.

<div align="center">

Figure 266 Figure 267

</div>

AM23 S1.1.2.1.2.1.1. AM23 is a scrap quilt which contains a quantity of white fabric, presumably purchased, in the cells and as setting squares. The selection of scraps ranges from extremely light in value to black. All combinations of values appear in the cells, each of which contains two values and white. Blues predominate, and there is no regular order to the distribution of cells according to the values and colors they contain. AM23 is borderless, backed in unbleached muslin, and bound in white. The quilt is well used and quite soiled, though with no particular stains. Piecing and quilting are adequately neat.

Figure 267 shows the cell structure for AM23. The cells alternate with plain setting squares in the quilt. All cells and setting squares are oriented diagonally to the quilt's edges. Where the top and bottom corners of the cells meet, the pattern formed by the colored patches continues from cell to cell. The appearance of continuation is mitigated by the variation in color and value from cell to cell. The cells of AM23 are quilted in vertical rows, with respect to the quilt, and the setting squares are quilted in diagonal rows. Each cell and setting square measures 10″ × 10″, and the quilt is 58″ × 65″.

Of all the quilts, AM23 is the one which shows the most soiling. AM25 shows staining, but not so much soiling. Questions of life history should explain the condition of the quilt. The cell in AM23 could have a counterpart that is the same in construction but shifted 90°. The fact that the quilter has not made use of this option for AM23, when she has so often made use of it for other quilts, is notable. Something about the character of the pattern in AM23 may have constrained her choice regarding orientation of the unit of construction. Unlike the other patterns, in which variation of orientation

or construction occurs, AM23 shows a linear pattern across the cell. The linearity may have determined the quilter's perception of directionality in the pattern. The patterns which show variation have two or more axes, which may obscure directionality or make it less important for the quilter.

AM24 S1.1.2.3.2.2.l.a. The maroon and white quilt AM24 is another example of a design which gives an impression of absolute regularity, but which in fact has irregularities built in. The cells are pieced of maroon and white, but two shades of maroon are used in some of them. The setting squares are maroon, the same shade as one of the fabrics used in some of the cells. Along one length is a 3″ wide border which is maroon except for a patch of brown at one end. The quilt is backed in unbleached muslin and bound in white. The piecing and quilting are neat, though the quilting is very plain. AM24 is greatly faded and worn, with many tears.

Figure 268*a–b* shows two sections of AM24, with the cells and setting squares set diagonally to the edges of the quilt. In 268*a,* the dark fabric of the cells matches that of the setting squares, so that when the cells are set together an octagonal shape emerges where they intersect. In 268*b,* a lighter color of maroon fabric is used for the outermost triangles of the cells, so that the square shapes of the cell and the setting square are demarcated. The cell structure is evident in 268*b.* It is radially pieced around a central patch, with two steps out from the center. The points of the four point star shape of the cell are pieced and joined to the central patch and the outer triangles set in afterward. Nine of the cells and all five of the half cells which make up one edge (at the end where the brown border patch is) are of the type shown in 268*a.* Nineteen are of the type shown in 268*b.* One cell has a mixture of fabrics for the outer triangles. The cells and setting squares measure $8\frac{1}{2}″ \times 8\frac{1}{2}″$. The quilt's measurements are $61″ \times 75″$. The quilting of AM24 is very simple. Rows of stitching run diagonally through the cells and horizontally through the setting squares.

The two colors of maroon are of the greatest interest in AM24. It would be important to know what the difference in color was before the excessive fading of the quilt. The presence of the brown patch is also interesting. The two colors of maroon and the use of the brown would seem to indicate that the quilter did not have sufficient material of one kind to carry out her idea in a perfectly regular fashion. This did not stop her, however, from completing her project as if she were using all the same kind of fabric. The condition of the quilt indicates heavy use, and perhaps even an especially traumatic incident in its life history which precipitated the tearing. The quilting emphasizes the square cell structure, even though the pattern, if pieced all in the

Figure 268a

Figure 268b

same fabric as the setting square, does not. This, coupled with the fact that the quilter has used colors which demarcate the square cell in most cases, would seem to indicate that the emergence of the octagonal shape was of little or no importance to her relative to the design of the pieced square cell alone.

AM25 S2.1.2.t(four point star #1) = (S1.t.2.3.2.1.l).u(diamond) = (S1.u.1). AM25 is a scrap quilt built on the same constituent cells as AM4. Irregularity of patchwork shapes and color distribution is part of the design concept of the pattern. AM25 is less mixed in color than AM4, and it is less erratic in its piecing. Recurrent scraps in AM25 include a dark green solid and a dark green print, a medium blue, a maroon, and other dark colors. Unpieced cells are of white fabric. The quilt is neatly constructed and

quilted. The quilt is backed in unbleached muslin, has no borders, and is bound in white. AM25 is well used. It shows fold lines and a series of dark stains which look as if a single spot has bled through folded layers.

The cells which make up AM25 are shown in Figure 249. The measurement of the star-shaped cells is $17\frac{1}{2}''$ and the finished quilt is 60" × 80". The quilting of AM25 is similar to that in AM7, AM13, and AM14. An approximation of the design is shown in Figure 84. In AM25, the circular pattern of the quilting begins at the top and the bottom of the quilt and meets along a horizontal line across the center of the quilt.

The great similarity between AM4 and AM25 is notable. Both quilts have been used, as would seem prototypically appropriate to their construction as scrap quilts. Other kinds of similarity in their life histories might be suspected, such as their creation for similar purposes. The quilting in AM25 and the other quilts which have similar patterns is interesting because of the dual orientation of this overall circular design. No practical reason can account for this feature in the quilting, and it must be seen as an aesthetic choice.

AM26 S1.1.2.3.1.2.l.a. AM26 has been well used but is not excessively faded or worn, except that the white binding is ragged in spots. The whites of the quilt show a degree of soiling, but the quilt is not stained. The thin cotton batting has shifted and bunched somewhat, due to laundering. The quilt's cells are made of various scrap cotton prints and white. The 5" wide sashing is a vivid blue solid with intersecting squares of rose solid, both presumably new materials judging from the quantity and condition of the fabric. The quilt has no borders and is backed with unbleached muslin. AM26 is constructed of two constituent cells which are mirror images of one another. There are anomalies of color in some of the patches of some of the cells. One cell is entirely anomalous. The piecing is not terribly precise. The quilting stitches are small and even (ca. nine to the inch, counting both under and over portions of the stitching); the lines of the quilting pattern waver very occasionally from the straight.

AM26 measures 63" × 80". The design of the quilt's top is composed of a series of twenty cells, 12" square, oriented parallel with the quilt's edges and arranged in rows of four and columns of five, separated by sashing as described above. The colored cells for AM26 are shown in Figure 269a–b. Each cell features a different combination of scrap materials, although the same scrap material may appear in several cells. The setting scheme in Diagram 7 shows the arrangement of the constituent cells, with those as in Figure 269a labeled *a* and those as in Figure 269b labeled *b*. The anomalously colored cell

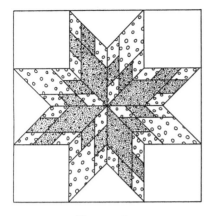

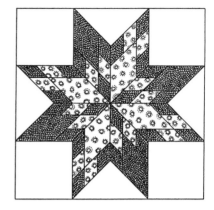

Figure 269a Figure 269b

b	b	a	b
b	b	a	a
a	b	a	b
a	b	a	a
B	a	b	b

Diagram 7

is labeled *B*. This anomaly is discussed fully in Section 5.5, which also contains a more detailed description of the cell structure and its realization in color.

The quilting pattern of AM26 follows the piecing design, with individual patches outlined in lines of quilting $\frac{1}{4}''$ in from the seamlines. Larger patches also contain some simple motifs and overall patterns: corner squares in the pieced cells contain X shapes, and sashing strips contain longitudinal parallel lines of quilting forming a grid pattern at the intersecting squares.

Discussion

Much about Mrs. Mayo's methods and her aesthetic can be learned from a rigorous examination of the formal features of her quilts. In addition, careful analysis can generate appropriate interview questions for her descendants

who may have watched her quilt and who have lived with her quilts in their homes. The corpus comprises a number of overlapping groups of quilts, distinguished by apparent formal/functional category, quilting type, design variation type, and taxonomic designation. Each of these groups will be discussed in turn.

Apparent formal/functional categories are evident in the corpus. These categories are not absolute, but are relative and derived from the corpus itself. The unused, prototypic best quilts, made from purchased fabrics (all in solids), are AM1, AM2, AM3, AM8, AM9, and AM18. The used, scrap quilts include AM4, AM7, AM11, AM12, AM13, AM14, AM16, AM17, AM19, AM20, AM21, AM23, AM24, AM25, and AM26. Three quilts are ambiguous as to category. AM5 is an appliqué hybrid worked in solids of two colors and white, but it is well used. AM6 is an elaborately pieced scrap quilt, used very lightly and extremely well kept. The use of scraps (or at least a wide variety of small amounts of fabrics) is built into the design concept, and there is some regularity of color use. AM15 is slightly more used than AM6, and intricately quilted. AM15 is made of solids, regularly distributed, but they are of two slightly different colors and white. The two remaining quilts belong to the two final categories, anomalous and unfinished. AM10 is anomalous relative to the rest of the corpus, because of its ragged machine quilting. It features large amounts of purchased solid colored fabric. The unfinished AM22, which also contains large areas of purchased solid fabric, is an unquilted top.

The categories arise from an examination of the quilt's morphological features and their condition. The former may constitute the quilter's conception of the quilt's category, while the latter may be the result of the owner's (or owners') notion of the quilt's category or status. All of the prototypic best quilts and two of the three ambiguous quilts are stitched of solid colors of fabric. The anomalous and unfinished quilts, both of which are unused, also contain purchased solids used for large setting squares, along with scraps for the pieced cells. This usage of solid colors might seem to group AM10 and AM22 with the prototypic best quilts in one way, although the best quilts feature no scraps at all. Among the scrap and used quilts, only AM24 is cut from solid colors, but the use of the two slightly different shades of maroon is irregular, and there is an anomalous patch of brown along one edge. Thus, the owners of quilts pieced from solids have tended to treat them as best quilts, with a few exceptions. Quilts pieced from scrap have generally been used, though some much more than others.

Before going on to consider categories based on the designs of the tops, we will briefly discuss the quilts in terms of the type of quilting employed.

All of the quilts are quilted by the piece, with the exception of those which are quilted in an overall motif which covers the entire quilt without regard for cell boundaries. This latter group includes AM4 and AM18, which are quilted in straight rows; and AM7, AM13, AM14, and AM25, which are quilted in an overall curvilinear pattern. Other quilts have areas which contain an overall or textured quilting design: AM2, AM3, AM9, AM11, AM16, AM19, AM20, AM23, AM24, and AM26. AM5 and AM8 are quilted in an overall pattern which is related to but crosscuts the cells. The quilts which contain quilted motifs are: AM1, AM6, AM9, AM12, AM17, and AM21. AM10 is anomalous in its quilting and AM22 is not quilted. The groups by type of quilting are not isomorphic with those based on formal/functional categories or on taxonomic groups. The factors influencing the different kinds of groupings appear to function independently. It is interesting to note the range of types of quilting seen in the corpus. Given the quilter's strong predilection for specific types of patchwork patterns, discussed below, the variety of quilting styles is notable.

Taxonomic designations allow for the arrangement of Anna Mayo's quilts in a kind of family tree (Figure 270). The designations represent broad groups only and are not full designations of the quilts at the species level, but they show relationships according to the method of construction employed in the quilts' production. Thus the groupings show proclivities of the quilter in terms of her preferred methods. It cannot be known whether the quilter chose the designs primarily on the basis of construction method. The presumption would be that she did not, but rather that she chose them for their appeal to her eye. Because of the geometric properties of the designs, however, their visual appeal is linked with certain facts of construction method. Thus the choice of certain types of design implies the choice of a specific kind of construction method, which the quilter either actively preferred, or at least did not object to.

All of Anna Mayo's quilts but one fall into the seamed base category. The exception is AM5, which is a hybrid. Mrs. Mayo worked in patchwork, and even AM5 is built of cells which involve the appliqué of a pieced unit onto a plain square. The corpus is more or less evenly divided between quilts based on multiple cells and those based on a single cell. The hybrid AM5 is made of multiple cells; of the seamed base quilts, thirteen are based on a single cell and twelve are built of multiple cells. All of the multiple celled quilts are built of regular cells. Further, only five of the twelve multiple celled quilts are built of cells which are not squares. The large majority of Mrs. Mayo's quilts, therefore, are built of square patchwork cells.

The five quilts which contain nonsquare cells fall into three groups: AM6 and AM21 contain lens-shaped cells and curving diamond-shaped cells, AM4 and AM25 contain four point star shape cells and diamond-shaped cells, and AM12 contains cells of a different four point star shape and octagon-shaped cells. Thus there are in total only five nonsquare cell shapes. In the quilts which have multiple square cells, the constituent cells within each quilt are extremely closely related taxonomically. This fact is connected with certain forms of variation which characterize Mrs. Mayo's quilts, and which are discussed below. The square cells of the multiple celled quilts also bear close relationships with the cells of certain of the single celled quilts, a matter which is taken up below and in Sections 5.4 and 5.5. The quilts based on a single pieced square cell fall into two main groups. Of these single cells, there are six which are pieced in straight strips (one four-based and five nine-based, the latter divided between two with equal and three with unequal units) and eight which are radially pieced (three around a central point and five around a central patch). Thus, a preference for radial piecing is indicated, with no marked bias for either central point or central patch designs.

The constituent cells of Mrs. Mayo's multiple celled quilts can be coded for their piecing methods, and a taxonomy of individual cells can be built which includes cells from multiple and single celled quilts (Figure 271). The taxonomic designations of the quilts relate items of the corpus on one level, and those of the cells on another. The taxonomic designations of cells relate items of the corpus in terms of the construction of constituent units. Looking at the taxonomy of cells, it is clear that Mrs. Mayo's overwhelming preference was for the radial method of piecing. Of a total of fifty-one cells, thirty-four employ radial piecing. (This enumeration includes the pieced appliqués of the hybrid AM5 and all of the multiple patch nonsquare cells, and counts as distinct the cells of quilts which are taxonomic twins.) It should also be noted that eight quilts in the corpus require curvilinear seams in piecing, and ten quilts require insetting. The cells which include these types of seams are all radially pieced.

Mrs. Mayo's tendency toward radially pieced designs is notable, particularly since within her own corpus, as in the tradition in general (in large part due to fundamental geometric facts), such designs may frequently require insetting. Added to her penchant for designs featuring insetting is Mrs. Mayo's apparent attraction to patterns which include curved seams. Both kinds of seams, inset and curved, call for a skilled and experienced hand with the needle. Perhaps the quilter (or the recipients of her quilts) liked the patterns based upon association (names or sources of the designs, say). Maybe

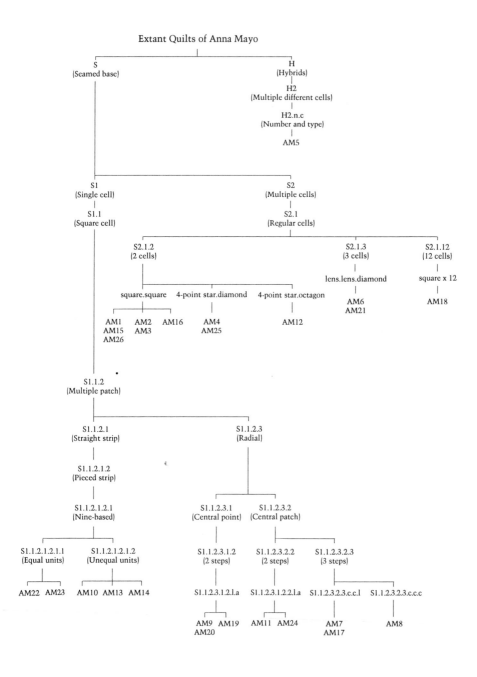

Extant Quilts of Anna Mayo

S
(Seamed base)

H
(Hybrids)

H2
(Multiple different cells)

H2.n.c
(Number and type)

AM5

S1
(Single cell)

S2
(Multiple cells)

S1.1
(Square cell)

S2.1
(Regular cells)

S2.1.2
(2 cells)

S2.1.3
(3 cells)

S2.1.12
(12 cells)

lens.lens.diamond

square x 12

square.square 4-point star.diamond 4-point star.octagon

AM6
AM21

AM18

AM1 AM2 AM16 AM4 AM12
AM15 AM3 AM25
AM26

S1.1.2
(Multiple patch)

S1.1.2.1
(Straight strip)

S1.1.2.3
(Radial)

S1.1.2.1.2
(Pieced strip)

S1.1.2.1.2.1
(Nine-based)

S1.1.2.3.1
(Central point)

S1.1.2.3.2
(Central patch)

S1.1.2.1.2.1.1
(Equal units)

S1.1.2.1.2.1.2
(Unequal units)

S1.1.2.3.1.2
(2 steps)

S1.1.2.3.2.2
(2 steps)

S1.1.2.3.2.3
(3 steps)

AM22 AM23 AM10 AM13 AM14 S1.1.2.3.1.2.l.a S1.1.2.3.1.2.2.l.a S1.1.2.3.2.3.c.c.l S1.1.2.3.2.3.c.c.c

AM9 AM19 AM11 AM24 AM7 AM8
AM20 AM17

Figure 270

The Natural History of the Traditional Quilt

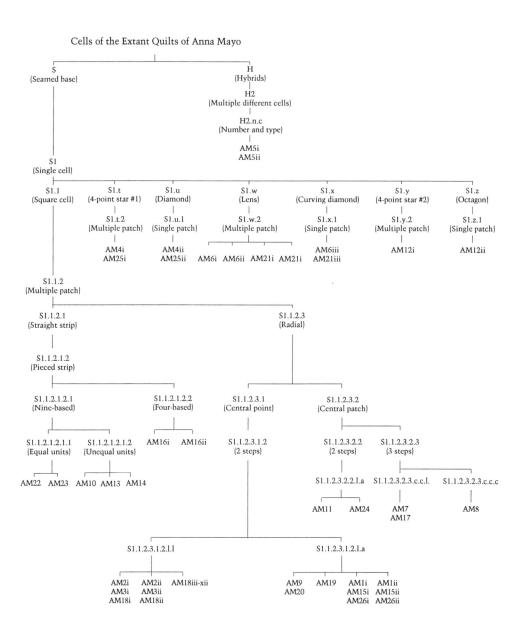

Figure 271

Mrs. Mayo was proud of her skills as a needleworker and wanted to display them, or maybe she took pleasure in the challenge of exercising them. These are the kinds of possibilities, suggested by formal features, which can be explored in interviews with relatives or in ethnography if the quilter is living.

A further possibility, however, not mutually exclusive with the other two, is presented by and can be investigated through the formal features alone. That is, the quilter may have selected the designs based upon some shared formal features and the ways in which they intersected with her own aesthetic tendencies in realizing them. Clues abound in the corpus that this is in fact the case, but in order to consider them it is first necessary to discuss one other set of groupings into which the quilts can be arranged.

A number of Mrs. Mayo's quilts show special kinds of variation in construction and design. These kinds of variation go beyond the permutations of color and texture common to all scrap quilts, including Mrs. Mayo's. Subtle variation on a number of levels characterizes Mrs. Mayo's corpus, a fact which is all the more remarkable because many of the quilts displaying such variation give an immediate impression of regularity. The paradox of an impression of regularity arising from the use of subtle but radical variation and the formal attraction for Mrs. Mayo of radial piecing and curvilinear designs are the two major issues which can be addressed through a consideration of her tendencies in variation.

Before turning to the different kinds of variation, however, it is important to stress that variation and anomaly are not the same thing. Anomalies, which do occur in Mrs. Mayo's quilts, may or may not be deliberate. An anomalous quilt stands out in relation to the corpus as a whole. AM10 is the only quilt which is machine quilted, and that quilting is wildly erratic. Therefore the quilt is anomalous. An anomalous feature in a quilt stands out in relation to the rest of the quilt. AM22 has a few patches which themselves are pieced from small bits of like fabric, and therefore are anomalous in relation to the majority of patches, which are unpieced. The quilts that include anomalies are: AM1, which has an anomaly in piecing (discussed in Section 5.5); AM24, whose border features an anomalously colored patch; and AM26, one cell of which is anomalously colored relative to the rest of the cells (see Section 5.5). The latter case is ambiguous and might be considered an instance of variation in coloration. It is treated here as anomalous because it is a single cell which varies so significantly in coloration from all the rest that a separate pattern emerges. A different pattern, the same from cell to cell, emerges in all the others.

The kinds of variation seen in the piecing of some of Mrs. Mayo's quilts can be classified as follows: variation in shape of patches, variation in con-

struction, variation in orientation, variation in number, and variation in coloration. The quilting in some of the quilts also shows variation, in either orientation or number. Of course, wherever the quilts that show variation in piecing are quilted by the piece, the quilting will show variation congruent with that of the piecing.

AM5 shows variation in the number of lines per quilted section (Figure 250c). The overall pattern looks regular despite the fact that lines of quilting frequently do not meet at intersections of quilted portions. Other quilts with variation in number of lines per section are AM16, AM19, AM20, and AM23. The differences from section to section suggest that the quilter did not use fixed measurements for the placement of the lines of stitching, but instead used her eye to situate them as she went. This principle of operation was apparently preferable to the quilter and overrode considerations of exactness and regularity, since even in AM5, where evenly spaced rows would have met in right angles, mechanical measurements were not used. The method may have suited the quilter better than one involving exact measurements, and she either tolerated or embraced the aesthetic result.

AM2 and AM12 vary in the orientation of the quilting design. In AM2, the overall quilting design in the whole setting squares is oriented in a different direction from that in the partial setting squares, which fill in between the cells at the edges of the quilt. AM12 (Figure 257) has motifs oriented in two directions, with variations randomly distributed throughout the quilt. The quilting concepts in AM2 and AM12 appear to operate relative to the unit being quilted at the moment. The concepts in the abstract apparently do not include a fixed notion of orientation. The variations in AM2 and AM12 do not read as irregular. The quilts continue to appear regular even after close attention has revealed the discrepancies.

Variations of shape, number, coloration, orientation, or construction characterize many of Mrs. Mayo's quilts. AM5 (Figure 250a–b) shows variation in the shapes of constituent patches from cell to cell, and even within the cell, suggesting that no templates were used. Evidently, no templates were used for the smallest patches in AM6 (Figure 251a) and AM21 (Figure 265), because there are variations in their number from cell to cell in both quilts. Several quilts have variation in coloration which affects the apparent design or the orientation of that design: AM12 (Figure 257), AM14 (Figure 259), AM19 (Figure 263), and AM24 (Figure 268a–b). Four quilts have cells which are the same in construction but vary in orientation. They are: AM2 (Figure 247b–c), AM3 (Figure 247b–c), AM16 (Figure 261a–b), and AM18 (Figure 262a). Four quilts have constituent cells which differ from one another in construction, though using the same number, shapes, and

color values of patches and the same method of piecing: AM1 (Figure 246a–b), AM15 (Figure 246a–b), AM26 (Figure 269a–b), and AM18 (Figure 262b–e).

The variation in Mrs. Mayo's quilts can be discussed from two points of view: that of the viewer (whose relation to the quilt is one of *perception*), and that of the quilter (whose relation to the quilt is one of *conception*). From the point of view of the former, the quilts do not present eccentric irregularities to the eye. They appear regular in geometry and in stitchery, though of course the scrap quilts show characteristic variation in color. Put Mrs. Mayo's quilts side by side with those made by a revival or art quilter, however, and the difference between the two types is immediately felt. The revival quilt is generally characterized by a mechanical regularity which is not typical of the tradition. The revival quilt displays what could be called a "hard" regularity and precision, while the regularity and excellence of needlework manifested in the traditional quilt is "soft." That is, the traditional quilt appears gently regular and exact in many respects, while in fact it may contain irregularities on a number of levels. Color use alone, while markedly different in traditional quilts as compared with revival quilts, cannot fully explain the felt sense of dissimilarity between the two types of quilt. Only a detailed formal analysis which gives attention to the material facts of the individual quilt reveals the basis for the distinction.

Differences in appearance between the two types of quilt necessarily are paralleled by—indeed, produced by—different modes of quiltmaking. Many customary procedures and approaches to technical and aesthetic problems in quiltmaking are, in general, largely unconscious. This is perhaps even more likely to be the case for the traditional quiltmaker, who has received her impetus and skills through the process of oral transmission. Her attitudes are embedded in a daily life which embraces and extends them in a larger cultural context in which quiltmaking naturally takes its part. This is not to say that there are no traditional quiltmakers who are conscious of and articulate about process—it is quite evident from field research that some women derive great satisfaction from describing and analyzing the effects of their techniques. That these quiltmakers are the exception should come as no surprise, considering the difficulty which most visual artists have in verbalizing their aims and methods. The quilt is like other material forms in that it *is* material and cannot be wholly subsumed under verbal categories. A kind of analysis, therefore, which results in the reconstruction of traditional technique is the surest way into the mind of the quilter and the conception and gestation of the quilt.

An examination of the types of variation in Mrs. Mayo's quilts reveals evidence of some initially surprising techniques. It is clear that in AM5 she did not use a template for the patches; in AM6 and AM21 she probably did not use an individual template for the smallest patches. This discovery about Mrs. Mayo's quilts raises the question of how many other traditional quilters have certain patterns which they produce without templates or exact measurement of some kind. It is possible that certain types of patterns are more likely than others to be produced in this manner. Directly related to Mrs. Mayo's willingness to cut patches without a template is her use of variation in the number of patches per cell in AM6 and AM21. Variations in number of units per section also appear in the quilting of many of her quilts.

Discrepancies of shape and number bespeak Mrs. Mayo's tolerance for inexactness and suggest a processual rather than rigidly predetermined approach to quiltmaking. In AM5, for example, it is unlikely that Mrs. Mayo cut all of the patches for the entire quilt at one sitting. If she had, one would expect the shape of the patches to be similar from cell to cell. Instead, it appears as if she worked on a cell or group of cells from start to finish, and then began anew on another cell or group of cells. Cutting apparently led to piecing, and when the piecing was finished, the quilter returned to cutting again. One step in Mrs. Mayo's activities seems to have led organically to the next, rather than the whole series following an abstractly rational plan. A processual approach is also suggested by the other types of variation in Mrs. Mayo's quilts; tied to the processual approach is a unit-relative concept of pattern which seems to characterize Mrs. Mayo's way of working. These tendencies can be seen in Mrs. Mayo's approach to construction and orientation as well as in her handling of color.

The variations in shape, construction, coloration, and orientation in Mrs. Mayo's work frequently have the effect of varying the orientation or apparent directionality of the repeated unit. Radiating points of central motifs in AM1, AM15, and AM26 are oriented in one of two different directions with respect to the edges of the cell. The entire constructed unit is oriented in two different ways in AM2, AM3, AM16, and AM18. The differing shapes of the patches in the two cells of AM5 result in two different orientations of the radiating angled points of the patches. In AM12, some groups of the four point star shape cells are colored in identical dark and light colors, but the dark points do not face in the same direction from cell to cell. In AM14, alternating radiating points of many of the cells' subunits are cut from a striped fabric which gives the points a sense of directionality which varies within the cell and from point to point. The striped points appear sometimes

in the top left and sometimes in the top right. The sense of directionality in the subunit is thereby affected.

The fact that so many of Mrs. Mayo's variation schemes involve orientation or directionality expresses an aesthetic preference which is linked with her affinity for radially pieced cells and curvilinear designs. Radially pieced cells tend to have two or more axes of symmetry, so that directionality is not so pronounced in the finished design as in cells which have only one axis. Similarly, many curvilinear designs tend to emphasize circularity over bipolar directionality. In AM23, where there is only one axis of symmetry, Mrs. Mayo has not varied directionality from one cell to the next. Thus it would seem clear that in the case of AM23, the quilter conceived of the constructed unit as having a single correct orientation. In AM16, however, where there are two axes of symmetry, the quilter has produced two cells from identically constructed units. The directionality of the unit was apparently not seen as necessarily fixed. A number of other quilts in which the square cells have two or more axes of symmetry also display variation in the orientation of the emergent design, either by variation in orientation of the unit of construction or by variation in method of construction while using the same shapes and numbers of patches. Circularity, radial pattern, and lack of obvious bipolar directionality seem to have been aesthetic qualities Mrs. Mayo favored. Consciously or unconsciously, she exploited their special potential for variation in design.

5.3. THE QUILTS IN THE LIVES OF THE QUILTER AND HER FAMILY

Many of the questions raised in the formal analysis of Mrs. Mayo's quilts can be pursued through exploration of the known social facts surrounding the quiltmaker and her quilts. Hypotheses derived from an examination of the quilts can be tested against what is known of the way in which the quilts were made and used. Understanding gained from the formal analysis aids in the interpretation of information given by Mrs. Mayo's relatives. The slight awkwardness of partitioning the discussion of Mrs. Mayo's quilts into a section on formal features and a section on aspects of life history is justified by the fact that two quite different kinds of data and analysis are entailed. An integration of all of the information into a single exposition might have narrative advantages, but the analytic clarity would be obscured. An overview of Mrs. Mayo's life provides a background for data specific to the quilts.

Anna Mayo was born Nancy Jane Butcher, in 1874, the eldest of five children of a prosperous Floyd County, Kentucky, farming couple. The family

later moved to Elliott County to run a general store. By that time, the eldest daughter had married Solomon Seymour Mayo, whose father's extensive lands bordered the Butcher farm—the Mayos' wedding day, in 1892, fell just two months before the bride's eighteenth birthday. The Mayos were wealthy, relatively speaking, influential, and well educated. Like the Butchers, they were staunch Methodists of English stock, both of which factors motivated their families' original migration into Appalachia.

Anna and Seymour Mayo (her husband gave Mrs. Mayo a new first name as well as a new surname) raised four children in Floyd County, two sons and two daughters, of whom a son and two daughters were still living at the time of the initial fieldwork in the mid-1980s. All of the children were college educated at a time when this was not common among the general population. Seymour Mayo farmed, traded in mineral rights and timber, and generally supported the family in comfort. Anna Mayo was a versatile woman who sewed, gardened, made and sold butter and bonnets, spun wool and knitted socks for home use and trade, fashioned intricately dressed rag dolls, and quilted. As a young woman, she often assisted at births, and she was known for her herbal teas and remedies. In the earliest days of her marriage she had sheared sheep and prepared and dyed wool yarn for her own and her mother-in-law's loom.

When their oldest child was nineteen, around 1912, the Mayos moved to Oklahoma and raised cattle for a brief time. In this they were like numerous other families who, having moved as far into the frontier as Kentucky, saw no great obstacle to moving even further west. Also like many other Appalachian families, the Mayos retained close ties to their mountain homeland. Seymour Mayo soon had to return his homesick wife to their Kentucky farm. The family never again left Kentucky.

After the death of her husband in 1950, Anna Mayo stayed on for a time at the old homeplace. When she became too blind and infirm to stay comfortably on her own, she lived in turn with each of her three eldest children and their families. Two of these children were still living in the mountains when they took her in, but some years before her death she moved to the bluegrass city of Lexington. Photographs of Mrs. Mayo in this period show her to have been fond of fine clothing and heavy jewelry, a love which her children attest to as lifelong. She loved to visit kin and friends. Later, in her old age, she often received them as visitors or paid extended visits to distant relatives. Because she lived for so long, and because by the time of her husband's death she had developed inoperable cataracts, she had a long period of old age during which she depended on her daughters. Piecing quilts and visiting kin were two activities which she never gave up. In the summer of

1965 she made a trip back to Floyd County where she was taken sick for the final time, and died. She is buried there.

The facts of Mrs. Mayo's life bear upon her work as a quilter in a general way, as will be discussed later in this section. First, it is important to consider the history of her quiltmaking and to examine it in terms of some of the questions raised in the previous section on the quilts' formal features. The social and historical information was gathered during interviews which took place after the formal documentation of the quilts had been accomplished. The discussion which follows does not mirror the order in which the information was brought to light, but has been rearranged to reflect the reconstructed chronology of Mrs. Mayo's history as a quiltmaker.

The exact age at which Anna Mayo began quilting is unknown, but she did piece and quilt in company with her mother and sisters. AM3 is the product of such family collaboration and is the oldest finished quilt in the corpus. Its special status explains its unused condition. It is a cherished family heirloom which represents Mrs. Mayo's family of origin. Its owner, Mrs. Mayo's younger daughter, refers to the pattern as "Wonder of the World." It is not known whether the quilter ever used a name for the design, but she may have. AM18, constructed on a closely related pattern, is referred to by the elder daughter who owns it as "The World's Wonder." AM3 and the closely related AM2, discussed below, are pieced in solid colors of purchased, new fabric, a choice of materials which does not appear again in the corpus (with the possible exception of AM5) until the time of Mrs. Mayo's old age (in quilts such as AM18). The formal relationships among the three quilts, AM2, AM3, and AM18, will be discussed at length in Section 5.4. The formal continuity between the quilts of youth and old age will be discussed as the quilts of Mrs. Mayo's final years are considered.

The pieced cells of AM2 were also made by Mrs. Mayo, her sisters, and their mother. The cells may have been pieced during a visit by Mrs. Mayo to her family in Elliott County after she was married. The units were found in the Butcher home after Mrs. Mayo's death, and were identified by her younger sister. They were given to a professional quilter to set, quilt, and finish. The serial collaboration required to finish AM2 is the reason for its two colors of blue. The arrangement of the cells and the quilting reflect the tradition of the professional quilter. It is especially significant, therefore, to note that the variation in orientation which results from the use of two cells (see Figure 247b–c) is consonant with the kinds of variation seen in quilts pieced start to finish by Mrs. Mayo. The presence of similar kinds of variation in Mrs. Mayo's solo quilts and AM2 suggests a shared community or regional

aesthetic. The shared aesthetic in turn suggests a shared processual method of working, as discussed at the end of Section 5.2. A large number of other quilts pieced by Mrs. Mayo were given to one or another professional quilter to quilt. As with the use of bought solids, the use of professional quilters appears in connection with the quilts of her youth and of her old age, and so will be discussed further in the examination of Mrs. Mayo's later quilts.

It is significant that AM2 and AM3 are both kept as part of Mrs. Mayo's corpus, regardless of the fact that they are the products of family collaboration. When the pieces of AM2 were found in the old family homestead in Elliott County, after the death of the elder brother who had continued to live there and after the death of Mrs. Mayo herself, the cells were given to Mrs. Mayo's daughter by Mrs. Mayo's sister, who had presumably taken part in their construction. The sister's advanced age may have made it impossible for her to cope with the disposition of the quilt pieces, and so they were given to the younger woman, who had had experience in having Mrs. Mayo's tops quilted. Another consideration, however, may have conditioned the sister's decision. The conjoining of the pieces with Mrs. Mayo's corpus would seem to be justified in the minds of the family by the fact that Mrs. Mayo carried on a solo tradition of quiltmaking, and thus became the noted bearer of the family tradition. Thus, in retrospect, they have become part of a traditional continuity which did not exist as such when they were made.

Besides these very early quilts, no quilts survive from Mrs. Mayo's youth and young married years. This may be due to the fact that as a young wife and mother, Mrs. Mayo had little time to quilt, and so her corpus of that time was small. Possibly, too, whatever quilts were made during that time were utilitarian and were used until they disintegrated. The survival of the early quilts AM2 and AM3 is due to their prototypic best character, and, in the case of AM2, to the special circumstances of its not having been finished until after Mrs. Mayo's death. What is known of Mrs. Mayo's quilts from that period is taken from the memories of her children. Her younger daughter recalls, for instance, that some special quilts were used only for guests and were therefore relatively unworn. She also remembers that when company came, which was often, because of the extent of the family, each child was bedded down on a pile of quilts on the floor. Quilts were not only used as bedcovers but also were used to "cover things" in the Mayo household.

Although the elder daughter associates them mostly with her grandmother's time, the younger daughter recalls that there were quilting bees during her own childhood. Besides giving information about Mrs. Mayo's quilting bees, the younger daughter's narrative, in its natural flow of associated

thoughts, reflects the way in which the quilts fitted into a whole complex of traditional life. Family history, geography, the seasonal round, use of domestic space, domestic technology, social relations, foodways, aesthetic values, and more are evoked in this brief portrayal of women's gatherings for quilting:

> When I was a child they used to get together quite often, especially during the winter. Mother would have this quilt upstairs and we had about four families that lived above us on the branch, we called it, Ely Branch. And after Mother and Dad spent a year in Oklahoma they called it Oklahoma Branch, but it is really Ely Branch on the map. Well, these families lived above there, and they would come in on a cold afternoon and they'd go upstairs and the heat from downstairs— Mother at that time had gas in the house in her big cookstove, she didn't get a gas stove, she just put it inside this big coal stove. And they would go upstairs and quilt. And she'd always have some kind of little gingerbread or something, you know, they'd snack on in the afternoon. But I was rather small when that happened. And sometimes she would go to somebody else's house and quilt and try to trade it out that way. And then, Tildy Mayo lived below us, and she and Mother would quilt with each other a lot. Mother was very particular with her handwork, and she knew the ones that could do good work and she would invite them in. It was more or less of a social get-together. But she gave her invitations out.
>
> (AUTHORS' FIELD TAPE)

All of this activity appears to have vanished before Mrs. Mayo's children were very old. Perhaps, even then, the necessity for utilitarian quilting was waning; or maybe Mrs. Mayo and the other women became too caught up in the work of raising families and farming to afford time for bees; yet again, it is possible that Mrs. Mayo came to prefer quiltmaking entirely on her own. The fact that no quilts from this period survive suggests that the quilts being quilted at the bees were probably utilitarian quilts, or "everyday quilts," as Mrs. Mayo's younger daughter terms them. This daughter believes that her mother would choose only tops that were not her favorites to be quilted at a bee:

> Now, I know Mother, if she had one special kind that she'd made a special design or something that was carrying a pattern out with a

The Natural History of the Traditional Quilt

definite pattern of colors, too, and she'd probably bought some of the material, she'd want to do it herself.

(AUTHORS' FIELD TAPE)

Thus a quilt with some regularity of color was likely to have contained some amount of purchased fabric and had more value to Mrs. Mayo than a quilt which was made entirely of scrap. Such a relatively more valued quilt was not to be trusted to the work of neighbors' hands.

Chronologically, the next group of quilts which survives dates from the years of her daughters' marriages, when Mrs. Mayo stitched bedcoverings for them to "take to housekeeping." According to her younger daughter, Mrs. Mayo made five quilts and two goosedown pillows, remade from old featherbeds, for each child at the time of marriage. Some of the quilts were newly made for the occasion, and some of these were made according to request. Others were selected from the household supply of lightly used guest quilts. The daughters' surviving wedding quilts are AM4, AM5, and AM6, all belonging to the younger daughter; and AM21, belonging to the elder.

AM4 is a scrap quilt which is worn but has not been used to death. Though presumably made for everyday use, it was at some stage in its life cycle retired from service and put into storage. Undoubtedly, its sentimental significance as a wedding gift made by the bride's mother has influenced its life history and saved it from use to the point of disintegration. AM5 was originally a guest quilt, a function which might edge it toward the prototypic best category which its formal features suggest. It is the sole surviving quilt in the corpus which features appliqué of a pieced motif, and it is constructed in white plus two solid colors of what may have been purchased fabric. Although AM5 had already been used before being given to the younger daughter, it is less worn than AM4, which was given new. The relative conditions of the two quilts bespeak their relative status and function. AM6 was made by request of the bride, who knew the pattern by the name of "Double Wedding Ring." The quilt is very lightly used, a clear sign of its having been cherished by its owner. Mrs. Mayo was still quilting her own tops at this time, but soon thereafter she gave it up. This may lend even more sentimental and aesthetic value to AM6.

AM21 was made for the elder daughter's wedding. Its pattern is closely related taxonomically to that of AM6, and its owner calls it by the same name her sister uses for AM6, "Double Wedding Ring." The two patterns may have been considered the same by the quilter or by her daughters, although they are not made from the same set of templates (see Figures 251a–c and

265). The name "Double Wedding Ring" may indicate to the quilter a certain configuration of cell shapes and overall pattern, which the two quilts share. The quilting in AM6 and AM21 is similar, and both were quilted as well as pieced by Mrs. Mayo. While AM6 is in excellent condition, AM21 is tattered, faded, and stained. The elder daughter was somewhat apologetic for the quilt's appearance, explaining: "It was used quite a lot when my babies were little, you know, and so it's not in very good condition" (Authors' field tape). Nevertheless, it has been saved among the very few treasured possessions which the elder daughter still keeps in her small retirement apartment.

AM6 and AM21 were formally very similar when new, and both were given on the occasion of a daughter's wedding. Regardless of these similarities, they have had strikingly different life histories. AM6 was generally kept from use, while AM21 was used regularly under conditions not conducive to its intact preservation. At some point, the two quilts' life histories converged once again in that AM21 was retired from use, put into storage, and elevated to the status of family keepsake, despite its ragged state. Formal features and circumstances of conception influence but do not determine the course of a quilt's life history, and that influence may be differentially felt during different stages of the quilt's life cycle.

AM15 is the next quilt in the chronological sequence of the corpus, though it is possibly roughly contemporaneous with those quilts made for the younger daughter's wedding. The elder daughter, for whom the quilt was made, gives the story of its conception and birth in a narrative touched with the romance of reminiscence about an exotic friendship:

> Quite a few years ago, I believe before I was married and was working in Huntington, West Virginia, I met a lovely Canadian girl; and she didn't know so much about Kentucky and West Virginia, and she was so anxious to know about these parts; and after I had taken her to places of interest in Huntington, and also went to the train with her when she left, she seemed to prize our friendship. And then quite a few years then after I was married and settled down, we moved from Huntington to Allen [Kentucky] for that winter, I received this package, and she had sent me the pattern for the quilt "Four Birds— Four Doves—at the Window." And my mother was—she was so good with the needle. She could copy—she could take a quilt and just look at it and know the right pattern, she could copy it. So she copied this quilt and mailed it to me and had it finished, and I've always prized it, because of the history of this friend of mine. And I've often

thought I'd like to have it copied in different colors, but I've never
gotten around to it.

(AUTHORS' FIELD TAPE)

Evidently, the pattern was sent in the form of a pieced cell or a drawing,
rather than templates, since Mrs. Mayo was obliged to "copy" it from sight.
The formal features of the quilt are further discussed in Section 5.5. By this
time, Mrs. Mayo was apparently beginning to use professional quilters to
quilt her tops, since she "had it finished." The locution indicates the daugh-
ter's attitude that the creation of the quilt lies in its piecing, and that quilting
is labor necessary to render the creation complete in a functional sense.
Mrs. Mayo is said to have made the quilt, even though she did not do the
quilting, which is quite elaborate and decorative (see Figure 260).

AM15 appears at first glance to be pieced in two solid colors, lavender and
white. The reality disclosed by attentive observation, however, is that the
lavender of the cells is just slightly lighter in value than that of the sashing
strips. The quilt actually contains three colors of fabric, with the two laven-
ders being so close in color and value as to be nearly indistinguishable. When
asked if the material for the quilt was purchased new, the elder daughter's
reply was couched in terms of both aesthetics and practicality. Although the
fabric may have been unused, the daughter believes that it is unlikely that it
was bought specifically with the making of AM15 in mind:

I believe she happened to have it on hand—I believe she did—or
she'd have carried out different colors, you know, little birds. I believe
she must have. And she lived quite a way, you know, from shops, and
she couldn't always get out to select different colors to go in her quilts.

(AUTHORS' FIELD TAPE)

The scrap fabrics of AM15 are used in such a way as to suggest newly
bought materials, and the fancy quilting contributes to the prototypic best
character of the quilt. The quilt's category is further established through its
significance to the daughter for whom it was made. The quilt represents a
particular phase of the daughter's life, when she lived and worked in a distant
city; and it reminds her of her one-time role as friend and guide for a foreign
visitor. Personal significance and formal characteristics intersect to produce a
quilt which falls into the prototypic best category. That category is function-
ally upheld, as attested to by the quilt's excellent condition.

Compared with AM21, also owned by the elder daughter, the categorical status of AM15 is marked. AM21 was made for a social ceremonial occasion, the daughter's wedding, and has formal complexity in both piecing and quilting, yet it is ragged, while AM15 is only lightly used. The difference in condition between AM15 and AM21 may indicate something about the relative significance to the owner of marriage (an expected social circumstance) and of this unusual friendship; or it may stem from functional differences based on need and circumstance; or perhaps the daughter's aesthetic preference is reflected in her treatment of the quilts. Most likely, a combination of factors are at play in creating differences such as those seen between the wedding quilt and the quilt made on the pattern sent by a friend.

Another quilt owned by the elder daughter, AM17, is especially prized because it is among the last which was both pieced and quilted by Mrs. Mayo. The elder daughter does not recall the exact number of wedding quilts she received, but she recalls that her mother often made her gifts of quilts pieced while visiting her. AM17 is most likely one of the latter. For the elder daughter, its emblematic quality is enhanced by the fabrics which appear in it:

And one thing about this quilt—it's made of remnants of all the cotton dresses that we . . . I can pick out dresses—can't you remember dresses that you had in prints? I've had a dress like that, and I believe this was one of Mother's . . . I always think it's sort of like a lot of souvenirs when you see all of them—the different prints, you know . . .
(AUTHORS' FIELD TAPE)

The quilt takes on the characteristics of its maker, and of a particular passage in her life history (and that of her children), because the materials in it partake of that life history, and because the work in the quilt reflects the totality of the quiltmaker's devotion. AM17 is an example of a quilt which has taken on almost sacred value due to the intimacy between maker and materials, and due to the moral worth attached to the work. The quilting is valued because it is the labor of the mother, and not because of any special formal qualities. Here may be a reflection of traditional Appalachian Calvinism, in which domestic labor is a mark of woman's righteousness.

Mrs. Mayo pieced quilts for each of her grandchildren and for many of her great-grandchildren. Two survive as part of the research corpus: AM7, made for a grandson from the same cell as that in AM17 (discussed above), and AM24, made for a granddaughter. Interestingly, neither of the two quilts is currently in the possession of the descendant for whom it was made. AM7 is

owned by Mrs. Mayo's younger daughter, whose son was the original recipient. AM24 now belongs to a great-granddaughter of Mrs. Mayo, although it was originally made for the present owner's mother. AM7 is in good condition. Though it is used, it is not worn, and the whites in the quilt gleam from careful laundering. In comparison, AM24 hangs in tatters, the fabric faded, torn, and limp.

Other quilts in the corpus which have moved down the generations, AM23, AM25, and AM26, also show greater wear and soiling than those kept by Mrs. Mayo's children. It may be that the sentimental significance of the quilts to younger owners, farther removed in time, space, and lineal distance from the maker, is not as pronounced as it is to the children of the quilter. In addition, traditional techniques of preservation and laundering have not been handed down along with the quilts, so that the latter have suffered either from machine laundering or from lack of laundering (due to fear of their deterioration from washing). Finally, the quilts of younger owners may show more wear simply because the younger owners did not have a store of quilts for daily use, and had to rely on only one or a few if they were to use quilts for bedcovers. Many quilts used by Mrs. Mayo's children on a daily basis have undoubtedly fallen apart or been deconstructed; but because of the greater number of quilts which have been available to them, there are still a number left.

Returning to the discussion of the grandchildrens' quilts, it is instructive to compare AM7, made for Mrs. Mayo's grandson, with the genetically identical AM17. The genetic identity of AM7 and AM17 relates them in terms of formal conception and possibilities for material realization. The striking differences between them, however, indicate the vital importance of phenotypic characteristics in determining a quilt's appearance.

The formal characteristics of the two quilts in part reflect the social characteristics embodied in the materials used. Therefore, the aesthetic differences between the quilts is to some extent isomorphic with the social differences between the people for whom the quilts were made. The very fabrics pertain to and bespeak the histories of the quilts' owners. The following analysis of materials and techniques suggests some specific ways in which the quilts may show forth the ethos associated with the owners. It is important to note, however, that these are suggestions arrived at by the anthropologist in contemplation of the quilts outside of the field. While the functional associations between owners and materials are objective fact, further fieldwork would be necessary in order to determine to what extent the following interpretations reflect native categories and concepts.

AM7 features the cotton and flannel pajamas of the little boy for whom it was made. AM7 is a bedcover which is made from the remnants of night-clothes. Cozy slumber is indicated by association and by the soft, napped character of the cloth, which in its prints of airplanes, rockets, and so forth, also suggests conventionally boyish playfulness and bravado. The bright red diamond-shaped patches sharply accent the airy, lively selection of fabrics of AM7 and give the quilt an open, vivid quality. These characteristics of the top are enhanced by the broad, curving forms created by the overall quilting design, which crosses and unites the cells. Thus might be suggested the ex-pansiveness and social heedlessness of an Appalachian boy.

While AM7 incorporates the fabric of the grandson's history, AM17 carries the material from a certain period in the lives of the quilter and her daughters. AM17 is made of prints from summer dresses. The diamond-shaped patches (see Figure 252b) are lavender. They are serene, light points of stasis in an array of dark and light sedate prints. The effect is not unlike that of the dress and demeanor of a proper Southern Victorian lady: decorative but unosten-tatious, and therefore dignified. The quilting, which follows the shapes of the patches as if to hold them securely in their places, also seems in accord with a social ethos of control and carefully preserved order.

AM24 has been handed down from its original owner to her daughter, Mrs. Mayo's great-granddaughter. The quilt had seen household use in the home of the original owner since her marriage. It was beloved by the chil-dren of the household and received some hard wear on that account. A bout with a commercial washing machine and dryer has left it in its current tat-tered state, and it was retired from use after that destructive washing. The great-granddaughter who now owns it, and who gave it its last, disastrous laundering, pieced a replica of the quilt, to be given to her mother as a re-placement. The transmission of the quiltmaking tradition to Mrs. Mayo's descendants will be discussed more generally below. Here it is sufficient to note that Mrs. Mayo's granddaughter, for whom AM24 was made, has never quilted. Both of her daughters, Mrs. Mayo's great-granddaughters, however, have made quilts.

Although AM24 was made in commemoration of Mrs. Mayo's grand-daughter's birth, it was not given until the granddaughter was nearly grown; thus it was given not too far in advance of AM25, the marriage quilt which Mrs. Mayo made for her. AM24 is used but not overly worn. Its owner com-ments on the reasons for its condition: "I wanted to keep it from getting torn up, because I knew that I would never have another one like it" (Authors' field notes). The quilt is connected in the mind of its owner with a past way of life from which she has become estranged, due to the passage of time and

her own childhood migration from Appalachia, in the company of her siblings, her mother, and her father, Mrs. Mayo's eldest son. That migration is seen as having been necessary for the family's material and social well-being, and the granddaughter has no desire to return to the mountains. Nevertheless, she values what she has come to see as hallmarks of the traditional way of life into which she was born.

AM25 was made in honor of the wedding of the same granddaughter for whose birth AM24 was made. AM25 is built on the same pattern as that in AM4, which is owned by Mrs. Mayo's younger daughter. It is interesting that both AM4 and AM25 were made as wedding quilts, both constructed from the same two cells (see Figure 249). The association of the genetic type with weddings may be coincidental, but there is the possibility that some significance was attached to the pattern which made it appropriate in the mind of the quilter for a wedding gift.

A comparison of AM4 and AM25 in terms of color scheme and quality of work reveals some differences, though these are not so marked as the differences between AM7 and AM17. AM4 contains patches of more erratic shapes than does AM25. The colors of AM4 range from pale pink to many vivid reds and acid yellows, in highly contrasting combinations. AM25, on the other hand, is more regular in the shapes of its patches and more somber in its colors. In AM25, dark greens and maroons predominate on a white ground. Unlike the distinction between AM7 and AM17, the differences between AM4 and AM25 do not seem obviously to arise from the association between quilts and owners. The differences may be circumstantial, related to the store of scraps on hand at the time of the quilts' making. The two color schemes and ways of cutting patches may also reflect more purely formal aesthetic choices on the part of the quiltmaker, who may have enjoyed piecing two very disparate quilts from the same pattern.

AM19 is another product of familial collaboration, in this case the women working serially rather than simultaneously. It is unclear when the quilt was completed, but it may have been begun in the 1920s, and so its origins may predate the quilts made for Mrs. Mayo's grandchildren in the 1930s. The patches for AM19 were cut by a niece, who began the piecing and found that the project was too demanding for her skills. Mrs. Mayo took the partially finished quilt, rectified the errors, and completed what her niece had started. The full story of this quilt, referred to as "Lone Star" by Mrs. Mayo's elder daughter, who owns it, and its relationship to other quilts in the corpus is told in Section 5.5.

A sizable group of Mrs. Mayo's surviving quilts are not associated with particular events in the lives of her descendants and are therefore difficult to

place within a chronology. These quilts were all made sometime during the middle period of Mrs. Mayo's life. The quilts made in her old age are marked as a group by formal similarities, and are referred to by their owners as having been made when Mrs. Mayo was old. The undated middle period quilts are AM11, AM12, AM13, AM14, AM16, AM20, AM23, and AM26. Of these, AM14, AM20, and AM26 belong to a related group of quilts discussed in Section 5.5, but a few remarks at this point will place them in the context of the rest of the corpus.

AM14 belongs to Mrs. Mayo's younger daughter and is in use as a guest quilt. It is neither more nor less worn than AM11, which is on her husband's bed. (On her own bed is a polyester quilt that she made.) AM12 and AM13, the other quilts from this period owned by the younger daughter, show a similar amount of wear, which is comparable also with the wear seen in AM16 and AM20, owned by the elder daughter. The latter is another quilt called "Lone Star" by its owner. It is a scrap quilt which shows much less wear than the earlier made "Lone Star," AM19. Greater wear and soiling are seen in AM23 and AM26, owned respectively by two great-granddaughters. The owner of AM24 also owns AM26, but AM26 has not suffered the damage that AM24 has. AM23 is the sole quilt of Mrs. Mayo's owned by the other great-granddaughter. It is not known for whom the quilts were originally made, but probably they belonged to Mrs. Mayo's elder son. Eventually they made their way into the household of his second daughter, and thence to her two daughters. AM26 is in intermittent use.

It is worth mentioning that some of the households where Mrs. Mayo's quilts now reside also contain other quilts. The granddaughter for whom AM24 and AM25 were made also owns a number of quilts which originally belonged to her husband's family. Two of these, an appliqué and a scrap patchwork, have been carefully preserved. A pair of quilts made from hexagonal cells is heavily worn. Another quilt which is worn is one of a pair which was made on commission for her husband and his brother as boys. The other of the pair is owned by the great-granddaughter who owns AM24 and AM26. This second of the pair is worn to rags and is stained; it is presently in use as a picnic and beach blanket. Another quilt originally owned by the granddaughter's husband's family has also passed directly to the great-granddaughter and is packed away and retired from use. This same great-granddaughter has three quilts of her own making which are in daily use. Mrs. Mayo's elder daughter also has pieced five quilts, some of which are not quilted. In addition, she owns a crocheted coverlet made by a brother of Mrs. Mayo. The coverlet is packed away and never used. Thus in each household are affinal and consanguineal relationships among the quilts, and there

are patterns of use and wear which pertain to each according to its place in the family, its aesthetic value, and other circumstances. The analysis of these relationships among the quilts is a study in itself and outside the scope of the present work.

The final group of Mrs. Mayo's quilts is made up of those made in her final years: AM1, AM8, AM9, AM10, AM18, and AM22. These may be divided into three groups representing chronological periods and formal and technical attributes. AM8 and AM9 date from Mrs. Mayo's early old age, when her technical skills were perhaps at their peak. AM1 and AM18 belong to a period of middle old age, when those skills began to decline, as seen in the character of the quilts. Together, the quilts of Mrs. Mayo's early and middle old age form a grouping distinguished by the use of similar kinds of materials and color schemes. AM10 and AM22 are the two last quilts made by Mrs. Mayo in advanced old age. Their formal characteristics reflect her deteriorated eyesight and faltering dexterity, as well as her descendants' reverence for her work.

The four quilts of Mrs. Mayo's early and middle old age are all made from purchased fabric, all in vivid solid colors and white. They are all quilted by professional quilters, not by Mrs. Mayo herself. These quilts are all made from fabrics and patterns supplied by Mrs. Mayo's daughters. During this period, Mrs. Mayo was living with one or another of her children, who sometimes made special requests for quilts and sometimes fulfilled their mother's desire for the acquisition of a particular pattern. The children also assisted in locating a quilter and taking the tops to be quilted.

The practical influence of Mrs. Mayo's daughters on the quilts of her old age is evident. They brokered materials for their mother and provided her with some of the impetus for her work. It is unclear, therefore, how much of the aesthetic quality of the quilts is to be attributed to the daughters' influence and how much to other circumstances. In old age, Mrs. Mayo was free from the economic strictures connected with raising a family. Moreover, her daughters were supplying the materials as well as the means of her upkeep. Therefore, she could use new fabrics at will. Certainly, the choice to use new fabric rather than scrap could be thought to have an economic component.

Mrs. Mayo was no longer making her quilts for use as everyday bedcovers. The necessity for utilitarian quilting had passed, partly because of changes in the times, partly because of changes in the ages and needs of her family members, and partly because she had already made a large number of utilitarian quilts which were in use on family beds. Thus, Mrs. Mayo was free to concentrate on the making of a different category of quilt. Mrs. Mayo's younger daughter, when asked the name for the kind of quilt which was not what she

would call an "everyday" quilt, and for which the fabric had perhaps been purchased, said that there was no fixed term, but that she would call such a quilt a "hobby quilt." In her old age, then, Mrs. Mayo had the luxury and the inclination to take up "hobby quilting."

It is difficult to determine to what extent the quilts reflect Mrs. Mayo's aesthetic preferences as distinct from those of her daughters. The fact that she used similar color schemes and presumably new fabric in earlier times (in the quilts made with her sisters and mother) suggests that the quilts of her old age do reflect an aspect of Mrs. Mayo's own aesthetic. This mode of working—in vivid solid colors of purchased fabric, using regular color schemes—is an aspect of the tradition which lay dormant in Mrs. Mayo throughout most of the years of her life. The quilts which survive from the earliest period of Mrs. Mayo's life may be analogous in functional category with the quilts of her old age. As prototypic best or "hobby" quilts, they were not intended for the everyday use which would have worn them out of existence. The formal and functional parallels between quilts of Mrs. Mayo's youth and quilts of her old age may reflect a similarity in her economic status during the two phases of her life. In both periods, she was dependent upon others for support, and she did not have dependents of her own. Thus she was relatively freer than in the middle period of her life to use her material and temporal resources for other than strictly utilitarian production.

Three of the four quilts in the corpus made in Mrs. Mayo's early and middle old age, AM1, AM9, and AM18, are closely related to or genetically identical with quilts made earlier in Mrs. Mayo's life. The fourth, AM8, is not terribly closely related to any other quilt in the corpus, although genetically it shares a number of features with AM7 and AM17, discussed earlier. AM8 is the only quilt in the corpus made in solids of dark green and white, whereas there are three quilts made in red and white. Two of the three red and white quilts were made in Mrs. Mayo's old age, and each is related to quilts made in earlier periods. Thus, both color and cell structure seem to connect later quilts with earlier ones.

AM9 is called "Lone Star" by its owner, Mrs. Mayo's younger daughter. It is closely related to AM19 and is made from the same cell as AM20, both also called "Lone Star" by their owner, Mrs. Mayo's elder daughter. All of these quilts are discussed fully in Section 5.5. AM9 is made from brightly colored solids. Mrs. Mayo's younger daughter ordered the pattern and procured the materials for her mother. Although AM9 and AM20 are made from the same cell, they were apparently not made from the same set of templates, since the pattern for AM9 had to be mail ordered. Perhaps the templates used earlier were lost.

The same puzzle arises with respect to AM1, genetically identical with AM15 and AM26, and AM18, closely related to AM2 and AM3. In both cases, a daughter claims to have ordered the pattern through the mail, even though both represent cells already used by their mother earlier in her quilting career. Both daughters claim that their mother had superior skills in copying a pattern from a finished quilt. This being so, the necessity for newly purchased patterns is curious. Perhaps Mrs. Mayo's capacity for or interest in copying diminished with age. Possibly it was the daughters, wanting copies of the earlier quilts or thinking that their mother would take pleasure in working with the same designs, who felt that since purchased patterns were available they should be taken advantage of.

Whereas the quality of needlework in AM8 and AM9 is superb, in AM1 and AM18 it has begun to show irregularity. Still, the designs chosen by the quilter are exceptionally demanding. By the end of her life, however, Mrs. Mayo was piecing the simplest of designs, as represented by the two last quilts she ever made. AM10 and AM22 are both constructed in straight strips of nine subunits per cell. All seams are straight. The patches are large in relation to the cell. The colors of scrap materials are extremely bright, which her daughters explained made it easier for her to see the patches as she worked on the tops. In her last quilts, Mrs. Mayo returns to the use of scrap materials, presumably because projects requiring quantities of purchased materials seemed too ambitious.

As with the fancier quilts, AM10 is quilted by a professional quilter. Its ragged machine quilting is explained by the fact that this quilter, too, was very aged at the time she completed the work. The younger daughter took the quilt to her because she had worked on many quilts of Mrs. Mayo's in the past. The purpose of the quilting, according to the younger daughter, is to keep the quilt together. Because the top itself is not considered a beauty by the daughter, the fact that the quilting is not neat is not an intolerable detriment. It is interesting that the quilting services of this particular woman were sought even though she was no longer capable of doing the work neatly, either by hand or machine. Her status as a professional quilter with a long-standing relationship to the family, and her willingness to take on the task, apparently superseded the fact that her skills had declined.

AM10 is the only unfinished quilt in the corpus. It is an unquilted top, which was kept for a time by Mrs. Mayo's younger daughter and then given to her great-niece, the same great-granddaughter of Mrs. Mayo who owns AM24 and AM26. As the last top ever pieced by Mrs. Mayo, it has special value for its owner, who keeps it packed away. The pattern of AM10 is the simplest of nine-based cells, made up of nine equal squares—the classic nine-

patch. Appalachian quilters frequently use this cell in teaching a girl to quilt, and so it is especially moving and significant that Mrs. Mayo should return to it as the last cell she ever used. Interestingly, this cell also occurs in the single top pieced by Mrs. Mayo's elder daughter. This daughter was struck by a car and critically injured when she was in her seventies. During her period of recuperation, as part of her self-prescribed therapy for regaining the use of her arms, she began to piece a quilt top. The pattern she chose was one she knew was appropriate for a novice, which she was despite her advanced years.

It is fitting here to discuss the transmission of the quilting tradition from Mrs. Mayo to her descendants. The commonly received notion of traditional skills and lore as passing directly from generation to generation is too simplistic to account for the ways in which Mrs. Mayo's quiltmaking has influenced the practices of her kin. In the first place, as has been pointed out, her daughters had a marked effect on Mrs. Mayo's traditional practices in her old age. In the transmission of this material tradition, the young influence the old as well as the other way around; this pattern of influences has been found generally in our fieldwork.

Mrs. Mayo did not teach her skills directly to her daughters as they were growing up. Their exposure to the tradition was through observation of their mother's work and the use of her quilts. Both daughters recall that their mother was fiercely protective of her scrap bag, and that she was reluctant to let them work on her quilts. The younger daughter explains how it was that she began to quilt in her young adulthood, gave it up during her working years, and then resumed it after retirement:

> I had helped Mother a little bit, quilt some in her later—after I grew up, and came back, and if she had one she wasn't *real* particular with, she'd let me quilt a little bit. But I enjoyed it, and then my husband and I pieced a quilt one time. We'd been married about a couple of years and the winter, oh it was *so* cold, and there was snow on the ground so much of the time. And we had a couple that lived next door to us, and we'd get together, and she pieced a quilt, and *I* pieced a quilt, and we'd get material, trade materials, you know, for a square, enough for a square. And then when I got—my husband and I got our squares fixed—mostly he cut the material, take the pattern and cut— then when we got our squares ready we hardly knew what to do with them, so we called on Mother to help us put the squares together. And I still have that quilt. It was a little Dutch girl.
>
> My quilting, though, most of my quilting, though, has been done since I retired from teaching. When we moved down to Florida for the

winter, we lived near my cousins, and their wives—well one of them is a lady cousin, too—they all pieced quilts. And I felt left out, and so I started it too. And since then I have pieced *and* quilted—I have pieced, let's see, one—[counting to herself]—five quilts, and I've quilted two. Or I've quilted one and started on the other one, have a pretty good start on it.

(AUTHORS' FIELD TAPE)

A wealth of information is contained in this brief narrative. Even when the younger daughter was grown, she was still not permitted to work on a quilt of her mother's if it were considered special. Her mother clearly preferred to have complete control over her products, though in later years that control was exercised through selecting a professional quilter. The pattern which the daughter chose for her first quilt, made as winter recreation in a social context with her husband and another couple, was not one which was part of her mother's repertoire as represented by the corpus. In fact, it is an appliqué design, whereas Mrs. Mayo's quilts are almost exclusively patchwork. In creating the quilt, the couples worked together. The women traded fabrics, and at least one husband took a technical role, cutting the pieces. When the "squares" were finished, they were given to Mrs. Mayo to set. A clue as to the reason for this decision lies in the younger daughter's attitude toward the aesthetics of setting. The daughter's account of her mother's way of working, to be discussed presently, contains an expression of her own understanding of the setting process.

The younger daughter did not quilt during her working years but took up the practice in earnest after retirement. The tradition was received and borne passively through the middle years of the daughter's life, to be revived in the company of kinswomen many miles from their original homeplace. Thus the gatherings of neighbors and kin which the daughter remembers from her early childhood were recreated by her in her old age. She has carried into her own work the sense of a split between piecing and quilting. Piecing a top does not necessitate immediately going on to quilt it before proceeding to piece another. The two processes are distinct and to some extent isolated from one another conceptually and functionally. Like her mother, the daughter apparently prefers piecing to quilting.

The tradition as carried by Mrs. Mayo does not appear in mechanically exact replica in the next generation. Instead, systematic fragments of knowledge and tendencies in motivation and attitude combine with new ideas and new contexts to embody a new generation of traditional practice. In the generation of her grandchildren, there are no quilters. The women of that

generation, however, are all expert seamstresses and regularly sew clothing for themselves and their families. One of Mrs. Mayo's granddaughters is a weaver, reviving a craft which Mrs. Mayo practiced only briefly as a young married woman, before the practice died as a regional necessity. Many of Mrs. Mayo's great-granddaughters are family seamstresses, and at least two have made quilts. The latter sense a connection between their work and that of their great-grandmother, although the style of their work reflects the differences in time and circumstance which distinguish their lives from hers.

Much can be learned about Mrs. Mayo's way of working from looking at the finished results, as discussed in the previous section. Information from interviews with her daughters confirms and adds to what the material evidence suggests about Mrs. Mayo's processual and unit-oriented manner of working. In certain respects, however, what her daughters say contradicts what can be seen in the quilts, particularly in the realm of regularity versus variation. This discordance between what is reported and what is observed reflects the fact that native conceptions of traditional aesthetics do not always accord with objectively measured formal traits of traditional aesthetic items. Both subjective and objective descriptions must be taken together to build a complete understanding of the tradition.

From the elder daughter comes a description of the early stages of her mother's quiltmaking process:

Mother kept a big bag of scraps. And she'd get in that, you know, and—we mustn't bother her scrap bag, either! And when she wasn't busy, then with gardening and the flowers, and all the many other chores she had to do, she'd sit down, cut her quilt pieces, and then—she'd cut quite a few. And to pick the colors, she'd used her own imagination—course in a quilt like this [AM15] she only had the two colors to carry out. But in this one [AM17] she had to pick colors that sort of harmonize, you know—light and dark. Sometimes she'd sit and cut for a long time.
(AUTHORS' FIELD TAPE)

Here is an implication that in scrap quilts, at least, Mrs. Mayo did not follow a mechanical plan but used intuition to select fabrics from her bag. Then, because she cut a large number of patches at once, she would have had a variety to choose from in making up the cells. At the stitching stage, even if she had originally thought to put the patches together in a certain combination, she would still have been free to choose another if it occurred to her

through the juxtaposition of available materials. Traditional aesthetic principles are indicated by the terms "harmonize" and "light and dark." Without a great deal of systematic field investigation, however, the precise local meaning of these terms cannot be known. Also embedded in this description of traditional quiltmaking is the sense that the right to indulge in work which utilized the "imagination" is won through prior attention to other domestic duties.

The younger daughter recalls the way in which her mother would set together the cells she had constructed. She begins with some general comments about the significance of the setting to the finished design:

I do think it [setting] makes a lot of difference, and I think that each individual has different ideas about how to set their blocks together. For instance, in the one I made in the polyester, I have a cousin who decided she wanted to do it a different way, and so I think that's an *individual* thing, really. And I think my mother had a good eye for that, because she'd figure out her own patterns. And she was very uniform, though. If she started one a certain way she really went on and finished the whole quilt that way. And she liked variety; just for instance, the strips that she put between the squares, she liked little contrasting blocks; like she was doing blue, she'd put a little white block at the intersection. [To decide how to set them] she would put them on the bed, and maybe change them three or four times before she'd decide on a pattern in which to finish the quilt.

She always got the colors—that wasn't white, you know—she [used] harmonizing colors. And she would make one block—and if she was using, say white, you know, she'd use one whole color, she'd be sure she had enough to cut one whole square before she would put that color in, and then she'd use it with white, for instance, red and white, or brown and white. And she was very particular about that, putting the right colors in the right squares, getting the same color.

And then I know that when she got her blocks all fixed and she'd put them on the bed, she would put, say, she only had four red blocks, ones with *red* and white, she'd try to put them in each corner, maybe, or in the center in a design. And that way she'd have her blocks, the colors, scattered about the quilt in the right, same proportion. And I remember if—she had an expression—she was "setting up" her quilt and she found out that she needed a block in a certain spot, she *had* enough blocks, but she needed one in a certain spot or with a certain

color, she'd go back and make an *extra* block to put that where she wanted it.

(AUTHORS' FIELD TAPE)

The younger daughter's discussion of the importance of setting is evidence for the usefulness of the cell concept. For the younger daughter, the pattern is the result of the individual's choice of what to do with the cells; some quilters are more adept than others at realizing the alternatives. Not all patterns in all traditions may be assumed to arise in this way (indeed, it is known that some kinds of patterns created from some kinds of cells are quite stable), but it is clear from descriptions such as the one above that cell and setting are separable factors in the makeup of a design.

Even where pattern is not the question, the younger daughter attests to her mother's expertise in setting because of her eye for color relations. Mrs. Mayo's way of working is processual and focused at the outset upon each individual unit, so that her concern for color operates first at the level of the individual cell. Here her daughter's description of how her mother puts together each cell is contradicted by the appearance of the quilts themselves. The daughter insists that her mother was extremely particular about regularity of color within a cell, when in fact there are many examples among the quilts owned by the daughter in which color use within cells is irregular.

It may be that the daughter is articulating a principle of preference rather than of absolute practice, and her attribution to her mother of strict functional adherence to the principle is by way of praise. Indeed, in the next breath, the daughter asserts that her mother liked variety, so that the daughter acknowledges a tension between regularity and irregularity in her mother's work. It could also be that the daughter is expressing a principle voiced by her mother, in the face of Mrs. Mayo's own contradictory practice. If this is the case, it might be hypothesized that Mrs. Mayo was consciously striving at all times for regularity, yet at times gave in to the need for irregularity in coloration and placement of cells. A brief consideration of the quilts, however, controverts this notion. In many cases, as for example in AM12 (see Figure 257), the principles outlined by the daughter are broken, even though with the same available materials they might have been carried out.

In AM12, as previously described in Section 5.2, two sets of similarly colored cells are loosely concentrated into groups which are placed asymmetrically in the quilt, with the colored cells of one group oriented in two different directions. Placement and orientation of the colored cell is a choice which is not determined by available materials. Mrs. Mayo could just as well

have oriented all of the similarly colored cells in the same way and situated them at regular intervals throughout the quilt.

As another example, AM26 (see Figure 269a–b) shows enormous variation of coloration within cells, and this variation is the focus of attention in Section 5.5. The variant diamond patches of AM26 are quite small, and it would seem that Mrs. Mayo might have found enough of one kind of scrap from which to make a single cell uniform in coloration had this been her main concern. Instead, some cells contain tiny diamond patches of as many as three different scraps in the places where most of the cells have tiny diamond patches of a single kind and color of fabric.

The material evidence shows that Mrs. Mayo was not bound in practice to the principles reported by her daughter, even though it is entirely possible that those principles were originally expressed to the daughter by her mother. The variation in coloration appearing in the quilts is consonant with a proclivity by the quilter for many kinds of variation which read as regularity, a feature which is explored in the previous section. Like the productions of most other artists and creators of aesthetic forms, Mrs. Mayo's work is informed by aesthetic principles which are not easily made conscious and explicit by the practitioner.

Further evidence for the supposition that Mrs. Mayo worked deliberately—in accordance with complex internal aesthetic motivation—to achieve the effects she wanted in her quilts lies in the reported manner in which she set them. Mrs. Mayo arranged the finished cells on a bed, which seems to imply that for her the aesthetic of the quilt importantly entailed a relationship with that piece of household furniture. She arranged and rearranged the pieces until she had a matrix which pleased her. The composition of cells within the finished quilt was not random or casual, but carefully and purposefully worked out by the quilter. Her daughter recalls times when Mrs. Mayo was not satisfied with the possibilities presented by the array of cells she had already pieced; despite having enough in number to finish the quilt, she would piece another of more desirable coloration. In the daughter's description of the setting procedure is corroborating evidence not only of a guiding aesthetic in Mrs. Mayo's work, but also of the processual and unit-oriented approach which the formal analysis of the quilts suggests. Without such purely formal analysis of the quilts, the implications of the daughter's explanation of her mother's way of working might easily be missed.

The functional meanings of terms and principles as expressed by traditional artists remains a subject for intensive field investigation. Although native expressions of traditional aesthetic principles most certainly have mean-

ing, the meaning is not straightforward and cannot be understood simply via dictionary definitions. The case of Mrs. Mayo's quilts exemplifies the dangers in relying upon a simplistic acceptance of native descriptions of aesthetic principles, which may lead to inattention to material facts. The natural history method begins with the quilt itself, the formal description of which guides further research.

It remains to add a few remarks about the influence of certain of the facts of Mrs. Mayo's life history upon her work as a traditional quilter. The time-span of her life bridged periods when quilts were a domestic necessity and when their general use was superseded by purchased bedcovers. This fact undoubtedly had an impact upon the development of her career as a quilter. In her middle years, she created many utilitarian quilts because they were needed by family members. In later years, her quilts tended not to be of the type Mrs. Mayo's younger daughter calls "everyday" quilts. It is a mark of her singular devotion to quiltmaking that she continued to quilt past the time when quilts were essential domestic accessories, beyond the days of her own good health and eyesight, and into a period when she was dependent upon family members for materials.

Mrs. Mayo's relatively comfortable social station also had an effect upon the nature of the quilts she produced. All of her quilts had purchased backing, and most of them contained at least some purchased or unused fabric in the top. Not for her were patches cut from tobacco pouches or backings eked out of feed sacks, though some of her sister quilters in Appalachia at the same time were using such economical materials to produce quilts stitched with loving pride. Economics and locale played a part as well in the batting material which Mrs. Mayo used. Women only a little further south and just a bit less well-to-do were using homegrown cotton for battings. Others used rags, paper, or old quilts, and therefore tacked the layers together rather than quilting them. Mrs. Mayo purchased her batts and quilted her coverlets.

Mrs. Mayo never sold her quilts, and she gave them only to family members. Certainly this choice was in one sense connected with her relatively secure economic position. She was not in such need of cash that selling the quilts ever became a necessity. But it is possible that the choice was aesthetic and possibly spiritual as well. A woman so driven to make quilts that she would piece tops she could barely see might be so invested in them that she would not wish to see them leave the family. As her descendants were products of the body, of time and energy spent in their nurturing, so the quilts proceeded from the physical work of her fleshly hours. Oftentimes the quilts were made of materials which as clothing had once before lain next to her own and her family's skins. The quilts embodied and continue to embody

something of the quilter and her family, all pieced and patched and quilted together into lasting patterns for the eye to see and the hand to touch. The descendants who own the quilts treasure them. Along with the quilts themselves, Mrs. Mayo apparently bequeathed to her children, grandchildren, and great-grandchildren a sense of the quilts' place in the life of their maker. Though her life has ended, in the lives of her quilts her aesthetic passion lives on to affect all who see them.

5.4. KINDRED CELLS IN KINDRED QUILTS

The two earliest quilts and one much later quilt in the corpus of Mrs. Mayo's work are very closely related. The kinship between AM2, AM3, and AM18 is apparent at first glance. What is not immediately evident is the exact nature of the formal and genetic relationships among the three, and the clues contained in each quilt concerning the construction of the others. The smallest subunit of the cell is widely used in the tradition to construct an unknown number of closely related cells. This section of the case study examines the connections among Mrs. Mayo's three related quilts. The discussion then turns to the larger tradition for other examples of kindred quilts, placing Mrs. Mayo's work in a context which helps to make sense of her choices.

AM3 is a red and white quilt of regular construction and coloration (see Section 5.2 for a full description, and Figure 248 for a section of the quilt). In analyzing the cell structure of AM3, two possibilities must be considered. The first is that the quilt is made up of three cells repeated according to a complex but regular sequence. Figure 272a–c shows the three cells. AM3 can be made of these three cells according to the setting sequence shown in Diagram 8. The cell in 272a is indicated by a, the cell in 272b is indicated b, and the cell in 272c is indicated c. The half cells of each, which make up the edges, are indicated by a', b', and c'.

Although the analysis represented in Diagram 8 accounts for one possible means of constructing the pattern in AM3, two pieces of evidence suggest that this analysis does not represent the actual method of construction used. The first piece of evidence is internal. The quilt could have been made from the three suggested cells and then finished off with half cells. Yet this decision by the quilter would seem somewhat odd, given that the cells are square and go together in regular sequence with edges of the cell parallel to the edges of the quilt. There would be no need, as in a quilt using cells with edges at a diagonal to the quilt's edges, to use fragments of cells to finish out the quilt's square shape. If the quilter had indeed constructed the quilt using the three cells shown in Figure 272a–c, it would be more likely that the edges of the

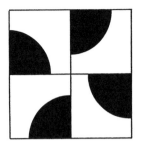
Figure 272a

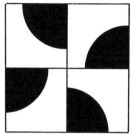
Figure 272b

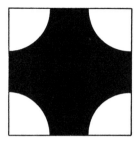
Figure 272c

	c'	b'	c'	a'	c'	b'	c'	a'	c'	b'
.	a'	c	a	c	a	c	a	c	a	c'
	c'	a	c	b	c	a	c	b	c	a'
	a'	c	a	c	a	c	a	c	a	c'
	c'	b	c	a	c	b	c	a	c	b'
	a'	c	a	c	a	c	a	c	a	c'
	c'	a	c	b	c	a	c	b	c	a'
	a'	c	a	c	a	c	a	c	a	c'
	c'	b	c	a	c	b	c	a	c	b'
	a'	c	a	c	a	c	a	c	a	c'
	c'	a	c	b	c	a	c	b	c	a'
	a'	c'	a'	c'	a'	c'	a'	c'	a'	c'

Diagram 8

The Natural History of the Traditional Quilt

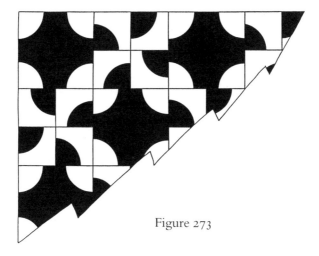

Figure 273

quilt would appear as in Figure 273. In this figure, the edges of the quilt are constructed of whole cells, as would ordinarily be expected.

Still, the quilt might have been finished out with half cells for the sake of dimensions. That is, the quilter might have completed the central portion of full cells and then decided that she wanted the quilt to be just one cell longer and wider. But if this were the case, why would she not have simply added one more row and column of full cells to the width and length, following the same sequence as in the already completed portion of the quilt? The half cell solution seems relatively improbable, though not impossible. The answer to the question of which method Mrs. Mayo actually used might not be resolvable, were it not for the existence of another closely related quilt, probably roughly contemporaneous with AM3.

AM2 is a blue and gold quilt with cells using the same subunits as seen in the cells of AM3 (see Section 5.2 for a full description, Figure 272a for a section of the quilt, and Section 5.3 for elements of the quilt's life history). Two cells appear in AM2 (see Figure 247b–c), set in an irregular sequence and alternating with plain setting squares, with the edges of cells and setting squares on a diagonal with the quilt's edges. Half cells complete the quilt's square shape along one edge.

The fact that the cells were found after the death of the quilter and set by another quilter helps to explain why the quilt may have been constructed using half cells. There were insufficient whole cells to complete a quilt without the use of setting squares. The diagonal orientation of the cells is understandable if one guesses that the four half cells were found as two full cells.

The total number of full cells could be set in a square shape only by the use of half cells. The use of half cells made sense to the quilter only in terms of a diagonal orientation of the cells relative to the quilt's edge. Thus there is indirect evidence that within the local tradition the use of half cells is associated with diagonally oriented cells, which makes sense in terms of practical geometry.

The final bit of evidence against the initial analysis of the cell structure of AM3 is the one which suggests the correct analysis. That is, the cells in AM2 can be put together in regular sequence to create AM3. If the cells shown in Figure 247a–b are set in alternating sequence, the pattern shown in Figure 248 emerges, with the edges of the pattern matching the actual edges of AM3. The fact that the cells appear in AM2 is evidence of their existence in AM3, which evidence is upheld by the fact that the edges of AM3 accord with the edges which would result from the use of the two cells in AM2 without the use of half cells.

The cells of AM2 can be thought to represent the units of construction and of replication, since they were found as separate pieced units. The units of construction for both cells are identical, and their orientation within the quilt makes them two different cells. It is interesting that both orientations appear in AM2, despite the fact that their sequence is irregular and their set prevents them from forming a continuous design. That is, there is no immediately apparent reason in terms of overall pattern why both orientations should appear. However, the fact that they do appear suggests three possibilities: (1) that variation in the orientation of units of construction is a common practice within the local tradition; and/or (2) that variation in the orientation of this particular unit seemed natural to the quilter; and/or (3) the quilter was unconscious of the fact that variation in the orientation of this particular unit creates differences of appearance.

Mrs. Mayo's quilts show a great deal of variation in orientation, and her practice may well fit in with a larger traditional tendency, as suggested by the first possibility. As for the naturalness to the quilter of variation in the orientation of this particular unit of construction, the quilter who set AM2 may have been aware of the pattern seen in AM3, which requires such variation. Finally, it is possible that the quilter who set AM2 may have been unaware that she was creating differences in appearance by varying the orientation of the cells. The quilter may have been familiar with other closely related cells, in which variation of the orientation of units of construction does not create different cells. Some examples of this type are discussed later in this section, although they do not appear in Mrs. Mayo's corpus.

I	II	III	IV
V	VI	VII	VIII
IX	X	XI	XII
XIII	XIV	XV	XVI

Figure 274

Before moving outside of Mrs. Mayo's corpus, however, it is appropriate to examine the pattern of one final closely related quilt in the group. Like AM3, AM18 is made in solid colors of red and white (see Section 5.2 for a complete description and Figure 262*a* for a section of the quilt). AM18, however, was made toward the end of Mrs. Mayo's life, while AM3 is one of the earliest extant examples of her work. AM18 reverses the coloration seen in AM3. AM18 contains twelve different cells, some varying from others in orientation, and some varying from one another in construction. Figure 262*b–e* shows examples of constituent cells of AM18. Figure 262*e* is numerically predominant in the quilt and recurs twelve times.

The discovery of the correct cell structure of AM3 assists in the recognition of cells in AM18. An analysis of the construction method of all cells in AM2, AM3, and AM18 reveals the parallels and variations among the cells of AM18, and suggests a solution to the problem of how such variations were introduced into the quilt. The larger square in Figure 274 represents the subunits of a cell of the type found in AM2, AM3, and AM18, with each subunit numbered for reference. The smaller square represents a subunit shape. The corners are numbered for reference to the four possible subunit variations, based on which numbered corner coincides with the corner of the quarter

I / ii	II / iv	III / iii	IV / i
V / ii	VI / iv	VII / i	VIII / i
IX / iii	X / iii	XI / ii	XII / iv
XIII / iii	XIV / i	XV / ii	XVI / iv

Diagram 9

I / iv	II / iv	III / iii	IV / iii
V / ii	VI / iv	VII / i	VIII / i
IX / iii	X / iii	XI / ii	XII / iv
XIII / i	XIV / i	XV / ii	XVI / ii

Diagram 10

circle patch. For example, in variation *i,* the quarter circle appears in the upper left.

Using the reference system indicated in Figure 274, the constituent cells of AM2 and AM3 can be coded to show the positions of constituent sub-cell variations. Thus the cell in Figure 247*b* can be coded as shown in Diagram 9. The cell in Figure 247*c* can be coded as shown in Diagram 10.

It is clear from a comparison of the two cells (which differ in orientation but not in construction) that the only differences lie in the subunit variation which appears in each of the four corner sectors of the cell (I, IV, XIII, and XVI). Consideration of the variant and invariant features of the cells leads to an understanding of what the construction method must have been. From the point of view of stitching, it would seem that the most straightforward way of putting together a grid of sixteen square subunits would be the straight strip method. However, dictates of design can in some cases prevail over shape of subunit.

In all of the cells of AM2, AM3, and AM18, the center four subunits are invariant. In AM2 and AM3 they are (VI/i; VII/ii; X/iv; XI/iii); in AM18 they are (VI/ii; VII/iii; X/iv; XI/i). This leads to the speculation that they were in all probability constructed as a larger central subunit group as the beginning step in creating the cell (VI + VII + X + XI). The inner two

The Natural History of the Traditional Quilt

subunits along each edge of the cell are also invariant from cell to cell, and the pairs are identical with one another except for orientation. These would also seem to constitute larger subunit groups, put together as step two of assembling the cell (II + III; V + IX; VIII + XII; XIV + XV). The next step of the cell's construction would then be the addition of two of the four corner subunits at either end of two of the edge subunit pairs, forming two strips of four subunits each in length. Then the two shorter edge subunit strips would be stitched to opposite sides of the center subunit group, and the longer strips added to the remaining two opposite sides of the center subunit group. This general method of construction is paradigmatic for a whole family of related designs that are examined later in the section.

Perhaps a very close examination of the quilt might reveal which of the edge subunit pairs were chosen to receive the corner subunits. The longer strip would be attached to the central subunit group and attached shorter edge subunit pairs with one continuous seam. The shorter edge subunit pairs might show a slight disjunction with the corner subunits. It is otherwise not possible to know more about the exact order of construction of the cell; but this much information is in itself enough to account for the variations seen among the cells in AM18. The variations in construction were introduced at the point of attaching the corner subunits to the edge subunit pairs, and again at the point of orienting the fully constructed lattice of sixteen subunits.

The variations in the related cells of AM2, AM3, and AM18 can all be accounted for by the above analysis. Reference to related quilts in the tradition at large confirms the analysis. At the same time, application of the analysis to related designs reveals the nature of the formal, and possibly historical, connections among them. For this portion of the discussion, we refer to published examples of related designs, both in pattern form (drawings or photographs of cells, templates, instructions for assembly, etc.) and in the form of photographs of completed quilts. Where a design is indicated by name, the name is that which has been attached to the design or quilt in publication. The matter of naming in the case of this group of designs is convoluted, pointing up the difficulties of relying upon names for classificatory purposes. It is not practical in this work to lay out all of the complexities of the relationships among the variously applied names and the designs. However, peripheral attention to the issue over the course of the discussion is sufficient to delineate the problem.

Four closely related cells recur in the literature, frequently under the name "Drunkard's Path" (see Figure 275a–d). These cells are constructed on the same kind of grid as that represented in Figure 274, and of the same subunits. The same paradigmatic subunit groups which appear in the cells of

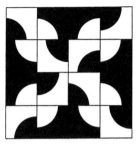

Figure 275a

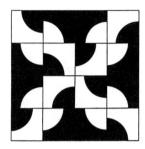

Figure 275b

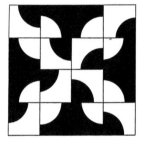

Figure 275c

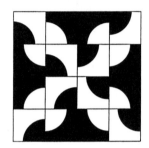

Figure 275d

Mrs. Mayo's quilts also appear in these four. As in Mrs. Mayo's quilts, the edge subunit pairs (II + III; V + IX; VIII + XII; XIV + XV) are invariant within and between cells, and are identical with one another except for orientation. The cells differ from one another according to the orientation of the subunits in the central subunit group (VI + VII + X + XI) and in the corners (I, IV, XIII, and XVI).

The cell in Figure 275a has the same central subunit group as the cell in Figure 275c (VI/ii + VII/iii + X/i + XI/iv). The pattern created by this arrangement of subunits is a pinwheel shape, with the curved edges of the quarter circle patches facing in a counterclockwise direction. For easy reference, this configuration can be called a left pinwheel. The cell in Figure 275b has the same central subunit as the cell in 275d (VI/i + VII/ii + X/iv + XI/iii). The pattern created by this grouping is a pinwheel shape with the curved edges of the quarter circle patches facing clockwise, and for shorthand reference can be called a right pinwheel.

Similarly, the corner subunits of each cell form either a right or a left pinwheel with the vanes of the pinwheel separated by the other subunits of the cell. The cells in Figure 275b and 275c have left pinwheels formed by

The Natural History of the Traditional Quilt

the corner subunits (I/ii; IV/iii; XIII/i; XVI/iv). The cells in Figure 275*a* and 275*d* have right pinwheels formed by the corner subunits (I/i; IV/ii; XIII/iv; XVI/iii). Thus the four cells form a set of all possible combinations of the right and left pinwheel configurations in the center and the corners.

It is important to note that the term "pinwheels" is applied to the shapes and configurations in the cells as a convenience only and is not intended to reflect native conceptions or terminology. It is also necessary to stress that, although the analysis of the designs in question turns in part on the orientation and location of pinwheel shapes, the overall design in each case generally appears in the tradition as a twisting grid of dark pathlike strands against a lighter ground. In the variations discussed subsequent to those based on the above cells, neither the pathlike shapes nor the pinwheel configurations necessarily occur; however, reference to the latter helps in drawing relationships among all the designs in this family.

Of the four cells described above, the cell in Figure 275*a* predominates in documented quilts in the literature. For photographs of quilts constructed using this cell, see Pellman and Pellman (1984:118), Lasansky (1985:53), *Quilter's Choice* (1978:31), Hall and Kretsinger (1935:172), and Pottinger (1983:37, 69). These quilts were made in Pennsylvania and the Midwest and date from the late nineteenth century through 1930. The names associated with the quilts may or may not be those used by their makers. Pellman and Pellman designate their Amish example as "Drunkard's Path." In the Pellman and Pellman quilt, the integrity of the cell is most noticeably evident because each cell is executed and signed by a different quilter. The cells are pieced in different colors, and the relationship between darks and lights is not consistent from cell to cell. Pottinger gives "Rocky Road to Kansas" and "Solomon's Puzzle" as names for his Indiana Amish examples. Rehmel (1986:161) gives a drawing of a cell of this type, though her lack of attributions for her patterns makes it impossible to know the provenience of the design.

The cell which predominates in the pattern book literature is that in Figure 275*c*. For examples of pattern cells, see Ickis (1949:74), Hall and Kretsinger (1935:90–91), Rehmel (1986:160–161), Malone (1982:194), Beyer (1979:152), Beyer (1980:123), and Seward (1987:37). Beyer (1980:90–91) cites as her source for the pattern the Ladies' Art Company catalogue of 1898. In the pattern books, the cell is variously colored and is referred to by one or more of the following names: "Drunkard's Path," "Country Husband," "Rocky Road to California," "Rocky Road to Dublin," "World's Puzzle," "Rob Peter to Pay Paul," and "Solomon's Puzzle." Though a comprehensive search of the literature might turn up examples of a quilt made to the specifications of these pattern books, it is interesting to note the apparent schism

between the pattern books and traditional practice; that is, the cell which appears by far the most frequently in documented examples of traditional quilts is not the one which appears by far the most frequently in pattern books.

Further evidence of the schism is seen in Rachel Pellman's interpretation of a pattern of this type. Oddly, in her pattern book based on quilts documented in Pellman and Pellman (1984), R. Pellman (1984:72−73) gives a pattern for a design called "Drunkard's Path," which calls for the assembly of the subunits into strips as wide as the finished quilt, rather than into squares. This method can only work if the quilter has a representation of the entire design before her and follows the sequence mechanically. Though the method produces a design which is visually identical with that produced from the setting together of cells like that in Figure 275a, this is almost certainly not a traditional method of construction.

The cell in Figure 275b is not commonly represented in the literature. Rehmel (1986:161) gives a cell of this type under the name of "Drunkard's Trail." Pottinger (1983:37) shows a quilt constructed from this cell under the name of "Solomon's Puzzle." Beyer (1979:150−151) also includes a photograph of a quilt top constructed from this cell and labels it "Drunkard's Path." Interestingly, neither of the two patterns which she gives immediately following the photograph conform to the cell structure seen in the latter (Beyer 1979:151−152, see our discussion above). The discrepancy between Beyer's documentary illustration and her prescriptive patterns provides further evidence of the disjunction between the practices of traditional quilters and revivalists. The cell in Figure 275d is also uncommon in the literature. Rehmel (1986:161) calls her drawing of a cell of this type "Solomon's Puzzle." Additional examples of these two types would undoubtedly turn up in an exhaustive literature search, but one would not expect the relative frequencies of the four types of cells to be other than they appear from the evidence already surveyed.

When any of the four cells is put together in a lattice, an overall pattern results. This method of setting the cells together is the most common traditional handling of this type of cell. Figure 276a−d shows two cell by two cell lattices of the cells shown in 275a−d respectively. Although the designs are quite similar in effect, there are significant differences. Where the corner subunits of four cells meet in the lattice, a counterpoint image emerges. The configuration of the four subunits which form the counterpoint image is shown in Diagram 11, where each of the subunits belongs to a separate cell. The image formed in each case is a pinwheel shape, just as the configuration

The Natural History of the Traditional Quilt

Figure 276a

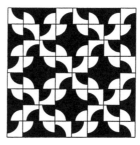

Figure 276b

Figure 276c

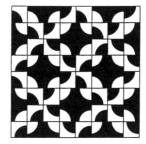

Figure 276d

XVI XIII

IV I

Diagram 11

of each cell's central subunit group forms a pinwheel shape. The direction of the counterpoint pinwheel shape depends upon the direction of the pinwheel formed by the cell's corner subunits. Where a right pinwheel is formed by the corner subunits, as in Figure 275a and 275d, the counterpoint image in the lattice is a left pinwheel, as in Figure 276a and 276d. Where a left pinwheel is formed by the cell's corner subunits, as in Figure 275b and 275c, the counterpoint image is a right pinwheel, as in Figure 276b and 276d. That is, the counterpoint pinwheel's direction is opposite to that of the pinwheel formed by the corner subunits.

At the same time, there is a visual relationship between the pinwheel shape formed by the cell's central subunit group and the counterpoint pinwheel. Figure 275a and 275c have left pinwheels at the cells' centers, but because the

corners of the cells are different, the counterpoint pinwheels are different. The lattice of the cell in 275*a* has a counterpoint image which is a left pinwheel, geometrically identical to the one in the center of the constituent cell (see Figure 276*a*). The lattice of the cell in 275*c*, however, has a counterpoint image which is a right pinwheel, or the mirror image of the pinwheel in the center of the constituent cell (see Figure 276*c*). Likewise, the cells in 275*b* and 275*d* have right pinwheels at the cells' centers. A lattice of the cell in 275*b* produces a counterpoint image of a right pinwheel (see Figure 276*b*), while a lattice of the cell in 275*d* produces a counterpoint image of a left pinwheel (see Figure 276*d*).

A quilt made up of cells like that in Figure 275*a* or one made up of cells like that in Figure 275*b,* set directly together in rows, will have center and counterpoint pinwheels all going in the same direction. The former will have all left pinwheels and the latter will have all right pinwheels. The effect of all center and counterpoint pinwheel shapes being geometrically identical is achieved through the orientation of the corner subunits such that the direction of *their* pinwheel is opposite to that of the pinwheel in the cell's center. When the cell's center pinwheel and the pinwheel formed by the cell's corner subunits are identical to one another in direction (Figure 275*c* and 275*d*), the counterpoint pinwheel is a mirror image of that in the center of each cell (Figure 276*c* and 276*d*).

A quilt of this type, with central subunit pinwheels and counterpoint pinwheels which are identical, will have a pattern that shows row upon row of identical pinwheels, each offset from those above and below it. Figure 277 shows a section of a quilt made from the cell in 275*a,* the cell which appears most frequently in documented quilts. In this kind of configuration, the row of counterpoint pinwheels is interpolated between the rows of central subunit group pinwheels, but jogged, so that the pinwheels are checkerboarded with the shapes created by the intersections of the edge subunit pairs (VIII + V + IX + XII or XIV + XV + II + III). A quilt of this type, with central subunit pinwheels which are mirror images of the counterpoint pinwheels, will also have jogged rows of pinwheels, but with the pinwheels in alternate rows going in alternate directions. Figure 278 shows a section of a quilt made from the cell in 275*c,* the cell which appears most frequently in pattern books.

Returning to Mrs. Mayo's quilts, it is now possible to understand a bit more about the nature of their patterns. The cells in AM2 and AM3 (see Figures 247*b* and 247*c*) have central subunit right pinwheels. The corner subunits, however, do not form a pinwheel shape. Thus if the cell in 247*b* is set

Figure 277

Figure 278

Figure 279a Figure 279b Figure 279c

directly with other cells of its type to make a quilt, no counterpoint pin-wheels emerge (see Figure 279*a*). Similarly, if the cell in 247*c* is set with other cells of its type, no counterpoint pinwheels emerge (see Figure 279*b*). In order for counterpoint pinwheels to emerge, an alternation of both cells in a lattice is necessary (see Figure 279*c* for a 2 × 2 cell alternating lattice, and Figure 248 for a larger section of AM3).

In both cells, the unit of construction is the same. They differ only in their orientation. Therefore, it can be conjectured with a high degree of certainty that Mrs. Mayo's conception of the pattern consisted of a unit of construction plus the desired effect of counterpoint pinwheels. The unit of construction being what it is (its integrity having been established by its unitary appearance in AM2, see Figure 247*a*), the only way to achieve the effect of counterpoint pinwheels is through the use of two cells which are the same unit of construction oriented at 90° to one another. Note that because of the orientation of the corner subunits of the two cells, the row of counterpoint pinwheels in AM3 alternates right and left pinwheels. The alternation of pinwheels within the same row never occurs with the use of a single cell in which the corner subunits form a pinwheel.

The intended pattern in AM18 is presumably similar to that in AM3, though the central subunit pinwheels in AM18 are left rather than right pin-wheels. The orientation of the corner subunits varies from cell to cell, but the predominant configuration is like that in Figure 247*b*. It can be supposed that Mrs. Mayo had in mind the unit of construction which she used for AM2 and AM3, but variations crept in as she attached the corner subunits. Mrs. Mayo's elder daughter, the owner of AM18, recalls that her mother considered this "the most difficult pattern." We can attest to the difficulty of constructing patterns of this type. Although professionally skilled in analysis and drafting, we have made and corrected numerous errors in the interpre-tation and representation of these designs in the course of preparing the pres-

ent text. It is therefore completely unsurprising that even a very experienced needleworker could produce inadvertent eccentricities, particularly if she were elderly and her sight was failing. More will be said of Mrs. Mayo's conception of the pattern following the discussion of other varieties of cells of this type.

As should be clear from the discussions in previous sections, it is by no means the case that variation in traditional quilting should be attributed generally to error. On the contrary, creative variation is at the heart of the tradition. This family of patterns is fascinating precisely because it lends itself to the discovery of both inadvertent and purposive variation, and the possible relationships between the two. Before going on to examine further varieties of cells constructed on the same grid and from the same subunits as in Figure 274, it is useful to consider another set of cells entirely which produce an overall pattern similar to those produced by 275a–d.

The cells in 272a–c represent an incorrect analysis of the pattern in AM3. However, many quilts in the tradition are made of pairs of cells taken from these three. The cell in 272a and the cell in 272c form one such pair. The cells are set together alternately, with rows jogged. The effect is of checkerboarded rows of right pinwheels (see Figure 280). McKendry (1979:190) gives a quilt labeled "Rob Peter to Pay Paul," made in Upper Canada in the first quarter of the nineteenth century. It has half cells along two lengths and one width. A quilt in Clarke (1976:55), labeled "Drunkard's Path," is from Kentucky and dates from the end of the nineteenth century.

Risinger (1980:80) and McKim (1962:9) give pattern cells of this type and instructions for setting, both under the name of "Drunkard's Path." Beyer (1979:151–152) gives the two as examples of two ways in which the four subunits can be put together, the process subsumed under the heading "Drunkard's Path" (although she also lists a cell like that in Figure 275a under the name "Drunkard's Path"). Rehmel (1986:164–165) includes drawings of these cells variously colored and named "Drunkard's Path," "Fool's Puzzle," and "Wonder of the World."

The cells in Figure 272b–c can also be combined to create an overall pattern, and quilts made in this way are common in the literature. In examples of this type, left pinwheels appear in a checkerboard array (see Figure 281). Bishop, Secord, and Weissman's quilt #45 (1982) is one of this type, made in the Midwest around 1930 and labeled "Drunkard's Path." Betterton (1978: 40) gives an example from upstate New York, dated 1886. The design is executed in red and white, with names embroidered on each white patch. It is labeled "Robbing Peter to Pay Paul," but Betterton also gives the names "Drunkard's Path," "Country Husband," and "Rocky Road to California."

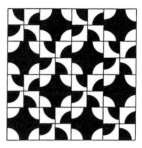

Figure 280 Figure 281

Pellman and Pellman (1984:119) show an Amish quilt from Wisconsin, made between 1920 and 1930 and labeled "Drunkard's Path." This quilt has half cells along one width and one length.

Naturally, a design made up of the cells in Figure 272a and 272c, or a design made up of those in Figure 272b and 272c, have rows of pinwheels which are identical. There are no counterpoint pinwheels in these designs. The only pinwheels which appear in the designs are those of one of the two types of constituent cell. Except for the skill required to stitch the curved seams, the realization of either of these two patterns is simple. The two cells of each are simple in construction and design, and they are set together in a straightforward manner. The visual complexity of the pattern unfolds under the quilter's hands from the use of two basic patches and two simple cells. This simplicity of construction coupled with complexity of appearance leads to the conjecture that this method was the original way of creating the design. The visual features of the design are complex and confusing, and a recasting of the pattern in terms of another cell structure may have been the work of someone outside of the tradition in which the design was common.

A comparison of the overall pattern in Figure 280 with that in Figure 276b proves the two to be geometrically identical, although the edges of quilts made from the two would differ. Likewise, the pattern in Figure 281 is geometrically identical with that in Figure 276a. A quilter looking at a finished quilt made as in Figure 280, and seeking to analyze it in terms of a single cell rather than two cells, could reproduce the design using the cell shown in Figure 275b; and the design in Figure 281 could be recreated by using the cell in 275a.

Note that although the appearance of the overall geometric design is the same in each case, the quilts and their constituent cells are genetically distinct from one another, and in fact are rather distantly related. The two celled

The Natural History of the Traditional Quilt

versions involve a four-based strip construction, while the single celled versions call for radial piecing. The two celled versions and single celled versions have different sets of possibilities for variation; it is the latter which have undergone creative transformations within the tradition, to be discussed below. Note also that while the overall designs in Figures 276b and 280 are identical, the edges of quilts made from the constituent cells in each would differ. Likewise for the designs in Figures 276a and 281.

It is interesting to speculate how the creation of the single celled AM3-type family of designs may have come about. Certainly, the appearance of the overall patterns are far from obvious when looking at the single cells which have been used to produce this type of design. It would seem unlikely that the single cell of this type would have been conceived without a prior aim to produce an overall pattern such as the one in Figure 280 or Figure 281. No firm conclusions are warranted, but it is tempting to speculate that perhaps the single celled versions of the designs were first propagated by the pattern companies, revivalists, or other sectors of the quilting network which had become wedded to the notion of patterns as being composed of "blocks." An example of this kind of reinterpretation of a traditional pattern can be found in Beyer (1980: 135), where she gives a single square pattern cell for the production of a pattern similar to that of AM6 and AM21. Figures 251 and 265 show the cells in Mrs. Mayo's quilts of this type. Figure 26 shows Beyer's square "block," and Figure 27a–b shows the difference between a quilt made using Beyer's "block" and one using two cells.

The fact that there is a disjunction between pattern book prescriptions and traditional renditions of the single celled versions of the AM3 type of design also suggests that there was a different, prior reference for the design in the tradition. Analysis of the disparity also suggests that the pattern book designers were working on the basis of a different aesthetic from that of the traditional quilter. The most frequently appearing pattern book instructions for single celled quilts of this type give the cell in Figure 275c. The central subunit group and corner subunits of this cell both form left pinwheels. The cell itself is thus characterized by an internal consonance with respect to the directionality of its pinwheels. However, this consonance within the cell results in the production of right counterpoint pinwheels in the overall design, so that central subunit pinwheels and counterpoint pinwheels are reflections of one another. The pattern thus features jogged rows of pinwheels, with the directions of the pinwheels alternating row by row (see Figure 276c).

The most frequently found traditional rendition of the single celled pattern of this type features the cell shown in Figure 275a, in which center pinwheels and counterpoint pinwheels are identical. Thus the overall design

(see Figure 276a), with its checkerboarded rows of left pinwheels, is geometrically identical with that in Figure 281. Traditional quilts of the single celled type showing central subunit and counterpoint pinwheels going in opposite directions are uncommon (Mrs. Mayo's quilts being exceptional in this regard). It is interesting to suppose that traditional quilters may have "corrected" the cell given in the pattern books to fit their expectations in terms of the overall design produced. That is, they may have altered the pattern in order to produce the design with which they were familiar in its two celled version, as realized in older quilts.

The "corrected" single cell is perhaps more difficult to piece accurately because of the lack of consonance between central subunit pinwheels and corner pinwheels, and the difficulty is exacerbated by the need to refer back to the "uncorrected" instructions. These factors may help to explain some of the many eccentricities in piecing found in traditional quilts of this type. For examples of eccentrically pieced single celled quilts of this general type, see McKendry (1979:100), *Quilter's Choice* (1978:30), and Schwoeffermann (1984:i). In all of these examples, the corner subunits show eccentric variations from cell to cell. In some cases, the central subunit pinwheels also vary in direction from cell to cell. This variation in direction would presumably occur only if the quilter was focused on the individual cell rather than the pattern as a whole; the complexity of the single cell allows for such variation to enter in with relatively subtle visual effect.

No matter their origins, the single celled AM3-type designs have become part of the tradition. The presence of numerous other closely related cells (including those in Mrs. Mayo's quilts) in the tradition suggests that the folk process has resulted in many modifications of the concept inherent in the group of cells in Figure 275a–d. What is interesting is that some of the innovations appear to draw upon characteristics of the constituent cells of the two celled designs which are geometrically identical or closely related to the single celled AM3 types. Thus, units of construction, features of the individual cell, and aspects of overall design combine and recombine to produce variations in which the newer cell is infused with formal features which recall the older and genetically unrelated cell.

The paradigmatic single cell of the type under discussion has a number of characteristics, any of which can be varied to create new cells. First, the central subunit group (VI + VII + X + XI) may form a pinwheel shape in either direction, or some other configuration. Second, the four center edge subunits (II + III; VIII + XII; XIV + XV; IX + V) may vary, although in practice they generally do not vary except in orientation. The standard arrangement is that seen in all of the cells in Mrs. Mayo's quilts of this type.

Finally, the four corner subunits (I, IV, XIII, XVI) may form a pinwheel shape or some other configuration.

Beyond designs based on the paradigmatic cell, other related cells exist which move outside of these strictures; also, some designs are made up of a larger grid of the same individual subunits and use some of the same design concepts. Further, in some designs the subunits are arranged and oriented identically with those of one of the four cells in Figure 275a–d, but with the subunits differently constructed. In the most common examples of this kind, the quarter circle shape is pieced of smaller patches so as to have a striped or sawtoothed edge. These forms of variation cannot be examined in detail in this work. They are mentioned by way of underscoring the fertility of the folk process and emphasizing that any cutoff point for discussion of related forms is more or less arbitrary.

Rehmel (1986:163) gives a drawing of a cell which varies the paradigm in the orientation of its corner subunits, which she labels "Sunshine and Shadows." The central subunit group forms a right pinwheel, and the edge subunit pairs are in the standard configuration. The four corner subunits do not form a pinwheel. Instead, the two upper corners (I and IV) are reflections of the two lower corners (XIII and XVI); the two left corners (I and XIII) mirror the two right corners (IV and XVI). The cell is identical to one of the two constituent cells in AM3 (see Figure 247c), though in Rehmel it is differently colored. See Figure 279b for a lattice of this cell which has no counterpoint pinwheels. Of course, the other constituent cell in AM3 (see Figure 247b), being the same unit of construction differently oriented, is a similar kind of variation.

Another variation of the paradigmatic cell also involves the orientation of the corner subunits, with the upper two corners reflecting the lower two corners, and the left corners mirroring the right corners (see Figure 282a). The cell has a center right pinwheel and edge subunit pairs in the standard configuration. It is apparent that a lattice of this cell produces no counterpoint pinwheels or twisting pathlike shapes. This is because the quarter circle patches in each corner subunit appear in the innermost corner (see Figure 282b), and therefore do not meet in a lattice. The cell appears, variously colored and named, in numerous pattern books: Ickis (1949:75, 76); Hall and Kretsinger (1935:90–91); Beyer (1979:152; 1980:123); Risinger (1983:79); Malone (1982:194); and Rehmel (1986:161–162). The names typically associated with this variation are "Fool's Puzzle" and "Wonder of the World." Rehmel also lists "Tumbleweed" and "Whirlpool."

A traditional quilt of this type is documented in Clarke (1976:103). Clarke gives no date for this Kentucky quilt, and it is unclear whether or not the

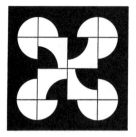

Figure 282a

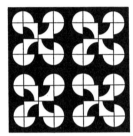

Figure 282b

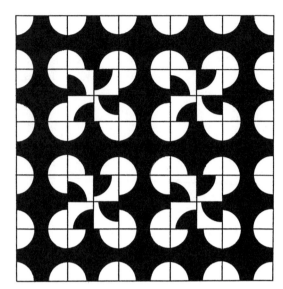

Figure 283

maker is Ellen Barrow, whose name for the design ("I Wish You Well") is cited by Clarke. Clarke claims that "The same two shapes are used for this pattern as for Drunkard's Path" From Clarke's earlier discussion (p. 54) of the pattern she calls "Drunkard's Path," it might be supposed that the two shapes she is referring to are the shapes of the patches which make up the subunit. It is possible, however, that Clarke means that the same two cells which make up the design which she calls "Drunkard's Path" can be arranged to produce the design she labels "I Wish You Well," for it is true that they can be.

Figure 283 shows a 4 × 4 cell lattice of the two cells in Figures 272a and 272c, arranged so as to produce the geometric pattern seen in a lattice of cells, as in Figure 282. The first and third rows are made up of cells as in Figure 272c; the second and fourth rows alternate the cell in Figure 272c with that in Figure 272a. The photograph in Clarke shows so small a portion of the quilt that it is not possible to determine the manner in which it is constructed. Nevertheless, the possibility of creating this pattern with two constituent cells forms another link between the two celled and single celled designs in the larger geometric family.

Another set of variations features a central subunit group which instead of being arranged so as to produce a pinwheel configuration presents the image

The Natural History of the Traditional Quilt

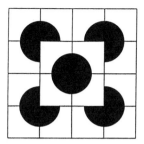

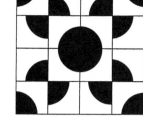

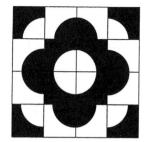

Figure 284a Figure 284b Figure 284c

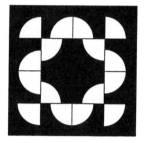

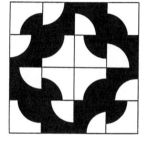

Figure 285a Figure 285b

of a full circle (VI/iii + VII/iv + X/ii + XI/i). Figure 284*a–c* shows three possibilities of this type. Of these, the cell in Figure 284*b* is the most commonly seen in pattern books, appearing as "Around the World" in Malone (1982:197) and Hall and Kretsinger (1935:90–91); as "Design Made of Striped Material" in Ickis (1949:76); and as "Drunkard's Path Variation," "Harvest Moon," and "Around the World" in Rehmel (1986:162, 163). The cell in Figure 284*a* is found in Rehmel (1986:161) under the name "Harvest Moon." The cell in Figure 284*c* is labeled "Illinois Rose" by Rehmel (1986: 163).

In these examples, the edge subunit pairs are either in the standard configuration (see Figure 284*a–b*), or, as in Figure 284*c*, the subunits are turned so as to form semicircles with the flat edge toward the center of the cell (II/iii + III/iv; V/iii + IX/ii; VIII/iv + XII/i; XIV/ii + XV/i). The corner subunits may be oriented as in the cell in Figure 282*a* (see Figure 284*a* and 284*c*), or they may be turned, as in Figure 284*b*, so that the curved edge of each quarter circle patch faces toward the center of the cell (I/i; IV/ii; XIII/iv; XVI/iii).

In another set of variations, the central subunit group is identical with the cell in Figure 272*c*, one of the constituent cells for the two celled designs in

this geometric family (VI/i + VII/ii + X/iv + XI/iii). The cell in Figure 285*a* is fairly common in the literature. Rehmel (1986:163) calls it "Cleopatra's Puzzle." Beyer (1980:123) and Risinger (1980) give the name "Baby Bunting." In it, the edge subunits are oriented as in the cell in Figure 284*c*, and the corner subunits are oriented as in Figure 284*a* and 284*c*. Figure 285*b* shows a cell which is called by Rehmel (1986:165) both "Doves" and "The Doves," and by Malone (1982:194) "Dove I." Rehmel (1986:163) also gives a cell which she calls "Drunkard's Path Variation," which is the same unit of construction turned 90° to the right.

In Figure 285*b*, the corner subunits are turned in the same way as for Figure 284*a*, but the edge subunits are different. In this example, II and V mirror XII and XV, with the curved edges of the quarter circle patches turned toward the center of the cell. Then III and VIII mirror IX and XIV, with the curved edges turned toward the outside. The edge subunit pairs II + III and XIV + XV are identical except for orientation, as are the edge subunit pairs V + IX and VIII + XII. The symmetries are not obvious, and therefore the construction of the cell requires the closest attention. It is not surprising that this cell is uncommon in the tradition.

The cell shown in Figure 272*c* is also used on its own to create traditional quilts, often with coloration reversed in alternate cells. The cell is found in Malone (1982:196) under the name "Pullman Puzzle," and in Rehmel (1986:165, 166), Beyer (1979:149), and Risinger (1980:80) under the name "Mill Wheel." Ickis (1949:77) lists the cell as "Reverse arrangement of Fig. No. 9," referring to another of her illustrations.

In Ickis' Figure 9, which is labeled "Arrangement for large blocks" (Ickis 1949:77), the four subunits of the cell are arranged so that the quarter circle patches meet in the center of the cell to form a circular shape, as in the cells in Figure 284*a*–*c* (see Figure 286*a*). Malone (1982:195) calls the cell "Snowball III." Hall and Kretsinger (1935:90–91) give this cell the name of "Rob Peter to Pay Paul." Rehmel (1986:162) gives the following array of names for the cell, variously arranged and colored: "Snowball," "Vine of Friendship," "Indiana Puzzle," "Rob Peter to Pay Paul," and "Mill Wheel." Note that four cells like the one in Figure 286*a*, when arranged in a lattice, form a larger pattern (Figure 286*b*) which can also be created by the use of the cell shown in Figure 272*c*. Here is another instance in which a pattern in this geometric family can be achieved using two genetically distinct cells.

To return to the variations seen in the single celled types, it is necessary to consider another possibility for the arrangement of subunits in the central

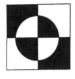

Figure 286a

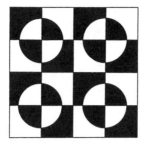

Figure 286b

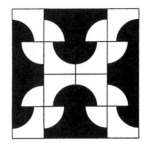

Figure 287

group of four. The quarter circle patches may be arranged so that two semicircles are formed, with curved edges facing toward the center of the cell (VI/ii + VII/i + X/iv + XI/iii or VI/iv + VII/iii + X/i + XI/ii). The central edge subunits are in the standard configuration, and the corner subunits are mirror images right and left and upper and lower. The cell in Figure 287 is an example of this type. The orientation of the corner subunits is the same as in Figure 247c, which shows one of the constituent cells of AM3. The cell is shown in Malone (1982:197) under the name of "Drunkard's Path Variation." Ickis (1949:76) labels it "Arrangement for Figured Material." Rehmel (1986:165) gives it the title "Unknown." The same unit of construction turned 90° is listed in Rehmel (1986:165) as "Falling Timbers," which is the name given by Hall and Kretsinger (1935:90−91) for the same unit of construction turned 45°.

So far, the possibilities discussed for the large cell made up of sixteen subunits, each of a quarter circle and notched square patch, are based on a single paradigm: central subunit group of four, edge subunit pairs, and corner subunits. Some pattern books give other designs which purport to be constructed on the same grid and of the same subunits. Analysis shows, however, that the cells involved are not in fact of this type. One example is the design shown in Figure 288a. This design is given by Malone (1982:194) under the name "Falling Timbers," and by Rehmel (1986:164), Ickis (1949:75), and Hall and Kretsinger (1935:90−91) as "Vine of Friendship." The same unit of construction is listed variously under the same two names when variously rotated. Rehmel (1986:164) gives versions rotated 90° to the left, 90° to the right, and 180°. Hall and Kretsinger (1935:90−91) give a version rotated 180°, and Malone (1982:194) gives one rotated 90° to the left.

Figure 288b shows the cell from which the design in Figure 288a could be made. The cell consists of four subunits rather than sixteen. It is unlikely that

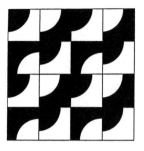

Figure 288a

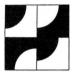

Figure 288b

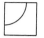

Figure 288c

the cell in this case is traditionally a unit of construction for this design. Because the design appears to have descended from those discussed above, the construction method would probably be based upon a conception of the design as a grid of sixteen subunits. However, because the design is not based upon the paradigm of the original single celled designs of the AM3 type, the method of construction is not the same as for those designs. The design in Figure 288a would not be constructed radially, but in straight strips (as would its constituent cell). A reconsideration of the cell structure of the design then reveals another possibility which is more in keeping with the construction method. The two cells shown in Figure 288c can be arranged in strips according to straightforward instructions to produce the design in Figure 288a.

This third analysis would appear to be the correct one, since it lends itself also to other designs in the tradition. Figure 289 shows another design which is constructed in strips from the two cells in Figure 288c. Rehmel (1986: 165) lists this design under the name of "Chain Quilt." Figure 290 shows a single cell arranged in strips to produce an overall design. Malone (1982: 196) labels this design as "Unnamed." Rehmel (1986: 164) lists a differently colored version of it as "Rippling Waters" or "Diagonal Stripes." Ickis (1949: 77) calls it "All Over Pattern." Turned at 180°, the design appears in Rehmel under the name "Dirty Windows."

The trail of connections goes on from here, of course. Other kinds of designs are made from combinations of subunits such as those in Figure 290. Some designs are made of subunits which have two quarter circle patches and a square patch notched at diagonally opposite corners. In some designs the quarter circle shapes are further subdivided and the subunits are variously arranged to produce feathered or variegated paths across the quilt. However, our discussion must now turn to the relationship between Mrs. Mayo's quilts and the traditional complex just analyzed.

Figure 289

Figure 290

It is clear that Mrs. Mayo was working with a design which has many traditional variations. Her own proclivity for variation in construction and orientation is apparent from the rest of her corpus. Thus, the fact that AM2, AM3, and AM18 show variation from cell to cell is not surprising. The source of Mrs. Mayo's pattern for the cells in AM2 and for the quilt AM3 is unknown. Mrs. Mayo and her family may have had a mental pattern from which the cells were constructed; or they may have had a material pattern of some sort. The design may have come into their hands via family, friends, or commercial sources. The pattern for AM18 was purchased by mail order, according to Mrs. Mayo's elder daughter. The close formal relationship between the earlier quilts and the later one, then, is a puzzle.

The cells in AM2 and AM3 are relatively unusual in the tradition, and it is therefore striking that the cells in AM18 are similar. In AM18, Mrs. Mayo would appear to have been attempting to replicate the earlier pattern, but without reference to the earlier quilts. At the time when Mrs. Mayo was piecing the later quilt, she was living with her elder daughter, several counties away from the home of the younger daughter, where the earlier quilts were kept.

The central subunit groups in the cells of AM18 form left pinwheels, while those in AM2 and AM3 form right pinwheels. Though the directionality is different in the earlier and later quilts, the direction is consistent within each quilt. Therefore, central pinwheel consistency would appear to predominate in importance over directionality per se in Mrs. Mayo's conception of the pattern. The presence of counterpoint pinwheels would appear to be less important than the presence of central subunit pinwheels, since in AM18 there are many instances in which the placement of corner subunits does not create counterpoint pinwheels. Also, the direction of counterpoint pinwheels need not be consistent within the quilt, as is apparent from their al-

ternating directions in AM3. Their presence is more important than their directionality, but neither presence nor directionality is as important as the presence and directionality of the central pinwheels. In AM2, of course, no counterpoint figures emerge because the cells are separated by setting squares (not the work of Mrs. Mayo and her family).

The rules outlined above, coupled not only with Mrs. Mayo's tendency toward variation, but also with the existence in the tradition of variations on the pattern she was using, all go far to explain the particular features of the cells in Mrs. Mayo's quilts. It may be that, in addition, Mrs. Mayo "corrected" her purchased pattern in order to produce a design more in keeping with a remembered pattern. It may even be that her purchased pattern contained options, and that she mixed features from more than one.

In any case, creative variation and anomaly are both commonly seen in the case of this family of designs. Mrs. Mayo's work fits solidly within a traditional framework—a framework which shows influences from revival or commercial sources. The array of designs in this geometric family, represented by two different genetic strains within the taxonomy of traditional quilt cells, attests to the fertility of the basic design idea. When the principles of geometry and the rules of traditional construction and innovation interact, a complex kindred of cells is the result. Mrs. Mayo's cells and the quilts made from them take their places in the kindred, their remarkable individual features comprehensible only in relation to their traditional taxonomic context.

Though the case has been made for this set of quilts in particular, the more general point to be taken is that nearly all families of traditional quilt designs will most likely yield to analysis a similarly intricate picture of relationships between shared and varied features. It is within this context—yet to be established in all of its particulars—that all traditional quilt designs are most fully appreciated.

5.5. ANOMALY AS A CLUE TO INNOVATION

One unusual quilt in the corpus of Anna Mayo, AM26, contains the clues to a complex story of aesthetic innovation. The reconstruction of Mrs. Mayo's creative invention entails the examination of several of her other surviving quilts, as well as information obtained in interviews with her two daughters. The precise nature of the innovation embodied in the quilt might be guessed at solely through looking at the quilt. Contextual information confirms and amplifies surmises made in visual observation and analysis.

AM26 was made sometime in the 1930s or later, judging from the scrap materials of its component patches. At some point in its life history, it was

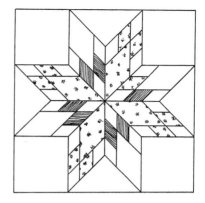

Figure 291 Figure 292

given to one of Mrs. Mayo's granddaughters, in whose home the authors first saw it. It is likely that the granddaughter obtained the quilt from her own parents' household after the death of her father, Mrs. Mayo's elder son, though the granddaughter does not recall the exact circumstances of the quilt's acquisition. Despite its age, the quilt is not excessively worn. Part of the explanation for the quilt's condition lies in the fact that the quilt came into being at a time when the family no longer relied solely on quilts for purposes of bedcoverings. Nevertheless the family used them, for practical or aesthetic reasons or both. It would appear that the quilt has been given special care relative to other household blankets: it has been neither torn nor so soiled as to require sufficient laundering to fade or excessively abrade its fabrics. The care is an indication of the express aesthetic and sentimental value placed upon Mrs. Mayo's quilts by her descendants.

A general description of the quilt's morphological and formal features is given in Section 5.2 and need not be repeated here. What follows is a more detailed examination of the quilt's appearance and construction. In nineteen of the twenty cells, an outline of a star shape appears in colored fabrics against a field of uncolored muslin. Each star shape is made up of patches of more than a single kind of fabric—mostly two fabrics per cell (see Figure 269a–b), but in some cases three or four different fabrics (see Figure 291). In the twentieth cell, located at one corner of the quilt, no star shape is immediately visible—until one looks closely enough to perceive seam lines which demarcate a muslin star shape against the muslin ground (see Figure 292).

A first possible interpretation of the design, and of the odd twentieth cell, revolves around the perception of the star shape as the dominant gestalt. In this interpretation, Mrs. Mayo created the same design twenty times—except

that in one version, she used the same fabric (uncolored muslin) that she used for the ground as part of the star shape. Ample evidence for this practice in traditional quilting is to be found, and other quilts in Mrs. Mayo's corpus show this kind of variation (see, for example, Figure 268a–b showing two colorations of the same cell in AM24).

A second possible interpretation is that Mrs. Mayo began with the design idea of a traditional pattern. She then made a discovery and an innovative decision which led to the pattern seen in the rest of the cells in the quilt. In the cells in Figure 246a–b, if the diamonds surrounding the colored shapes are cut from colored fabric different from that of the original shapes, an over-all star shape emerges against an uncolored background. The original shapes remain distinct but incorporated into a new design (see again Figures 269a–b and 291).

The evidence in support of one interpretation over another is to be found through the examination of the rest of Mrs. Mayo's extant corpus and through consideration of information obtained from her two daughters re-garding patterns used by their mother. Most pertinent to the discussion are quilts of three different types: (1) quilts featuring a large central star shape—AM9, AM19, and AM20; (2) quilts made up of a number of repeated cells showing a star shape in its subunits—AM14; and (3) quilts made up of cells showing the shape which is seen in the twentieth cell of AM26 or its mirror image—AM1 and AM15.

Prominent among the quilts of Mrs. Mayo's later years are a series of quilts showing a single large central star shape, the entire design composed of dia-monds of a uniform size (see Figures 254a, 263a–b, and 264). Mrs. Mayo made an unknown number of these quilts, in bought fabric and in scrap. The design was originally introduced into her repertoire by a niece who had begun a quilt she found too difficult to complete (AM19, shown in Fig-ure 263a–b). AM19 may date from the 1920s. Its red, white, and blue color scheme suggests a possible association with the national sesquicentennial in 1926. The niece had cut at least some of the patches for the quilt and had begun to stitch them together. Mrs. Mayo's elder daughter recalls that her mother was obliged to deconstruct and restitch the quilt in order to correct the niece's mistakes in piecing, which had resulted in imprecision of seams and eccentricity of overall shape.

AM19 is the only surviving quilt of this type in which Mrs. Mayo has used pieced corner squares (see Figure 263b). Mrs. Mayo's other quilts showing a central star-shaped pattern have unpieced squares in the corners. It is un-known whether Mrs. Mayo's niece cut the pieces for the corner squares or whether they were cut by Mrs. Mayo herself. It seems likely that Mrs. Mayo

cut the patches, since they are quite irregularly colored as compared with the patches of the central star shape. The corner squares of the quilt, though each made up of the same numbers, shapes, and arrangement of patches, are variously colored. The result is that a different design emerges visually in the case of each square (see Figure 263 a).

The method of piecing of the corner squares in AM19 relates to that of the central star shape of the same quilt: in each case, a starlike shape is made up of diamonds pieced in strips, and the outer edges of the shape are filled in with a series of squares and triangles to form a square. A similar design idea underlies the pattern of the cells in AM26. Thus, both the central star shape and the corner squares of AM19 bear a close conceptual and technical relationship with the cells of AM26, and the cell in AM19 is closely related to that in AM26.

The corner squares of AM19 demonstrate Mrs. Mayo's awareness of creative possibilities inherent in the design concept. Whether or not Mrs. Mayo selected the colors and cut the patches which create the variation in visual pattern, she could not have pieced the quilt without comprehending the underlying geometry. AM19 documents Mrs. Mayo's involvement in experimentation with variation in color while holding constant the underlying geometry; it also establishes an engagement with variation in a cell which is closely related to those of AM26.

In the decades which followed the completion of AM19, Mrs. Mayo made an unknown number of similar, though not identical, quilts. Her younger daughter explains that the design was much admired by many family members, and that her mother responded to the admiration by making such quilts for several relatives. The younger daughter owns one of these, AM9, made of new cotton fabric in solids of vivid hues, with white squares and triangles filling out the square shape of the overall quilt. Each white corner square forms the ground for a showy quilting pattern in the shape of a feathered wreath. By this period in her life, Mrs. Mayo was no longer doing her own quilting, due to her preference for piecing and to her failing eyesight. The quilting is the paid work of a neighbor. An unquilted top of a similar kind appears in a photographic portrait of Mrs. Mayo, taken when she was in her eighties. This may or may not be the top which when quilted became AM20, owned by Mrs. Mayo's elder daughter. The photograph is not clear enough to show whether the scrap top is the same as that of the scrap quilt AM20, constructed from the same cell.

The cells in all of the surviving quilts of this type (including the one in the photograph) are identical except for that in AM19. In AM19, each of the eight large diamond-shaped points of the central star shape is made up of

sixty-four small diamonds, set on an 8 × 8 grid (see Figure 263a). The other quilts have points made up of one hundred small diamonds apiece, on a 10 × 10 grid (see Figures 254a and 264). The size of the quilts is the same. AM19 is composed of larger diamond-shaped patches than the others, which therefore must have been made using a different template. Most likely, Mrs. Mayo did not have the templates used by her niece and was obliged to find or create a new set for herself in order to make the subsequent similar quilts. The fact that the newer quilts are more intricate may have been a deliberate choice on Mrs. Mayo's part, since she was by her daughters' accounts very proud of her skills as a seamstress. The more elaborate version of the design may have appealed to her as a means of showing off her considerable expertise.

Here again is evidence that Mrs. Mayo was experientially aware of the close relationship between two structurally similar patterns which differ only in the number of constituent patches within a grid. The elder daughter refers to all of the quilts of this general type subsequent to AM19 as "copies" of that quilt. "Mother copied it several times after that" is how she describes the creation of the other quilts (Authors' field tape). Whether or not Mrs. Mayo saw the designs as identical cannot be known; but it is demonstrated that she had practical knowledge of the structural possibilities inherent in the grid based arrangement of component smaller diamond shapes into a larger diamond shape, and the larger shapes into a star shape.

A single extant quilt, AM14, exemplifies the type in which the repetition of cells featuring star-shaped subunits makes up the quilt. Sashing strips separate the cells in an overall straight setting. In this quilt, owned and used by the younger daughter, each star-shaped subunit is made of eight diamonds radially pieced, with the square shape of the next higher subunit filled out with patches of square and triangle shapes (see Figure 259b). The arrangement of the diamonds is the same as the arrangement of the large diamonds made up of smaller diamonds seen in the quilts with the large central star shape: eight radially arrayed diamonds with one point of each converging at the center of the star shape and the other point of each extending to the edge of a unit of square shape, and with added squares and triangles of a contrasting or neutral color or colors. Again, the evidence shows that Mrs. Mayo was familiar with variations on a single design theme of radially arranged diamonds. It may be strongly surmised from this evidence that Mrs. Mayo explicitly recognized the large diamond shape of each of the points of the central star shapes made of many smaller diamonds.

The final type of quilt which bears significantly on the explanation of the variation seen in the case study quilt is a type made up of cells which resemble

the one odd cell in the latter or its mirror image (see Figure 246a–b). Two quilts of this type survive. AM1 is the possession of the younger daughter, and AM15 belongs to the elder daughter. Interestingly, the pattern for this quilt type may have come to Mrs. Mayo in the same general time period in which the partially completed quilt, which became AM19, was brought to Mrs. Mayo by her niece. Mrs. Mayo's elder daughter's story of her acquisition of the pattern (see Section 5.3) is probably set in the 1920s. AM15 appears to be the first quilt of this kind made by Mrs. Mayo.

It will be seen from a comparison of the cells in AM15 with the cells of the other quilts discussed so far that all are related in terms of pattern structure and construction type. They are closely situated within the taxonomy of pieced quilt designs because of being radially pieced around a single point, with constituent subunits of similar shapes. This close relationship among several of the designs known to be favorites with Mrs. Mayo allows us to follow the quilter's conceptual path toward the innovation which appears in AM26. Before returning to a final discussion of that quilt, one last quilt will be examined.

AM1, owned by the younger daughter, was made after AM26 during the period of Mrs. Mayo's old age. The general formal features of AM1 are described in Section 5.2. One unusual feature of this quilt is the appearance of a single anomalous cell (see Figure 293). Irregularities and variation in coloration are common in Mrs. Mayo's scrap quilts, but the anomalous cell in the red and white quilt is the only surviving example of such irregularity in a quilt made of bought goods. The irregular character of the coloration of patches in the odd cell presents a puzzle. If the cell were intended to be identical in coloration to the others, it would have to be said that one diamond which "should" have been white is red instead.

The construction of the other cells (see Figure 246a–b), consists of eight large diamonds which make up the central shape, plus squares and triangles. The construction of each large diamond in terms of the shapes of patches is identical. The only difference is in coloration, with alternating large diamond "points" showing alternating colors for the larger of the constituent diamond patches. Figure 294a shows a subunit in which the largest diamond patch is dark. In Figure 294b, the largest diamond patch is light. Alternating subunits are oriented in opposite directions, with the larger constituent diamond closer to the inside when it is one color and to the outside when it is the alternate color (see Figure 294c).

With this understanding of the construction of the cell, it can be seen that the oddity of the anomalous cell in AM1 is due to the use of three of the *same* kind of large diamond subunits in a row, with the orientation alternated

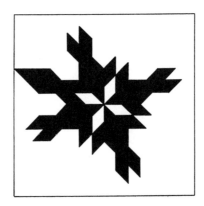

Figure 293

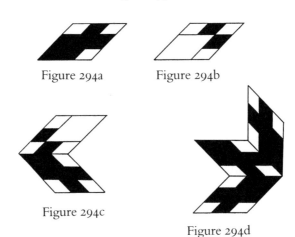

Figure 294a Figure 294b

Figure 294c

Figure 294d

(see Figure 294*d*). The variation is not due simply to an irregularity involving a single patch, but to a constituent shape distinguished in overall coloration from the other constituent shape in the central star shape. The existence of this kind of variation in the appearance of the central shape, due to the unique positioning of constituent shapes, again attests to Mrs. Mayo's practical experience with the possibilities inherent in the design structure and construction method of this and related patterns.

It cannot be said with certainty whether Mrs. Mayo would have regarded this variation in her quilt as an error. It might be supposed that she would have, since no other example of such variation survives in a quilt of bought goods (although there is then the question of why the error was not spotted and corrected before the cells were set together). If it were an error—perhaps attributable to the toll of years on the quilter's visual acuity and concentra-

tion—it could either have arisen from or given rise to conscious innovation. Since AM1 was created after AM26, whatever occurred in the former's construction incorporated experience gained in the stitching of the latter. It could be argued that the anomalous cell shows a trace of memory, on a pragmatic if not mental level, of the discoveries made through the years of working with the types of patterns under discussion—discoveries which led to the innovation seen in the case study quilt.

The cells of AM26 are closely related to those of the other quilts discussed, and identical with those in AM1 and AM15. Designs of this type figure prominently in Mrs. Mayo's repertoire, and many have been used by her repeatedly. Mrs. Mayo's innovation would have begun with the recognition of the relation between the Canadian woman's pattern, seen in AM1 and AM15, and the star-shaped patterns with which the quilter was already familiar. Mrs. Mayo could then make use of that relationship to create a blending of the two types of design using a novel scheme of coloration.

The hypothetical course of the creation of AM26 might be reconstructed thus: Mrs. Mayo began the quilt as a scrap version of the Canadian woman's pattern. The anomalous cell was thus the first cell stitched. After the construction of the first cell, Mrs. Mayo conceived a new design idea. Her inspiration arose from the relationship of designs with which she was familiar and from the potential inherent in scrap materials as opposed to bought goods. She would use contrasting scraps to finish out the star shape surrounding the central shapes visible in the Canadian woman's pattern. The resulting richness of color and complexity of design is striking, and unique among Mrs. Mayo's surviving works.

It cannot be known for certain whether this was exactly the way in which the quilt came to be. The relation among a group of Mrs. Mayo's quilt pattern types becomes apparent through the use of a taxonomy of quilt designs that is based on principles of construction. The understanding of construction method as the basis for genetic relationships among quilt designs points toward a way of thinking about the visible innovation and leads to an understanding of the possible evolution of a creative idea. Other natural historical facts which emerge in the course of examination of the quilts and interviews with the quilter's daughters help to flesh out the picture of Mrs. Mayo's creative process. What appears at first glance as a curious novelty—an anomaly in a single quilt—turns out to be the material evidence for the culmination of years of exploration and experimentation with a complex design concept. The natural history approach, with its focus on the form and life of the quilt, uniquely reveals otherwise unrecoverable information about the life and process of the quilter.

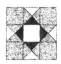
6. Conclusion
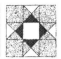

6.1. QUILTS AND THE TRANSMISSION OF CULTURE

Such study as we propose for the understanding of the lives of traditional quilts in human context brings into focus a complex of questions and issues best conceived as problems in the transmission of culture. First, a number of interrelated topics are indicated briefly below. Then, the various strands are taken up in turn.

The study of the transmission of culture is the natural domain of such fields as cultural anthropology and folklore. A primary benefit of the kind of study mapped out in this work is the better understanding of this field of inquiry. The proposed program explores the linked mechanics and dynamics of production and transmission from the point of view of process. This exploration leads to an assessment of the finished quilt as a product which contains hints of the process, technical and cultural, by which it is derived and becomes a mode of transmission in itself. Herein lies the usefulness of the method to archaeology, for the method specifies the way in which process may be reconstructed from product. The case study shows the realization of this aim with respect to the works of a quilter who is no longer living.

The proposition that all material culture is a crystallization of process is not unique to the present work. Past and present theoreticians in cultural anthropology and aesthetic anthropology have expounded upon this concept (for further discussion see K. Hardin 1993), which is taken as foundational to the approach outlined in this work. The proposed program places the theoretical notion in an operational framework, and the case study articulates particular points which feed back into theory in aesthetic anthropology and cultural anthropology generally. An informed focus on product, therefore, leads to a profound understanding of process. The proposed method demonstrates that the product-versus-process dichotomy is false. Here it is interesting to note that a group of anthropologists working in an area seemingly far removed

from aesthetics have based their research program (and their polemic) on related theoretical premises. "Cyborg anthropology," with its focus on the interface between technology and culture, recognizes as fundamental the notion that process, product, and producer form a single, integral system (see, e.g., Downey, Dumit, and Williams, forthcoming; and Haraway 1991). Thus our natural history of the traditional quilt might be seen as the first programmatic description of a traditional cyborg.

The present work represents an intersection of diachronic and synchronic approaches, and of quantitative and qualitative analyses. The proposed research program partakes of all of these approaches and perspectives, and demonstrates thereby that they do not form oppositional pairs. Thus the proposed program integrates what are too often conceived of as mutually exclusive methodologies, at the same time as it provides integration through themes which tie together concerns in various disciplines and subdisciplines.

Finally, the analytic method presented in this work points toward a new conception of fieldwork. The kind of fieldwork motivated by the analytic concerns laid out in this work will be based in an adequate understanding of what issues are at stake. Field documentation, which so often has focused on the purely morphological, will now encompass all of those elements which are necessary in order to make the morphological mean something.

The natural history method, with its emphasis on the life of the traditional material object, systematically brings to attention all of the aspects of coming to be, being, and passing out of being. The traditional material object is the key to all of the forces which shape it. It is the crystal in which can be seen the structure of the transmission of culture. Observed in this way, the traditional material object yields to the investigator a multifaceted image of the interaction of influences upon the knowledge and actions of traditional practitioners. In turn, this image can be compared with theoretical abstracts in order to verify or challenge the latter. Some examples drawn from the case study illustrate the point.

In Section 5.2 we suggested that the pattern of distribution of the quilts of Anna Mayo mirrors social patterns. That there is a distribution pattern for objects is of course not a novel notion, nor is the thought that social realities can be understood through the correct analysis of that pattern. However, a deep study of the distribution patterns of actual traditional material objects, traceable through the lines of kinship stemming from a single traditional practitioner, reveals the complexity of the problem. Marriage, descent, residence, migration, social class, social mobility, and modernization all have a part to play in explaining the distribution of objects.

As a simple example, the available extant quilts of Anna Mayo belong primarily to her two daughters, and beyond them, to other female descendants. This pattern reflects a wide variety of social facts. The daughters of Mrs. Mayo housed her and cared for her in her old age for much longer periods than did either of her sons, and so they received more quilts by dint of their mother's constant proximity. After marriage, the daughters remained closer to their natal homes than did the sons. The daughters' relatively closer ties with their homes and their mother are an element in the composition of the available corpus.

Many other quilts, scattered and possibly used out of existence, are known to have been made; yet it is unlikely that the fieldworker will ever see them. Quilts can diffuse with or without all kinds of other cultural elements, and the nature of cultural transmission is determined by the particular type of diffusion at work. Mrs. Mayo's daughters inherited and kept her quilts, and that inheritance is embedded in a context of cultural transmission which includes the daily interactions of mother and daughter in a geographically stable but temporally changing environment. Culture is also transmitted through the inheritance of quilts by those who did not have daily dealings with the quilter, or whose daily dealings with her were mainly coterminous with their own childhoods. The traditional material object itself is a mode of transmission, even if the passage of the object from hand to hand occurs entirely outside of the original traditional context.

The influences of age and gender on the nature of cultural transmission must be taken as problematic, even in the case of a traditional practice such as quiltmaking, which is conventionally associated with a single gender. The classic model of traditional influence is that of the elder practitioner guiding the younger as techniques and attitudes are transmitted. In the case of Mrs. Mayo, it is clear that influences have moved in both directions. The quiltmaker has instilled in her descendants a love of the traditional forms, and has transmitted certain articulations of aesthetic principles. In return, those descendants have shaped the quiltmaker's practice through the provision of materials and through their own requests and preferences.

The influence of the quilter on her descendants in the transmission of the tradition is not uniform through time. Depending upon the composition of the quilter's household, different people are differentially exposed to her practice of quiltmaking. Her young sons may have seen her at work and not been as involved or aware of her technique as were her daughters. The techniques and aesthetic preferences which a daughter observes as a young girl may not be the same as those practiced by her mother when she is part of the

same daughter's household after marriage. Mrs. Mayo's technique and aesthetic can be seen to have changed over time, due perhaps to various circumstances. The aspect of the tradition which is active at any one point in the quilter's life may be the aspect which is most readily transmitted at that point.

Direct transmission of technique is not the only way in which a traditional practice survives. Mrs. Mayo's daughters each, in a sense, recreated the tradition after their mother's death. Other more distant descendants have recreated it in different guises, despite never having seen their ancestor at work. The quilts themselves embody the tradition and continue to exert a living impetus to its transmission. In this regard, it is important to note that quilters and owners of quilts often display them selectively. Certain types of quilts may be seen by only close family members, and therefore those aspects of the tradition may be transmitted only in the context of the most intimate and quotidian domestic experience.

Although none of her male relatives practiced the form in which Mrs. Mayo excelled, the tradition is not borne by women alone. Mrs. Mayo's own unmarried brother was a notable needleworker, skilled in the manufacture of crocheted lace, and his interest must be seen as part of the context of her work. But there is evidence of a more direct participation in the quiltmaking tradition by her male relatives. An affinal relation, the younger daughter's husband, made remarks in the course of the field research for the case study that indicated personal experience with the quilting needle. After a few such comments, he revealed that he had quilted with his mother as a boy. His wife was astonished. He had never before mentioned to her his experience with quilting (a reasonably common experience for Appalachian boys of his era), despite the fact that they had pieced a quilt together as newlyweds. Only in the context, years later, of attention by an outsider to his mother-in-law's quilts did his part in the tradition come to light.

This same man made his own photographic record of each quilt as it was documented for the case study, despite the fact that the quilts had lain in his own home for decades prior to the fieldwork. His demonstration of appreciation, an appreciation never before expressed by photographing the quilts, may indicate a covert or latent tradition which was called forth by an outsider's interest. Aspects of the tradition had been transmitted to him, and presumably might be transmitted further given the proper set of circumstances.

The transmission of culture operates differently according to the sphere within which the technical practitioner works. The professional quilter may differ significantly in practices and attitudes from the traditional domestic quilter—though both personnel and practices may overlap. The influences

acting upon and proceeding from the works of each are distinctive to the circumstances of her status as an artisan. A hobbyist and a revival quilter are not necessarily the same, and the influences acting upon each may be traditional, commercial, or a combination of both. The extended example of related quilt designs discussed in Section 5.4 traces the path of possible influences back and forth from tradition to revival on the development of a geometric design idea. The specifics of such instances of transmission in terms of individual women, their shared information and their innovations, are yet to be documented with any degree of detail; although Section 5.5 of the case study presents a reconstruction of one segment of such transmission.

From the materials presented in the case study, it is clear that a correct understanding of the transmission of traditional culture must take into account the fact that traditional practitioners often work in collaboration, but that collaboration is not always straightforward. Within Mrs. Mayo's corpus, for example, are products of collaborations of at least six different kinds, yet all of the quilts are presented as being the works of Mrs. Mayo. Quilts in the corpus have been made through both serial and simultaneous collaboration. Serial collaborations in which one or more of the collaborators are dead at the time of the work's completion have produced some of the quilts. Certain quilts are pieced by one hand and quilted by another. Other quilts have been pieced and quilted by multiple hands. Some quilts have been serially pieced by two quilters, or pieced by one or more and set by another, and then quilted by whoever finished the top. And from the narratives of Mrs. Mayo's daughters, there is evidence that some of her quilts were pieced by her own hand exclusively and quilted by a group of women at a bee. Thus a traditional object may embody a variety of traditional practices in each of which the transmission of culture may operate differently.

The traditional material object is a crystallization of the cultural processes which produced it and in the context of which it moves through its life cycle of creation, bestowal, and use. A focus on the life history of the traditional quilt leads to an awareness of all aspects of the cultural milieu in which it is situated. The transmission of traditional culture as embodied in a single form implies the entire cultural matrix, the appropriate understanding of which is made possible through attention to questions of the traditional object's life history.

This embodiment of cultural process can take place in personal terms which are recognized and valued by members of the traditional culture. The traditional scrap quilt frequently represents a significant transformation of materials, resulting in an object of sentimental worth. Mrs. Mayo's elder daughter expresses especial regard for a quilt in which she can spot fragments

of her mother's and her own clothing. The same daughter also cherishes a quilt made from a pattern which has special associations for her. In the quilt is embodied the experiences of her leaving home, working in a distant city, and meeting the gracious foreigner who later sent the pattern—then at last returning to the bosom of the family, in which context the quilt was made for her.

Even when the pattern and the individual fabrics are not familiar to the quilt's owner, the quilt may take on a personal historical meaning. Several of Mrs. Mayo's granddaughters and great-granddaughters articulate the feeling that the quilts link them to a heritage from which they have become separated in geographic, temporal, and social distance. This is so even in the case of great-granddaughters who have never lived in Appalachia, and for whom many aspects of the tradition are lost. The traditional quilt is often regarded by its owners as a crystallization of memory, and it becomes the task of the researcher to discern its structure as such. The proposed method, focusing on the object and its life history, provides a lens through which such discernment becomes possible.

The quilt embodies technical and aesthetic process; if properly analyzed, it can yield an enormous amount of information about the way in which a quilter works. The case study includes many examples of this kind of analysis, and Sections 5.4 and 5.5 are extended meditations upon quilts as crystallizations of aesthetic ideas and technical practices. The aesthetic ideas which become apparent in the course of analysis may take the form of general principles, individual decisions, or moments of innovation. Note, too, that the principles revealed through observation of the quilt do not always accord in an obvious way with those articulated by the quilter and those around her. Such is the value of close and systematic observation, that it may uncover a much more complex aesthetic structure than is explicit in native terminology.

From the foregoing discussion, it should be clear that the proposed method finds no sharp dichotomy between an emphasis on product and one on process. If the traditional quilt embodies the process which created it, including all of the influences and meanings which give it a place within traditional culture, then an appropriately motivated and informed examination of the product leads to a multifaceted understanding of process. The proposed research program is designed to lead the scholar along the proper paths in considering the product, so that an understanding of process is the inevitable point of arrival.

There may be variant analyses of process derived from product, but an adequate understanding of process determines which is correct. Therefore,

prior grounding in the understanding of the components of process in the life cycle of a traditional material object is imperative. The natural history method provides such a basis, because it directs the scholar to consider the widest possible context for the material object. The natural history approach sets forth a model, already familiar from biology, in which all the features of cultural process find a logical place.

Process can be the link among related products, as seen in the case study sections concerning families of related designs. In Section 5.4, a geometric design family is found in the tradition to comprise two separate taxonomic branches connected by technical and social process. Section 5.5 traces technical and aesthetic relationships among a group of designs, showing how the knowledge gained by the quilter through her experience of those relationships leads to innovation.

The natural history method integrates diachronic and synchronic approaches and concerns into a coherent research agenda. The traditional quilt is a synchronic object, but an investigation of it yields both synchronic and diachronic information. As seen in Section 5.4, it is possible to recover historical sequences from an examination of simultaneously occurring forms. This procedure is the hallmark of classic structural linguistics, and its application to the understanding of material forms is possible only where there is an adequate understanding of the rules of change. In the case of material objects, those rules are contingent upon the facts of construction. The present work lays out a blueprint for the formulation of that set of rules for traditional quiltmaking, but the method proposed could be used to generate rules for any material form.

The approach taken in the present work represents an intersection of qualitative and quantitative methods. The taxonomy itself, while guided by logically formal principles, is not governed by them to the extent that native categories are entirely overridden. Rigorous formal analysis, as advocated in the research program and demonstrated in the case study, is not a sterile exercise in tabulation and classification, but is turned to the service of rich information about human ideas and activities. Far from being an end in itself, or a way of leading away from informants and living situations, formal analysis as prescribed in this work brings the scholar face to face with human manifestations otherwise unrecoverable. The exacting contemplation of the intricate oddities of Mrs. Mayo's quilts AM2, AM3, and AM18 inspires a detailed picture of the quilter as she pieces, and a glimpse at what conception of pattern directs her. A formal analysis of all of Mrs. Mayo's quilts discovers an aesthetic principle of subtle but often radical variation which unifies the cor-

pus. An essentially quantitative account discloses the considered touch of a human hand.

It should be evident that fieldwork holds an important place within the proposed program of research, and that fieldwork must proceed from an adequate understanding of the issues. For example, it is perhaps useful to know that scholars have often divided quilts into the categories scrap and best, or some such equivalent pair of classes. However, if fieldwork is governed by a slavish adherence to such categories, without due consideration given to what they could mean in functional and operational terms, confusion or procrusteanism will be the result. Mrs. Mayo's quilts seem to lie along a continuum which ranges from the prototypic best quilt to the prototypic scrap utilitarian quilt. In between, however, are many gradations and combinations of features belonging to the two ideal types. To call a quilt one or the other in these cases is to oversimplify the tradition and the traditional culture.

It should go without saying that, wherever possible, participant observation is called for in order to understand the full cultural context in which the quilts participate, and which gives shape and meaning to the quilts. Even when the quiltmaker is no longer living, as in the case of Mrs. Mayo, participant observation leads to a familiarity with many aspects of the quilts' life histories and the past and present lives of their current owners. Participant observation may be necessary simply to be certain that all available examples of the traditional form have been considered. Owners of quilts use and display them differentially. A significant portion of the data regarding a quilt pertains to the circumstances in which it might be encountered, and by whom. A fieldworker who does not live with the quilts will never know how the quilts live.

The natural history method requires the most comprehensive sort of field documentation. First, documentation of the quilt's morphological features must be sufficiently fine-grained and extensive to override the fieldworker's own prejudices as to what is being documented. For instance, in the case of some of the apparently highly regular best quilts in Mrs. Mayo's corpus, we did not fully appreciate the variations until after lengthy and repeated scrutiny of documentary photographs. Second, the documentation of morphological features must be accompanied by full attention to the contextual and processual facts which give meaning to the morphological. For example, it is almost never the case that traditional material objects are adequately documented in situ. Although much processual information can be recovered from the consideration of the object itself, much contextual information is lost forever if the only documents available have already lopped it off.

Of course it is our hope that scholars of traditional aesthetics and material culture will be inspired to take a natural history approach. Studies informed by the natural history perspective, even if they do not themselves constitute full natural histories, will produce a wealth of data not yet available to scholarship. The lives of humans are played out in intersection with the humblest of materials, fashioned into forms of meaning, beauty, and usefulness. If humans are dust, they also work with dust; and if they are enspirited, they also enspirit. Yet the study of the connections between the life processes of humans and the objects they make need not be arcane. One of the most obvious benefits of the study of material forms is that, literally, they embody otherwise intangible human processes. The natural history method offers a way of regarding with reverence the lives of everyday objects in the traditional cultural round, and of spelling out the significance of those lives in concrete terms. The spiritual and the material are not separate and they are not mutually antagonistic. Opposition between radical materialism and radical idealism is based upon a false dichotomy of perspectives. The present work is offered as a contribution to the healing of an intellectual and cultural breach which has endured past its time of usefulness.

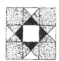 # *References*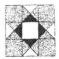

Betterton, Sheila. 1978. *Quilts and Coverlets from the American Museum in Britain.* London.

Beyer, Jinny. 1979. *Patchwork Patterns.* McLean, Va.

———. 1980. *The Quilter's Album of Blocks and Borders.* McLean, Va.

Binney, Edwin III, and Gail Binney-Winslow. 1984. *Homage to Amanda: Two Hundred Years of American Quilts.* San Francisco.

Bishop, Robert, and Elizabeth Safanda. 1976. *A Gallery of Amish Quilts: Design Diversity from a Plain People.* New York.

Bishop, Robert, William Secord, and Judith Reiter Weissman. 1982. *Quilts, Coverlets, Rugs and Samplers.* New York.

Boorstin, Daniel J. 1983. *The Discoverers.* New York.

Chang, K. C. 1967. *Rethinking Archaeology.* New York.

Clarke, Mary Washington. 1976. *Kentucky Quilts and their Makers.* Lexington, Ky.

Collins, Willie R. 1992. "Use What You Got: A Profile of Arbie Williams, Quilter." In *African-American Traditional Arts and Folklife in Oakland and the East Bay*, 13–16. Oakland, Calif.

Cooper, Patricia, and Norma Bradley Buferd. 1978. *The Quilters: Women and Domestic Art.* New York.

Cowan, Mary L. 1962. *Introduction to Textiles.* New York.

Davis, Dave D. 1983. "Investigating the Diffusion of Stylistic Innovations." In *Advances in Archaeological Method and Theory*, edited by Michael B. Schiffer, 6:53–89. New York.

Deetz, James. 1965. "The Dynamics of Stylistic Change in Arikara Ceramics." *Illinois Studies in Anthropology*, no. 4.

———. 1967. *Invitation to Archaeology.* New York.

Downey, Gary Lee, Joseph Dumit, and Sarah Williams. Forthcoming 1995. "Cyborg Anthropology." In *The Cyborg Handbook*, edited by Chris Hables Gray, Heidi J. Figueroa-Sarriera, and Steven Mentor. New York.

Dunnell, R. C. 1978. "Style and Function: A Fundamental Dichotomy." *American Antiquity* 43(2):92–202.

Finley, Ruth. 1929. *Old Patchwork Quilts and the Women Who Made Them.* Philadelphia.

Forrest, John. 1988. *Lord I'm Coming Home: Everyday Aesthetics in Tidewater North Carolina*. Ithaca, N.Y.

———. 1991. "Visual Aesthetics for Five Senses and Four Dimensions: An Ethnographic Approach to Aesthetic Objects." In *Digging into Popular Culture*, edited by Ray Browne, 42–51. Bowling Green, Ohio.

Friedrich, Margaret Hardin. 1970. "Design Structure and Social Interaction: Archaeological Implications of an Ethnographic Analysis." *American Antiquity* 35: 332–343.

Glassie, Henry. 1975. *Folk Housing in Middle Virginia: A Structural Analysis of Historic Artifacts*. Knoxville.

Grünbaum, Branko, and G. C. Shephard. 1987. *Tilings and Patterns*. New York.

Haders, Phyllis. 1976. *Sunshine and Shadow: The Amish and their Quilts*. New York.

Hall, Carrie A., and Rose G. Kretsinger. 1935. *The Romance of the Patchwork Quilt in America*. New York.

Hammond, Joyce. D. 1986. *Tifaifai and Quilts of Polynesia*. Honolulu.

Haraway, Donna J. 1991. "A Cyborg Manifesto." In *Simians, Cyborgs, and Women: The Reinvention of Nature*, 149–181. New York.

Hardin, Kris L. 1993. *The Aesthetics of Action: Continuity and Change in a West African Town*. Washington, D.C.

Hardin, M. A. 1977. "Individual Style in San José Pottery Painting: The Role of Deliberate Choice." In *The Individual in Prehistory*, edited by J. N. Hill and J. Gunn, 109–136. New York.

———. 1979. "The Cognitive Basis of Productivity in a Decorative Art Style: Implications of an Ethnographic Study for Archaeologists' Taxonomies." In *Ethnoarchaeology: Implications of Ethnography for Archaeology*, edited by C. Kramer, 75–101. New York.

Hilbert, David R. 1987. *Color and Color Perception: A Study in Anthropocentric Realism*. Stanford.

Hill, J. N. 1967. "Structure, Function, and Change at Broken K Pueblo." *Fieldiana: Anthropology* 57:158–167.

———. 1970. "Broken K Pueblo: Prehistoric Social Organization in the American Southwest." *University of Arizona Anthropological Papers*, vol. 18.

Hockett, Charles. 1958. *A Course in Modern Linguistics*. New York.

Horton, Roberta. 1986. *Calico and Beyond: The Use of Patterned Fabric in Quilts*. Lafayette, Calif.

Hymes, Dell. 1975. "Breakthrough Into Performance." In *Folklore: Performance and Communication*, edited by Dan Ben-Amos and Kenneth S. Goldstein, 11–74. The Hague.

Ickis, Marguerite. 1949. *The Standard Book of Quilt Making and Collecting*. New York.

Irwin, John Rice. 1984. *A People and Their Quilts*. Exton, Pa.

Jelinek, Arthur J. 1976. "Form, Function, and Style in Lithic Analysis." In *Cultural Change and Continuity: Essays in Honor of James Bennett Griffin*, edited by C. Cleland, 19–33. New York.

Lasansky, Jeannette. 1985. *In the Heart of Pennsylvania: 19th and 20th Century Quilt-making Traditions.* Lewisburg, Pa.

Lindsay, Ellen. 1857. "Patchwork." *Godey's Lady's Book,* February 1857.

Lockwood, E. H., and R. H. Macmillan. 1978. *Geometric Symmetry.* Cambridge, England.

Longacre, William A. 1964. "Sociological Implications of the Ceramic Analysis." *Fieldiana: Anthropology* 55:155–170.

———. 1974. "Kalinga Pottery Making: The Evolution of a Research Design." In *Frontiers of Anthropology,* edited by M. J. Leaf, 51–67. New York.

McKendry, Ruth. 1979. *Quilts and Other Bed Coverings in the Canadian Tradition.* Toronto.

McKim, Ruby. 1962. *101 Patchwork Patterns.* New York.

Malone, Maggie. 1982. *1,001 Patchwork Designs.* New York.

Malraux, André. 1967. *Museum without Walls.* (Trans. Stuart Gilbert and Francis Price.) New York.

Newman, Joyce Joines. 1978. *North Carolina Country Quilts.* Chapel Hill, N.C.

Pellman, Rachel. 1984. *Amish Quilt Patterns.* Intercourse, Pa.

Pellman, Rachel, and Kenneth Pellman. 1984. *The World of Amish Quilts.* Intercourse, Pa.

Plog, Stephen. 1978. "Social Interaction and Stylistic Similarity: A Reanalysis." In *Advances in Archaeological Method and Theory,* edited by Michael B. Schiffer, 1:143–182. New York.

Pottinger, David. 1983. *Quilts from the Indiana Amish: A Regional Collection.* New York.

Quilter's Choice: Quilts from the Museum Collection. 1978. Helen Foresman Spencer Museum of Art, University of Kansas. Lawrence, Kans.

Rehmel, Judy. 1986. *The Quilt I.D. Book.* New York.

Risinger, Hettie. 1980. *Innovative Machine Quilting.* New York.

———. 1983. *Innovative Machine Patchwork Piecing.* New York.

Safford, Carleton L., and Robert Bishop. 1980. *America's Quilts and Coverlets.* New York.

Schwoeffermann, Catherine. 1984. *Threaded Memories: A Family Quilt Collection.* Binghamton, N.Y.

Seward, Linda. 1987. *The Complete Book of Patchwork, Quilting and Appliqué.* New York.

Shubnikov, A. V., and N. V. Belov. 1964. *Colored Symmetry.* Oxford, England.

Slone, Verna Mae. 1979. *What My Heart Wants to Tell.* Washington, D.C.

Stanislawski, M. B. 1969. "The Ethno-Archaeology of Hopi Pottery Making." *Plateau* 42:27–33.

Washburn, Dorothy Koster. 1977. *A Symmetry Analysis of Upper Gila Area Ceramic Design.* Papers of the Peabody Museum, vol. 68. Cambridge, Mass.

Washburn, Dorothy Koster, and Donald W. Crowe. 1991. *Symmetries of Culture: Theory and Practice of Plane Pattern Analysis.* Seattle.

Whallon, Robert Jr. 1968. "Investigations of Late Prehistoric Social Organization in New York State." In *New Perspectives in Archeology*, edited by S. R. Binford and L. R. Binford, 223–244. Chicago.

———. 1969. "Reflection of Social Interaction in Owasco Ceramic Decoration." *Eastern States Archaeological Federation Bulletin* 27–28:15.

Woodard, Thos. K., and Blanche Greenstein. 1988. *Twentieth Century Quilts: 1900–1950*. New York.

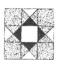

General Index

acrylic fabrics, 76

aesthetics: study of, ix, xvii–xviii, xxiii, 96–97, 183–186, 211, 214, 283–284, 318–325; traditional, ix, 68, 83, 92–94, 128, 132, 139, 140, 143–144, 148, 166, 167, 183–186, 191–193, 194, 197–199, 202–204, 208–214, 233, 252–262, 264–265, 266, 271, 275, 277, 281, 282–284, 310, 311, 320–321. *See also* anthropology; art; art history; folk art; folklore; material culture; Mayo, Anna Butcher: aesthetics and process of; styles

African-American quilts, xxi, 97, 206, 207

age of quiltmaker, x, 150, 151, 188, 197, 209, 263–265, 274–279, 284, 299, 313, 315, 316, 320

Alaska, 161

album quilts, 6, 7, 157. *See also* sampler quilts

Alhambra, 125, 200

Amish quilts, ix, 5, 7, 22, 192, 197–198, 202, 293, 300

animals, quilts and: farmyard, 156, 161, 182; pets, xii, 154, 159, 161, 171, 206

anomalous quilts, taxonomy of, 60

anomaly, in quilts: general issues, 70, 91–95, 258; quilts of Anna Butcher Mayo, 211, 214–217, 241–243, 247, 251–252, 253, 254, 258, 310–317

anthropology: aesthetic, 211, 319; cyborg, 318–319; diachronic and syn-

chronic approaches, 319, 324; ethnography, 258; general issues, xxiii, xvii–xviii, xxi, 209, 318–326; historic/geographic method, 192, 195; process and product in, 318–319, 322–326; qualitative and quantitative methods, 319, 324; structural, 18–19; symbolic, 175–176, 179, 180, 189. *See also* aesthetics; archaeology; documentation; ethnoarchaeology; fieldwork process; folklore; kinship; language and linguistics; material culture

Appalachia, xv–xvi, 5, 151, 200–202, 207, 209, 213, 263, 270, 273, 284, 321, 323

appliqué: borders, 65; designs, 3, 8, 191, 195, 222–225, 253–254, 267, 274, 279; dimensionality, 68, 126, 172; drafting, 120–124, 98, 120–213; embroidery and, 69; group process, 149; materials, 80, 83, 84, 194; quilting pattern and, 73–74; quilts of Anna Butcher Mayo and family, 222–225, 253–254, 267, 274, 279; reverse appliqué, xxi, 56–57; shadow appliqué, 56; symmetry analysis of, 54–56; taxonomy of, 12, 51–58; topological analysis of, 54

archaeology: distribution patterns, 209, 211–212; ethnoarchaeology, 19; general issues, xxi, xxxix–xxiv, 318–326; "new archeology," 17; residence pat-

terns, 209, 211–212; style, 8, 17–18, 209; symmetry analysis, 8; typology, 16–18. *See also* anthropology; kinship; material culture; styles

architecture: quilts and, xii, 94, 156, 160, 168–169, 170, 173, 186, 189, 191, 204, 205, 266; study of, 18–19

Aristotle, 10

Arkwright, Richard, 161

art, xvii, xviii, xix, xx, xxii–xxiii, 96–97, 157, 161, 183–184, 260, 283. *See also* aesthetics; art history; folk art

art history, xxiii–xxiv, 1, 96

atlas of quilt features, 192–193

Aunt Jane of Kentucky (E.C. Hall), 200–201

Australia, 162

baby quilts, 7–8, 62. *See also* births

backing of quilts: materials, 20, 89–90, 214, 284; as morphological feature, 61, 69, 71, 74, 89–90; process, 69, 89; quilts of Anna Butcher Mayo, 214–252, 284

backstitch, 74

Baptist belief and practice, 191, 202–204

Barrow, Ellen, 304

baskets, 8, 9

basting, 169

batting, in quilts: function, 70, 74, 89, 172, 197–198; materials, 70, 88–89, 159, 163, 172, 184, 197–198, 214, 284; as morphological feature, 61, 68, 70–71, 77, 88–89, 90, 126; quilts of Anna Butcher Mayo, 214, 284

bedcovers, quilts as, xv, xvi, 78, 95, 154, 156, 157, 161, 169–170, 171, 172, 173, 183–184, 189–190, 204, 206, 212, 232–233, 235, 237, 265, 267, 271, 272, 275, 284, 311

beds: as context for viewing quilts, xii, xiii, 49, 160, 169–170, 212, 225, 232–233, 235; makeshift, from quilts, xvi, 154, 155, 156, 265; quilts used as, by pets, 156, 159, 160, 161, 206; quilts used on, xvi, 94–95, 154, 155, 156, 160, 169, 172–173, 183–184, 190, 204, 206, 212, 232–233, 235, 237; sizes and shapes of quilts, relation to, xi, 62, 169, 214; used for setting quilts, 281, 283

beetling of fabric, 81

Belov, N. V., 8

best quilts: aesthetics of, 83–84, 94, 140, 143, 185–186, 199, 214; anomalies in, 94, 243; color, 83, 163; economic factors, 84, 193, 196, 199; function, 153–154, 183–184, 185–186, 205, 253, 265; prototypic features, 153–154, 155, 157, 193, 196, 217, 218, 223, 227, 229, 231, 241, 253, 265, 267, 269, 276, 325; quilts of Anna Butcher Mayo, 217, 218, 223–225, 227, 229, 231, 238, 243, 253, 265, 267, 269, 276, 325; scrap quilts versus, 83–84, 182–183, 185–186, 199, 205, 325; source of materials, 83–84

Betterton, Sheila, 4, 299

Beyer, Jinny: block concept in, 27–29, 37; classification in, 11–15; designs in, 14, 28, 293, 299, 301, 303, 306; drafting methods of, 12–15, 16, 27–28, 37; illustrations adapted from, 9, 13–14, 29

Bible, the, 3, 179, 182, 201

binding of quilts: materials, 20, 90–91, 152–153; as morphological feature, 49, 74–75, 90–91, 95; process, 74–75, 90–91, 152–153; quilts of Anna Butcher Mayo, 214–252. *See also* edges

Binney, Edwin, III, 4

Binney-Winslow, Gail, 4

birth of quilts, 97, 153, 157, 225, 268

births, quilts and, x, 158−159, 190, 197, 201, 272
biscuit quilts, 60
Bishop, Robert, 4, 6−8, 299
blankets: as batting, 89; as bedcovers, 195, 197, 311
bleeding, in quilts, 91, 94, 221, 251
block: cell versus, 26−30, 37; in pattern books, 27−28, 301; setting versus, 28−30; as traditional unit, 15, 16, 26−27, 28−30, 191, 281−282
Bluegrass region, xvi, 263
bobbin lace, xxiii
bobbins, 166
bonnets, xv, 263
books: quiltmaking and, 14, 96, 98, 128, 158, 191, 293−294, 301−302. *See also* magazines
Boorstin, Daniel, 10
borders. *See* setting elements: borders
Britain, 7, 161, 162, 179. *See also* England; English quilts; Scotch-Irish quilts; Welsh quilts
broadcloth, 78, 162
brocade, 71, 79
broderie perse, 87
brushing of fabric, 82
Buferd, Norma Bradley. *See* Cooper and Buferd
buttonhole stitch, 68

calendering of fabric, 81
calico, 77, 191, 200
Calvinism, 200, 270
Canada, 21, 269, 299, 317
candlewicking, 69
carding combs, 163
carpets, 9
Cartesian geometry, 105
Cartwright, Edmund, 162
case studies of quiltmaking: Amish, Indiana (Pottinger), 197−198; Appalachia, 201−202; Blincoe, Deborah,

xv−xvii; cell and innovation, 126−142; central star type patterns, 310−317; construction and innovation, 106−110; drafting and innovation, 108−120; "Drunkard's Path" type patterns, 285−310; Mayo, Anna Butcher, 207, 208−317, 319−323; North Carolina (Forrest), ix−xii, 183, 185−186; North Carolina (Newman), 192, 194−197; Red Cross quilt, 188−189
cell concept: block versus, 23−26; color and, 23−34, 47, 50, 85−87, 94, 105, 108, 116, 127−128, 132, 135−136, 138−139, 145, 282−283; innovation and, 102−123, 127−142, 143, 145−148; orientation, 24, 49, 50, 136, 218, 239, 259, 261−262, 288; quilting pattern and, 225, 228, 229, 252, 254; quilts of Anna Butcher Mayo, 211, 212−213, 214−251, 254, 255, 257−258, 261−262, 264−265, 276−277, 282−283, 285−310; replication, 21−22, 24, 42, 44, 50, 52, 53, 58, 105−123, 136, 214, 288, 299−302, 308; setting and, 28−30, 62−67, 105−106, 113, 114, 136, 147−149, 287−288; taxonomy and, 20−30, 32−44, 51−60, 102. *See also* construction of quilts; genetic relationship in quilts; taxonomy of quilt designs
ceramics: historic, ix; prehistoric, xxiii, 8, 9, 17. *See also* tiles, ceramic
chalk, for marking quilts, 92, 152, 164
Chang, K. C., 18
charity, quilts and, 149, 191, 202
Chelf, Annie, 15
China, 162
chintz, 77, 83, 193
Christianity, 200. *See also* religious values; *and under individual sects*
church, quiltmaking and the, xvi, 150, 151, 186, 191, 202−203. *See also* reli-

gious values; *and under individual faiths and sects*

Civil War, U.S., 161, 162

Clarke, Mary Washington: classification in, 4; designs in, 15, 299, 303–304; ethnographic data in, 15–16, 180, 186, 303–304

class, quiltmaking and, xvi, 193, 196–197, 209, 263, 284, 319

classification of quilts. *See* taxonomy of quilt designs

climate, quilts and, 161, 204–205

clotheslines, quilts and, xi, xii, 94

coffins, quilts and, 158–159

collectors of quilts, xix, 1, 4, 6–8, 96, 157, 158, 247. *See also* museums

Collins, Willie R., 206

color, in quilts: cell concept and, 20, 23–24, 26, 47–50, 85–87, 105, 116, 127–128, 135, 136, 138–139, 140, 145, 181; as clue to process, 217, 218–221, 247, 249, 269, 276, 282, 315, 317; color theory, 23–24, 143–145, 313; dimensionality and, 140; fabric features and, 142–145, 185; folk systems, 143–144, 175, 203, 280–282; general issues, 69; group process and, 149; illustrations and, 213; innovation and, 108, 127–128, 135, 211; light and, 140–145; monetary value and, 7; pattern variation through, 20, 85–87, 127–128, 142, 181, 259–261, 269, 283, 293, 303, 311–313, 315, 317; quilt names and, 181; quilts of Anna Butcher Mayo, 214–252, 259–261, 268, 269, 273, 275, 276, 280–284, 289; regional palettes, 191–192, 197–198; scrap versus best quilts, 83, 85–87, 194, 237–238; seams and, 85–87; symbolism, 7, 179, 312; temporal palettes, 193. *See also* value

commemorative quilts, 149, 157, 158

community, quiltmaking and, ix, xii, 84, 160–161, 164, 165, 178, 186, 189, 191, 197, 199, 264–265

conception of quilts, 11, 62, 97–126, 149, 152, 153, 157, 161, 210, 225, 260, 268

construction of quilts: appliqué, 52–58; central star type patterns, 310–317; creativity and, 44–50, 126–142, 185; drafting versus, 13, 14–16, 34, 37, 38–39, 107–108, 128, 300; "Drunkard's Path" type patterns, 289–310; general issues, 9–10; 105, 153, 171, 186, 192, 234, 239, 248–249, 254, 310; innovation and, 10, 99, 108, 116, 126, 128, 145–146, 310–317; oblique strip piecing, 34, 38; quilts of Anna Butcher Mayo, 211, 214–252, 254–259, 262, 264, 285–317; radial piecing, 34, 38–42, 46–48, 146, 215, 228, 230, 232, 236, 237, 249, 255, 262, 301, 308, 314–315; straight strip piecing, 34–37, 38, 145, 146, 232, 235, 255, 277, 290, 301, 308; taxonomy and, 9, 12–16, 19, 26, 28–30, 32, 34, 39, 50, 53, 55, 57–58, 315, 317. *See also* cell concept; life cycle; morphology of quilts; quilting pattern; quilting stitch; replication of quilt designs; seams; setting; setting elements; taxonomy of quilt designs

context: in aesthetic theory, xxiii, 96; of quilts, xii–xiii, xx–xxi, 96–97, 160–161, 165, 166, 168–171, 208, 210, 260, 279, 318, 319, 323, 325. *See also* ecology of quilts

Cooper, Patricia. *See* Cooper and Buferd

Cooper and Buferd: classification in, 4; ethnographic data in, 150, 151, 154, 158–159, 163, 165, 184, 186, 187, 191, 203

cording, on quilts, 91, 153

corduroy, 214, 247

corn shucks, as batting, 89

coton à broder, 88

cotton: batting, 88–89, 154, 158, 163, 172, 197–198, 214, 284; cording, 69; fabric, x, 76, 84, 96, 162, 171, 172, 187–188, 214, 217, 270, 271, 313; growing and processing of, 88–89, 162, 163, 284; thread, 87–88. *See also under individual fabric names*

counterpoint images in quilts, 135, 138, 228, 241, 249, 294–297, 300–302, 309–310

Cowan, Mary L., 71, 77

crazy quilts, 6, 7, 22, 44, 69, 70–71, 74, 194, 196, 206

creativity, 44–50, 98–99, 102, 113, 116, 135, 140, 145, 178, 197, 211. *See also* aesthetics; innovation in quiltmaking; inspiration; replication of quilt designs; tradition

Crompton, Samuel, 162

Crowe, Donald, 8

culture, quilts and, 318–326

cutting of quilt pieces: general issues, 12, 15–16, 22, 84, 87, 120, 122, 159, 163–164, 167, 193–194, 200, 223–225, 261, 278–279; quilts of Anna Butcher Mayo, 225, 261, 273, 280, 312–313; taxonomy and, 54, 58, 60

cyborg, quilt as, 319

cyborg anthropology, 318–319

damask, 79

darks and lights. *See* value

Davis, Dave, 16, 17–18

deaths, quilts and, x, 154, 158–159, 187, 188, 189, 190, 201, 321

decoys, xxiii

Deetz, James, 17, 18

denim, 78

Depression era quilts, ix, 88, 173

diachronic and synchronic methods, 319, 324

dimensionality, in quilts: appliqué, 67–68; batting, 70; color, 143–144; cording, 69; fabric type, 69, 71; general issues, 61, 67–68, 70, 106–108, 125–126, 169–171, 175; lighting, 72, 140, 170–171, 175; piecing, 67, 68; quilting stitch, 71–74, 90, 231; seams, 68, 71–74; trapunto, 68, 74

dimensions of quilts: general issues, 213; quilts of Anna Butcher Mayo, 213–252. *See also* measurement

dimity, 78

distribution patterns, 209, 211–212, 319–320

dobby weave, 79

documentation, of quilts, xi–xiii, 184, 205, 247, 264, 319–326

double knit, polyester, 77

dower chest, 179. *See also* hope chest

Downey, Gary Lee, 319

drafting of quilt designs: construction versus, 12, 28, 34, 37, 38–39, 102, 300; innovation and, 98, 102–123, 128, 145; methods, 12, 14–16, 26, 102–105, 106–108, 111–113, 120–123, 124, 125, 128, 186; taxonomic principle, 12–16

dressmaker's rule, 164

drill (fabric), 78

Dumit, Joseph, 319

Dunnell, R. C., 18

ecology of quilts: artifactual, 160, 161–170, 210, 213–232, 263–277, 280–284, 285–317; general issues, xx, xxi, 160–161, 210, 218–326; human, 160, 171–204; natural, 160, 204–207, 211–212, 262–264, 266, 272; quilts of Anna Butcher Mayo, 209–252, 253, 262–285, 310–325

economic factors and quilts: class, xvi, 193, 194, 196–197, 209, 263, 284,

319; ethos, 162, 199, 204; market value of quilts, xix, 6–8, 96, 157–158, 197–198, 247; materials, 75, 83, 84, 90, 193–195, 203, 233, 269, 275, 284; modernization, 319; preservation of quilts, 157–158, 196; professional quilting, xvi, 22, 151–152, 196–197, 231, 264, 265, 269, 270, 275, 277, 279, 313; quilts of Anna Butcher Mayo, 263, 268, 275, technology, 161–169, 205; time investment, xvi, 233; wage labor, 195, 268. *See also* collectors of quilts; functions of quilts; sale of quilts; scraps for quilts

edges of quilts: borders and, 49–50, 65–67; as clues, 28, 108, 113, 285–288, 300–301; contours of, 66, 225; finishing, 49, 74–75; general issues, 49–50, 65–67, 70, 138; wear, 74, 95, 154. *See also* binding of quilts; setting elements: borders

Edict of Nantes, 161

embossing of fabric, 81

embroidery, 69, 71, 88, 187, 194, 299

embroidery cotton, 88

embroidery hoops, 69

embroidery scissors, 164

emergencies, quilts and, 149, 159, 191

England, ix, xvii, 263

English quilts, 83

Enlightenment, the, 11

errors: in analysis, xii, 298; innovation and, 108, 317; in quiltmaking, xii, xvii, 92–93, 108, 232, 273, 299, 316; religious beliefs and, 93, 199–200

Escher, M. C., 125

ethnoarchaeology, 19, 211. *See also* anthropology; archaeology; material culture

ethnography, 258. *See also* anthropology; documentation; ethnoarchaeology; fieldwork process; folklore

ethos, quilts and, 185, 186–187, 199, 201–202, 203–204, 271, 272. *See also* religious values; *and under individual faiths and sects*

Euclidian geometry, 26, 49, 64

Euro-American quiltmaking traditions, synchretism and, xxi

European quiltmaking traditions, synchretism and, xxi

everyday quilts, 153–154, 183, 266, 276, 284

evolution, quilt designs and, 113, 119

exhibition of quilts, x, 158, 179, 188, 189–190, 197, 201, 209, 267, 268, 270, 272, 273, 319, 321

experimentation, analysis through, xviii, 19

eyesight, loss of: quiltmaking and, 201, 263, 275, 277, 284, 299, 313, 316

fabric: bonding, 77, 80, 85; dyeing, 69, 82, 85, 86, 163; fiber type, x, 74, 76–77, 78, 80, 81, 82, 84; finish, 69, 80–82, 171, 172, 173; grain, 69, 81, 82, 85, 86, 92, 141; hand, 171, 175; knit, 77, 80–81, 84–85, 97, 165; print, 69, 82, 85, 86–87, 141–143; production, 75–82, 161–163; purchase of, 149, 269; weave, x, 69, 74, 77–80, 84–85, 86, 89, 90, 142, 163, 171, 172. *See also* scraps for quilts; *and under individual fabric types*

fading, in quilts, 91, 94, 249, 268

family history, quilts and: discussion, 157, 187, 189–190, 209, 319–321; family of Anna Butcher Mayo, 209–212, 262–285, 319–321; other examples, x–xi, xv–xviii, 150, 151, 153–154, 154–155, 156, 157–158, 187–189, 203

featherbeds, 267

feathers, as batting, 89

feed sacks, in quilts, 154, 184, 284

felt, 80

felting of fabric, 80, 81

fieldwork process, ix–xiii, xvii–xviii, 158, 184–185, 209–210, 212, 247, 252–253, 258, 260, 263, 264, 271, 319–320, 321, 325

figure/ground relationship: in quilt designs, 108, 128. *See also gestalt* image

Finley, Ruth, 197

five-patch, 11, 34–35, 36, 37

flannel, 81

Florida, 278

flour sacks, in quilts, 88, 173, 184

flying shuttle, 162

folk art, xxii–xxiii. *See also* aesthetics; art; folklore

folklore, ix, xvii–xviii, xxi, xix, xxi, xxiii–xxiv, 176, 209, 211, 318–326

folk process, 30, 200, 302–303. *See also* folklore; tradition; transmission: of quiltmaking tradition

folksong, 176

foods, quilts and, xvi, 154–155, 156, 157, 161, 170, 173, 266, 274

Forrest, John, 91, 171, 176, 178, 183, 185

four-based cells: designs, 119, 301; four-patch blocks versus, 37; taxons, 36–37

four-patch, 11, 12, 16, 37

Friedrich, Margaret Hardin, 16. *See also* Hardin, M. A.

friendship quilts, 149, 157

frills on quilts, 75, 153

functions of quilts: as bedcovers, xv, 78, 95, 161, 172–173, 183–184, 189–190, 204, 206, 212, 232–233, 235, 237, 265, 271, 272, 275, 284, 311; changes in, 94, 153, 159, 161, 173, 183, 185, 198, 246; general issues, xix, 209, 212, 251, 253–254, 268, 270, 274, 276; household, xii, xv–xvi, 166, 173, 189, 191, 265;

outdoor, 161, 274; quilts of Anna Butcher Mayo, 212, 232–233, 235, 237, 246, 251, 253–254, 268, 270, 274

fundraising and quilts, 149–150, 186, 189, 202

futon, xvi

gender, quiltmaking and, xvi, xix, xxi, 158, 180, 190, 194, 203, 209, 266, 278, 279, 320–321

genetic relationship in quilts: analogy and homology, 47–48, 58, 59–60, 105, 113, 116, 119; consanguineal (versus affinal), 274; genotype and phenotype, 20, 22, 23, 30, 44–45, 49, 50, 62, 97, 105, 128, 132, 136, 241, 271; particular designs, 44–50, 105, 241, 271, 274, 276–277, 285–317, 324; quilts of Anna Butcher Mayo, 241, 271, 274, 276–277, 285, 317, 324; taxonomic principle, xxi, 11, 37. *See also* cell concept: taxonomy and

genre approach, to aesthetic forms, 97

geography, 266

geometric shapes, nonsquare: axhead, 40; circle, 305; clamshell, 40; diamond, 22, 111, 113, 116, 215, 220–221, 227, 230, 231, 236, 239, 241, 243, 244, 250, 255, 272, 312–315; diamond (concave), 225–226, 228–229, 246; hexagon, 16, 22, 40, 67; lens (convex), 225, 228, 246, 255; octagon, 42–43, 44, 234, 249, 255; parallelogram, 99, 102, 103, 113, 116; quarter circle, 289–290, 292, 305, 306, 307, 308; rectangle, 40, 234; trapezoid, 223, 243; triangle (various types), 16, 42, 98, 127, 215, 221, 225, 230, 232–233, 236, 239, 243–244, 249–250, 313, 315

gestalt image: in quilt designs, 103, 108, 113, 114, 116, 119, 311. *See also* fig-

ure/ground relationship; pattern: as
concept
gestation of quilts, 62, 97, 116, 125,
126–153, 161, 166, 210, 260
gifts, quilts as, 160, 189–191, 231
gingham, 77, 82, 221, 234, 247
give-aways, Sioux, xxi
Glassie, Henry, 16, 18–19
glazing of fabric, 81
Good Housekeeping, 194
graph paper, in drafting of quilt
designs, 103, 105, 111, 123
Greenstein, Blanche, 4
Grünbaum, Branco, 8, 25, 125
guest quilts, 265, 267, 274

Haders, Phyllis, 4
half-oval quilts, 62
Hall, Carrie. *See* Hall and Kretsinger
Hall, Eliza Calvert, 200
Hall and Kretsinger: block concept in,
27; classification in, 1, 2, 3–4, 7, 8,
181–182, designs in, 1, 2, 3, 44, 50,
293, 303, 306, 307; ethnographic data
in, 179, 180, 196; illustrations adapted
from, 51; instructions in, 151–152;
literary citations in, 151, 200
handcraft revival, 202
Haraway, Donna, 319
Hardin, Kris, 318
Hardin, M. A., 16
Hargreaves, James, 161
Hawaii, 161
Hawaiian quilts, xxi, 7, 120. *See also*
Polynesian quilts
heirlooms: quilts as, x, 154, 157, 160,
183, 190, 197, 264
herbal medicine, 263
Hilbert, David R., 143
Hill, J. N., 17
historic/geographic method, 192, 195
history, study of, xix, 209
Hmong reverse appliqué, xxi

hobby quilts, 276, 322
Hockett, Charles, 16
hope chest, 154, 158, 203. *See also*
dower chest
Horton, Roberta, 87
hotbeds, quilts and, 156, 161, 204
houndstooth, 247
hybrid quilts: quilts of Anna Butcher
Mayo and family, 222–225, 253–
255; taxonomy, 58–60
Hymes, Dell, 97

Ickis, Marguerite: classification in, 11;
designs in, 293, 303, 306, 307, 308;
drafting methods, 103, 120–122; il-
lustrations adapted from, 120–122
identification of quilts, 3, 6–8. *See also*
names of quilt designs; taxonomy of
quilt designs
illustrations: analytic errors and, 298;
purpose and aesthetics of, xxii, 213
India, 161, 162
Indiana, 197–198, 293
Industrial Revolution, 161
inheritance, 320. *See also* heirlooms
innovation in quiltmaking: case studies,
108–120, 126–142, 310–317, 322;
cell concept and, 47–50, 99, 102–
103, 105–123; drafting and, 98, 102–
103; general issues, xxiii, 10, 99,
178–179, 322; quilts of Anna
Butcher Mayo, 211, 310–317, 322.
See also creativity; inspiration
inspiration: in quiltmaking, 97–98,
124–125, 135, 207, 317
iron (for pressing fabrics), 167
Irwin, John Rice: classification in, 4;
designs in, 187; ethnographic data in,
125, 151, 153–154, 155, 184, 187–
188, 206
Islam, 200
Islamic rugs, 200

Jelinek, Arthur J., 18

Kansas, 7
Kay, John, 162
keepsakes, quilts as, 157, 160, 268
Kentucky, xv–xviii, 186, 200–202, 209,
 262–264, 268, 289, 299, 303
kinship, x–xi, xv–xvi, 161, 187, 188,
 189–190, 207, 209–210, 212, 262–
 285, 312–313, 319–321. See also
 family history
knitting, hand, 80, 263
Kretsinger, Rose. See Hall and
 Kretsinger

lace, 158, 321
Ladies' Art Company, 293
lappet weave, 79
language and linguistics: quilts and, 18–
 19, 97, 176–189, 260. See also names
 of quilt designs; narratives
Lasansky, Jeanette: classification in, 4;
 designs in, 293; ethnographic data in,
 150, 191, 193
lattices, in quilt designs, 135–138
laundering of quilts, xxiii, 76, 94, 155–
 156, 172–173, 218, 220, 271, 272,
 311
Lawson, Lareu, 187
Leslie, Eliza, 193
life cycle, of quilts: birth, 97, 153, 157,
 210, 225, 268; conception, 11, 62,
 97–126, 149, 152, 153, 157, 161, 210,
 225, 260, 268; death, 97, 157–159,
 185; general issues, xx, xxi, 91, 96–
 97, 185, 193, 210–212, 218–220,
 229, 246, 247, 249, 251, 268, 322–
 325; gestation, 62, 97, 116, 125, 126–
 153, 161, 166, 210, 260; life span, 97,
 153–157, 210; quilts of Anna
 Butcher Mayo, 210–211, 223–225,
 229, 247, 249, 251, 264–285
life span of quilts, 97, 153–157, 210

lights and darks. See value
Lindsay, Ellen, 193
linen, 76, 162
Linnaeus, xxi, 5–6, 10–11, 21
linsey-woolsey, 76, 162
lockstitch, 167
Lockwood, E. H., 8, 56, 142, 152
log cabin quilts, 6, 7
Longacre, William, 16, 17
loom: hand, 162, 263; powered, 162

McKendry, Ruth, 4, 299, 302
McKim, Ruby, 299
MacMillan, R. H., 8, 56, 142, 152
magazines: quiltmaking and, xvi, xxi,
 15, 98, 164, 193–194, 293
Malone, Maggie, 1, 293, 303, 306, 307,
 308
Malraux, André, 184
markers, for marking quilts, 92
marriages, quilts and, x, 158, 179, 188,
 189–190, 197, 201, 209, 267, 268,
 270, 272, 273, 319, 321
Massachusetts, 189
material culture, xxiii–xxiv, 16–19,
 182, 211, 318–326. See also anthro-
 pology; archaeology; art; art history;
 documentation; folk art, folklore
mathematical analysis of quilt designs,
 xviii, 24–25, 26, 30, 49, 64, 103–
 105, 116, 127–128, 138, 140, 300.
 See also symmetry; symmetry analysis;
 tiling; topological analysis
mattresses, 95
Mayo, Anna Butcher: aesthetics and
 process of, 209–211, 252–262, 319–
 325; central star type designs of, 310–
 317; "Drunkard's Path" type designs
 of, 285–310; family and life history
 of, 209–212, 262–285, 319–323; in-
 novation by, 310–317; quilts of, 214–
 252, 319–325
measurement: quiltmaking and, 99,

103–105, 111–113, 120–125, 163–
164, 259, 261
medallion quilts, 22, 65
memory, quilts and, x, 160, 188, 194,
268, 317, 323
Mennonite quilts, 7
Methodist belief and practice, 186, 263
mice, 94
Midwest, U.S., 293, 299. *See also under
individual states*
mildew, 94
miniature quilts, 21
modernization, 319
moiré, 81
morphology of quilts: anomaly, xxi, 61,
70, 91–94, 211, 214–217, 241–243,
247, 251–252, 253, 254, 258, 310–
317; changes over time, 61, 96; gen-
eral features, ix, xx, xxi, 61–62, 70;
general issues, 19–20, 60, 193, 253,
319, 325; materials, 61, 75–91, 193;
overall construction, 61–75; pa-
thology, xxi, 61, 70, 91–95; quilts of
Anna Butcher Mayo, 210, 213–252,
253, 311. *See also under component parts
and processes*
moths, 94
mule (Crompton's), 162
museums, quilts and, xxii–xxiii, 1, 3,
4–5, 96, 158, 196
muslin, 77, 214, 220, 221, 227, 231, 234,
241, 243, 246, 249, 251, 311–312

names of quilt designs: as classifying
principle, 1–6, 181–182; functions
of, 177–180; general issues, 160;
problems with, 1–4, 176–181, 293;
quilts of Anna Butcher Mayo, 264,
267–268; significance of, 178–182,
204, 255. *See also Index of Quilt Names*
Napoleonic Wars, 162
napping of fabric, 82

narratives, quilts and: discussion of, x–
xi, 97, 160, 188–189, 210, 265–266,
279, 322; examples of, x, 150, 151,
153–154, 154–155, 156, 158–159,
163, 165, 186, 187, 188, 189, 191,
203, 206, 268–269, 270, 278–279,
280, 281–282
Native American quilts, xxi, 98, 165,
207
natural history method, xx–xxii, 207,
208, 214, 317, 318–326
needles, xvi, 77, 78, 89, 160, 165, 166,
167, 168, 321
"new archeology," 17
Newman, Joyce Joines, 4, 192, 194–195
newspaper, as batting, 89
New York (state), 188–189, 299
nine-based cells: nine-patch blocks ver-
sus, 34, 35; quilts of Anna Butcher
Mayo and family, 232, 235, 277; tax-
ons, 34–36, 37
nine-patch, 11, 16, 34, 35, 37, 277–278
North, U.S., 180, 205
North Carolina, ix–xiii, xvii, 192, 194–
195
Nova Scotia, 21

Oklahoma, 263, 266
old age, quilting and, 188, 263–265,
274, 275–278, 284, 299, 313, 316,
320. *See also* age of quilter
"old" quilts, 156–157, 159, 173, 183,
284
one-patch, 28
orientation: cell concept and, 24, 42,
49–50, 136, 218, 239, 248, 261–262,
288–289; colored cell and, 49–50,
140, 226, 234, 236, 261, 282–283;
fabric, 69, 236, 261–262; finished
quilt, ix, 225; overall, in setting, 24,
106; quilting pattern, 223–259; quilts
of Anna Butcher Mayo, 223, 225,

226, 234, 235, 236, 239, 248, 259, 261–262, 282–283, 288–317; sub-units, 289–317
ottoman (fabric), 78
outing (fabric), 154
oversewing, 74
oxford cloth, 77

pallets, quilts used for, xvi, 154, 155, 156, 265
paper, as batting, 89, 284
patch, as quilt repair, 91, 94–95
patchwork. *See* piecing
pathology, in quilts, xxi, 70, 91–95
pattern: as concept, 16, 20, 21–23, 26, 30, 97, 98, 99, 105, 108, 113, 116, 177, 178–182, 184, 186, 194, 211, 267–268, 273, 282, 306, 309, 312; in-novation, 85–87, 102, 105–123, 126–142, 187; quilts of Anna Butcher Mayo, 214–252, 253, 255, 258–261, 267–268, 273, 275–277, 282, 285–317; sources, xvi, xxi, 14, 15, 22, 98, 124–125, 164, 231, 255, 268–269, 275, 276–277, 293–294, 301, 309–310, 317; variation, 126–142, 253, 258–261, 325. *See also* block; cell concept; quilting pattern; templates; *and Index of Quilt Names*
pearl cotton, 88
Pellman, Kenneth. *See* Pellman and Pellman
Pellman, Rachel, 293–294. *See also* Pellman and Pellman
Pellman and Pellman: classification by, 4; designs in, 293, 294, 300; ethno-graphic data in, 198–199
pencils, for marking quilts, 92, 164
Pennsylvania, 150, 188, 191, 293
percale, x, 77
perfection, in quilts, 93, 199–200
performance, as emergent, 97

photodocumentation, xi–xiii. *See also* documentation
picnics, xvi, 154, 170, 274
piecing: anomalies in, 92–94, 241–243, 247, 251–252; appliqué versus, 3, 22, 54, 59, 80, 83, 87, 98, 120–123, 124–125, 192; backing, 90; borders, 65, 148, 223, 243, 244; dimensionality, 67–68, 172; group process, 149, 278–279, 322; hand versus machine meth-ods, 164–167, 168; origins, 83, 193–194; precision, 68, 105, 215, 218, 220, 223, 225, 230, 232, 233, 235, 238, 244, 251, 312; quilts of Anna Butcher Mayo, 214–317, 322; sash-ing, 149; setting squares, 149; small patches, 74, 314; subcells, 116; thread, 90, 165, 213, *See also* block; cell concept; construction of quilts; scrap quilts; scraps for quilts; seamed base quilts; seams; stitching; tax-onomy of quilt designs
pillows, 169, 267
pinking shears, 164
pins, 167
piping, on quilts, 75, 91, 153
Plog, Stephen, 16, 17
poetics, 97, 180
polyester: batting, 89; fabric, 76–77, 274, 281; thread, 87, 88
Polynesian quilts, xxi, 154, 170, 274. *See also* Hawaiian quilts
poplin, 78
Pottinger, David: classification in, 4; de-signs in, 293, 294; ethnographic data in, 197–198
pouncing powder, 164
precision, in quiltmaking: piecing, 68, 105, 215, 218, 220, 223, 225, 230, 232, 233, 235, 238, 244, 251, 312; quilting, 223, 225, 226; quilts of Anna Butcher Mayo, 215, 218, 220, 223,

225, 226, 230, 232, 233, 238, 244, 251, 312

preservation of quilts, xxiii, 157–158, 173, 185, 189, 196, 268, 271

"pretty" quilts, 183

process and product, in aesthetic anthropology, 318–319

processual approach to quiltmaking, 225, 260–261, 265, 280–284

Protestant ethic, 185, 186–187, 201–202. *See also* Calvinism

qualitative and quantitative methods, 319, 324

questionnaires, x. *See also* documentation; fieldwork process; surveys

Quilter's Choice: classification in, 4; designs in, 293, 302

quilting bees, 150–151, 177, 186–187, 189, 205, 265–267, 322. *See also* quilting groups

quilting frames, 160, 168–169, 186–187

quilting groups, 149, 150, 151. *See also* quilting bees

quilting hoops, 160, 169

quilting pattern: general issues, 20, 22, 71–74, 125–126, 149–153, 322; group process, 150–151, 158–159, 169, 186–187, 206, 322; marking, 22, 92, 125, 152, 164; professional quilters, xvi, 22, 151–152, 196–197, 231, 264, 265, 269, 270, 275, 277, 279, 313; quilts of Anna Butcher Mayo, 213, 214–252, 253, 254, 259, 264, 265, 266–267, 269, 270, 272–277, 279, 313, 322; varieties and examples, 71–74, 149, 151, 152–153, 169, 186, 215, 218, 223–225, 226, 228–229, 230–231, 233, 234, 235, 237, 239, 241, 244–245, 246, 248, 249, 251, 252, 253, 254, 259, 272, 277–278. *See also* quilting stitch; tacking; tufting; tying

quilting stitch: as clue to process, 71, 150–151, 206; dimensionality, 61, 68, 72–74, 78, 90, 170, 231; hand methods, 71, 89, 90, 167–168, 215, 218, 222–225, 226; hand versus machine methods, 168, 214, 232, 253, 277; general issues, 61, 71–74, 76, 78, 89, 90, 126, 184; machine methods, 71, 168, 214, 231–232; morphological feature, 62, 70, 71–74, 90, 126, 149, 162, 184, 194, 214, 217, 284. *See also* quilting pattern; tacking; tufting; tying

quilt shelf, 154–155, 170

quilt tops: as basis for taxonomy, 19–20, 77; group process, 149; hand versus machine methods, 162–167; materials, 75–88, 90; morphological feature, 61, 62–70, 96, 125, 153, 163, 164, 167, 253, 275; quilting and, 22, 151–152, 196, 214–252; quilts of Anna Butcher Mayo, 212, 214, 247, 253, 275. *See also* life cycle; morphology of quilts; piecing; scraps for quilts

raffles, quilts and, 149

rag dolls, xv, 263

rags, as batting, 184, 284

randomness in quiltmaking, 139, 234, 283

Red Cross quilt, 188–189

Rehmel, Judy: classification in, 8; designs in, 293, 294, 299, 303, 306, 307, 308

religious values, 161, 180, 186–187, 191, 194, 199–204, 207, 210, 270

repairs, to quilts, 92, 94–95

replication of quilt designs: cell as unit of, 21–22, 24, 28, 42, 44, 50, 52, 53, 58, 105–123, 136, 214, 288, 299–302, 308; particular patterns, 272, 277, 309, 314; taxonomic principle,

xxiii, 10–11, 50, 97. *See also* cell concept; innovation in quiltmaking; life cycle; pattern; templates

residence patterns, 209, 211–212

revival, quiltmaking, xix, xx–xxi, 60, 151, 158, 165, 200, 202, 260, 301, 322

Reynolds, Sarah, 158

Risinger, Hettie, 128, 299, 303, 306

rites of passage and quilts. *See* births; deaths; marriages

roller printing of fabric, 82

Romance of the Patchwork Quilt in America, The. See Hall and Kretsinger

rotary rule, 164

ruffs, on quilts, 153

rugs, Islamic, 200

rulers, 164

rules, for quilt construction, xviii, 92

running stitch, 68, 166–167

Safanda, Elizabeth, 4

sale of quilts, 197–198, 202, 284

salt bags, in quilts, 187

sampler quilts, 7, 42. *See also* album quilts

sashing. *See* setting elements: sashing

sateen, 78

satin, 71, 78, 84, 171, 172, 175

Schwoeffermann, Catherine, 4, 302

scissors, 164

Scotch-Irish quilts, 5

scrap bag, 185, 203, 278, 280

scrap quilts: aesthetics of, 93, 128, 132, 139, 140, 143, 178, 185–186, 194, 199, 232, 234, 240, 260, 280–283, 325; best versus, 84–85, 140, 143, 153–154, 182–183, 185–186, 194, 253, 325; general issues, xxi, 87, 325; preservation, 157–158; prototypic features, 153–154, 193, 222, 232, 240, 251, 253, 325; quilts of Anna Butcher Mayo, 211, 220–222, 225–228, 232–237, 238–240, 243, 246–

248, 251, 253, 260, 267, 274, 280–283, 310–317, 325. *See also* scraps for quilts

scraps for quilts: bag of, 185, 203, 278, 280; garments, 184, 187–188, 214, 227, 228, 270, 272, 284, 323; economic factors, 81–84, 184, 185, 193, 199, 203; quilts of Anna Butcher Mayo, 214, 221, 227, 228, 231, 233, 234, 238, 239, 243, 246–248, 253, 267, 269–273, 277, 280, 283–285, 310–317, 323; sentimental significance of, 188, 214, 227, 228, 270, 271, 284–285, 323; trading, 84, 203, 278–279; used versus, 84, 233; variety through, 78, 93, 105, 147, 149, 163, 185, 203, 221, 231, 234, 239, 243, 246–248, 273, 280, 283, 310–317

seamed base quilts: quilts of Anna Butcher Mayo, 254; taxonomy, 30–44, 52, 53

seams: allowance for, 163–164, 193; anomalous, 93, 247; as clues, 23, 105, 106, 108, 113, 175, 228, 310–317; color and, 85, 87, 128, 136, 142; curved, 9, 11, 38, 40, 87, 142, 227–228, 255, 300; dimensionality, 48, 172; general issues, 77, 78, 87, 92, 102, 108, 120, 125; machine versus hand, 167; pattern and, 85–87, 102–103, 116, 128, 136, 140–141; pressing, 167; quilting stitch and, 48, 152–153; quilts of Anna Butcher Mayo, 214–252, 255; set in, 38, 40, 125, 232, 255; straight, 9, 38, 40, 46–48, 87, 142, 232, 277; taxonomic designation and, 32, 35, 38, 40; undoing, 167, 312. *See also* cell concept; stitching; taxonomy of quilt designs; thread

seasons and quilts, 96, 170–171, 186, 203, 206, 266, 278–279

Secord, William, 6–8, 299
Seminole patchwork, 165
senses and quilts: general issues, 171, 174, 175–176; hearing, 173; sight, 174–175; smell, 172–173, 174; taste, 173; touch, 170, 171–172, 174, 175
serge, 78
setting, of quilts: aesthetics and process, 264, 278–279, 281–283; cell concept and, 24, 26, 62–67, 136; oblique set, 24, 65, 106, 108, 114, 119, 218, 232, 247, 248, 249, 287–288; quilts of Anna Butcher Mayo, 215–252, 264, 281–283, 285–288; straight set, 24, 108, 119, 215, 220, 222, 227, 232, 237, 239, 251, 285. *See also* setting elements
setting elements: borders, 24, 29, 30, 49–50, 59, 62–63, 65, 71, 132, 147–148, 191, 215, 222–223, 225, 231, 232, 234–235, 236, 241, 244, 249; materials, 84, 147; quilts of Anna Butcher Mayo, 215–252, 281, 314; sashing, 24, 29, 30, 59, 62–63, 64, 105, 113, 132, 147–149, 186, 215, 222–223, 232–233, 235, 236, 237, 251–252, 281, 314; setting squares, 24, 29, 62–63, 64, 71, 106, 132, 147–148, 186, 214, 218, 231–232, 234–235, 239, 247, 248, 249–250, 253, 287. *See also* setting
setting squares. *See* setting elements: setting squares
seven-patch, 11, 34–35, 36, 37
Seward, Linda, 83, 293
sewing machines, 164–165, 166–167, 168
Sheard, Bonnie, 188
shears, 164, 167
sheeting, 90
Shephard, G. C., 8, 25, 125
Shubnikov, A. V., 8

signatures on quilts, 157, 188–189, 293, 299
silk, xv, 71, 75–76, 78, 82, 87, 88, 89, 158–159, 162, 171, 172, 173, 194, 196
silk screening of fabric, 82
Sioux quilts, xxi
slip stitch, 68, 74, 92
Slone, Billie, 158
Slone, Verna Mae, 154–155, 156, 158, 206
social history, 210
sociology, 209
soiling, in quilts, 94, 154, 155, 248, 274
Song of Solomon, 179
South, U.S., 163, 180, 186. *See also under individual states*
Southwest, U.S., 150. *See also under individual states*
spinning jenny, 161
spinning wheel, 163
stains, on quilts, 91, 94–95, 155, 213, 248, 268, 274
Stanislawski, M. B., 16
stenciling of fabric, 82
stencils, for quilting designs, 164
stitching: by hand, 54, 68, 77, 89, 165–167, 214; by machine, 54, 68, 164–167, 214, 231; types of, 68–69, 74, 165–167, 231. *See also* quilting stitch; seams; thread
Stooksbury, Sarah Oaks, 188
storage of quilts, 94, 154, 155–156, 170, 173, 189, 212, 246, 247, 251, 266, 274, 277
store-bought fabrics: general issues and examples, x, 163, 183, 185, 193, 194, 195, 199, 203–204; quilts of Anna Butcher Mayo, 214, 215, 218, 220–221, 222, 225, 227, 228, 229, 233, 234, 241–243, 248, 253, 267, 275–277, 284, 312–313, 317

Stowe, Harriet Beecher, 151
string quilts, 44
strip quilts, xxi, 22
structuralism, 18–19
styles, regional and ethnic: Amish, 192,
 197–199; Appalachian, 213, 264–
 265; as classifying principle, 4, 7;
 general issues, 161, 191–204, 205;
 North Carolina, 192, 194–195;
 Pennsylvania, 191, 192. See also aes-
 thetics: traditional; archaeology: style
sugar sacks, in quilts, 88, 173
Sunday quilts, 153–154, 183
surveys, in fieldwork, 184. See also
 documentation; fieldwork process;
 questionnaires
symbolism, quilts and, 179, 180, 189,
 190, 191
symmetry: design variation and, 95,
 132, 142, 218; general issues, 125; in-
 dividual designs, 132, 136–140, 146–
 147, 218, 228, 306, 307; quilts of
 Anna Butcher Mayo, 218, 223, 225,
 228, 238, 262, 282–283, 306, 307.
 See also symmetry analysis
symmetry analysis: appliqué and, 54–
 60; archaeology and, 8; general is-
 sues, ix, 8–10; individual designs of,
 16, 132, 136, 138–139; taxonomy
 and, 8–10, 25–26, 54–60. See also
 symmetry
synchretism, xxi
synchronic and diachronic methods,
 319, 324
synthetic fibers: batting, 197; fabrics,
 76–77, 89, 197; thread, 87, 88

tablecloths, 187
tacking of quilts, 70, 71, 89, 90, 284
tape measure, 164
taxonomy, biological: Linnaean, xxi,
 5–6, 11, 21; pre-Linnaean, 10–11

taxonomy of quilt designs: anomalous
 taxons, 60; cell concept, 20–30; cod-
 ing of, 32, 33; diagrams, 33, 256, 257;
 example, 44–50; folk, 3–4, 21; gen-
 eral issues, xx, xxi, 17, 19–30, 32, 92,
 97, 102, 317; hybrid taxons, 58–60;
 outline of, 30–44, 51–60; prior at-
 tempts at, 1–8, 10–16; quilts of Anna
 Butcher Mayo, 210–211, 212, 214–
 252, 253–257, 315, 317; seamed base
 taxons, 30–50; unseamed base tax-
 ons, 51–58. See also archaeology: ty-
 pology; cell concept; genetic rela-
 tionship in quilts
Taylor, Dora Bell, 158
technology, hand versus mechanized,
 162–168, 205, 266
templates: as abstractions, 26; drafting
 and, 102–104, 111–113, 120–126,
 225, 226, 261; innovation and, 102,
 111–113, 128; kinds of, 163–164;
 materials, 15, 22, 98, 164; mental, 98,
 309; print scale and, 143; quilts of
 Anna Butcher Mayo, 225, 226, 231,
 245–246, 261, 267, 276, 314; sets of,
 16, 20, 22, 98–99, 111, 149, 164;
 sources of, xvi, 164, 231, 276
terry cloth, 79
Texas, 21, 206
thimbles, 167–168
thread: hand quilting, 152, 196; hand
 stitching, 165, 214; hand weaving,
 163; machine quilting, 168, 231; ma-
 chine stitching, 167; as measure of
 cost, 152, 196; types of, 87–88
tifaifai, xxi
tiles, ceramic, 9, 124–125, 200
tiling, in mathematical analysis, 25–26,
 30, 32, 40, 49
tobacco pouches, 284
topological analysis, 54, 58, 59, 223
T-quilts, 62

tradition: nature of, 198, 209, 210, 211, 247, 265, 278–279, 302, 310. *See also* aesthetics: traditional; folk process; transmission

transfer printing of fabric, 82

transmission: cell as unit of, 30; culture of, 209, 318–326, designs of, 11, 26, 30, 178–182, 302; of quiltmaking tradition, 150, 165, 177–178, 198, 210, 260, 271, 272, 278–279, 320–326. *See also* cell concept; folk process; replication of quilt designs

trapunto, 68, 74

tricot, 80

tufting of quilts, 70

twill weave, 78

tying of quilts, 70, 71, 74

unseamed base quilts, taxonomy of, 30, 51–58

utilitarian quilts, 75, 183–186, 195, 197, 205, 237, 266, 275, 276, 284

value (light and dark), in quilt designs, 85–87, 106, 108, 116, 128, 135–136, 140, 143–145, 175, 178–179, 181, 241–243, 248, 280–281, 293, 316. *See also* color

velvet, 71, 79, 84, 85, 171, 172, 175

velveteen, 79

Victorian quilts, ix, 71, 194

Virginia, 18–19

wadded quilts, 22

wallpaper, 9, 142

War between the States, 161, 162

Washburn, Dorothy Koster, 8

water frame (Arkwright's), 161

wear, in quilts: general issues and examples, 74, 78, 83, 94–95, 154, 155–157, 161, 171, 172; quilts of Anna Butcher Mayo, 204, 213–252, 268, 270, 271, 272, 273, 274, 311. *See also* laundering; life cycle; "old" quilts; soiling; stains

weaving, hand, 9, 162, 280

Weissman, Judith Reiter, 6–8, 299

Welsh quilts, 22

West Virginia, 268

Whallon, Robert, Jr., 17

whole cloth quilts, 22, 52, 74, 76, 90, 125, 162, 163

Williams, Arbie, 206

Williams, Sarah, 319

Wisconsin, 300

Woodard, Thos. K., 4

wool, 75–76, 78, 80, 81, 82, 88–89, 154, 162, 172, 263

yarns: for cording, 69, 91; in woven fabrics, 77, 79, 81, 82, 88

Young, May, 15

yo-yo quilts, 60

zigzag stitch, 163, 231

 # Index of Quilt Names

Note: The following names appear as they are referenced from the literature or from field tapes.

All Over Pattern, 308
Arabian Star, 182
Arabic Lattice, 125, 200
Arrangement for Figured Material, 307
Autumn Leaf, 182

Baby Blocks, 144
Baby Bunting, 306
Basket of Lilies, 2
Bear's Paw, 182
Broken Plate, 180
Broken Star, 14

Cathedral Window, 60
Chain Quilt, 308
Churn Dash, 180, 181
Cleopatra's Puzzle, 306
Cockscomb, 191
Colonial Tulip, 3
Country Husband, 293, 299

Diagonal Stripes, 308
Diamond in the Square, 199
Dirty Windows, 308
Dolly Madison's Star, 182
Double Wedding Ring, 28, 44, 267–268
Dove I, 306

Doves, 306
Doves, The, 306
Ducks and Ducklings, 182
Dutch Doll, 192
Drunkard's Path, 291, 293, 294, 299, 304
Drunkard's Path Variation, 306, 307
Drunkard's Trail, 294

Eight Point, 177

Falling Timbers, 307
Flock of Geese, 2
Flying Crows, 177
Fool's Puzzle, 299, 303
Four Doves at the Window, 268–270
Four Point, 1
Full Blown Tulip, 3

Geometric Star, 182
Goose in the Pond, 7
Grandmother's Flower Garden, 182
Greek Cross, 180
Greek Square, 180

Happy Home, 177
Hens and Chickens, 182
Hexagonal Star, 182
Hole in the Barn Door, 180, 182

Indiana Puzzle, 306
I Wish You Well, 306

Jacob's Ladder, 15, 178, 181
Job's Troubles, 1, 3

Kite, 1

Lincoln's Platform, 180, 181
Log Cabin, 14, 20
Lone Star, 5, 177, 274, 276
Love Knot, 180

Mexican Star, 182
Mill Wheel, 306
Missouri Star, 182
Mosaic Patchwork, 177, 179
My Beloved Flag, 7

Nelson's Victory, 2, 179
Nine-Patch, 200
North Carolina Lily, 191

Ohio Star, 177, 179, 182

Peony, 191
Peony Patch, 182
Pieced Star, 182
Pomegranate, 191
Pullman Puzzle, 306

Quilted Rattlesnake, 187

Rabbit's Paw, 197
Reverse Arrangment of Fig. No. 9, 306
Rippling Waters, 308
Robbing Peter to Pay Paul, 299

Rob Peter to Pay Paul, 293, 299, 306
Rocky Road to California, 293, 299
Rocky Road to Dublin, 293
Rocky Road to Kansas, 293
Roman Cross, 3
Rose of Sharon, 179
Rose Wreath, 191

Satin Stitch Rose, 187
Sherman's March, 180
Shoo Fly, 180
Single Wedding Ring, 188
Snake Trail, 20
Snowball, 1, 181, 306
Snowball III, 306
Solomon's Puzzle, 293, 294
Star of Bethlehem, 182
Stepping Stones, 178, 181
Sunshine and Shadow, 303

Tail of Benjamin Franklin's Kite, 178,
 181
Texas, 206
Texas Star, 177, 182
Tulip, 191
Tumbleweed, 303
Turkey Tracks, 179

Underground Railroad, 178, 181
Unknown, 307
Unnamed, 308

Variable Star, 177
Vine of Friendship, 306, 307